PICTURES AND PROGRESS

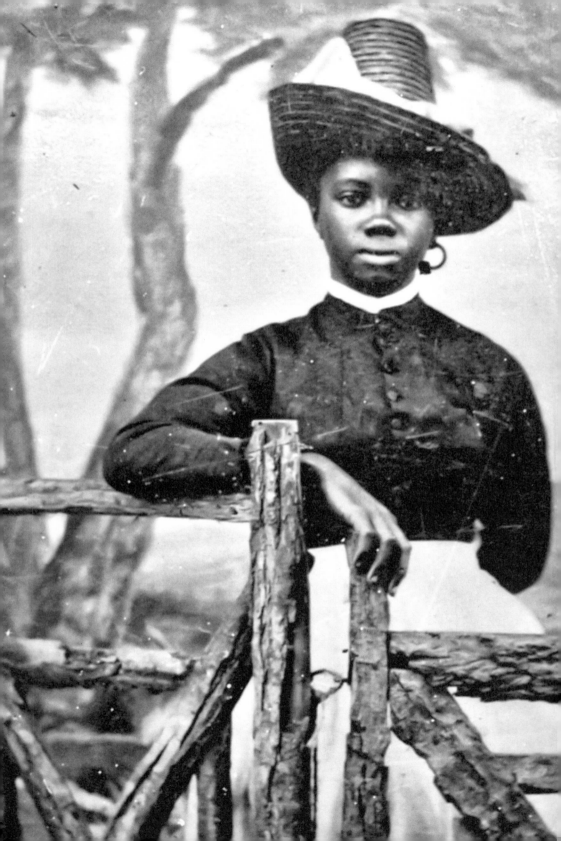

PICTURES AND PROGRESS

EARLY PHOTOGRAPHY AND THE MAKING

OF AFRICAN AMERICAN IDENTITY

Edited by Maurice O. Wallace and Shawn Michelle Smith

DUKE UNIVERSITY PRESS ❧ DURHAM AND LONDON ❧ 2012

Frontispiece: Portrait of a woman
with earring. Tintype, circa 1870s;
detail.

Chapter 5 was previously published
as "Who's Your Mama?: 'White'
Mulatta Genealogies, Early
Photography, and Anti-Passing
Narratives of Slavery and Freedom,"
by P. Gabrielle Foreman, *American
Literary History* 14, no. 3 (2002):
505–39. Reprinted by permission
of Oxford University Press.

Chapter 9 was previously published
as "'Looking at One's Self through
the Eyes of Others': W. E. B. Du
Bois's Photographs for the 1900 Paris
Exposition," by Shawn Michelle
Smith, *African American Review* 34,
no. 4 (Winter 2000): 581–99, and
reprinted in *The Souls of Black Folk:
One Hundred Years Later*, ed. Dolan
Hubbard (Columbia: University of
Missouri Press, 2003), 189–217.

 # CONTENTS

ACKNOWLEDGMENTS vii

INTRODUCTION Pictures and Progress
Maurice O. Wallace and Shawn Michelle Smith 1

ONE "A More Perfect Likeness":
Frederick Douglass and the Image of the Nation
Laura Wexler 18

TWO "Rightly Viewed": Theorizations of Self
in Frederick Douglass's Lectures on Pictures
Ginger Hill 41

THREE Shadow and Substance:
Sojourner Truth in Black and White
Augusta Rohrbach 83

Snapshot 1 Unredeemed Realities:
Augustus Washington
Shawn Michelle Smith 101

FOUR Mulatta Obscura: Camera Tactics and Linda Brent
Michael Chaney 109

FIVE Who's Your Mama? "White" Mulatta
Genealogies, Early Photography, and Anti-Passing
Narratives of Slavery and Freedom
P. Gabrielle Foreman 132

SIX Out from Behind the Mask: Paul Laurence
Dunbar, the Hampton Institute Camera Club,
and Photographic Performance of Identity
Ray Sapirstein 167

 Snapshot 2 Reproducing Black Masculinity:
Thomas Askew
Shawn Michelle Smith 204

SEVEN Louis Agassiz and the American School
of Ethnoeroticism: Polygenesis, Pornography,
and Other "Perfidious Influences"
Suzanne Schneider 211

EIGHT Framing the Black Soldier: Image, Uplift,
and the Duplicity of Pictures
Maurice O. Wallace 244

 Snapshot 3 Unfixing the Frame(-up): A. P. Bedou
Shawn Michelle Smith 267

NINE "Looking at One's Self through the Eyes of Others":
W. E. B. Du Bois's Photographs for the Paris
Exposition of 1900
Shawn Michelle Smith 274

TEN Ida B. Wells and the Shadow Archive
Leigh Raiford 299

 Snapshot 4 The Photographer's Touch: J. P. Ball
Shawn Michelle Smith 321

ELEVEN No More Auction Block for Me!
Cheryl Finley 329

BIBLIOGRAPHY 349
CONTRIBUTORS 369
INDEX 373

✿ ACKNOWLEDGMENTS

The completion of this volume is owed to the generosity of several people and institutions. We thank the Arts and Sciences Council Committee on Faculty Research at Duke University for its support of a two-day symposium where this project had its formal genesis. Also at Duke, Karen Glynn, the visual materials archivist in the Rare Book, Manuscript, and Special Collections Library at Perkins Library, deserves special mention for her support of *Pictures and Progress* since the inception of this collaboration. We are indebted to Alisha Damron, Alana Damron, and Ashon Crawley for research assistance. At Duke University Press, we could not have asked for a more patient and expert partnership than the one we have with Ken Wissoker and Leigh Barnwell. There is little doubt their enthusiasm for our project improved this volume as we worked to make *Pictures and Progress* worthy of the care and attention Ken and Leigh gave to it. We are also grateful to Rebecca Fowler and Alex Wolfe for their help in attending to the details of the manuscript in the process of production. We want to thank as well all of the contributors to this book. Their cooperation and trust in us was a real gift in this undertaking. Pam and Joe, we reserve our most profound gratitude for you.

Oxford University Press, *African American Review*, and the University of Missouri Press have graciously given permission to reprint two articles for this volume.

INTRODUCTION

Pictures and Progress

Maurice O. Wallace and Shawn Michelle Smith

No other means of representing human likeness has been used more systematically to describe and formulate American identity than photography. Envisioning and exhibiting the American self has been a photographic venture since the inception of the medium. It is an ongoing social, cultural, and political project.
—Coco Fusco, "Racial Time, Racial Marks, Racial Metaphors"

Perhaps only now, at the dawn of our digital age, with our witness to the dramatic transformations wrought by this revolution still ongoing, has the comparable impact of photography's magic on the nineteenth century begun to be fully appreciated. With the mechanical and electronic reproduction of images in the modern mass media animating so much of our cultural lives and prepossessing so much scholarly thought, serious attention cannot but return to the material beginnings of our visual dispensation. Today, owing to historians, cultural critics, and theorists as vital to the study of early photographic practices as Alan Trachtenberg, Laura Wexler, Deborah Willis, Allan Sekula, and the late Susan Sontag,[1] what Walter Benjamin portrayed as "the fog which obscures the beginnings of photography" seems, at last, to be dissipating.[2] The signal importance of photography's advent to modernity's hold on history is now clearly in view.

To be sure, photography was a watershed invention. So profound was the influence of photography upon antebellum and postbellum American life and thought that, like today's digital technology, early photog-

raphy shifted the very ground upon which the production and circulation of knowledges, scientific and philosophical, had set only a half century earlier. With the discovery of the daguerreotype in 1839, a phenomenologically photographic species of vision was materialized and the foundations of our modern structure of perception were irrevocably constituted. "A marked revision occurred in all standards of visual knowledge," the French poet and philosopher Paul Valéry wrote, and "man's way of seeing began to change, and even his way of living felt the repercussions of the novelty, which immediately passed from the laboratory into everyday use, creating new needs and hitherto unimagined customs."[3] In the United States, in particular, where photography's flourishing went unparalleled, photographic technology radically altered the ways Americans viewed themselves as subjects and citizens.

It was no coincidence, then, that early photography was implicated in certain important shifts in nineteenth-century American social and material relations. The deep impact of war, emancipation, mechanization, expansionism, and late-century immigration on American social life and identity was in no small way secured by the aid of early photography and its rapid advance over the century. More subtly, photography helped advance a readjustment of racial ideas and identities that had prevailed up to and, often, inside of these major shifts and transformations. The ill-conceived notion that the American Civil War was "a white man's war," for instance, was not just debated in lecture halls, magazines, and newspapers. It was opposed visually — pictorially contested, that is — in daguerreotypes, tintypes, and cartes de visite appearing in abolitionist organs and circulated among black soldiers, their kin, and communities. Studio portraits documenting the freedom dreams of the newly emancipated, landscapes challenging the frontier myth of unpeopled virgin plains, and the popular press pictures of eleven million European immigrants in the closing decades of the century were all not only preserved in the colonial archive by the documentary utility of photography but also helped give force to photography's increasingly talismanic, proleptic power over the cultural course of a nation convulsing with change.

Among these changes, perhaps none was so momentous to the early co-production of photographic vision and American national identity as the event W. E. B. Du Bois described as "the sudden freeing of . . . black folk in the Nineteenth Century, and the attempt, through them, to reconstruct the basis of American democracy."[4] Evolving contemporaneously with this near-seismic shift in the demography and meaning of free persons, photog-

raphy helped to adjudicate the meaning of freedom, picturing its African American subjects from the day of the daguerreotype to that of the silver print. But more than that, the technologies of photographic vision and the cultural meaning of photographs were themselves advanced, if asymmetrically, by the very question of freedom, racial and otherwise, that emancipation de-philosophized. "Photography was most certainly used to portray this period," as Jackie Napolean Wilson has written.[5] It was there "to justify, explain, and record" the truth and consequences of slavery and freedom. But just as certainly, photography emerged not out of a social or material vacuum but out of the world slavery made and, according to Nicholas Mirzoeff, "the violent interplay of cultures and peoples from Africa, Europe, and the Americas."[6] The photographs thus did much more than simply reflect in substance and shadow the wider social, political, and material calculus of the Atlantic world. They conditioned a modern way of seeing, physically conveying the new visual code in their material circulation between persons and places as if themselves in search of an ideal philosophy and form. This edited volume explores both the early history of photography in African American cultural and political life and the dialectical bearing of photographic vision on the wider logic of nineteenth-century racial thought.

The brisk commercialization of the daguerreotype in 1839, and the carte de visite in 1861, wrought vast changes in the performance of identities and the circulation of racial knowledges. Photography not only revolutionized visual representation but made it available to those previously cut off from its more bourgeois expressions in painting and sculpture, and Americans of all stripes were swept up by the democratizing promise of the new technology. *Pictures and Progress* examines the ways in which African American men and women variously used this new technology of representation to perform identities and to shape a dynamic visual culture.

In recent years scholars have rightly problematized and complicated the democratizing tendency often claimed for photography. They have demonstrated how quickly the new technology was harnessed to repressive forms of knowledge and systems of surveillance, how enthusiastically early race scientists adopted it to survey and catalog people into new categories of "types."[7] This important work gives us pause and shapes our

re-examination of photography's democratizing promise. Nevertheless, we suggest that something vital has been overlooked in the effort to delineate photography's repressive functions. Today we know more about Louis Agassiz's dehumanizing scientific daguerreotypes of enslaved African Americans than we do about early African American photographers and the African American men and women who commissioned daguerreotype, tintype, carte de visite, and cabinet card portraits, collected stereocards, or made their own tourist snapshots and assembled them in albums. We know more about the imagery of racism than we do about what African American men and women did when they took photography into their own hands. In part, this edited volume aims to recover the various ways in which nineteenth- and early twentieth-century African Americans viewed, conceptualized, and most importantly *used* the new technology of photography to chart and change and enjoy new social positions and political identities.

Building upon the groundbreaking scholarship of Deborah Willis, who has brought to light the work of many early African American photographers and has collected reflections on the role of photography in black life from contemporary African American writers, this book explores how prominent African American intellectuals, authors, orators, and activists understood, responded to, and utilized photography to create new spaces for self and community in the nineteenth and early twentieth centuries.[8] *Pictures and Progress* reconsiders such famous figures as Frederick Douglass, Sojourner Truth, Ida B. Wells, Harriet Jacobs, Paul Laurence Dunbar, Louisa Picquet, W. E. B. Du Bois, and Booker T. Washington as important theorists and *practitioners* of photography. Although they might never have focused the lens or released the shutter on a camera, they put photographs to striking use in their varied quests for social and political justice, plumbing and expanding the political power of the photograph. While these men and women may not have been photographers, it is fair to say that they *practiced* photography.

By focusing on early African American practices of photography, *Pictures and Progress* highlights the multifaceted intellectual, cultural, and political work of African Americans who have been recognized to date primarily for their contributions to literature and oration. Several chapters restore the wide-ranging cultural production of these prominent figures, cutting against the tendencies of academic disciplines to more narrowly define cultural work according to discrete categories. In this sense the collection also contributes to important recent scholarship that expands visual culture studies to include producers who think, write about, and

use images in ways that transform their possible purpose and meaning. In other words, *Pictures and Progress* aims in part to show that the intersection of literary studies and visual culture studies is a rich and generative point of departure for understanding the cultural work of images.[9]

African Americans had a particular stake in practicing photography and engaging its emerging visual culture in the nineteenth and early twentieth centuries. For while photography offered Americans an unprecedented opportunity for self-representation, it offered African Americans that opportunity as they were making claims on new legal, political, and socially recognized American identities. For many African Americans, photography served not only as a means of self-representation but also as a political tool with which to claim a place in public and private spheres circumscribed by race and racialized sight lines. The photograph became a key site through which a new identity could be produced and promulgated.[10]

The chapters collected here give a sense of the high stakes involved in early African American practices of photography, delineating not only the heavy weight of a legacy of racist misrepresentation but also the material conditions of slavery and racial violence against which photography was wielded. In this context, African American faith in photography, in tiny bits of glass, metal, and paper flung in the face of slavery or the lynch mob, seems extraordinary. But, of course, photographs were not expected to accomplish radical social change on their own. They were but part of multifaceted social justice campaigns. Photographs entered, engaged, and transformed political and philosophical debates and social activism, and photographs were also shaped by those efforts.

No African American figure in the nineteenth century was more effusive or eloquent about the advent of photography than Frederick Douglass, and none evidenced so dialectical an apprehension of its discovery. Although it is mostly for his rhetorical genius that Douglass is remembered above the nineteenth century's other black men of mark, Douglass himself understood that the new age was one of pictures more than words. His lectures "The Age of Pictures," "Lecture on Pictures," "Pictures and Progress," and "Life Pictures" enthused over photography's social and epistemological potential. In his 1861 address, "Pictures and Progress," he praised "the great father of our modern picture," Louis-Jacques-Mandé Daguerre, for "the multitude, variety, perfection and cheapness" of his pictures.

Daguerre, by simple but all abounding sunlight has converted the planet into a picture gallery. As munificent in the exalted arena of art, as in the radiation of light and heat, the God of day not only decks the earth with rich fruit and beautiful flowers—but studs the world with pictures. Daguerreotypes, Ambrotypes, Photographs and Electrotypes, good and bad, now adorn or disfigure all our dwellings. . . . Men of all conditions may see themselves as others see them. What was once the exclusive luxury of the rich and great is now within reach of all.[11]

That the country was just entering upon a war with itself at exactly the time Douglass desired to preach on pictures did not escape him. In a later version of his "Pictures and Progress" oration (probably early in 1865) Douglass acknowledged the "seeming transgression" of desiring to lecture on pictures, "in view of the stupendous contest of which this country is now in the theater, this fierce and sanguinary debate between freedom and slavery."[12] But the war, he perceived, was rapidly coming to a close, and he believed that "each new period, and each new condition seeks its needed and appropriate representation."[13] For Douglass and others, it was photography that was to be looked to for an "appropriate representation" of the dynamic new period ahead.

Among other things, Douglass applauded the accessibility of photography for ordinary people: "The humblest servant girl may now possess a picture of herself such as the wealth of kings could not purchase fifty years ago."[14] Leveling social hierarchies of portraiture that had been in place for centuries, photography offered a ubiquitous and seemingly universal tool of self-representation. But while the very proliferation of possibilities for picture making that photography enabled was noteworthy in itself, Douglass also suggested that more expansive forms of social change and thought might be effected by images beyond the mere fact of their universal consumption.

Indeed, one cannot overstate the importance Douglass accorded pictures. He argued that it was the "picture making faculty" that fundamentally determined what it meant to be human; "picture making" and "picture appreciating" distinguished men from animals: "The process by which man is able to invert his own subjective consciousness into the objective form, considered in all its range, is in truth the highest attribute of man's nature."[15] And as picture making uniquely defined human nature, so did it also serve as the impetus for all progress. For Douglass, picture making and viewing provided the primary catalyst for social change as these practices uniquely enabled criticism: "It is the picture of life contrasted with the fact

of life, the ideal contrasted with the real, which makes criticism possible. Where there is no criticism there is no progress—for the want of progress is not felt where such want is not made visible by criticism." It is only by making ourselves and others objects of "observation and contemplation" that we can begin to imagine better selves and better futures. Portraits uniquely enable us to "see our interior selves as distinct personalities as though looking in a glass," and from this "power we possess of making ourselves objective to ourselves," arises the potential for "self-criticism out of which comes the highest attainments of human excellence."[16] For Douglass, pictures enable us to see ourselves as if from the outside and, from this more distanced view, to contemplate and assess ourselves, drawing up plans for improvement. Encouraging self-critique in this way, pictures, according to Douglass, are the very foundation of progress, and photographic portraits can be catalysts for social change.

The recovery of Douglass's lectures on the social promise of photography poses a critical challenge to the prevailing view of him as "black master of the verbal arts." In 1987, with a century of biographical writing on Douglass supporting him, Henry Louis Gates Jr. posited Douglass as the first black "Representative Man" in American letters, pronouncing Douglass a "Representative Man because he was Rhetorical Man."[17] Since Gates's persuasive, path-breaking criticism on Douglass, few scholars have had any reason to imagine the ways Douglass's urgency to represent a collective Africanist voice to European racialists and slavery apologists might exceed writing.

During the Enlightenment and for some time afterward, the most important European thinkers—Immanuel Kant, David Hume, G. W. F. Hegel, and others—maintained that the absence of a visible black writing tradition attesting to the African's historical self-consciousness proved the African was not, in fact, innately human in the way the civilized European so decidedly was. Lacking a literature, the African possessed no voice, no expression of his objective differentiation from what Hegel described as "the universality of his essential being."[18] Although Douglass's commitment to registering a self-conscious, and thus human, black voice was pursued sensibly in public letters, to argue for the primacy of pictures in the age of reason and writing is no contradiction.

"Voice, after all, presupposes a face," Gates reminds us.[19] And a clear black voice presupposes the vision of a unified black subject whose face is the picturable assurance of his objective self-knowledge. As his several lectures intimate, Douglass looked eagerly to photography to lend a new

empiricism to the truth of the African's humanity and to the propitiousness of the future of the freeman.

Douglass intuited that photographs would uniquely carry the past into any future they might inspire. While providing an impetus toward progress, photographs would also conserve the past, allowing one both to measure distance from and to remain connected to previous epochs. Douglass proclaimed: "It is evident that the great cheapness, and universality of pictures, must exert a powerful though silent influence, upon the ideas and sentiment of [the time] present [and] future generations."[20] In the persistence of photographs, in the presence of absent subjects over time, Douglass saw a force that could shape the future. Loved ones absent or gone, preserved and treasured in the miniature forms of photographs, would maintain their presence and exert influence over their descendants. In this way the most common of photographic forms, the family portrait, could shape the present and future of African American life.

One of the most striking aspects of Douglass's response to pictures is his optimism. The unique capacity of humans to objectify themselves in images provides the grounds for study, criticism, and improvement. The idea that photography enables men and women to "see themselves as others see them" is productive for Douglass. His estimation holds nothing of the negative, shattering effect of Du Bois's later understanding of "looking at one's self through the eyes of others," which defined for him the state of "double consciousness."[21] Whereas Du Bois would emphasize the power of racism to distort the self-image of African Americans, Douglass imagined a much more autonomous African American viewer, seeking progress and improvement through a study of the self objectified as image. In Douglass's account, African Americans are the primary and most important viewers of their own images.

Although optimistic, Douglass was also highly attuned to the importance of the struggle over and for representation, and like Du Bois, he knew photographs circulated in a contested visual culture. Describing it as a "mighty power," Douglass proclaims that "this picture making faculty is flung out into the world—like all others—subject to a wild scramble between contending interests and forces."[22] Douglass particularly contended against the force of scientific racism institutionalized by the American School of Ethnology.[23] Indeed, while Douglass has long been a founding figure of African American literature and history, his place in the black social sciences, from W. E. B. Du Bois and Zora Neale Hurston to Frantz Fanon and, more recently, Stuart Hall, deserves special note. Although cast for the most part in a dialectical register, Douglass's lectures on pictures an-

ticipate a later assumption in black empirical thought, namely that a scopic regime subtends scientific racism in the modern West. Photography does not so much subvert the scopic regime for Douglass as it promises to readjust its sight lines and correct its habits of racist misrecognition. "The Age of Pictures," "Lecture on Pictures," "Pictures and Progress," and "Life Pictures," then, may belong as much to a canon of early black scholarship set against the scientific racism of the American School of Ethnology as to the prehistory of formal black philosophical discourse.

Put another way, despite their vague phenomenological cast, Douglass's meditations on pictures are of a piece with other, more scientifically driven works of nineteenth-century antiracist thought, including Martin Delaney's *The Condition, Elevation, Emigration, and Destiny of the Colored People of the United States, Politically Considered* (1852) and James McCune Smith's "Civilization: Its Dependence on Physical Circumstances" (1859). These important works oppose and answer back to a prevailing hegemony of academic proslavery apology advanced by the likes of the American ethnographers Samuel George Morton and Josiah Nott. However, Douglass's reflections on pictures and the promise of photography may share the closest kinship with James McCune Smith's "Heads of the Colored People" (1859), a series of ten sketches published in *Frederick Douglass' Paper* between 1852 and 1854. Together, "Heads of the Colored People" and Douglass's lectures give the lie to the pseudosciences of polygenesis, phrenology, and craniology in starkly visual terms. Far more intentionally than McCune Smith, however, Douglass fashioned a theory of visuality years ahead of its time. His own face, pictured in scores of daguerreotypes, tintypes, and engravings from the period, would prove to give that theory not only its "proper representation" but its proper "voice" as well.

Pictures and Progress brings to light the wide-ranging practices of early African American photography that Douglass celebrated, and it also attends to the more elusive social, political, and even epistemic ideals he saw rooted in picture making and its appreciation. This edited volume brings together chapters by scholars in a number of different fields to illuminate the historically understated influence of photography on African American cultural, political, and expressive production. It seeks to understand the many different meanings African Americans accorded photography and the variety of effects photography had on racialized thinking. It explores how African

Americans adopted and utilized photography in all its cultural forms to represent a new people, a new period, and new modes of black thought.

Laura Wexler opens with a discussion of the little-known public lectures Douglass gave in 1861 and 1865, delivered under the same heading as the title of this volume. She attends closely and carefully to Douglass's lectures on pictures, putting them into dialogue with their immediate audience as well as presenting their challenge to later theories of photography. She argues that Douglass was responding directly to Lincoln's inaugural addresses and that the conceptual shifts in his lectures on pictures accord with transformations in Lincoln's thoughts about the nation. Showing how deeply imbedded the lectures were in the important conversations of their moment, Wexler also shows how Douglass's lectures offer a theory of photography that expands modern conceptions of photography. She claims that Douglass's photography theory broadens understandings of the medium currently dominated by three subjects—photographer, viewer, and sitter—by proposing a fourth position, the *revenant*, or the one who returns from social death. Douglass is portrayed as a thinker deeply engaged in the most important national and technological debates of his time, whose insights extend well beyond his moment, offering new ways to think about the meaning and import of photography today.

Ginger Hill also studies Douglass's lectures on pictures. Examining closely Douglass's ongoing public thoughts on the critical meaningfulness of the advent of photography, she argues that more than an orator, writer, and publisher, Frederick Douglass was "a visual theorist." Douglass's lectures reflect the mind of a philosopher, a deep-thinking gnostic, equally as much as an abolitionist. As Hill shows quite powerfully, Douglass's fascination with photographs is not foremost an aesthetic one in his lectures but one very nearly phenomenological in character. Hill's study of Douglass's multiple lectures reveals the man to have found gripping the new technology's capacity for "photographing the soul." And, of course, Douglass's reworking of theories of human interiority implicitly bore on the place each soul held on the social hierarchy and thus, for Douglass, on racial progress. Carefully examining Douglass's multifaceted visual theory, Hill also proposes that Douglass was more than an *abstract* theorist, and her focus on how often Douglass sat for portraits suggests that he was enacting theory as well.

Evidently, however, Douglass was not black America's only practical visual theorist. For Sojourner Truth, as well, photography was part of a broader set of self-representational strategies she used to claim an autho-

rized voice and an audience for her work. Augusta Rohrbach examines the ways in which the famous orator crafted her photographic portraits to signal self-possession. Rohrbach shows how Truth utilized the photograph to claim her embodied presence for an audience, a presence she also celebrated in her commitment to orality over print culture. As Truth promoted herself through print, and through the writing of others, she announced her ultimate control over those representations by marking her presence in photographs. However, as she drew upon the indexicality of the photograph to mark her presence, she also cannily manipulated the pose to produce a persona, playing with both the constructed nature of the photograph and its associations with unmediated representation. According to Rohrbach, Truth utilized a variety of representational forms to create a marketable persona over the course of her life, but her self-fashioning is most evident in her photographic portraits and her shrewd use of the photograph's varied cultural meaning and power. For Rohrbach, Truth is an implicit feminist challenge to the priority and originality of ideas with which Douglass is traditionally credited, both in this volume and elsewhere.

Following chapters by Wexler, Hill, and Rohrbach is the first of four critical "snapshots" written by Shawn Michelle Smith. These snapshots are historical reflections on the visual practices of several early African American photographers. Snapshot 1, "Unredeemed Realities: Augustus Washington," foregrounds the Connecticut portrait photographer's haunting daguerreotype of the radical abolitionist John Brown in order to show how historic photographic images may serve an unrealized futurity as much as the narrative interests of history itself. It also anticipates the concern of Michael Chaney, P. Gabrielle Foreman, and Ray Sapirstein for the visual politics of slavery, abolitionism, and "uplift."

As Chaney shows, for example, Harriet Jacobs challenged the decorporealization of white subjects promised by the early visual technology of the camera obscura in her critique of slavery's visual culture. Consistently highlighting vision, especially looking, as inescapably embodied in *Incidents in the Life of a Slave Girl*, Jacobs grounds vision within the political landscape of slavery. She refuses to allow her reader the removed and disembodied vantage of the camera obscura, always placing the reader, by proxy, within slavery. Challenging the blindness of sentimental vision, as well as the privilege of the distanced view of the camera obscura, Jacobs insists that slavery must be seen from within.

While for some, like Jacobs, photography was simply the most con-

crete example of a racialized visuality, others used photography in ways that undermined the photograph's claim to make race visible. As Gabrielle Foreman powerfully shows, light-skinned heirs to a long legacy of forced interracial mixing could deploy the associations of photography with visual verisimilitude to challenge the definition of race according to visual signs. Foreman explores how several light-skinned African American women utilized photography to pass through representations coded "white," undermining the visual determinacy of race even as they claimed African American identities. Importantly, Foreman emphasizes that women made these strategic interventions in order to claim the legal, economic, and social rights of their white look-alikes but to do so as *African American* women. They utilized the photograph to pass *through* whiteness to a more fully autonomous African American identity.

Shifting the emphasis away from the abolitionist politics of the visual, highlighted by Chaney and Foreman, to the local politics of image production, Ray Sapirstein examines the understudied work of the Hampton Camera Club, a group of mostly white photographers and teachers at the Hampton Institute who photographed rural black life in Virginia for six of Paul Laurence Dunbar's volumes of poetry. Situating these photographs within the context of the racist caricature that prevailed at the time, while also comparing them to other forms of documentary practice, and reading them alongside Dunbar's poetry, Sapirstein reveals how the Hampton Camera Club posed African Americans at thresholds of social and historical change and considers how photographers and subjects could use these images strategically as "masks," carefully controlling what viewers would and would not see.

Snapshot 2, "Reproducing Black Masculinity: Thomas Askew," reflects upon the problem of black male misrepresentation in public life at the turn of the century and upon Askew's labor to create an image not simply of proper middle-class black masculinity but also of its reproducibility, both visually and socially. Snapshot 2 thematizes the visual politics of masculinity. It presages the prurient and political white interest in visible black male bodies explored by Suzanne Schneider in her re-reading of Louis Agassiz's infamous daguerreotypes of enslaved men and women. Schneider incites us to see Agassiz in these images and to recognize his homoerotic desire for the black male bodies under his putatively scientific gaze. As Schneider argues, viewers have too often been captured by the legitimizing discourse of science and its purportedly objective gaze, the same discourse that authorized Agassiz, and it has blinded them to the pornographic nature of the images and of Agassiz's investment in them. Schneider encour-

ages us to read these images against the grain of scientific "evidence" and to see them as records of the scientist's desire.

Maurice Wallace turns our attention to the production of the African American Civil War portrait. He argues that the production of so many cartes de visite of black men in uniform served to harmonize black men to the post-emancipation imperatives of national manhood. Against the contemporaneous shadow images of the mug shot and their visual codification of the myths of black male incorrigibility and sub-humanity, these images, Wallace contends, participated in no less than the invention of black manhood as a viable, culturally intelligible category of social identity. This is not a triumphalist argument, however. For, as Wallace is careful to point out, the dubious invention of black manhood in this wartime context relied upon these pictures' power to lie, deceive, and manipulate in such a way as to hide the wartime labor of black women and, thus, sacrifice their lives to the visual spectacularity of shiny brass buttons and crisp Union caps. Further, Wallace shows how the photographic chiasmus of "before and after" that U.S. Colonel Reuben D. Mussey designed when Private Hubbard Pryor of the Forty-fourth United States Colored Troops sat for his likenesses (one slave, one free) might be reversed and, in effect, subverted. Black men risk losing too—the violence of war and slavery indelibly written on their skin obscured by the dignifying camouflage of uniform. In more ways than one, then, photography has "framed" black male subjects forcefully.

As reliably as black male subjects have been "framed" by the duplicities of photography, early black photographers like A. P. Bedou worked to call attention to the practical framing of photographs, to the act of photographing registered within the photograph itself, in other words, and to effectively disrupt the otherwise invisible machinations of the "frame-up" vexing the photographic archive of black masculinity. Smith's "Unfixing the Frame(-up): A. P. Bedou," Snapshot 3, announces the theoretical concerns, if not also the very methodology, of chapters that follow by Smith and Leigh Raiford on W. E. B. Du Bois and Ida B. Wells, respectively, as photo strategists of racial progress and political sympathy.

Smith examines the photographs W. E. B. Du Bois compiled for the Paris Exposition of 1900, attending to their strange formal consonance with both criminal mug shots and middle-class portraits. Signifying across the bounds of property and propriety that separated criminal from upstanding middle-class citizen, Du Bois's photographs, according to Smith, challenge the discourses and images of "negro criminality" that reinforced the racialized boundaries of the white middle class at the turn of the cen-

tury. In Du Bois's hands the photograph becomes a disruptive force that troubles the oppositional paradigms of race and racism.

Resistance to representations of racism and its violence through photography were both subtle and overt. In her discussion of photography in the political work of Ida B. Wells, Leigh Raiford shows how Wells transformed a surprising range of photographs into antilynching images. Wells famously reproduced lynching photographs in her texts, turning the white lynch mob's moral outrage and protestations of black savagery back on themselves. In an original reading, Raiford shows how Wells also inventively used her own portrait, and the family portrait of a lynch victim's survivors, as antilynching photographs. The "political portrait" of lynching's survivors emphasized the place of African American women in the struggle against lynching and affirmed a politicized community of mourners. Shifting focus away from the abject male body as icon of lynching, the political family portrait drew attention to what the white mob's images obscured— African American communities of affection and resistance. Through her reading of Wells's varied deployment of photographs, Raiford widens the scope of lynching and antilynching's visual archive.

The final chapter is immediately preceded by Snapshot 4, "The Photographer's Touch: J. P. Ball." This snapshot shares a thematic focus on lynching with the previous two chapters, as well as an emphasis on the liberatory impulse to "unfix the frame(-up)" by calling attention to the act of photographing within the photographic field. It also harmonizes with Cheryl Finley's concluding chapter, as both deal with the material tactility of photographs. Finley reads closely and carefully an album of nineteenth-century tintypes of anonymous African American men and women. She considers how the art auction through which the album *came into her hands* resonates disturbingly with other auctions that might have haunted the album's subjects. Further, she considers the unique but always only partial testimony that anonymous photographs convey. Literally, in Finley's hands the anonymous images become not symbols of loss but tangible sources of creative imagining that provide an enigmatic promise to the future. As Frederick Douglass predicted, photographs of the past continue to inform the present, and Finley explores the persistence of photographic images and their importance for later generations.

In all, the chapters collected here exhibit the exciting work that is being done across disciplines in early African American photography. This work has much to teach us about African American social and cultural history and much to teach us about photography as well. Indeed, this work is helping to chart a new course in photography studies, shifting the focus of analy-

sis away from the photographer as sole producer of photographic meaning to the subject as performer and the viewer and collector as interpreters of photographic meaning.[24] Although the edited volume is weighted toward the productive uses of photography's early consumers, it does not neglect the important work of early African American photographers.

Pictures and Progress is about what subjects, consumers, viewers, and photographers *do* with photographs. It explores how African Americans made photographs and produced photographic meaning in the service of social progress—how African Americans *practiced* photography—in the late nineteenth and early twentieth centuries. As Frederick Douglass noted at the time, the late nineteenth century was indeed the "age of pictures," and photography helped to define the ethos of the era as well as direct the path of African American advancement. *Pictures and Progress* shows how African Americans sought to envision the "condition" and create "appropriate representation[s]" of black identity for the modern future.

Notes

1. See Alan Trachtenberg, *Reading American Photographs: Images as History, Mathew Brady to Walker Evans* (New York: Hill and Wang, 1982); Laura Wexler, *Tender Violence: Domestic Visions in an Age of U.S. Imperialism* (Chapel Hill: University of North Carolina Press, 2000); Deborah Willis, *Reflections in Black: A History of Black Photographers 1840 to the Present* (New York: Norton, 2000); Allan Sekula, "The Body and the Archive," *October* 39 (1986): 3–64; and Susan Sontag, *On Photography* (New York: Noonday Press, 1977).

2. Walter Benjamin, "A Short History of Photography," in *Classic Essays on Photography*, ed. Alan Trachtenberg (New Haven: Leete's Island Books, 1980), 199.

3. Paul Valéry, "The Centenary of Photography," in *Classic Essays on Photography*, ed. Alan Trachtenberg (New Haven: Leete's Island Books, 1980), 193–94.

4. W. E. B. Du Bois, *Black Reconstruction in America, 1860–1880* (New York: The Free Press, 1998), xix.

5. Jackie Napolean Wilson, *Hidden Witness: African-American Images from the Dawn of Photography to the Civil War* (New York: St. Martin's Press, 1999), ix.

6. Nicholas Mirzoeff, "The Shadow and the Substance: Race, Photography, and the Index," in *Only Skin Deep: Changing Visions of the American Self*, ed. Coco Fusco and Brian Wallis (New York: Henry N. Abrams, Inc., 2003), 112.

7. Allan Sekula's work has been especially influential in this regard. See Sekula, "Body and the Archive." Looking at visual culture more broadly, Michael Harris has studied the circulation of racist images in the nineteenth century, as well as African American artists' reappropriation and recontextualization of them. See Michael D. Harris, *Colored Pictures: Race and Visual Representation* (Chapel Hill: University of North Carolina Press, 2003).

8. Deborah Willis, *Reflections in Black*; and Deborah Willis, ed., *Picturing Us: African American Identity in Photography* (New York: The New Press, 1994).

9. Several recent books have explored that intersection in the later period of the Harlem Renaissance: Sara Blair, *Harlem Crossroads: Black Writers and the Photograph in the Twentieth Century* (Princeton: Princeton University Press, 2007); Anne Elizabeth Carroll, *Word, Image, and the New Negro: Representation and Identity in the Harlem Renaissance* (Bloomington: Indiana University Press, 2005); Cherene Sherrard-Johnson, *Portraits of the New Negro Woman: Visual and Literary Culture in the Harlem Renaissance* (New Brunswick: Rutgers University Press, 2007).

10. Henry Louis Gates Jr., "The Face and Voice of Blackness," in *Facing History: The Black Image in American Art, 1710-1940*, by Guy C. McElroy (San Francisco: Bedford Arts, 1990). Gwendolyn DuBois Shaw, with contributions by Emily K. Shubert, *Portraits of a People: Picturing African Americans in the Nineteenth Century* (Seattle: University of Washington Press, 2006). Deborah Willis, *Let Your Motto Be Resistance* (Washington, D.C.: Smithsonian Institution, 2007).

11. Frederick Douglass, "Pictures and Progress: An Address Delivered in Boston, Massachusetts, on 3 December 1861," in *The Frederick Douglass Papers: Series One, Speeches, Debates, and Interviews; Volume Three*, ed. John W. Blassingame (New Haven: Yale University Press, 1985), 452–53.

12. Frederick Douglass, "Pictures and Progress" [1865], Frederick Douglass Papers at the Library of Congress: Speech, Article, and Book file, 1846–1894 and Undated; American Memory, Library of Congress Manuscript Division, available online at http://memory.loc.gov/ammem/doughtml/dougFolder5.html, ms. page 1.

13. Frederick Douglass, "The Age of Pictures" in "Lecture on Pictures" [title varies], Frederick Douglass Papers at the Library of Congress: Speech, Article, and Book file—A: Frederick Douglass, Dated; American Memory, Library of Congress Manuscript Division, available online at http://memory.loc.gov/ammem/doughtml/dougFolder5.html, ms. page 35.

14. Douglass, "Pictures and Progress" [1865], Frederick Douglass Papers at the Library of Congress, ms. page 8.

15. Ibid., ms. page 12.

16. Ibid., ms. page 18.

17. Henry Louis Gates Jr., *Figures in Black: Words, Signs, and the 'Racial' Self* (New York: Oxford University Press, 1987), 108, 115.

18. G. W. F. Hegel, *The Philosophy of History*, trans. J. Jibree (New York: 1956), 93.

19. Gates, *Figures in Black*, 104. Although Gates did not invoke photography specifically as a complement to writing's powers of black self-creation, his ongoing concern for the meaning-filled "face" of the ex-slave Douglass raises the visual to an equal tropological status with the vocal in African American literature and history: "There remains to be done a great work of scholarship, one that in full rhetorical power can create a life of Frederick Douglass. . . . Perhaps a great scholar can restore to the life of Douglass its decidedly human face. . . . Just as [John] Blassingame has given to Douglass that fact [Douglass's certain date of birth] for which he searched to his death in vain, so perhaps will he give us the face of Douglass

as resplendently as he has given us, through his speeches and writings, Douglass's great and terrible voice" (124).

20. Frederick Douglass, "Pictures and Progress: An Address Delivered in Boston, Massachusetts, on 3 December 1861," in *The Frederick Douglass Papers, Volume Three*, ed. Blassingame, 458.

21. See Shawn Michelle Smith's chapter included here and *Photography on the Color Line: W. E. B. Du Bois, Race, and Visual Culture* (Durham: Duke University Press, 2004).

22. Douglass, "Lecture on Pictures," Frederick Douglass Papers at the Library of Congress: Speech, Article, and Book file—A: Frederick Douglass, Dated, ms. page 12.

23. Frederick Douglass, "The Claims of the Negro Ethnologically Considered: An Address, Before the Literary Societies of Western Reserve College, at Commencement, July 12, 1854, Delivered in Hudson, Ohio," in *The Frederick Douglass Papers: Series One, Speeches, Debates, and Interviews; Volume Two, 1847–1854*, ed. John W. Blassingame (New Haven: Yale University Press, 1982), 497–525.

24. Richard Powell provides extensive analysis of the subject's agency in black portraiture in Richard J. Powell, *Cutting a Figure: Fashioning Black Portraiture* (Chicago: University of Chicago Press, 2008).

 ONE

"A More Perfect Likeness"

FREDERICK DOUGLASS AND THE IMAGE OF THE NATION

Laura Wexler

We the People of the United States, in Order to form a more perfect Union . . .
— *Preamble* to the *Constitution of the United States*

Prologue

Born a slave, Frederick Douglass paid particular attention to photography.
Throughout his life, he sat for numerous photographic portraits and cir-
culated them as widely as possible. He also wrote a number of articles and
lectures on the subject. His ideas about the uses of photography are dif-
ferent from those articulated by many of his contemporaries, who were
chiefly engaged by how well the camera reflected and cemented existing
social relations. Like others of his generation, Douglass was interested in
pictures of family sentiment, but at his most intense he looked to pho-
tography for kindling rather than for kinship. During slavery, Douglass
heard in the click of the shutter a promise of the shackle's release. If black
people could appropriate by means of the camera the power of objectifi-
cation that slavery wielded, Douglass perceived that photography would
become an agent of radical social change. After emancipation, Douglass
thought photography could be a tool for remaking the American imagina-
tion. Such photography was a visionary force, offering an important ave-
nue for change.

Scholars of photography have only recently begun to attend seriously
to Douglass's contributions to the theory of photography.[1] Most of what

Douglass wrote on photography has not been widely read; much has not yet been published but remains in manuscript form in the Frederick Douglass Papers at the Library of Congress. This current book is a crucial contribution to addressing that oversight. In the present chapter I trace some of what is to be discovered about Douglass's ideas of photography by comparing his published lecture of 1861, "Pictures and Progress," with his major revision of that lecture believed to have taken place circa 1865, which still exists only in manuscript form and is undated. In particular, I believe that by closely reading and comparing each piece of writing we can see how Douglass is in conversation with Lincoln over the image of the black man and the image of the American Union. Photography is central to that conversation. Each lecture contains a timely response to one of Lincoln's inaugural addresses. In the first, written at the outset of the American Civil War, Douglass is troubled by Lincoln's hesitation to arm black troops. He proposes that the new technology of photography humanizes the image of the enslaved so that black men might be more widely seen as suitable recruits to the Union forces. In Douglass's revision of the essay, he encourages Lincoln and the country to anticipate the successful end of the war and turn toward rebuilding the nation. There he tries to describe how photography could now disseminate a prophetic image of the nation. Photography could make a likeness of the "more perfect Union" the Constitution had originally failed to deliver.

This is a distinctly different approach to the potential of photography than the one currently most in vogue among photography scholars. In *Camera Lucida* (1980; translated into English in 1981), Roland Barthes famously defined the three positions from which many critics today analyze the institutions of photography: that of the *Operator* of the camera, the *Spectator* of the photograph, and the *Spectrum* (or target) of the image. But in effect, in his pre- and post-slavery engagement in the 1860s with Lincoln's inaugural addresses, Douglass excavated a fourth position: that of the *Revenant*, or one who returns from the dead.

The word *revenant* derives from the French *revenir* meaning "to come back," "to come again," "to return."[2] Historically, it has been used to express the uncanny sense of déjà vu of something or someone previously thought to be absent or dead. It also contains within itself the French word *reve*, or "dream." All are implicated in Douglass's sense of the possibilities of photographic art and technology. Douglass believed that the formerly enslaved could reverse the social death that defined slavery with another objectifying flash: this time creating a positive image of the social life of freedom and proving that African American consciousness had been there

all along. For one thing, a motivated photographer could deflect the reifying gaze back upon the oppressor (i.e., return, send back). For another, if trained upon one's own self and people, the camera's unprejudiced gaze could undercut the slave power's ostensible "truth," that African Americans were only fractionally human, by showing a fully realized consciousness (i.e., the uncanny return of the socially repressed). And finally, photographs from around the world could reveal the scope of human similarity across difference, building an awareness of human commonality that had never before reached so deeply into ordinary everyday experience (i.e., the dream). Any one of these interventions would be enriching; all three together would support social revolution. From this vantage, photography sheds the melancholy fixation on death and loss with which Barthes has taught us to imbue it. As an avatar of social progress, the photographic *Revenant* enlivens the present and hails a better world.

Both Frederick Douglass and Roland Barthes wrote their brilliant accounts of the nature of photography by the light of meditations on death. The death toward which Barthes was looking was individual, the death of his mother, a private loss for which photography was so personal a solace that Barthes would not publish the image he found of his mother in his book about his search for that image. But the death that concerned Douglass was massive, public, and socially transformative. Upward of 20 million had suffered and died under the slave system, and at least 620,000 more people were killed in the war undertaken to end it. Amid such carnage, the position of the *Revenant* that appeared to Douglass through photography was available to all who would seek an image of a new birth of justice by black inclusion in American society. The potential commonness of this vision, like a leaf of Whitman's grass, gave Douglass hope for national renewal.

"Pictures and Progress"

On December 3, 1861, Frederick Douglass responded to an invitation to give a lecture in the Fraternity Course lecture series at Tremont Temple in Boston with a highly uncharacteristic act. Normally a powerful extemporaneous speaker, this time Douglass read his lecture aloud from a written text—and apologized for so doing. The lecture was about photography. Douglass was an enthusiast of the invention. Americans at the time generally understood photography to be a product of the union of science with nature. To Douglass, this new kind of picture promised to remedy what he saw as badly distorted visual representations of black people made by white

artists. As early as 1849 in a review of *A Tribute for the Negro* in his newspaper, the *North Star*, he had complained, "Negroes can never have impartial portraits, at the hands of white artists. It seems to us next to impossible for white people to take likenesses of black men, without most grossly exaggerating their distinctive features."[3] He castigated the ways in which illustrators commonly made black people seem a lower order of human: "The Negro is pictured with features distorted, lips exaggerated—forehead low and depressed—and the whole countenance made to harmonize with the popular idea of Negro ignorance, degradation and imbecility."[4] In his Tremont Temple address, he emphasized how the invention of photography could be used for unraveling the problem of racist representation.

Praising Louis-Jacques-Mandé Daguerre as the "great father of our modern pictures," Douglass celebrated photography among the other advanced technologies of the age.[5] He placed Daguerre in the company of other prominent inventors, such as Sir Richard Arkwright, James Watt, Benjamin Franklin, Robert Fulton, and Samuel F. B. Morse: "If by means of the all pervading electric fluid Morse has coupled his name with the glory of bringing the ends of the earth together, and of converting the world into a whispering gallery . . . [,] Daguerre by the simple but all abounding sunshine has converted the planet into a picture gallery."[6] He argued that the art of mechanical reproduction was a *natural* phenomenon: "As munificent in the exalted arena of art, as in the radiation of light and heat, the God of day not only decks the earth with rich fruit and beautiful flowers— but studs the world with pictures."[7] And he called attention to the social impact of the accessibility of such an invention: "Daguerreotypes, Ambrotypes, Photographs and Electrotypes, good and bad, now adorn or disfigure all our dwellings. . . . A man who now o'days publishes a book, or peddles a patent medicine and does not publish his face to the world with it may almost claim and get credit for simple modesty. . . . Next to bad manuscripts, pictures can be made the greatest bores. . . . They are pushed at you in every house you enter, and what is worse you are required to give an opinion of them."[8]

All these observations initially stayed within received opinion. Douglass along with nearly everyone else at the time espoused without irony a belief in photography's democratizing influence: "Men of all conditions may see themselves as others see them. What was once, the exclusive luxury of the rich and great is now within reach of all. The humbled servant girl whose income is but a few shillings per week may now possess a more perfect likeness of herself than noble ladies and court royalty, with all its precious treasures purchase fifty years ago." Douglass repeated the com-

mon claim that in the United States, "the smallest town now has its picture gallery." With the figure of the "humblest servant girl" he paired another stereotype, the "farmer boy [who] can get a picture for himself and a shoe for his horse at the same time, and for the same price."[9] He observed that vanity fed photography because "most men easily see in themselves points of beauty and excellence, which wholly elude the observation of other men."[10] And he spoke also about the influence of family photographs, especially of the dead, which "bring to mind all that is amiable and good, in the departed, and strengthen the same qualities."[11] At the outset of his lecture Douglass was using the theme of photography to break the ice, trying to relate to the already held opinions of his audience because he would soon have other things to say that would be much less familiar.

About a quarter of the way in, he abruptly changed course, declaring, "But it is not of such pictures that I am here to speak exclusively."[12] Douglass wanted to take the discussion of photography somewhere else. The second anniversary of the execution of John Brown found the country nearly a year into the Civil War that the wily old warrior had sought to ignite. Immediately after Lincoln's election in January, seven Southern states had seceded. In his inaugural address on March 4, 1861, Lincoln sought to persuade the South that there was no cause for war, even though Jefferson Davis had already been sworn in two weeks earlier as president of the Confederacy. "We are not enemies, but friends. We must not be enemies," Lincoln stressed in his speech, claiming that, "though passion may have strained, it must not break our bonds of affection."[13] Particularly, he sought to persuade the Confederacy that he would not interfere with the right to own slaves: "I have no purpose, directly or indirectly, to interfere with the institution of slavery in the States where it exists. I believe I have no lawful right to do so, and I have no inclination to do so."[14] In quick succession Fort Sumter came under attack and more states left the Union. Douglass was appalled by Lincoln's inaugural speech. He *did* believe the slaveholder was his enemy, and—the war having finally begun—he felt it was imperative to dedicate it to ending the peculiar institution that Lincoln seemed ready to protect.

Thus as he stood reading about photography before the audience at Tremont Temple on the second anniversary of John Brown's death, Douglass feared for his vision of race and nation. In direct response to Lincoln's remarks nine months earlier, Douglass attacked as many of the arguments of the inaugural address as he could. It was essential to give up on the idea that slavery was legal and "have done with the wild and guilty fantasy that man can hold property in man." Douglass told the audience that the coun-

try must "lay the ax at the root of the tree—and hurl the accursed slave system in to the pit from whence it came."[15] He found Lincoln's defense of the Union weak and dangerously conflicted. "While I do not charge—as some have that the Government is conducting the war on peace principles," he said, "it is plain that they are not conducting it on war principles." Chief among Lincoln's mistakes was his failure to enlist Southern slaves as soldiers. This could be fatal to the Union:

> We are fighting the Rebels with only one hand when we ought to be fighting them with both. We are recruiting our troops at the north when we ought to be recruiting them at the south. We are striking with our white hand, while our black one is chained behind us. We are catching slaves instead of arming them. We are repelling our natural friends—to win the friendship of our natural enemies. We are endeavoring to heal over the rotten cancer, instead of cutting out its death dealing roots and fibres. We seem . . . a little more concerned for the safety of slavery than for the slavery of the Republic. . . . The Government at Washington has shouldered all the burden of slavery in the prosecution of the war—and given to its enemies all its benefits.[16]

Douglass found a mechanical analogy that explained how time itself was out of joint. The country was like a broken clock whose machinery needed to be fixed: "The cause [of our troubles] is deeper down than sections, slaveholders or abolitionists. These are but the hands of the clock. The moving machinery is behind the face. The machinery moves not because of the hands, but the hands because of the machinery. To make the hands go right you must make the machinery go right. The trouble is fundamental."[17]

But change was inevitable. Nature herself, "a picture of progress," was a "rebuke to moral stagnation." In the age of invention, "nothing stands today where it stood yesterday . . . there is no standing still, nor can be."[18] Political as well as technological realities were shifting. John Brown himself was an example of this process, "and the faith for which he nobly died [was] rapidly becoming the saving faith of the Nation." Two years earlier, John Brown's own son was "hunted in Ohio like a felon," but now "he is a captain under the broad seal of the U.S. Government."[19] Meanwhile, "those who came to torment" John Brown in his jail cell, "stretched on his pallet of straw, covered with blood, marred by sabre gashes in the hands of his enemies, not expecting to recover from his wounds," were now themselves accused of "treason and rebellion."[20]

Photography, an emblem of human progress, was another such rebuke.

Underlying Douglass's attack on Lincoln's inaugural address is a theory of photography as revolutionary vision. For Douglass, the temporizing of Lincoln's defense of the legality of slavery in the slave states was just as much a distortion of reality as the grotesque images that white artists made of black faces and bodies, rendering them unacceptable to serve in the armed forces. Photographic seeing could help address that problem because it could correct the distorted representations of black manhood that put the Union at risk. Viewed correctly, black men would come to life in the white imagination, and Lincoln would find the soldiers the Union needed to win the war and vindicate the government.[21]

Photographic seeing would also address the problem of "moral stagnation." Douglass was sure that eventually, slavery *would be* destroyed, in part by this very nineteenth-century scientific progress of which photography was, itself, a symbol: "In every bar of rail road iron a missionary—In every locomotive a herald of progress—the startling scream of the Engine—and the small ticking sound of the telegraph are alike prophecies of hope to the philanthropist, and warnings to the systems of slavery, superstition and oppression to get themselves away to the mirky shades of barbarism."[22] A powerful new form of communication like the train and the telegraph, photography would help "dissolve the granite barriers of arbitrary power, bring the world into peace and unity, and at last crown the world with just[ice,] Liberty, and brotherly kindness."[23] In his inaugural address, Lincoln was standing in the way of progress, and "he who despairs of progress despises the hope of the world—and shuts himself out from the chief significance of existence—and is dead while he lives."[24] Photography could bring him back from this despair as a *Revenant*.

But Douglass, thinking beyond his quarrel with Lincoln, also extrapolated from modern photography an even greater principle of reform. *Inside* of a man were images as well, and these too could be improved upon by the progress that was epitomized by photography: "Rightly viewed, the whole soul of man is a sort of picture gallery[,] a grand panorama, in which all the great facts of the universe, in tracing things of time and things of eternity are painted." Photography showed mankind its own "right vision." Technological progress could bring not only the external but also the inner nature of man—the dreams of his soul, his "thought pictures"—more clearly to light, and better and better pictures would succeed one another.[25] Douglass believed that picture making—"the process by which man is able to invert his own subjective consciousness, into the objective form, considered in all its range"—was "in truth the highest attribute of man's nature."[26] The process of learning to make objective images was society's highest task. It

reflected "great nature herself—[which], whether viewed in connection or apart from man, is in its manifold operations, a picture of progress and a constant rebuke to moral stagnation."[27] This picture making was the end and aim of science; it was the animating principle of the age; it would justify the war to end slavery and the future of the American nation.

The Tremont Temple talk was not a success. The audience was impatient with Douglass's abstract reasoning and disappointed that he did not stick entirely to the sensational subject he was famous for—abolition, from the point of view of a former slave. One reviewer remarked that the audience was "listless and unattentive." Only at the end of the lecture, said another reviewer, when he "saved himself by switching off suddenly from his subject . . . pitching in on the great question of the day" (i.e., the Civil War) did the audience become "attentive and enthusiastic."[28] Douglass, of course, had been "pitching in" on the war the entire time, but those who heard him couldn't place his thoughts about photography into that context. Sharing his meditations on photography and speaking like a transcendentalist philosopher, Douglass himself, it seemed to those who heard him, was out of place.

But Douglass did not cease to think about the uses of photography as prophesy. In 1865 he responded to another invitation to give a public lecture by rewriting the text of his original talk and gave his theory of photography another try. Unlike the Tremont Temple lecture that he presented early in the war, this lecture was never reviewed so we do not know if Douglass was more successful with the public this time around. But it is clear from his changes to the text that his thoughts had deepened.

When he gave the earlier lecture he was not conscious of the prejudice that his audience would hold against a black man speaking about this subject. Four years later, he certainly was more aware of the flashpoints revealed by the bad reviews of his first lecture. At the same time, he was equally if not more engaged with the potential of photography in the field of reform. His fear of compromise was gone. Not only did Lincoln's reelection indicate that the Union would after all prevail; the sound defeat of his rival, General George V. McClellan, who had run as a "peace" candidate promising to negotiate with the slave power, promised at the war's end that the Union would stand for the abolition of slavery. Douglass now could say that: "the American people are not remarkable for moderation. They despise halfness. They will go with him who goes longest and stay with him who stays longest. What the country thinks of halfness and half measures is seen by the last election. We repudiate such men and all such measures. The people said to the Chicahominy hero—we do abhor and spurn you and

all whose sympathies are like yours,—and to Abraham Lincoln, they say go forward, don't stop where you are, but onward."[29]

Significantly, Douglass had also changed his opinion of Lincoln, whom he no longer thought of as the walking dead. In the second version of "Pictures and Progress," Douglass was again in dialogue with the president, but this time he was concerned with photography's ability to replenish both the devastated nation and its exhausted leader. Douglass opened his revised version of "Pictures and Progress" by explaining that he was conscious that the minds of his audience would be weighed down by the "stupendous contest" upon which, he wrote, "depends for weal or for woe the destiny of this great nation": "The fact is, that the whole thought of the nation during the last four years, has been closely and strongly riveted to this one object. Every fact and every phase of this mighty struggle has been made the subject of exhausting discussion. The pulpit, the press, and the platform—political and literary, the street and the fireside, have thought of little else and spoken of little else during all these four long years of battle and blood."[30] Yet even as he openly acknowledged that it might seem to them "an impertinence" to speak at such a time on the comparatively trivial theme of "pictures," Douglass led his audience once again into complicated meditations on the meaning of photography by means of a series of inter-articulated claims about picture making that were far from trivial. Moving from one perspective on the nation's "fierce and sanguinary debate" to another one more commanding and then to yet another, he again framed an argument by means of ideas about images, until at last an entire vision, a panorama of the magnificent meaning of the "mighty struggle," came into view. At the summit of the second "Pictures and Progress" manuscript, he harmonized discordant or jarring elements of four years of bloodletting as successfully as "scientific music" transcends the "wild and startling sounds in nature, of winds, waterfalls and thunder" that until then provided the only music to which "the poor savage" was accustomed.[31] The science was photography. The music was freedom.

When Douglass wrote this second version of "Pictures and Progress," the war was "rapidly drawing to its close." Douglass thought that the Confederacy was "perishing—not only for the want of men and for the materials and munitions of war, but from a more radical exhaustion—one which touches the vital sources out of which the rebellion sprung." It had become evident "that slavery, hitherto paramount and priceless, may be less valuable than an army—that the negro can be more useful as a soldier than as a slave."[32] The slave power's supply of energy, like the "moving machinery

behind the face of the clock" of the country that he had described in his earlier lecture, was broken. The time of the Confederacy was doomed.

Yet Douglass also recognized that exhaustion threatened the Union as well. As he had in his Tremont Temple lecture, he feared for the nation's well-being. But this time the reason was different. The tension of four years of war had narrowed the people's perspective. In this connection, his expansive thoughts about photography could be of use.

Douglass had no question that the war had been worth it, but he was worried especially about its cost to Lincoln. On the occasion of his second oath of office, despite clear signs to the contrary, Lincoln had refused to predict the Union's victory. The war was not yet officially over, and he claimed that "there is less occasion for an extended address than there was at the first" precisely because "the great contest . . . still absorbs the attention, and engrosses the energies of the nation . . . [such that] little that is new could be presented."[33] Lincoln was pensive and subdued: "Neither party expected for the war, the magnitude, or the duration, which it has already attained. Neither anticipated that the *cause* of the conflict might cease with, or even before, the conflict itself should cease. Each looked for an easier triumph, and a result less fundamental and astounding."[34]

Douglass acknowledged the vital need to stay the weary and difficult course. But as if in answer to Lincoln, he asserted that now *was* the time to develop a new and more expansive idea of what would have been accomplished when the war was over.

> The people can afford . . . to listen for a moment to some other topic. There is no danger of being injuriously diverted from the one grand fact of the hour.
>
> The bow will be unbent occasionally, in order to retain its elastic spring and effective power, and the same is true of the mind. . . .
>
> Thoughts that rise from the horrors of the battlefield, like the gloomy exhalations from the dampness and death of the grave, are depressing to the spirit and impair the health. One hour's relief from the intense, oppressive and heart aching attention to the issues involved in the war may be of service to all.[35]

Douglass felt that the weary Union was in need of new perspectives. In his brief second inaugural address, Lincoln had acknowledged that the old "offense of slavery" was dying, while God "gives to both North and South, this terrible war, as the woe due to those by whom the offence came."[36] Somberly, "with malice toward none; with charity for all," Lincoln's best

hope was that the nation could "achieve and cherish a just and lasting peace, among ourselves, and with all nations."[37] But Douglass thought "the people" should do more than bind their wounds. They should harness the "moral chemistry of the universe" to continue the work of progress.[38] The "elastic spring and effective power" Douglass now sought for the country would come, once again, from the contemplation of pictures.

To a historian of photography it is interesting to find Douglass still enthralled by Daguerre in 1865. In even more detail than in the first lecture, Douglass again enthused about the invention of the process of mechanical reproduction: "The art of today differs from that of other ages . . . as the education of today differs from that of other ages, . . . as the printing press of modern times, turning off two thousand sheets an hour, differs from the tedious and laborious processes, by which the earlier thoughts of men, were saved from oblivion." In glowing tones he echoed the boasts of the French Academy that "the great discoverer of modern times to whom after coming generations will award special homage will be Daguerre."[39] Yet once again, his focus was not on the literal history of photography. Rather, the existence of photography intimated to him that "a wilder and grander field of thought lies open before us."[40] Douglass this time directly acknowledged that it was not customary for a former slave to speak about photography. Yet with the war nearly finished, Douglass was determined to show his audience that his was a black American's point of view. "Pardon me," Douglass told his listeners in the most complex tone of the entire second lecture, "if I shall . . . be found discoursing of negroes when I should be speaking of pictures."[41] But really, he told them, he had little choice: "When I come onto the platform, the negro is very apt to come with me. I cannot forget him: and you would not if I did." His "friend Sojourner Truth," he confided, had said that she "does not speak to tell people what they don't know—but to tell them what she herself knows." He would have to give the speech he was "sent into the world to make." That would be "an abolition speech"—about photography.[42]

What Douglass was trying to get across to a somewhat uncomprehending audience was that "pictures" were inextricable from "progress," as much for the nation as "the negro." If "man," as Douglass repeatedly argued, is "the only picture making animal in the world," and "he alone of all the inhabitants of earth has the capacity and passion for pictures," then the kind of man who used to be an animal might be expected to produce a unique kind of picture in his passion for emancipation.[43] One had to differentiate freedom from slavery in one's mind's eye before one could produce or procure it for oneself or others. The past, the present, and the future

would have to be reimagined after slavery's demise. The nation, too, like the former slaves, must be taught to discern the new facts of existence. As the Civil War drew to its close, Douglass sought to demonstrate that image making—as in photography, painting, poetry, and music—was the means to this next emancipation. As Lincoln hoped for "firmness in the right, as God gives us to see the right,"[44] Douglass hoped photography would refocus "the right" that could be seen: "Poets, prophets and reformers are all picture makers—and this ability is the secret of their power and of their achievements. They see what ought to be by their reflections of what is, and endeavor to remove the contradiction."[45]

"Pictures and Progress" is surely among the earliest extensive theoretical works on the uses of photography to be written from the point of view of a former slave. From Douglass's perspective, American nature might be a "vast and glorious expanse which awes and thrills," but American *social space* could also be sublime.[46] The distance Douglass had traveled from slavery to self-actualization was literally vast. Douglass knew that photography held the potential to help others also bridge that chasm. His very manhood was the result of a picture-making imagination.

The Mask of Slavery

The tremendous originality of Frederick Douglass's theoretical engagement with photography has yet to be fully explored. I would argue that Douglass's dialogue with Lincoln's two inaugural addresses makes him the forerunner of what Leigh Raiford has called photography's "critical black consciousness," which she identifies as a body of African American photographic thought that ranges from antilynching activists in the late nineteenth century through the Black Panthers in the twentieth century.[47] Specifically, Douglass countered the death-in-life that was slavery's social truth with a radical vision of the potential life force to be gained through the photographic instrument. As such, Douglass's ideas critique contemporary representations of death as the ultimate truth of the photographic image.

This can be seen by comparing Douglass's thought to Roland Barthes's thought in *Camera Lucida*. There, Barthes elaborated three standpoints from which to analyze a photograph:

A photograph can be the object of three practices (or of three emotions, or of three intentions): to do, to undergo, to look. The *Operator* is the Photographer. The *Spectator* is ourselves, all of us who glance through

collections of photographs—in magazines and newspapers, in books, albums, archives. . . . And the person or thing photographed is the target, the referent, a kind of little simulacrum, any *eidolon* emitted by the object, which I should like to call the *Spectrum* of the Photograph, because this word retains, through its root, a relation to "spectacle" and adds to it that rather terrible thing which is there in every photograph: the return of the dead.[48]

To the first standpoint, that of the *Operator*, Barthes made no claim: "One of these practices was barred to me and I was not to investigate it: I am not a photographer, not even an amateur photographer: too impatient for that: I must see right away what I have produced (Polaroid?)."[49] As for the second, the *Spectator*, he famously derived the critical principle of his phenomenology by placing himself at the center and circumference of photography: "So I resolved to start my inquiry with no more than a few photographs, the ones I was sure existed *for me*. . . . So I decided to take myself as mediator for all Photography. Starting from a few personal impulses, I would try to formulate the fundamental feature, the universal without which there would be no Photography. . . . So I made myself the measure of photographic 'knowledge.' What does my body know of Photography?"[50] In a rolling series of justifications, Barthes determined that what a photograph is would have to be simply what it is *for him*.

But toward the third standpoint, that of the *Spectrum*—that person or that thing that *undergoes* photography—Barthes felt antipathy. He was fearful and did not like getting his picture made. To be photographed was to endure, according to Barthes, "a very subtle moment when, to tell the truth, I am neither subject nor object but a subject who feels he is becoming an object: I then experience a micro-version of death (of parenthesis): I am truly becoming a specter." To Barthes, this moment of reification was intolerable: "When I discover myself in the product of this operation, what I see is that I have become Total-Image, which is to say, Death in person: others—the Other—do not dispossess me of myself, they turn me, ferociously, into an object, they put me at their mercy, at their disposal, classified in a file, ready for the subtlest deceptions."[51] His privacy and even his civil rights are violated: "The 'private life' is nothing but that zone of space, of time, where I am not an image, an object. It is my *political* right to be a subject which I must protect."[52]

Barthes experienced submission to photography in much the same way that Frederick Douglass experienced submission to slavery: as social death.[53] But Barthes starts out alive and then dies into his picture, whereas the slave

starts out as a social corpse and is animated through the photograph. The terrible thing that was there in every photograph was for Barthes "a subject who feels he is becoming an object."[54] But for Douglass, the objectification of photography doubled back against his previous *lack* of a "*political* right to be a subject." Making another thing out of the making of a thing exposed the entire reifying process.

The question of slavery comes up explicitly in *Camera Lucida* only once, in connection with Richard Avedon's photograph of William Casby and its caption, "BORN A SLAVE, 1963."

> I think again of the portrait of William Casby, "born a slave," photo-graphed by Avedon. The *noeme* here is intense: for the man I see here *has been* a slave; he certifies that slavery has existed, not so far from us; and he certifies this not by historical testimony but by a new, somehow ex-periential order of proof, although it is the past which is in question—a proof no longer merely induced: the proof-according-to-St.-Thomas-seeking-to-touch-the-resurrected-Christ. I remember keeping for a long time a photograph I had cut out of a magazine—lost subsequently, like everything too carefully put away—which showed a slave market: the slavemaster, in a hat, standing; the slaves in loincloths, sitting. I re-peat: a photograph, not a drawing or engraving; or my horror and my fascination as a child came from this: that there was a *certainty* that such a thing had existed: not a question of exactitude, but of reality: the histo-rian was no longer the mediator, slavery was given without mediation, the fact was established *without method*.[55]

Casby is an old man who incontestably *was born* a slave. Yet Barthes sees only frozen time in the present-day face of this man, ignoring the fact of a long life after slavery. It is for Barthes as if Casby is *still* a slave, wearing the mask of that social station: "Photography cannot signify (aim at a gen-erality) except by assuming a mask. It is this word which Calvino correctly uses to designate what makes a face into the product of a society and its history. As in the portrait of William Casby, photographed by Avedon: the essence of slavery is here laid bare: the mask is the meaning, insofar as it is absolutely pure."[56] William Casby's changing personhood is opaque to Barthes. The photograph lays his "essence" bare: for Barthes, slavery was, is, and will always be Casby's "absolutely pure" meaning.

Nor does Barthes think further about William Casby. He especially does not remark upon the tiny reflection of Avedon and his camera that the photograph reveals in Casby's eyes. These two little cameras in his eyes

literally make the photographic apparatus into part of Casby's own body. Casby aims his doubled lenses directly at the spectator, shooting back the objectifying gaze. But Barthes ignores Avedon's remarkable reconceptualization of the power relations of photography. Indeed, he reproduces slavery's social relations by turning Avedon's animation of Casby's sight into a dead thing once again, "outside of society and of its history."

Instead, Barthes turns inward to consider himself as a boy, remembering a photograph of a slave market he cut out of a magazine and stashed carefully away. He would take it out upon occasion and regard it with fascination and horror. Barthes was intrigued by the image of slavery that was "not so far from us." But in his mind, the turning of humans into things had not to do with the French and the Algerians or the South East Asians or the deportation and death camps crowding onto the French horizon at midcentury. It had only to do with a picture, a mask. Hiding the picture in his mother's house — losing, eventually, the picture in his mother's house — Barthes played the *fort-da* game with slavery itself and kept a fuller sense of complicity at bay. *Roland Barthes* was not born a slave. *Roland Barthes* had a good mother.

Douglass, on the other hand, thought of himself as one born socially dead. Like Barthes, he also lost his mother. As a boy he was separated from her by the practical fact of slavery, and he never ceased to note her absence in his life. Nonetheless, Douglass learned how to make "something" of this "nothing" within the self. Douglass considered photography a weapon in his fight to become a man despite his status as a slave. If, he quoted Byron, "a man always looks *dead*, when his Biography is written," Douglass thought "the same is even more true when his picture is taken."[57] And here lay the crux of his photographic theory. Looking at a man who looks dead, but actually is not, can make the man seem more vividly to exist, bringing him forth and distinguishing him from his framing as a corpse. As in the incident of Douglass's famous fight with the plantation overseer Covey, if the enslaved could oppose the original scene of violence that turned him into a thing by means of a photograph's doubling of the initial objectification, then force against force would "bring him back alive."[58] Self-selected and administered, photographic reification could be appropriated and resignified by the formerly enslaved. In effect, Douglass added a fourth perspective to Barthes's more famous three: that of the *Revenant*, or one who returns from the dead. Barthes was afraid of the specter. But Douglass welcomed what came back from slavery's grave.

The *Revenant*

The *Revenant* is an effect of "liveness" produced over time. It requires images that repeat, or return, and to which *we* may also return multiple times to try to comprehend the intentions of their makers and what has happened to the fulfillment of their aims. The *Revenant* belongs as much to the future as to the past, as we project persistence of the liveliness that it inserts into the historical record. And thus it is in part a political concept, the appropriation and resignification of a scientific technology to serve the ends of freedom.

The *Revenant* appears when we contemplate not a single photographic image but images in sets and strings. I will briefly examine here a string of the multiple photographic portraits Douglass had made of himself over time. In this series, I propose, it is possible to discern decisions Douglass repeatedly made about self-representation and watch him holding firm to a particular interpolation into the American canon of "illustrious" men. Rather than masks of abjection imposed upon a former slave, the Douglass portraits are a different kind of social cover. They are signs of distinction assumed deliberately by a man who had formerly been denied it. The series of Douglass's images displays what an isolated image or a single moment in time cannot: the vital, active, subtle, informed, and determined will of an individual much more incorporated into the Zeitgeist than many of our imaginations (or many of our historians) tell us he was or possibly could have been as one who had been born and raised as chattel. Subtle differences appear as the subject ages, yet the continuity of his address to the camera and through it to the spectator and to the future is remarkable. Perhaps it is worth noting that in the sophistication of the management of his pose, Douglass may be paired once again with Lincoln, who also curated a photographic image carefully and consistently over time (even though the president was never socially dead). But be that as it may, it is the visibility of the evidence of his choices over time that produces Douglass as *Revenant*, for we see in the images something of how consistent Douglass was in this portrayal, how he thought about addressing the camera, and how he was imagining the promise of photographic portraiture generally, in accordance with his theory of "Pictures and Progress." We see, that is to say, Douglass making choices as a living man.

I have arranged the string of images chronologically, from early to late (figs. 1–5). In the first, assigned by historians to the late 1840s, Douglass is a young man in his twenties, a firebrand rising to fame in his career as an abo-

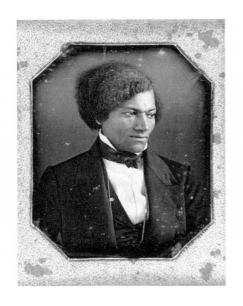

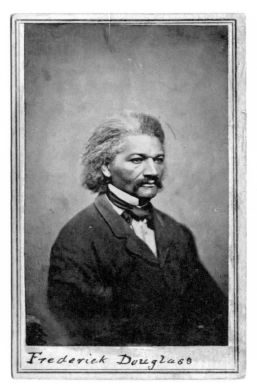

1. Portrait of Frederick Douglass, 1848.

Courtesy of Chester County Historical Society, West Chester, PA.

2. Portrait of Frederick Douglass, 1860.

Courtesy of Yale Collection of American Literature, Beinecke Rare Book and Manuscript Library.

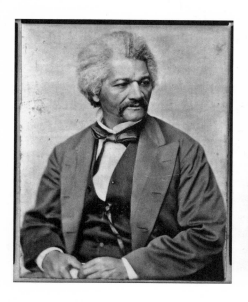

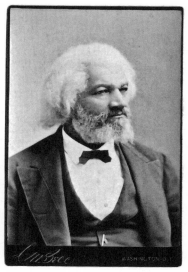

3. Portrait of Frederick Douglass, circa 1850–1860.

Prints and Photographs Division, Library of Congress, Washington, D.C. LC-USZ62–15887.

4. Charles Milton Bell, portrait of Frederick Douglass.

Courtesy of Yale Collection of American Literature, Beinecke Rare Book and Manuscript Library.

5. Cornelius Battey, portrait of Frederick Douglass.

Courtesy of Photographs and Prints Division, Schomburg Center for Research in Black Culture, the New York Public Library, Astor, Lenox and Tilden Foundations.

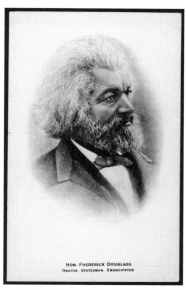

HON. FREDERICK DOUGLASS
ORATOR, STATESMAN, EMANCIPATOR

litionist orator (see fig. 1). In the last, from the end of the nineteenth century, taken near the end of his life in 1895, Douglass is an old man, worn by the effects of age and responsibility but still maintaining his consciousness of a mission that transcends his own mortality (see fig. 5). In between are three other photographs in which the maturation of the man from youth to elder statesman is visible (see figs. 2, 3, and 4).

What is striking in all these images—taken over the span of nearly half a century—is the consistency of the pose. It is true that widely accepted photographic convention dictated the three-quarter bust, the oblique angle, the gaze directed toward the right as the viewer sees it—just as we read from left to right, as our timelines move forward from early to late, and as we signify the space of the future. But here we see Douglass presenting himself with extraordinary consistency in many sittings over decades, beyond the requirements of the customary pose. Even in the middle image (fig. 3), where his body is turned the other way, he bears himself in virtually the same way as in all the others.

There are, of course, also many distinctions among the images. In the earliest one (fig. 1), a gold chain and ruffles on his shirt make Douglass into a little bit of a dandy compared to the later images. In the second two (figs. 2 and 3), he grows a handsome moustache while his hair becomes a streaked and distinguished grey. Later it turns entirely white and he grows a full beard (figs. 4 and 5). The suit and vest in the last three images (figs. 3, 4, and 5) are the same and differ from the suits in the earlier two (figs. 1 and 2), as if a younger exuberance has given way to an economy of purpose in the middle years when there is, perhaps, less time for, and less interest in, expenditure and vanity. The deep furrow over the bridge of his nose is consistent, marking him throughout. The piercing eyes and the resolute mouth are steady too, if not exactly replicated, although by the end of the series the beard is helping to jut forward a chin that may have lost some of its thrust to age. They are all pictures of a handsome man who lived an exceptional life. But they are also pictures of Douglass's attempt to make it a *representative* life—indeed, *to represent* that life and introduce the formerly excluded black man into the national pantheon.

Most Americans in the middle of the nineteenth century who referred to photography were decidedly not "discoursing of negroes," as Douglass put it in the second "Pictures and Progress" lecture. In 1850, Mathew Brady, to take a well-known example, published an album of twelve lithographs made after daguerreotypes, entitled *The Gallery of Illustrious Americans*. This album included figures such as Henry Clay, John Calhoun, and Daniel Webster, all of whom played prominent roles in compromises in-

tended to avoid the sectional conflict that resulted a decade later in war. C. Edwards Lester, Brady's coauthor, wrote in his text for the album that it "grouped together those American citizens, who from the Tribune and in the Field, in Letters and the Arts, have rendered the most signal service to the Nation, since the death of the Father of the Republic."[59] These serviceable men were all portrayed as sons of George Washington. The purpose, as Alan Trachtenberg noted in *Reading American Photographs*, was to unify Americans in a "figurative domestic circle" that would diminish the "threat of division, sectional and partisan."[60] But no black men, or women of any color, were included in the family: "*The Gallery of Illustrious Americans* veiled the fear at the heart of the book—fear of disunion descending into fratricide."[61] It pushed even further aside any acknowledgment of cross-racial family ties.

When he first lectured about photography in 1861, Douglass might well have thought that African American "sons" and "brothers" would soon appear in such national albums. He trusted that photographs along with the other inventions of the nineteenth century would "bring the world into . . . brotherly kindness."[62] But by the time he rewrote his talk, Douglass had lost the family illusion. The more than one million casualties of the fratricidal Civil War did not support confidence that brotherhood was the basis for lasting peace and progress. Instead, in his new version of the lecture Douglass made a critical move away from the familiar. Unlike so many of his contemporaries, Douglass this time offered the truth of photography as an *antidote* to sentiment. For Douglass, the nation's greatness was not threatened by disunion; it had been made possible only by the blood that was shed to end slavery. And only new visions of progress could consecrate that death.

A solemn Lincoln might tell the country to "hope for the future." But Douglass believed that photography would have to materialize that future first in order for hope to survive. What we have in this string of images, I believe, is evidence of how determined Douglass was to insert himself into the gallery as a living image of that progress. Such a degree of consistency as he displays had to be willed. Even while other kinds of pictures of him also exist, they do not diminish the significance of this particular performance. Over time, when Douglass might easily have wavered, he did not. As *Revenant*, he gathered himself up from social death in each and every instance and projected his vision of a more perfect likeness of the nation.

Notes

1. Of these, among the most important contributions, beyond those in this edited volume, are: Sarah Blackwood, "Fugitive Obscura: Runaway Slave Portraiture and Early Photographic Technology," *American Literature* 81, no. 1 (2009): 93–125; Sean Ross Meehan, *Mediating American Autobiography: Photography in Emerson, Thoreau, Douglass, and Whitman* (Columbia: University of Missouri Press, 2008); John Stauffer, "Race and Contemporary Photography: Willie Robert Middlebrook and the Legacy of Frederick Douglass," *21st: The Journal of Contemporary Photography and Culture* 1 (1998): 55–60; and John Stauffer, "Daguerreotyping the National Soul: The Portraits of Southworth & Hawes, 1843–1860," in *Young America: The Daguerreotypes of Southworth & Hawes*, ed. Grant Romer and Brian Wallis (New York: International Center of Photography, George Eastman House, and Steidl, 2005), 57–74.

2. See Avery F. Gordon, *Ghostly Matters: Haunting and the Sociological Imagination* (Minneapolis: University of Minnesota Press, 2008); and Sigmund Freud, "The Uncanny," in *The Uncanny*, ed. David McLintock (London: Penguin Books, 2003).

3. Frederick Douglass, quoted in Philip Foner, ed., *The Life and Writings of Frederick Douglass* (New York: International Publishers, 1950), 1: 379–80.

4. Frederick Douglass, "The Negro as Man," quoted in Donna W. Wells, "Frederick Douglass and the Progress of Photography," *HUArchivesNet: The Electronic Journal MSRC-Howard University*, no. 3 (February 2000), http://www.huarchivesnet.howard.edu/0002huarnet/current.htm.

5. Frederick Douglass, "Pictures and Progress: An Address Delivered in Boston, Massachusetts, on 3 December 1861," in *The Frederick Douglass Papers: Series One, Speeches, Debates, and Interviews; Volume Three*, ed. John W. Blassingame (New Haven: Yale University Press, 1985), 453.

6. Douglass, "Pictures and Progress" (1861), 453.

7. Ibid.

8. Ibid., 453, 455, 458.

9. Ibid., 454.

10. Ibid., 455.

11. Ibid., 458.

12. Ibid., 459.

13. Abraham Lincoln, [March 1861], *First Inaugural Address*, Final Version, The Abraham Lincoln Papers at the Library of Congress, available through the American Memory website of the Library of Congress.

14. Abraham Lincoln, [March 1861], *First Inaugural Address*.

15. Douglass, "Pictures and Progress" (1861), 469.

16. Ibid., 466.

17. Ibid., 465.

18. Ibid., 471.

19. Ibid., 470.

20. Ibid., 471.

21. For an excellent discussion of photography and African American manhood, see Maurice O. Wallace, *Constructing the Black Masculine: Identity and Ideality in Afri-*

can *American Men's Literature and Culture, 1775–1995* (Durham: Duke University Press, 2002).

22. Douglass, "Pictures and Progress" (1861), 472–73.

23. Ibid., 472.

24. Ibid., 471.

25. Ibid., 459.

26. Ibid., 461.

27. Ibid., 471.

28. Ibid., 452.

29. Frederick Douglass, "Pictures and Progress" [1865], Frederick Douglass Papers at the Library of Congress: Speech, Article, and Book file, 1846–1894 and Undated; American Memory, Library of Congress Manuscript Division, available online at http://memory.loc.gov/ammem/doughtml/dougFolder5.html, ms. page 1.

30. Douglass, "Pictures and Progress" [1865], Frederick Douglass Papers at the Library of Congress, ms. page 2.

31. Douglass, "Pictures and Progress" (1861), 460.

32. Douglass, "Pictures and Progress" [1865], Frederick Douglass Papers at the Library of Congress, ms. page 3.

33. Abraham Lincoln [March 4, 1865], *Second Inaugural Address*; endorsed by Lincoln, April 10, 1865, The Abraham Lincoln Papers at the Library of Congress, available through the American Memory website of the Library of Congress.

34. Abraham Lincoln [March 4, 1865], *Second Inaugural Address*.

35. Douglass, "Pictures and Progress" [1865], Frederick Douglass Papers at the Library of Congress, ms. pages 3–4.

36. Abraham Lincoln [March 4, 1865], *Second Inaugural Address*.

37. Abraham Lincoln [March 4, 1865], *Second Inaugural Address*.

38. Douglass, "Pictures and Progress" (1861), 465.

39. Douglass, "Pictures and Progress" [1865], Frederick Douglass Papers at the Library of Congress, ms. page 7.

40. Ibid., ms. page 9.

41. Ibid., ms. page 6.

42. Ibid., ms. page 5.

43. Ibid., ms. page 12.

44. Abraham Lincoln [March 4, 1865], *Second Inaugural Address*.

45. Douglass, "Pictures and Progress" [1865], Frederick Douglass Papers at the Library of Congress, ms. page 18.

46. Ibid., ms. page 6.

47. Leigh Raiford, *Imprisoned in a Luminous Glare: Photography and the African American Freedom Struggle* (Chapel Hill: University of North Carolina Press, 2011).

48. Roland Barthes, *Camera Lucida: Reflections on Photography*, trans. Richard Howard (New York: Hill and Wang, 1981), 9.

49. Barthes, *Camera Lucida*, 9.

50. Ibid., 8–9.

51. Ibid., 14.

52. Ibid., 15.

53. The fundamental reference for this idea is Orlando Patterson, *Slavery and Social Death: A Comparative Perspective* (Cambridge: Harvard University Press, 1982).

54. Barthes, *Camera Lucida*, 14.

55. Ibid., 79–80.

56. Ibid., 34.

57. Douglass, "Pictures and Progress" (1861), 455.

58. The incident is described in Frederick Douglass, *The Narrative of the Life of Frederick Douglass, Written by Himself*, ed. Henry Louis Gates Jr. (New York: Random House, 1997). The Abuelas de Plaza de Mayo use the phrase, "bring them back alive," to articulate the logical contradiction between the disappearance of their children and the denial of complicity by the Argentine government. In highlighting the improbability that their children are still alive, the Abuelas paradoxically rescue them from the social death imposed by the silence of the officials.

59. Alan Trachtenberg, *Reading American Photographs: Images as History, Mathew Brady to Walker Evans* (New York: Hill and Wang, 1989), 49. For an essential examination of gender, race, and class in nineteenth-century U.S. photography as a whole, see also, Shawn Michelle Smith, *American Archives: Gender, Race, and Class in Visual Culture* (Princeton: Princeton University Press, 1999).

60. Trachtenberg, *Reading American Photographs*, 49.

61. Ibid., 52.

62. Douglass, "Pictures and Progress" (1861), 472.

 TWO

"Rightly Viewed"

THEORIZATIONS OF SELF IN FREDERICK

DOUGLASS'S LECTURES ON PICTURES

Ginger Hill

Frederick Douglass, an esteemed if oftentimes-controversial orator, writer, and publisher, now remembered for a lifetime commitment to social justice and antiracism, was also a visual theorist. Through close analysis of Douglass's visual legacy, John Stauffer, Donna Wells, Colin Westerbeck, and others have demonstrated that the widespread circulation and familiarity of Douglass's visage is most likely a result of his willingness and probable resolve to be photographed according to a very particular, fastidious standard. The conventional portrait of Frederick Douglass, poised in an isolated, three-quarter view, with a serious facial expression and elegant, upper-class attire, is such a well-known image that even today his face often remains unhesitatingly recognizable.[1]

Frederick Douglass also gave multiple lectures between 1859 and 1865 celebrating the technological innovation enabling portrait photographs, linking the genius of individual invention to possibilities of shared human progress.[2] Variously titled "Life Pictures," "Age of Pictures," and, the best known, "Pictures and Progress," these lectures on pictures reworked reigning theories of what defined human interiority, relaying complex ideas engendered, in part, by response to the new and ubiquitous medium of the photograph. Douglass's musings on pictures served as a starting point for his more general and urgent concerns of human experience and social change. His ideas *about* pictures, I contend, should be considered just as important to histories of visuality in the United States as his sitting *for* pictures.[3]

Douglass spoke of pictures as a metaphor for, and expression of, human interiority. Most remarkably, his lectures on pictures explored the *constitution* of human interiority in photographic terms. Douglass celebrated photography because in viewing photographs, one had to grapple with the complexity of what it means to live an embodied existence. Douglass's lectures were concerned first and foremost with processes of exchange: the confrontations, accommodations, and accumulations that forge and transform sensate beings into something of a self. Douglass proffered a schematic description of an additive process, building from embodied existence a perceptual repertoire that, in turn, enables the possibility of self-creation. Two conclusions drawn from these compelling insights of Douglass's lectures on pictures are the focus on this chapter: First, the exclusion of persons from humanity based on racial criteria, though scientifically incorrect and epistemologically unsustainable, is maintained in large part through socially habituated visual perception, and may be challenged through both visual objects and, more importantly, *scrutinizing habits of looking*. Second, the complexities of how visuality functions in *creating* a self suggest that transcendentalist understandings of self-consciousness as unfettered by materiality are severely limited.[4] Explorations of these limits challenge both reigning definitions of human essence and the necessary conditions for realizing black social progress in nineteenth-century America.[5]

The individual image, as discussed in Douglass's lectures, is as limited as a solely transcendentalist focus on disembodiment. Douglass creates a visual metaphor of *serial* collecting and viewing of pictures as human interiority itself. "Rightly viewed," Douglass says, "the whole soul of man is a sort of picture gallery[,] a grand panorama, in which all the great *facts* of the universe, the *tracings* of *time* and *things* of eternity are painted."[6] More complicated than passive imprints, these internal pictures are the fodder for human engagement with, and transformation of, the now-distinct world. This internal gallery is a shifting seriality, from image to image, "which sets all the machinery of life in motion." It generates human interiority, enabling its proprietor to be an agent of creation: "The process by which man is able to *posses[s]* his own subjective nature outside of himself—giving it forms, color, space, and all the attributes of *distinct* personalities—so that it *becomes the subject* of *distinct* observation and contemplation *is at bottom of all efforts*, and the germinating principle of all reform and all progress."[7]

Douglass's own constant sittings for portrait photographs suggest a strict concern with visual reform. His precise public image conforms to monotonous, middle-class standards of legible self-possession and proper— which is to say, propertied—public standing.[8] Delivered during the vola-

tile war years, Douglass's lectures on pictures espouse a theory of the self as a contemplative interiority manifested through self-possession. Like his photographs, such notions adhere to a conventional definition of selfhood. In this liberal formulation, "the human essence is freedom from dependence on the wills of others, and freedom is a function of possession."[9] Thus, self is determined by the right to self-possess and possess rights.

Through descriptions of familiar experiences of perception, moreover, Douglass proposed that the self, rather than existing as an a priori autonomous subjectivity simply awaiting expression, is made by, and dependent upon, materiality. Subjective perspectives, what Douglass calls "individual truths," are formed via sensorial engagement with phenomena. That *newly* formed self acts upon and transforms his or her world.

Critically, though all subjective human experience grapples with the condition of being thrown into worlds not of our making, we are thrown differently according to *social* systems of value and relations of power.[10] To change habits of viewing, Douglass suggested, is more than an issue of the *content* of images. A new valuation must be placed on the viewing and creating of pictures, in order to accumulate internal, rich picture galleries of the soul. More simply put, the constant interdependence of human existence is both the most threatening and potentially liberating condition of possibility, wherein habits of humanity that "either lift us to the highest heavens or sink us to the bottomless depths" involve seeing and being seen.[11]

The initial response to these abstract arguments of lectures like "Pictures and Progress" is difficult to gauge, but it seems to have been tepid at best. Though the *Liberator* pithily stated it was "creditably written and warmly applauded," another reporter declared the lecture "came near being a total failure." The speech was salvaged only when Douglass switched from the topic at hand—pictures—to address slavery and the American Civil War, which then "gave evidence of some of Douglass's old power" and "relieved the audience from what they feared would be . . . an evening without result."[12] If Douglass's immediate listeners were unresponsive to his theorization of outer and inner representations, and instead looked for his speech to conform to their usual expectations of political excitement, only then rousing their "listless and unattentive body" to an "attentive and enthusiastic" state, his audience unknowingly conformed to the very behavior Douglass was trying to describe. "Pictures are decide[ed]ly conservative," he said, and once the public has a conception of a man by way of a picture, he must conform to it, for it is all they can see.[13] In "Pictures and Progress," by departing from his audience's expectations, Douglass had asked his lis-

teners to see him anew, with hopes of bringing them to see themselves differently as well. Douglass's lectures on pictures required more of his audiences than simply considering the content of a different view; they addressed the very process through which one arrives at a perspective.

In addition to their divergent content, Douglass's lectures on pictures also diverged from his better-known styles of authorship. His first narrative, both a political and literary achievement, succeeded through a laconic style. But as a public speaker, Douglass was "majestic in his wrath."[14] Still more differently, Douglass's lectures on pictures were often ambulatory, sprawling, difficult to follow, and, at times, self-contradictory. The audience's desire for Douglass's "old power" suggests a criterion of direct, youthful vigor, rather than the nuanced, speculative nature of "Pictures and Progress."[15] Ironically, these abstract, philosophical orations were most fully developed during moments of immediate threats of violence to his person (because of his ardent antislavery speechmaking). That Douglass was seeking to advance highly theoretical ideas about human interiority in this context of heightened vulnerability is a sign of the material and psychic urgency Douglass saw in the political potential of photography.

Douglass valorized the notion of the "self-made man" and used photography to this aim. Douglass's use and celebration of photography, though attempting to secure possessive individualism, actually divulges the contingency and failures of such a conception of selfhood. Douglass's lectures on pictures redefined the essential traits of humanity in order to dislodge racist views of both the American School of Ethnology and more commonly held popular assumptions. In explaining these processes, these lectures provide a more general theory of subjectivity that insists upon embodied perception and socially habituated practices. Douglass's explanations of the role of pictures in relation to appearance, experience, and truth are presciently similar to ideas developed in the much later work by the philosopher Maurice Merleau-Ponty. Such continuities underscore that Douglass constructed a composite definition of truth and explained selfhood as embodied, limited, and interdependent. These ideas complicate any espousal of disembodied transcendentalism. It remains important, however, that the violent historical context surrounding these lectures not be overlooked. Douglass's notion of "thought pictures" evokes a fugitive, vexed status between person and thing, interior and exterior. The most urgent significance of these lectures lies in their recurrent emphasis on the perpetual constitution of interiority, and Douglass's call for attentive consideration of the exchanges between human imagination and habit.

Douglass's original audiences may have felt impatient with these abstract ideas. As present-day scholars have warned, grappling with the conceptual challenges of the realities of slavery by way of philosophy risks "intellectual evasion," a bad faith sublimation running in the face of horrific facts.[16] Having long lived in a state of urgency due to conditions not of his making in slavery, and having endured continued threats to his life and limb at every turn of his resistance as a freeman, Frederick Douglass now pondered pictures and human subjectivity in an attempt to fully engage and counter the transcendentalist urge to leave behind lived experience and the concrete banality of everydayness. The difficulty of these lectures, then, fraught with complexity, lyricism, and contradiction, might reflect the gravity, necessity, and impossibility of their aim, no less than challenging definitions of the human to maintain hope for a collective future.

Properties of Freedom: Looking Out

Many of Douglass's lectures celebrate exceptional individuals, the "self-made men" who, through their own striving, rise above their conditions and surpass their peers to accomplish great deeds. In the lectures on pictures this theme appears in the figure of Louis-Jacques-Mandé Daguerre, the genius credited with the invention of photography. Douglass claims Daguerre's ingenuity benefited the entire age, and he implores his listeners to recognize Daguerre's labor in the modern marvel of photography: "We drink freely of the water at the marble fountain, without thinking for the assessment of the toil and skill displayed in constructing the fountain itself."[17] In admonishing his listeners to acknowledge individual achievement, Douglass suggests that praising the object of Daguerre's creation is insufficient to repay society's debt to him. Praise sustains the individuality of the person and refuses to subsume his memory into the object of his invention. The divide between personhood and object remains distinct.

Taking up Daguerre's invention and subsequent photographic innovations, Douglass underscored his own individuality and propriety through circulating numerous photographic portraits of himself. Douglass was highly invested in presenting a conventionally legible, believable portrait that would suggest a very *particular* sense of his character to solidify his claims to nothing less than full humanity. These visual affirmations were more than issues of vanity or celebrity; projecting an image of veracity and respectability was the foundation upon which any man could claim citizenship and the protective and protected natural rights attached to that

legal designation. Similar to the panegyrics to Daguerre, Douglass's portraits are visual arguments for a liberal conception of freedom that prizes individuality.

Since the eighteenth century, the political rights of the liberal citizen-subject, according to the political theorist C. B. Macpherson, can only be claimed by an autonomous, self-contained individual. This status relies upon property ownership, self-sovereignty, and the law, characteristics that Macpherson collectively calls "possessive individualism."[18] The historian Lynn Hunt recently extended this understanding beyond political and legal discourses and into habitual, daily practices. She demonstrates that the idea of the autonomous person claiming rights required a new, quotidian presentation of self-containment and control to differentiate self from others. This delineation presumes a highly developed individual interiority and also relies upon recognition from others. Citizenship, then, is not just a matter of political theory but an emotional capacity and lived experience of shared processes of identification.[19] Frederick Douglass's insistence upon honoring self-made men like Daguerre underscores that self-development, and its expression via material accomplishment must be affirmed by others. Paradoxically, these paeans to Daguerre reiterate the social exchange necessary for autonomy. Photographs were another means to establish emotional identification and political recognition.

As Douglass's writings expanded in scope and length, so did the production and circulation of his photographic portraits, especially after 1860. These widely disseminated images claim and proclaim his complex interiority and his status of self-possession in an easily recognizable visual rhetoric, adding truth-value to his public persona and increasing its dissemination and currency. Though he sat for photographs often, and was in the habit of giving away his pictures during his constant travels, Douglass never wrote about his personal experience as a photographic subject. What is known from the extant visual documents is that he posed for numerous sessions before multiple operators over four decades.[20] By scattering daguerreotypes, ambrotypes, cartes de visite, and cabinet cards during his travels, Douglass left a material reminder of his presence.[21]

And yet it was not so easy for Douglass to claim the status of rights-bearing autonomy through an increased empathy formed by way of portraits. If propagating photographs of himself became one means to signify and ensure Douglass's claim to rights, including liberty, it simultaneously invoked the historical specificity and limitations of such liberally conceived freedom. This use of photography, the medium that was often conceived

as fixing fleeting appearances into stable, delineated images, complicated any easy divide between person and thing, proprietor and property, freedom and slavery. Though no longer a fugitive slave, and irrespective of his monumental individual achievements, Frederick Douglass's social standing remained in question because of the ways assumptions about race have historically structured claims to citizenship.

Liberal democratic perspectives, such as those of Hunt, assert that the subject of human rights simply needs to be expanded to those who were formerly excluded. The literary theorist Samira Kawash, however, challenges this method of addition, showing that the free subject of rights exists through defining itself, fundamentally and inextricably, against slave status. By the late eighteenth century the visibly white body became a sign for such self-possession within the social system of racialized slavery in the United States; the black and now-presumed enslaved body, in contrast, existed as that which was not–citizen–subject, property of another.[22] Whereas slavery was the submission of one will to another, the free citizen was not defined by the opposite, a complete lack of restraint, but by an internalized self-containment. This self-mastery is what Frederick Douglass repeatedly attempted to document visually.

Within racial slavery and its aftermath, persons associated with blackness were considered inherently incapable of the self-restraint so necessary for freedom. Within liberally conceived freedom, freedom was for those who possessed. One's self-possession entitled the free subject to own property that, coterminously, must be recognized by others. Tautologically, exterior property was supposed to confirm one's interior personhood, full claims to humanity, and protections of citizenship.[23] In actual practice the citizen-subject's natural rights were thus culturally inscribed, granted to some through recognition of possession, while withheld from others through violent force.

If to be a citizen-subject, then, is to be free, and freedom is the unquestioned and legally protected right to property possession, then such freedom is not the same as physical escape for a fugitive slave. Kawash's most important insight is that the status of a fugitive slave divulges the limits of freedom conceived and practiced within liberal confines because the fugitive is neither slave nor free, neither a thing as property (since one has stolen oneself), nor a person with property (since one has no right to possession).[24] Structuring violence is not stopped by flight from slavery (nor, it should be remembered, through legal emancipation). Remaining under constant threat, fugitivity is unsustainable. It must dissolve, either through

re-enslavement, purchase, or death. Though it does not entirely destabilize or overhaul the presiding social order, fugitivity divulges that freedom is nonequivalent with an autonomous free will or natural rights.[25]

In 1846, under the threat of a forcible return to slavery, the fugitive Frederick Douglass chose freedom through economic purchase. Against the wishes of Garrison's American Anti-Slavery Society, Douglass allowed his supporters in England to buy his legal emancipation.[26] Strategically assembled portraiture confirmed this free status, accumulating the trappings—the properties—of the citizen-subject: self-control, bourgeois fashion, genteel sensibilities. Adhering to middle-class portrait conventions, these were visual appeals for recognition from the viewer. What can be inferred from visual evidence is that Douglass or the operators preferred the half-length or isolated bust format, furthering connotations of autonomy.[27] Furthermore, in contrast to images such as Mathew Brady's famed pictures of the standing Abraham Lincoln, Douglass's formal studio portraits from the 1850s to 1890s most often leave out the studio surroundings and focus on his characteristic serious facial expression. Visual portraits confirm biographers' speculations that Douglass paid rapt attention to his clothing, often wearing stylish yet somber suits, and well-pressed shirts and cravats, guarding a presentation of bourgeois respectability.[28] Douglass was so insistent on this image of order, esteem, and propriety, that while on the lecture circuit, his wife, Anna, ensured that a freshly pressed shirt awaited his arrival at each destination.[29]

A daguerreotype by Samuel L. Miller, dated approximately 1852, exemplifies this visual formula that Douglass would follow for the next forty years (fig. 6).[30] Here Douglass wears a luxurious tie, paired with a vest intricately embroidered with floral designs. Despite this sumptuous detail, it is an image of solemnity, as one side of Douglass's visage is in dark shadow while light accentuates his extremely furrowed brow. The coat and shirt collars are raised high on the neck, a style common during the mid-nineteenth century and a sign of moral rectitude.[31] The prominent side part of the hair was the accepted gentlemanly fashion, in contrast to middle parts of women's hair.[32] The head and shoulders fill most of the compositional space. The figure appears not only stately but imposing; even when viewed at eye level, the eyes seem to be looking down upon the viewer and commandeering the space between the image's surface and the point of the spectator.[33]

Douglass is photographed this way again and again, displaying this specific social standing for decades. The circulation of these pictures helped create and guarantee his citizen status, visually proclaiming Douglass's

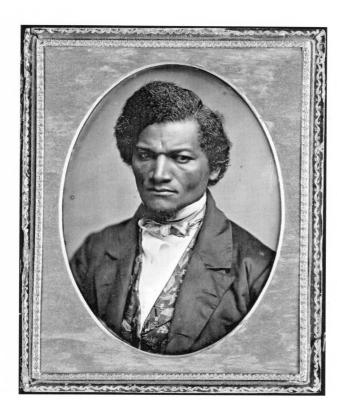

6. Samuel J. Miller, American, 1822–1888, *Frederick Douglass*, 1847–1852.

Cased half-plate daguerreotype 14 × 10.6 cm (5 1/2 × 4 1/8 in.). Major Acquisitions Centennial Endowment 1996.433. The Art Institute of Chicago.

"natural right" to own property and thus be seen as equal, which is to say autonomous and free. Both the attention to detail within each act of self-presentation and the repetition of that act foreground Douglass's precarious claim to such social status of equality and also the fact that he understood such states of possession and recognition as systems of accumulation. One is not just seen as autonomous, but autonomous because he displays multiple properties and continues to display and to be seen displaying such properties.

Such repetition and accumulation expose the limits of a freedom conceived as possession. Like fugitivity, the need to constantly reiterate in an object of representation what is allegedly natural for any self-possessed person "upsets the foundational divide between subject and thing."[34] These photographs blur the divide between proprietor and property; Douglass's own self-possession is visually asserted most when others own and recognize this image. In addition, the photographs assert self-possession and citizen propriety at the very locale that it is allegedly absent—upon a black body. That the body deemed black has difficulty sustaining citizen status,

credibility, and acceptability foregrounds both the violently enforced divide between slave and citizen and the belated constructedness of natural rights. The very instability and unsustainability of these divides help account for the repetition of this image. By making himself an object of the photographic gaze, Douglass's numerous portraits tacitly underscore that *all* standings as citizen-subject depend upon the affirmation of others. The incessant necessity to reproduce and distribute such precise images belies the tenuous and vexed relations to and of freedom. The fugitive slave challenged the free-slave binary by being neither property nor citizen-subject. Considered collectively, photographs of Douglass-as-image similarly highlight this vexation at the core of liberally conceived freedom; one is autonomous only through recognition from others, but this creates a prescribed debt or expectation. Douglass himself noted that once a man's picture became widely known, the public enforced conformity to that image. He is considered "a fixed fact, *public property*."[35]

For Douglass, self-possession was proven, paradoxically, by becoming just such a public icon. This hypervisibility of Douglass's upstanding citizen photographic portraits contrasts with an important trait of fugitivity, its unrepresentability.[36] In his *Narrative of the Life of Frederick Douglass* of 1845, Douglass explains for over two pages that he cannot represent the central event of his escape because to tell would bring untold harm to others.[37] This textual and visual evasion of how he escaped slavery continues ten years later in *My Bondage and My Freedom* (1855). In his final autobiography, *Life and Times* (1881, rev. 1892), Douglass finally details his escape. Unlike his first two autobiographies, this work contains many illustrations of specific scenes narrated in the text; but tellingly, a visual substitution is used for his flight from slavery. This event is narrated a third of the way into the book, and former and latter chapters are accompanied by illustrations of life events that parallel what is told in the immediately accompanying text. Instead of his escape of 1838, this illustration is of his home purchased in 1887, a full forty-nine years later, and the label reads, "His Present Home in Washington" (fig. 7).[38] The articulation between freedom and property ownership could not be made more vivid; the endpoint of *Life and Times*—at home in Anacostia—is pictorially moved to this pivotal, earlier scene of escape in order to affiliate his freedom with the eventual and conventional trappings of accumulated proprietorship. Visually the illustrated home secures a sense of order and grandeur. It is portrayed in frontal, rectilinear form, as if the spectator looks from below the imposing property, made an even more legible possession through framing trees to the left and right,

7. *His Present Home in Washington,* **from Frederick Douglass,** *Life and Times of Frederick Douglass, Written by Himself* **(Boston: De Wolfe and Fiske Co., 1892).**

Used with permission of Documenting the American South, University of North Carolina, Chapel Hill, Libraries.

contrasting the straight, uniform lines of the building.[39] The flight from the chaos and immorality of slavery to self-possession and self-imposed order and ownership is visually legitimated by his possession and maintenance of property.

A similar orderliness of self-presentation permeates most of Douglass's portraits. Douglass's visual assertion of his will remains legible only within the discourse of the sovereign subject as self-possessed and possessing. Douglass's radical subversion, then, is not quite located or locatable in his acceptance and appropriation of a conventionally middle-class visual standard but in the contingency and necessity that the very repetition and circulation of these portraits suggest. The formulaic photo format of most of Douglass's portraits stands out against the diversity of poses and guises taken on by contemporaneous celebrities such as Walt Whitman, whose theatrical, sensual images never foreclosed the social status always already assumed.[40] Even the somber images of Abraham Lincoln show more diverse postures, from full-standing figure, to sitting or standing with an array of books, to quiet repose in a studio parlor stocked with dainty Vic-

torian furniture.[41] Though Lincoln also used photography to circulate an image of statesmanship, ability, and order, subtle changes in his visual presentation would not alter his presumed right to citizenship.

Often adhering to claims of liberal autonomy, Douglass's lectures on pictures consistently elide an indispensable component of portrait photography, the photographer or operator. Given Douglass's numerous photo sittings before many operators, he was probably well aware of the commercial transaction of portrait photography. The lectures on pictures refer to market society by way of consumer desire. Douglass says Daguerre "supplied a deep seated want of human nature." Then, by way of none other than the Scottish philosopher of morality and political economy, Adam Smith, Douglass alludes to the increasing production of such desire via an abundance of pictures made possible by photography. Says Douglass, "The old commercial maxim, that demand regulates supply is reversed here. Supply regulates demand."[42]

In Douglass's "Pictures and Progress" lecture, the photograph as commodity is a natural progression from earlier technological innovation, and this refined and refining technology is made available through simple, nearby shopping. Douglass provides a terrifically detailed account of the itinerant operator's gallery, not an established, urban studio. Photography becomes a quotidian and, here, mobile site for the consumer to produce himself. The sitter he describes knows photography as a disembodied item for sale, produced by his own need for things and interaction with technology. The buyer's reliance upon the operator's labor and the face-to-face negotiation between operator as salesman and sitter as dependent consumer are suppressed. The "inevitable" gallery is granted a movement of its own, driven only by the sitters' demand and not by the daguerreotypist's financial necessity or creative decision. It awaits "perched" and "ready to move in any direction wherever men have the face to have their pictures taken."[43] It is familiar and routine:

> The smallest town now has its Daguerrian Gallery; and seven at the cross roads—where stood but a solitary Blacksmith shop . . . you will find the inevitable Daguerrian Gallery. Shaped like a baggage car, with a hot house window at the top—adorned with red curtains resting on gutter-percha spring and wooden wheels painted yellow. The farmer boy gets an iron shoe for his horse, and metallic picture for himself at the same time, and at the same price . . . the ease and cheapness with which we get our pictures has brought us all within range of the daguerrian apparatus.[44]

Commercial transactions become signs of civilization's progress, portrayed here as the exchange between buyer and object. Though an independent operator makes no appearance in Douglass's lectures—even Daguerre is lauded as an inventor, not photographer—the sitter's experience certainly does. Douglass describes the self-absorbed anxiety of self-presentation, "A man is ashamed of seeming to be vain of his personal appearance and yet who ever stood before a glass preparing to sit or stand for a picture—without a consciousness of some such gravity?"[45] He assents that the medium does produce overly detailed and somewhat harsh results, and hence "might deter some of us from operation." Though subjects are aware of "that girlish weakness" called vanity, Douglass recoups such a sitter's self-possession and autonomy by ignoring any role of an outside operator, tacitly presuming consumers are the producers and owners of their photographic image.[46]

Douglass's lectures on pictures were certainly intent on another kind of production. This specific object of property, the "metallic picture for himself," becomes a way to accumulate characteristics of self-possession. It does not reflect but *makes* a self. Photography's ease, ubiquity, and affordability provides the possibility—not inevitability—that sitters, rather than being objects of another's vision, could be in literal self-possession of their own pictures. The poor, for instance, could—in theory—not only make but also *own* and therefore control and revel in their own self-images. Notably, Douglass does *not* say that these picture owners can now own pictures of themselves as they want to be seen; instead, "Men of all conditions may see themselves *as others see them.*" He also expresses concern for how subjects will be seen by future generations.[47] The lectures underscore interdependence and influence, not solely self-possession but a possession of and by others. To be self-possessed is not just to present one's own image but to be intruded upon, aware of how one is perceived by others. This requires recognition from others. To achieve such recognition, one must participate in a self-objectification, become one's own object of scrutiny. Photographs are supposed to facilitate this process. Thus Douglass intimates that to be fully actualized, there is an objecthood status essential to all selves.[48]

Through a market transaction, even the "humbled servant" now "possesses a more perfect likeness" than those of previous aristocrats. The promise of photography, however, is not simply self-possession. There is already an incursion of fugitivity here, the disturbance between person and thing, liberty and dependence. Challenging liberal notions of labor as the only form of property that rightfully blurs distinctions between self-

hood and things, portrait photography, unlike any previous medium, now allows one to own one's self as a visible object, not as an inalienable, embodied personality. Douglass's unusual phrasing does not suggest that self-sovereignty is a result of ownership of a physical representation of a self. Instead, the portrait is valuable because what one possesses is the *view of the other*. Complexly, Douglass argues that what one sees and holds in the photograph is not one's authentic, isolated, or autonomous self as the sitter understands himself or wants to be understood. It is the unprecedented possession of the *sight of others* that lends precious value to portrait photography. This relays the contradiction of possessive individualism, as indicated by Kawash. Rather than document or secure self-possession, portrait photography shows that self does not reside within and subsequently look and emanate outward. Photography attempts to fix the fugitivity of personhood, the evanescent qualities of embodied existence. Yet in attempting to document fugitivity, what continually emerges is the suggestion that the interior so often synonymous with "self" is always, to some extent, formed from exterior forces looking in. There is no prior interior to possess and express outward prior to (dis)possession. For Douglass, picture galleries are not just visual metaphors for human interiority but metaphors for how interiority is constituted.

Properties of Self: Looking In

Frederick Douglass not only exploited portrait photography to form a specific public identity; his numerous lectures on pictures used pictures as a trope to resituate acts of looking. They argued that appreciating and making visual images is an essential yet under-appreciated human trait. Viewing pictures causes delight and, he suggests, changes viewers' comportment.[49] Hence pictures do *not* automatically reflect one unified truth but might certainly influence the *performance* of actual bodies. In contrast to audiences that heralded photographs as fixing and divulging a hitherto unseen and inaccessible truth beneath the surface, Douglass stressed the idea that looks were deceiving and that intentions or essential character could not be made fully transparent by visual means alone.[50] In lauding self-made men, these lectures lauded autonomous possessive individualism. Discordantly, they just as consistently presented interiority as formed, informed, and sometimes reformed by outer circumstances. There is not an evil or pure core or essence of individual character for photography to divulge visually.

This theme in Douglass's lectures on pictures is nothing less than a

multifaceted theory of subjectivity. He broadened the conventional parameters defining "man," in direct response to, and refutation of, the popular theories of the American School of Ethnology, consisting of certain respected, influential scientists who were known for their espousal of polygenesis. Their methods centered upon empirical measurement. Craniometry, for instance, used measurements of skulls to group human types, whereas phrenology catalogued physical traits of the skull assumed to correspond to mental capacities. All of these theories were applied to categorize and then rank human races, with people of African descent posited as the lowest form of humanity.[51] Douglass's theory of pictures challenged such groupings and hierarchies by reorienting the traits deemed essential to define humanity. He claimed that men and women could be distinguished as human by their ability to think representationally, to internally imagine forms, and to appreciate and interpret forms in the exterior world. Rendering forms outwardly, as an externalization of thought, was a secondary faculty, constrained or nurtured by one's social structures, relations of power, and resulting material resources. In addition to challenging the idea that Africans were somehow closer to brute creation than intellectual Europeans, Douglass's lectures also demythologized the romanticization of Europeans as lofty, disembodied minds and spirits.

"Pictures and Progress" states that the drive to make pictures and the ability to delight in images is proof of one's humanity. Douglass called this capacity, that which distinguishes man from beast, "thought pictures." This neologism evokes imagination as a function of interstitial permeability, forging and linking self and world.[52] This concept critiqued Western intellectual traditions that defined man by a limited purview, specifically mastery of written text and a certain legibility of reason.[53] For Douglass, the appreciation of images is a universal vernacular, an object-seeking drive, an ability for knowledge acquisition that does not require institutional schooling.

"Pictures and Progress" lambastes over-valorization of reason: "Reason, is exalted and called Godlike, and sometimes accorded the highest place among human faculties," even though it is "not the exclusive possession of men. Dogs and elephants are said to possess it." Far worse, reason has been used to delineate who supposedly is and is not human: "Ingenious arguments have been framed in support of this claim" that reason is the marker of humanity, in order to exclude those deemed "brutes."[54]

Douglass names a desire, rather than reason, as gesturing toward the human: "Still more grand and wonderful are the resources and achievements of that power out of which comes our pictures and other creations

of art." This "picture passion" is present in both childhood and the "savage."[55] These explanations adhere to a standard teleology categorizing the figure of the savage as childlike and thus inferior to Western civilization, but here it is not entirely pejorative, deterministic, or a function of essential differentiation. He uses the figure of the savage to claim a universal *affinity*, irrespective of nation, culture, or race. Douglass declares this predilection for pictures is also found in the elderly, those possessing the most wisdom. Douglass recounts the tale of savage men painting or tattooing European coats on their bodies, a story often used as proof of uncivilized stupidity. "Pictures and Progress" then demythologizes Europe by paralleling this story to "examples all around us," the pomp of church, state, religion, refinement, and learning.[56] In other words, the ability to think via images and take pleasure in them is the capacity from which all other faculties develop in the individual. This ability is shared by all and is the foundation of all social institutions of progress as well. Hence it is hardly reducible to the merely infantile, ultimately to be surpassed and renounced.

As a universal font of humanity, the ability to imagine through images is, for Douglass, "the Divinest of all human faculties."[57] The force that this theory would have had in 1861 is paramount, as it was *against* the assumption of literacy as sine qua non of humanity. It was also—without a doubt—in explicit conversation with contemporaneous pseudoscientific theories that aimed to prove a biological hierarchy of racial groups and the alleged inferiority of African descent. As early as 1854, Douglass censured Josiah Clark Nott, George Robert Gliddon, Samuel George Morton, and photography's own Louis Agassiz by name, all scientists who peddled theories of scientific racism.[58] Douglass updated this critique in his lectures on pictures. The "passion for pictures," he argued, should be explained "to the Notts and Gliddons who are just now puzzled with the question as to whether the African slave should be treated as a man or an ox."[59] These lectures aimed to undo writings that claimed bodies were already written by race.

Douglass's theory of "thought pictures" was a means of contesting scientific racism and, even further, underscored processes of *self*-development. Frederick Douglass's interest in photography centered upon what it revealed about acts of vision more broadly conceived. He argued that people do not simply see physiologically but as they have been socially conditioned.[60] Sight, therefore, is, in part, always projection of the perceiving subject: "Each picture is colored according to the lights and shade surrounding the artist. To the sailor, life is a ship. . . . To the farmer, life is a

fertile field. . . . To the architect, it stands out as a gorgeous palace. . . . To the great dramatic poet, all the world is a stage . . . but to all mankind the world is a school."[61]

In these romanticized equations between one's vocation and vision, Douglass suggests what one sees is shaped by one's habits, training, and intention. Douglass insists upon the pressure exerted by the matter upon which men labor: "A man is worked upon by what he works on. His occupation unites its history in his manners and shapes his character."[62] As Maurice Lee has demonstrated, Douglass relied upon the work of Scottish realism to emphasize "common sense" and "untutored individual perceptions."[63] These associations critique transcendentalism's lofty abstraction that sought to escape everyday realities.

Douglass extends these examples by arguing practices of vision are formed and informed within discourses of race and its corporeal enforcement. The stigmas attached to African-derived peoples are not due to "characteristics of the Negro race" itself, an ontological status, but originate from "the *peculiar standpoint from which we have been viewed* by those who have sought to investigate our true character and to ascertain our true position in the scale of creation," an issue of epistemology and embodied policing.[64] In the 1880s Douglass further elucidated how visuality is habituated through society's "schooling" in race and the gravity of such tendencies: "[Prejudice] paints a hateful picture according to its own *diseased imagination*, and distorts the features of the fancied original to suit the portrait. As those who believe in the visibility of ghosts can easily see them, so it is always easy to see repulsive qualities in those we despise and hate."[65]

It is the lens of the *viewer* him- or herself that creates what is seen. This predisposed, or one might say pre-*exposed*, vision was precisely the kind of viewing practiced and perpetuated by phrenologists and polygenists. Douglass maintained that these scientists made the repeated mistake of interpreting behaviors enforced by power relations—such as a black man speaking softly to a white man in U.S. society—as essential biological differences. Douglass argued that one's surface appearance was influenced by conditions such as poverty, hard labor, and denial of education. By 1861 Douglass stressed the vision, not of the person-made-object but of the skewed sight of the seers themselves. "Age of Pictures" focused on the vocational vision of phrenologists, describing it just after the discussion of mathematic vision of architects and just before the self-satisfied and dubious visions of spiritualists and the jesters' willed ignorance.[66] The suggestion is that though phrenologists claim scientific veracity, they are

closer to charlatans. "Pictures and Progress" defies the idea of surface legibility of one's inner character more overtly and repudiates the methods of the School of American Ethnologists. It proclaims, "man is not a block of marble—measured and squared by rule and compass—so that his inches can be set down on a slate."[67]

In the face of scientific racism wielding visual scrutiny and even cameras, photography might also be used to confer respect upon disenfranchised individuals and groups. Douglass explained images could be manipulated for public esteem: "You may put a prince in a pauper's clothes, and . . . the world will take him for a pauper . . . you may put the brightest gems of thought and feeling on a blurred and ragged sheet, and they will be flung down as trash by the masses." He then argued, "the respectability and dignity of colored Americans must be upheld."[68] Visual presentation was heralded as a means of persuasion against ideas of scientific racism and notions of surface legibility.

In spite of his warning about the very real abuses of representation and his faith in democratic potentials for photography, Douglass also had a humorous, cynical side and poked fun at the role of portrait photographs in polite parlor culture.[69] Photography could unmask privilege, revealing middle-class parlor culture and its physical deportment as less aggrandized, merely mundane, and even ridiculous. He joked that there could be too much of a good thing, even photographs: "Pictures can be made the greatest bores . . . they are pushed at you in every house you enter, and what is worse you are required to give an opinion of them." No honest opinion about a photograph could be given when its sitter "is right at your Elbow" awaiting your response: "To say anything is positively dangerous—and to say nothing is more so. It is no kindness to a guest to place him in such circumstances."[70] These lighthearted yet sardonic comments hardly suggest a strict adherence to the promise and infallibility of photography, as if it could expose the soul or create freedom for all.

While wryly critiquing parlor social life and persnickety public opinion, Douglass also valued its investment in sentimentality. The best pictures, he claimed, combined minute, detailed empirical information *and* emotional appeals. Douglass associated the love of pictures more with passions than with the mind, thereby complying to the conventional binary opposition of irrationality and rationality. However, "Pictures and Progress" also professes an amalgamated definition of truth, one in which the messy, material, immediate, emotional, and sensual qualities experienced in the process of looking are a necessary, constitutive part.

"The Inside of the Outside and the Outside of the Inside": The Phenomenological in Douglass's Lectures

At the outset of "Pictures and Progress," Douglass conceded that this era was one of "passionless utilitarianism," of which the advancements in the science of picture making played a definite part.[71] Yet pictures, he argued, can arouse feelings, incite the imagination, and strengthen ideas. Photographs are thereby valuable beyond just proving technological innovation. The newfound ubiquity of images helped fuel an immanent ability in all humans, their processes of making meaning and building new worlds. The appreciation and creation of images cannot be excluded in the search for truth, which for Douglass is nothing less than the continual movement of progress itself:

> With the clear perception of things as they are, must stand the faithful rendering as things as they seem. The dead fact is nothing without the living impression. Niagara is not fitly described when it is said to be a river of this or that volume falling over a ledge of rocks two hundred feet, nor is thunder when simply called a jarring noise. This is truth, but truth disrobed of its sublimity and glory. A kind of frozen truth, destitute of motion itself—it is incapable of producing emotion in others. But on the other hand to give us glory as some do *without the glorified object* is a still greater transgression and makes those who do it as those who beat the air.[72]

The empirical notation about the object—its measurement—is an element of description that contributes to understanding, but it is a fragment, rather than a representation of total knowledge. An idealist argument that claims to reach truth without any materialist grounding is just as, if not more, dangerous. In Douglass's lectures on pictures, truth is figured as a constant revelation, a process of perpetual movement. Within this system, the notion of fixity—so often prized in photography—is equated with death and, perhaps worse, evading or misrepresenting truth. For Douglass, this merging of the knowledge of facts with the awareness of animated emotions was a closer rendition of "truth" than that achieved with mere notations, even those rendered by the greatest technological innovation, the camera.

Frederick Douglass's lectures on pictures convey an emerging tenor wherein the absolutism of empiricism is questioned, while the autonomy of transcendental idealism is also challenged and circumscribed.[73] As an

empiricist, Douglass wanted to effectively describe objects in the world and the measures of mechanical, technological progress, like that realized by Daguerre and photography more generally. But empirical data are necessary but not sufficient means for understanding the development and transformation of human will and morality into ideals and truth, none of which can be achieved without a commitment to a certain worldliness, a recognition of the existence of things, others, and others-as-things. These lectures set up (at least) a tripartite system of knowledge acquisition. This structure suggests an interrelation and interdependence between passion, reason, and ideals, rather than simply an absolute split between mind and body, and a recognition of others' realities, rather than an absolute truth possessed by an autonomous human mind. Douglass introduces a fourth, mediating term, whose equivocal status allows it to circulate among all three paths toward knowledge: imagination. At once part and parcel of passion and yet a necessity for gaining empirical knowledge through secondary faculties of reason and also for actualizing ideals, Douglass's "thought pictures" summon this idea of intercession. He adds *another* evanescent, provisional medium neither wholly rational nor emotional: habit. Habits constitute and inextricably bind interior and exterior through embodied performances.

Mental images and physiological sight form and inform distinctions between world and self. Though, like idealism, Douglass suggests that the world cannot ultimately be known as it is, he refuses to sever perception and judgment from materiality as it is experienced through the body in a myriad of common gestures. Douglass's emphases on imagination and habit in his meditations on pictures are presciently akin to later concerns of Maurice Merleau-Ponty, whose studies concerning phenomenology accent the mediating role of embodiment in the process of human perception. To say that Douglass's ideas are similar to phenomenology is to say that he returns to ordinary, quotidian experiences and underscores that the world is always perceived from a particular, lived vantage point. This influences the production of knowledge, both about the world and self, as well as possibilities imagined within and out of both.

Douglass's work often questioned and revised ideals via everyday, lived experience. Similarly, Merleau-Ponty argued perceived objects have an identity that exists independently of the attitude or beliefs of subjects who see the object. And yet it makes no sense to speak of objects outside of human experience; mediation of any and all understanding is inescapable. The perceiving subject cannot be detached from the world, nor from its

perceiving body, and if one presumes the subject is completely autonomous, or that one's view is totalizing, ethical dilemmas result.[74]

Douglass argued, as Merleau-Ponty would similarly assert a century later, that perception as realized through the body is not truth but a portal, the means of access to an attitude toward truth. Douglass contended, "Truth has a distinct and independent existence, both from any expression of it, and any individual understanding of it."[75] According to Douglass, all existence in the world followed truth, and man is one object among many in this configuration. If the world is not the result of a thinking subject but its precondition, this shifts the understanding of objects within it. The idealism of "I think therefore I am" avers that the thinking "I" has a totalizing access to all, including the other. In contrast, a phenomenological reconceptualization proposes that the thinking "I" includes an external, visible skin and an unseen, inaccessible interior. "I" exist for myself, but there is also an "I-for-others," an outward appearance. The other who sees does not necessarily see me but instead sees an exterior, and likewise, I do not fully see the other but the other's exterior. The other also has a for-herself or for-himself that is not fully transparent to me.[76] Within this system, one cannot fully possess another through vision.

An anecdote in "Pictures and Progress" evokes just such an experience of this for-himself and for-others:

> When I come upon the platform the negro is very apt to come with me. I cannot forget: and you would not if I did. Men have the *inconvenient habit* of reminding each other of the very things they would have them forget.
>
> Wishing to convince me of his *entire freedom from* the low and vulgar prejudice of color which prevails in the country[,] a friend of mine overtook my arm in New York saying as he did so—Frederick I am not ashamed to walk with you down Broadway. *It never once occurred to him that I might for any reason be ashamed to walk with him down Broadway.* He managed to remind me that mine was a despised and hated color and his the orthodox and Constitutional one—at the same time he seemed endeavoring to make me forget both.
>
> Pardon me if I shall be betrayed into a *similar blunder* tonight and shall be found discoursing of negroes when I should be speaking of pictures.[77]

This vignette insists exterior appearances as perceived by others are not just emanations of one's true character—as much discourse on photogra-

phy contends. Similarly, phenomenology's postulate that one cannot fully possess another because one cannot fully know the other might suggest an irreducible path toward freedom. Douglass's understanding, in contrast, reminds his audience that another's perception of his external self-for-others is never free of that seeing subject's vision, whether or not it corresponds to his own self-understanding. Here, his for-others is seen through a visuality informed by assumptions of racial hierarchies of value and putative ontology.[78]

Douglass's strategy of narration is just as telling as the incident he conveys. In relaying how a friend circumscribed Douglass's visual body through a racist understanding, Douglass first frames the tale by calling attention to his presence on the platform, and then, after the story, he refers back to his role as orator. This strategy points toward the likelihood that his listening audience sees him on the stage through the same habits of viewing as Douglass's companion. Douglass's self-conscious reference to being so seen, however, does not allow him to fully repossess his body; it reveals that he, like everyone, can never fully escape others' perceptual habits conditioned by mental pictures. Though everyone is limited, some are more limited—via force, not essence—than others, as in the imposition of racial hierarchy. Douglass's rhetorical setup further suggests that his listeners, like the man in his tale, thus far cannot help but see through these habits. This lens constrains their own "thought pictures" concerning Douglass, thereby limiting what Douglass can communicate. With the phrase "it never once occurred to him," Douglass emphasizes that such lines of perception are neglectful of Douglass's for-himself; he has his own thought pictures to be externalized, visions of his companion and, by implicit comparison and extension, his "Pictures and Progress" audience.[79]

Douglass's friend "blundered" by saying race, metonymically represented here as color, was inconsequential. In making that statement, he proved the contrary. Douglass suggests that he, too, "blunders," speaking of one thing when he should speak of another. What Douglass's apology for his own alleged diversion suggests, though, is not that he has digressed but that to speak of racial identification always includes pictures, the mental projections that become irreducible components of perception. The label of "Negro" is real here—it exists but not as an ontological fact of Douglass's interior being. Rather, race is his companion's limit, one that conditions his perceptions that then structure the material reality of both men. To speak of how he is constantly misperceived by such habituated viewing subjects, Douglass *is* indeed discussing pictures. Douglass's friend attempted to speak the language of anti-prejudice but relied upon racial prejudice to make this

claim. Similarly, Douglass claims to be speaking solely of the Negro, but he cannot do so without a reference to pictures. The man tried to have Douglass forget his scorned racial assignment and in doing so only re-created it; Douglass tried to speak of pictures but could only do so with recourse to race as conditioned perception.

By paralleling his so-called blunder with that of his white counterpart, Douglass suggests that social acts of vision realized in individual practice are what create the sight of, the identification of, the "Negro," not what Douglass himself is. Coterminously, the friend's view is constructed as "white" through that very same practice of seeing and naming the "Negro."[80] The man cannot speak of his magnanimity without recapitulating the system of prejudice; Douglass can discuss pictures only through recapitulating this economy of race-as-picture. Just as the man's attachment to his own whiteness and ethical goodness could only be told within his ascription to the thing he claimed to resist, thereby showing that they were one and the same thing, Douglass suggests that the conception of the Negro—whether hated or accepted—is, finally, a system of pictures. This system structures whiteness-as-approved and the agent of approval, a perceptual system with dire material and psychic effects.

That projections from the other are inextricably part of one's for-others, the exterior seen by others, does not preclude that the for-oneself also creates, in part, the for-others.[81] Douglass describes "thought pictures" as "the process by which man is able to invert his own subjective conscious, into the objective form."[82] Embodiment is necessary as the porous medium between inside and out, a drawing in of the world only to be sent back again as offering. Subject and object are thus interdependent and require a constant permeability.

Douglass tempered assessments that dismissed pictures as merely fanciful saying, "Pictures, images, and other symbolical representations, speak to the imagination . . . revealing the profoundest mysteries of the human heart to the eye and ear by action and utterance."[83] Though long denigrated in Western philosophy as copies of things in the world, pictures are "the inside of the outside and the outside of the inside," the for-itself connected to and externalized into the for-others. This exchange relies upon sensation and its corollary of representation in the imagination.[84] Douglass claimed that thought pictures are "the element out of which our pictures spring." Analogously, Merleau-Ponty states, "things have an internal equivalence in me," correspondences that "in turn give rise to some [external] visible shape" that is recognizable by other perceiving subjects.[85]

"Thought pictures" are not just transcriptions of the external forms of

the world, nor are they fictional images entirely independent of external actuality. Douglass argues that imagination is the necessary "source of all progress," while it "is nevertheless the least safe of all our faculties for the discernment of truth."[86] Thought pictures are a dynamic process that functions as a counterpoint to external forms of things. As such, they facilitate the emanation of one's for-oneself into their own for-others. This act of bringing toward the world the accumulation of internal pictures is not just a means of understanding the world, nor expressions of an a priori interiority. This process forms one's self *and*, just as crucially, places one's thought pictures in the world, transforming material through setting forth "inward traces of vision," which are offered externally to *other* viewers so that they might "*join with* them."[87]

In other words, for both Douglass and Merleau-Ponty, a picture of the world, rather than a mere copy, is an image of the internal for-oneself by way of the perception of the world through the body of its maker. To say that an image *in* the world—a painting, a drawing, a photograph—is "the inside of the outside, and the outside of the inside" is to say that one does not see an external object merely empirically but *with* the vision of the creator.[88] Yet Douglass emphasizes that in viewing a photograph one is seeing how he is seen by others. Given Douglass's insistence that once one is aware of others' view of him the sitter conforms to a visual expectation, it might also mean that seeing with a photograph references one's own performance—did I objectify myself, show myself the way I want to be seen? The value of possessing the image of self "as others see him" might be in future offerings to that other's vision in hopes of changing it.

"Thought pictures" are more elusive than photographic portraits.[89] They develop an understanding of the world and facilitate creation of the self, a bringing forth of a newly formed interiority. This requires embodied interaction. Douglass exclaims, "All wishes[,] all aspirations, all hopes[,] all fears, all doubts[,] all determinations grow stronger by action and utterance, by being rendered objective."[90] These externalized thought pictures, neither entirely intangible nor wholly objective, are embodied habits.

Frederick Douglass elaborated these highly philosophical ideas at the very time that most U.S. inhabitants were feeling an urgency he had learned while still a young child. Given during the initial and bloody throes of officially sanctioned war, these lectures insisted that reason does not define the parameters of humanity, nor is reason the only or even predominant means of making meaning. "Pictures and Progress" vehemently contended that reasoned argumentation does indeed fail, citing the charge of Fort Sumter as a case in point. Furthermore, such worldly events change the limits of

what is deemed rational. In other words, interpretive shifts are often inaugurated not by the essence of an action or object but by broader contexts, whether idealist or material or some combination. Put another way, what happened yesterday might mean something else today. This lack of stolid, unwavering foundations was not a new fact causing panic for Douglass; if the war brought this shattering knowledge to some, it was only because their quotidian worlds were previously shielded from violence. At the precise historical moment when violence was more of an immediate possibility for the majority of the U.S. population, Douglass wielded his philosophy of the human imagination and habit to challenge dry empiricism as well as transcendentalism. These lectures underscore that human striving for truth is dependent upon the contingency and irreducibility of vulnerable embodiment.

Slavery, Freedom, Fugitivity: Inescapable Materiality

This truth of lived experience, the permeability of world and self, "things as they are" and "things as they seem," came from both Douglass's not-so-distant past of enslavement and the incessant terror in his post-emancipated world. Douglass worked through these ideas of embodied truth through the lofty language of Enlightenment discourse in the immediate aftermath of John Brown's raid on Harpers Ferry. For Douglass, this political insurrection was also the loss of a dear companion and a new flight into his own fugitivity; he had to surreptitiously escape a warrant for his arrest as a co-conspirator.[91] A telegraph operator helped Douglass evade a sheriff's posse by withholding orders that came over the wire to capture Douglass and, instead, informed Douglass, allowing him a head start. Eventually Douglass arrived in England and later described these days as "*anxious*," with dire feelings of "exile" and "permanent banishment."[92]

The biographer William McFeely argues that Douglass's initial lectures in England toned down his earlier revolutionary rhetoric—lest he be read as committing treason—until Douglass gave his first speech on John Brown in Edinburgh, Scotland.[93] Carefully indicating the limits of reason, this lecture prefigured ideas in his lectures on pictures. Douglass announced to his audience that they could not possibly imagine the degradation of slavery because of their lack of direct experience, while, simultaneously, he proceeded to use verbal imagery to do just that—facilitate imagination. As he drew others in and brought his interior knowledge outward and explained the necessity of such a reach, to see according to or *with* it, Douglass simultaneously reminded them of the limits between self and other.[94]

The context of the lectures on pictures was complicated by more than just his exile and loss of Brown, however. Douglass returned to the United States due to yet another loss, the death of his youngest child, Annie, and he did not resume public talks for months. When he did, the podium at Tremont Temple where he delivered "Pictures and Progress" was a particularly vexed site. Just a year prior, Douglass had been scheduled to speak there but canceled to escape overseas. At his first scheduled appearance there since his return, hecklers verbally assaulted him and finally broke into a riot, despite Douglass's rational argumentation. Douglass was "handled roughly" by a crowd so malicious they cried, "blood of some abolitionist must be shed."[95] This chaotic scene became widely known through an illustration in *Harper's Weekly*.[96] "Pictures and Progress" was given one year later on that same stage. This highly philosophical lecture on humankind's forging of interiority and exteriority, then, was explicitly linked to the physicality of Brown's ultimate sacrifice and to the losses and threats suffered by Douglass. Its discussion moves from itinerant daguerreotypists and their hoi polloi patrons, to polite parlor culture, to abstract theories of mind, back again to immediate warfare, and, finally, to the very stage Douglass occupied. Douglass asked, "Where is that mob tonight? Some of them are doubtless in the regiment from Massachusetts which recently marched to Virginia singing the hymns to the memory of John Brown. Where are the men who incited that mob? Urging upon the government to finish the very work which John Brown nobly began."[97]

Brown's anguished, bloody body and knowledge of impending death are carefully detailed, and his taunting inquisitors named as the same treasonous senators now imprisoned by the Union. At this point, the lecture takes an incredible turn, away from the interdependence of permeable interiority and exteriority, for-oneself and for-others, and, instead, toward the very transcendental justification it had so meticulously tried to abate and bring toward worldliness. In order to map the massive turnabout of public opinion, Douglass argues that an inevitable spirit brought such change, an indubitable progress toward a universal truth, unknowable to any individual man. This intellectual maneuver, however, while lessening the role of human action and exchange, still pivots upon profound recognition of a specific interiority made external, the convictions of John Brown. Verbal imagery of Brown's torn and open body forge imaginative bonds between Douglass and his audience.

Frederick Douglass's lectures on pictures used photography to celebrate technological invention and social progress, but, even more significantly, the lectures used photography for philosophically limning human interi-

ority and vulnerability. Time and again in these lectures this great invention that "studs the world with pictures" is bound to bodily susceptibility, traumatic loss, and the limits of visibility.[98] Douglass repeatedly described the everydayness of Brown's physical appearance and how a visual survey gave no indication of his extraordinary and revolutionary interior. Still, for Douglass, the visible image of this man remained poignant. Years later at his Anacostia home, he would hang more portraits of John Brown than any other of his public friends or private family.[99] In his final autobiography, Douglass reprinted an austere portrait of Brown, in much the same format as Douglass's own frontispieces.[100] This calm image of legible respectability mirrored Douglass's own perpetual creation, manipulation, and circulation of his photographic images as self-possessed citizen-subject.

As for his own photo sittings, Douglass's most widely disseminated pictures came from this same period. Now, multiple photographs could easily and cheaply be reproduced on albumen paper and mounted onto small cards. This format, known as the cartes de visite, first arrived in the United States in the same year Douglass fled after Harpers Ferry, 1859. By 1861, the year of Douglass's "Pictures and Progress," cartes de visite had replaced daguerreotypes as the most widely available and sought-after portrait photography.[101] Sitters' manuals focused on properly inhabiting prescribed social roles, especially that of masculine individualism.[102]

A photograph of Douglass printed by J. W. Hurn, the same telegraph operator who helped Douglass evade capture, was made roughly the same time as the lectures on pictures (fig. 8). It follows the formula established by the earlier daguerreotypes: stern facial expression, high collar, and masculine side part. Douglass wears a plain black suit, vest, and necktie and one sober gold chain.[103] This image discloses a poignant discrepancy between Douglass's lectures on pictures and his own formulaic portrait. Conceivably, this photograph might be experienced by the viewer as reaching into their own time and space. However, the standard shading directly encircling the head and shoulders of the figure, combined with the dominating empty space within the framing lines, work to distance the sitter from the viewer. Douglass's floating bust seems inaugurated into a pantheon of great worthies. This longstanding convention of the ethereal head portrait, now made attainable in photography through technical innovations, seems anything but phenomenological; the figure is removed from quotidian, banal realities, and appears absolutely autonomous. It relies not on the viewer's engagement with the extraordinary detail and intimacy of the daguerreotype but on the viewer's recognition of generalized distance. Whereas Douglass's lectures on the appearance of things as experienced

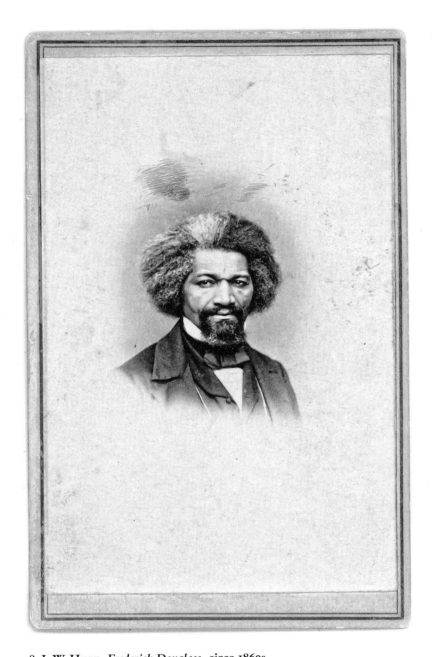

8. J. W. Hurn, *Frederick Douglass*, **circa 1860s.**

From the collection of the Friends Historical Library of Swarthmore College.

from an individual, embodied perspective accent contact and interdependence, this solitary portrait reinstates the myth of possessive individualism.

"Pictures and Progress" argues that pictures are incredibly important *not* because they reveal a truer depth, drawing to the surface an unassailable authenticity available to scrutiny and preservation. To believe in this function of pictures would be to ascribe to the idea that men and women can be fully known through empirical measurements. Douglass's lectures on pictures reference photography because it is proof of a process of thinking through potentialities, a method of comparing empirical fact with internal images. This is a creative, intuitive, almost mystical understanding that is all the more powerful because it is still reliant upon interaction with the material world. Photographs objectify the ever-moving context of phenomena. "Pictures and Progress" foregrounds the question of how truth is to be made material. Douglass argues that this process of taking in exteriority, forging and transforming interiority and sending the interior to the exterior, and the moments of a blurred division between the two, are all required for the attainment of truth. Douglass figures truth as formulated by and through sensate, embodied beings. The importance of visual experiences originating from the outer world is so fundamental and, further, fundamentally embodied, he argues, that to interrupt a person's rapt contemplation of forms in and of the world is nothing less than sacrilege. Self-revelation, here, is learning forms from external objects, and comparing and developing those internally. In perceiving the world and creating thought pictures, one experiences "a new birth . . . a new life . . . [a] discovery of every new agency. . . . The child experiences one with every new object, by means of which [he] is brought into a nearer and fuller acquaintance with [his] *own* subjective nature. With every step he attains a larger, fuller and freer *range of vision*. . . . [Pictures] speak to him in his own tongue."[104]

Pictures are both a lingua franca and a constantly new revelation. Douglass's premier and representative example of the production of thought pictures elucidates the continual relation between exterior and interior, self and world. He describes a young boy looking at clouds and projecting his own interpretation of forms onto the clouds. "At this altar," he exhorts, "man unfolds to himself the divinest of human faculties, for such is the picture conceiving and picture producing faculty of man—or flower of the human soul. This devotion is the prelude to the vision and transfiguration, qualifying men and women for the sacred ministry of life. He who had not bourne some such fruits—had some such experience in child[hood] gives us only barrenness in age."[105]

Douglass struggles to link inner and outer via reverie of images and insists that looking is the ultimate primer for the autodidact. Through the experience of looking, one encounters self and the world and thereby builds an understanding not only of the world but also of continual *self-understanding*. The child and, by extension, all people develop their understanding of self by perceiving objects in relation to their previous experiences with objects now internalized—the cities and ships seen in the clouds.[106] This development, these "thought pictures" are requisite for acting in the world, for not only looking at images but creating new ones, for imagining possibilities of organizing forms in and of the world.[107] Without a comparison between the exterior world and interior picture gallery, there is an inability to act in the world as a formed and informed agent.

Douglass's idea of "thought pictures" is a visual theory, a theory about systems of representation—the role of pictures in human creation—broadened into nothing less than a theory of subjectivity—how self-consciousness is constituted from without as well as from within, and how these processes subtend one another, endlessly. Douglass insists it is a "mistake" to assume this self-creation "can only happen to man once in a life time" because "the whole journey of life is a succession" of such "self revelation" enabled through perceptual engagement.[108] His lectures outline a picture *of* progress, posing the following arguments. First, even perceived objects have their own mode of givenness, and for humans perceived in the line of sight of others, for humans as *objects*, this means those viewed have their *own internal intentionality*, whether or not it is recognized as such by the viewing subject. Furthermore, all humans, contrary to the thinking of racial pseudoscience, possess the faculty of thought pictures, to imagine forms. These theories of perception and imagination specifically address the constitution of knowledge of the world and the self and the continual distinction and permeability between the two. How and what we as viewing subjects see in the world is experientially conditioned, via circulating, possessing, and accumulating representations. Just as significantly, in dealing with other people—who are also only known to us through our own mediated perception—we must always consider our own habits of viewing, how they influence others, and how they also determine our continual self and societal development. Finally, this theory of self formation is bound to theological and transcendental concerns. Douglass expands the definition of the human beyond mere reason—understood by some as only certain intelligences, like reading and writing—in order to divulge the wrongheadedness of racist theories. But he does adhere to an ultimate arbiter, a vision that outlasts and expands an embodied purview.

Douglass claims that those who adore pictures do so because their own human self-creation takes place via pictures, as does all human progress: "It is by looking upon this picture and upon that which enables us to point out the defects of the one and the perfections of the other. Poets, prophets and reformers are all picture makers—and this ability is the secret of their power and of their achievements."[109] This imaginative act of comparison is an act of quantification—how much is this like that?—and hence it is bound to acts of assessments of accumulative self-possession—does self-as-object display enough of the standards of respectability and recognizability? How does one measure, then, if the pictures of perfection realized by poets, prophets, and reformers are pictures of the limits of liberal freedom, as Kawash suggests, or of progress, which, as Douglass desired, is the constant and inevitable move toward an as yet unrealized freedom? Conceivably, these two stances are not so much opposed as analogous. Douglass's theories imply that the inevitable march of progress can only provisionally be comprehended by the self-possessed subject and certainly not measured by that same subject. As Douglass expands the definition of man, and posits the possibility of a fuller truth, he then limits the possibility of its whole possession: "The great philosophical truth now to be learned and applied, is that *man is limited by manhood. He cannot get higher than human nature* even in his conceptions. Laws, religion, morals, manners, and art are but the expressions of manhood and begin and end in man."[110]

Later lectures pithily explained that truth, "contemplated as a whole, is too great for human conception or expression."[111] Photography is one example of a limited expression. Douglass's lectures on pictures maintained the hope that photography could be wielded to assist the need for a productive self-representation, especially for those whose interiorities are so often denied. Perhaps Douglass also thought such pictures could be used to forge group identity and striving, a personal and political gesture. From some twenty-first-century standpoints, this reliance upon iconicity is hopelessly suspect. But it was a hope, not in spite of but in the face of the tragic. Perhaps the lectures' message most urgent for today lies not in the persuasive power of photography but the necessity that the function of images in mental and perceptual habits be constantly questioned and revised. Truth, as Douglass explained, requires imagination because it is a constant negotiation between "a clear perception of things as they are" and "things as they seem." It depends no less upon recognizing the limits of knowledge, of the range of knowability of the self and of the other. Attentively, assiduously, and critically *looking* is required. Such looking must happen by way of imagining. And imagining, figured here as a kind of fugitivity, is nec-

essary but only ever provisional and ultimately unsustainable. Perceived in significant and yet evanescent possibilities of something else, a fleeting presence, it cannot be synonymous with self-possession and control: "This picture making faculty is flung out into the world—like all others—subject to a wild scramble between contending interests and forces. It is a mighty power—and the side to which it goes achieved a wonderous conquest." Thought pictures, then, are just as fundamentally about repetitions of embodied labor: "For the *habit* we adopt, the master we obey in making our subjective nature *objective, giving it form, colour, space, action and utterance,* is the all important thing to ourselves *and to our surroundings.*"[112] Simultaneously independent and shared, internal and external, thought pictures might be utilized for pursuit of an ongoing search for truth but only if conjoined with new gestural habits. As a dynamic method, thought pictures might help re-envision that fuller truth ever on the horizon, "a universality to come."[113] This striving, as evidenced by Douglass's struggles with representation, must *be* continual, singular, and collective.

Notes

The development of this project is greatly indebted to the generous intellectual engagement of Sally A. Stein, Maurice O. Wallace, and the readers at Duke University Press. Archival research was made possible through a generous grant from the School of Humanities, University of California, Irvine. This chapter was completed during the immediate aftermath of the loss of my mentor, Dr. Lindon W. Barrett, and is dedicated to his life and legacy. His untimely death has forced me to consider legacies and continuities. If I am at all fortunate, I might be capable of passing on fragments of the thinking through which he so generously walked me. Douglass's project of carving out forms and spaces for newly imagined freedom is still a pressing necessity; however, unlike the solutions posed in Douglass's lectures on pictures, Dr. Barrett taught that these freedoms are already present—they just need to be fiercely taken up, nurtured, and expanded. Perhaps Douglass, whose breadth of scholarship and lived striving attest to a profound engagement with living and loving, would have agreed. I am indebted to Dr. Barrett's scholarship and his unflappable commitment to affirming that which brings joy, solace, and pleasure.

1. For analyses of how Douglass's portraits were manipulated to exert a specific public persona, see Lynn A. Casmier-Paz, "Slave Narratives and the Rhetoric of Author Portraiture," *New Literary History* 34, no. 1 (Winter 2003), 91–116; Peter A. Dorsey, "Becoming the Other: The Mimesis of Metaphor in Douglass's *My Bondage and My Freedom*," *PMLA* 111, no. 3 (May 1996), 445–47; Gregory Fried, "True Pictures," *Common-Place* 2, no. 2 (January 2002), www.common-place.org/vol-02/no-02/fried/; Rebecca Gardner, "The Face of a Nation: The Representation of

Ramses II in U.S. Debates over Race and Slavery" (MA thesis, University of California, Irvine, 2002); Ginger Hill, "In the Spirit of an Ongoing Search for Truth: Frederick Douglass and Representation" (MA thesis, University of California, Irvine, 2006); John Stauffer, *Black Hearts of Men: Radical Abolitionists and the Transformation of Race* (Cambridge: Harvard University Press, 2002), 45–56; Donna M. Wells, "Frederick Douglass and the Progress of Photography," *HUArchivesNet: The Electronic Journal MSRC-Howard University*, no. 3 (February 2000), http://www.huarchivesnet .howard.edu/0002huarnet/current.htm; and Colin L. Westerbeck, "Frederick Douglass Chooses His Moment," *African Americans in Art: Selections from the Art Institute of Chicago* (Seattle: University of Washington Press, 1999), 8–25.

2. These lectures will hereby be referred to collectively as "lectures on pictures" or synecdochally as "Pictures and Progress."

3. Summary of Boston correspondent for the *Republican*, quoted by John W. Blassingame, in editorial précis to Frederick Douglass, "Pictures and Progress: An Address Delivered in Boston, Massachusetts, on 3 December 1861," in *The Frederick Douglass Papers: Series One, Speeches, Debates, and Interviews; Volume Three*, ed. John W. Blassingame (New Haven: Yale University Press, 1985), 452.

4. These analyses of transcendentalism in relation to Douglass's oeuvre are greatly influenced by Jeannine De Lombard, "'Eye-Witness to the Cruelty': Southern Violence and Northern Testimony in Frederick Douglass's 1845 *Narrative*," *American Literature* 73, no. 2 (June 2001): 245–75.

5. Douglass defined progress as "making the world better." See Frederick Douglass, "It Moves," Folder 5 of 5, Frederick Douglass Papers at the Library of Congress: Speech, Article, and Book file, 1846–1894 and Undated; American Memory, Library of Congress Manuscript Division, available online at http://memory.loc .gov/ammem/doughtml/dougFolder5.html, ms. page 4. It should be noted that though Douglass most often uses the term *progress* in his lectures on pictures, in this later series of lectures, "It Moves," he foregrounds the term *reform*. This common parlance connotes the essential role of *form*, suggesting that the intention of all reform cannot be severed from material bodies, whether individual or societal. Today one of the most well known analyses of the processes of reform through productive, repetitive gestures is probably Michel Foucault, *Discipline and Punish: The Birth of the Prison*, trans. A. Sheridan (London: Penguin, 1977). The suggestion being made here is that Douglass's lectures on pictures are earlier examples of analyzing the productive relations of power engendered through practices, what Douglass would call habits.

6. Douglass, "Pictures and Progress," 459 (emphasis added).

7. Frederick Douglass, "Pictures and Progress," Frederick Douglass Papers at the Library of Congress: Speech, Article, and Book file, 1846–1894 and Undated; American Memory, Library of Congress Manuscript Division, available online at http://memory.loc.gov/ammem/doughtml/dougFolder5.html, ms. pages 19 and 18, respectively (emphasis added). Please note that the original manuscript has page numbers hand-written on it, and there are two pages labeled 19 (the first should be page 18), and that the quote on ms. page 19 is crossed out in the manuscript.

8. For "standing" as foundational to citizen-status, bound inextricably to recog-

nition from others, forged in and as racial hierarchy (thus suggesting why Douglass's claim might be so precarious as to need constant reiteration), see Judith N. Shklar, *American Citizenship: The Quest for Inclusion* (Cambridge: Harvard University Press, 1991), 2–16.

9. C. B. Macpherson, *Political Theory of Possessive Individualism* (London: Oxford University Press, 1962), 3.

10. Douglass suggests that this is the case in even the most innocuous of examples, such as a child gazing at the sky. That some youngsters can sit uninterrupted on grassy knolls and read stories into clouds requires not just an innate appreciation of nature but leisure time and the indulgence and encouragement from others to contemplate ("Pictures and Progress," 460).

11. Douglass, "Pictures and Progress," 461.

12. "The lecture of Frederick Douglass," *Liberator* 31, no. 49 (December 6, 1861), 195; Boston correspondent for the *Republican*, quoted by John W. Blassingame in Douglass, "Pictures and Progress," 452.

13. Douglass, "Pictures and Progress," 455.

14. Elizabeth Cady Stanton, quoted in William S. McFeely, *Frederick Douglass* (New York and London: W. W. Norton and Company, 1991), 383.

15. That these lectures are not as concise and overtly political as much of Douglass's oeuvre and, instead, focus on broad, abstract ideas of human interiority and agency prior to addressing abolition might also help account for why more recent scholars have ignored them more often than not. The resurgence of interest—including this current study—speaks to academic disciplinary shifts that belatedly address ideas already explored by earlier scholars such as Douglass.

16. Maurice Lee, *Slavery, Philosophy, and American Literature, 1830–1860* (Cambridge: Cambridge University Press, 2005), 13.

17. Douglass, "Pictures and Progress," 454. A line crossed out in the original manuscript also emphasized individuality and recognition, "Daguerre might have been forgotten but for incorporating his name with his wonderful discovery." Rather than a common, forgotten worker, Daguerre is singled out as a pioneering creator. Douglass's insistence upon acknowledging Daguerre's labor strangely parallels the notion that commodity fetishism elides the labor necessary to fashion the commodity. That acknowledgment of labor might be of particular concern because of the characteristic theft of labor under racial slavery.

18. Macpherson, *Political Theory of Possessive Individualism*, 3; see also Allan Sekula, "The Body and the Archive," *October* 39 (Winter 1986): 7–8.

19. Lynn Hunt, *Inventing Human Rights* (New York and London: W. W. Norton and Company, 2007), 27–34.

20. Given that photographers often copied others' prints, it is difficult to know precisely when and where Douglass sat for each of his portraits, but it is incontrovertible that he posed for many different sittings on a wide variety of occasions. Studios that produced portraits of Douglass during this period include: Benjamin F. Reimer of Philadelphia; George Kendall Warren of Boston; J. C. Sundelin of Flemington, New Jersey; Augustus Morand of Brooklyn; Samuel Montague Fassett of

Chicago; Samuel J. Miller of Akron, Ohio; Charles C. Giers of Nashville; Gibbs of Ottawa, Illinois; J. E. Small of Berlin, Wisconsin; A. Kracaw of Washington, Iowa; Luke C. Dillon of Washington, D.C.; Benjamin E. Hawkins of Steubenville, Ohio; studios in Michigan and Vermont, and many, many more, including the famed Mathew Brady Studio. This selection of studios is taken from the photography archives at the Frederick Douglass National Historic Site in Anacostia, Washington, D.C. Special thanks to the curator, Cathy Ingram, for her time and assistance. Douglass's stops in Michigan and Vermont are noted by Ross J. Kelbaugh, *Introduction to African American Photographs, 1840–1950: Identification, Research, Care and Collecting* (Gettysburg: Thomas Publications, 2005), 45.

21. Each photograph, as Sojourner Truth would call it, was a shadow, not the substance of the man, and thereby allowed the embodied Douglass to expand his realm of influence while remaining safe from physical harm and unwanted scrutiny. For Sojourner Truth's use of portrait photography, see Nell Irvin Painter, "Representing Truth: Sojourner Truth's Knowing and Becoming Known," *Journal of American History* 81, no. 2 (September 1994): 461–92.

22. Samira Kawash notes that the existence of free people of color did not fully challenge this structure; all people identified as white were presumed to possess freedom inevitably and inalienably, whereas a person seen as black always had to prove his or her free status. See Kawash's *Dislocating the Color Line: Identity, Hybridity, and Singularity in African-American Narrative* (Stanford: Stanford University Press, 1997), 43.

23. Kawash, *Dislocating the Color Line*, 49–50.

24. Ibid., 81.

25. As Kawash (ibid., 81–84) explains, this means that the state of fugitivity should not be celebrated as an unfettered or liminal spatial or temporal escape.

26. Frederick Douglass, *My Bondage and My Freedom* (1855; New York: Penguin Books, 2003), 275–77.

27. The few surviving full-length photographs of Douglass in a formal studio context were most often later family portraits of the 1890s, and even here Douglass is shown sitting. See, for example, the images in Frederick S. Voss, *Majestic in His Wrath: A Pictorial Life of Frederick Douglass* (Washington, D.C.: Smithsonian Institution Press, 1995), 20, 84, and 88. As Maurice Wallace has recently observed, "literally he sat for his likeness on every occasion" ("Riveted to the Wall: Coveted Fathers, Devoted Sons, and the Patriarchal Pieties of Melville and Douglass," in *Frederick Douglass and Herman Melville: Essays in Relation*, ed. Robert S. Levine and Samuel Otter [Chapel Hill: The University of North Carolina Press, 2008], 320). That Douglass sits for his portraits connotes an unflappable solidity. It also associates him more with men of science and learning.

28. McFeely, *Frederick Douglass*, 125, 140.

29. This according to Ka'mal McClarin, a park ranger at the Frederick Douglass National Historic Site and a PhD candidate at Howard University.

30. Colin Westerbeck ("Frederick Douglass Chooses His Moment," 9) and Gwendolyn DuBois Shaw (*Portraits of a People: Picturing African Americans in the Nine-*

teenth Century [Seattle: University of Washington Press, 2006], 12) date the image sometime between 1847 and 1852, while Ross J. Kelbaugh (*Introduction to African American Photographs, 1840-1950*, 6) dates it as 1852.

31. Joan L. Severa, *My Likeness Taken: Daguerrian Portraits in America* (Kent: Kent State University Press, 2005), xviii, 3, and 58.

32. Severa, *My Likeness Taken*, 28. A manual for sitters, written by a photographer two decades after this daguerreotype, even poked fun of pretentious young men who dared sport a middle part, resulting in a portrait of the utmost stupidity, "It would require a keener eye than a Voightlander or Dallmeyer lens, to discern the appearance of any brains in such a head, even if it was photographed from all points of the compass" (H. J. Rodgers, *Twenty-Three Years under a Skylight, or Life and Experiences of a Photographer* [Hartford: H. J. Rogers, 1872], 92; see also 100 and 152).

33. The art historian Colin Westerbeck ("Frederick Douglass Chooses His Moment," 13–15) has suggested that this daguerreotype was probably made for a friend or supporter, not for Douglass himself. This coincides with a statement made by Douglass's recent biographer, William McFeely, that Douglass often gave his portrait photographs to his admirers (*Frederick Douglass*, 274).

34. Kawash, *Dislocating the Color Line*, 81, 48.

35. Douglass, "Pictures and Progress," 455 (emphasis added).

36. This unrepresentability is not synonymous with invisibility; it is not so much that fugitivity cannot be seen, but that formally any visual image of it is fleeting. If its image was to be caught, as in a fixed photographic image, this risks (re)enslavement.

37. By refusing to narrate his escape, Douglass leaves the reader and slaveholder at a loss, thereby transferring the paranoia and threat back onto the slaveholder rather than the fugitive (Kawash, *Dislocating the Color Line*, 51–52).

38. Frederick Douglass, *The Life and Times of Frederick Douglass in His Own Words* (1881; New York: Citadel Press, 1983), 197.

39. That freedom is bound to claims of possession is made even more poignant when one compares the formal elements of this image to images of plantation "big houses." In his analysis of landscapes portraying southern plantations, the archaeologist and historian of architecture and art John Michael Vlach has shown that these images often followed a perspective that placed the viewer seemingly below the presiding homes, in contrast to the more common landscapes that placed the viewer above the scene looking downwards. See Vlach, *The Planter's Prospect: Privilege and Slavery in Plantation Paintings* (Chapel Hill: University of North Carolina Press, 2002).

40. For the bevy of poses taken of Walt Whitman, see Ed Folsom, *Walt Whitman's Native Representations* (Cambridge: Cambridge University Press, 1994), 127–77.

41. For the most famous image of Lincoln by the Mathew Brady Studio, see Robert Hirsch, *Seizing the Light: A History of Photography* (Boston: McGraw-Hill, 2000), 83, figure 4.11. Douglass was well aware of the political influence of visual images, creating both favor and recoil: "In the making of our Presidents, the political gathering begins the operation, and the picture gallery ends it" ("Pictures and Progress," 457). Referring to illustrations in *Harper's Weekly*, he declared, "In the last

election the President of this Republic was made by pictures, and the whole Liberal Republican party was unmade by pictures" ("Collection of Funds for Sumner Portrait: An Address Delivered in Washington, D.C., on 11 December 1873," in *The Frederick Douglass Papers: Series One, Speeches, Debates, and Interviews; Volume Three*, ed. John W. Blassingame [New Haven: Yale University Press, 1985], 358).

42. Douglass, "Pictures and Progress," Frederick Douglass Papers at the Library of Congress, ms. page 9; and Douglass, "Pictures and Progress," 454.

43. Douglass, "Pictures and Progress," Frederick Douglass Papers at the Library of Congress, ms. page 9. It is remarkable that Douglass chooses the humble, itinerant gallery, rather than the more formal urban establishments, given that most of Douglass's own portraits were made in urban photography studios and that the audiences of these lectures were most likely the relatively well-to-do of the urban northeast. Presumably, this choice asserts the ubiquity and accessibility of this new technological—and social—marvel.

44. Douglass, "Pictures and Progress," 454. That the studio replaces the blacksmith's shop suggests the progress of civilization as outlined by Adam Smith. See David Solkin, "Joseph Wright of Derby and the Sublime Art of Labor," *Representations* 83 (Summer 2003): 176–79.

45. Douglass, "Pictures and Progress," Frederick Douglass Papers at the Library of Congress, ms. page 9.

46. Perusing the copious extant copies of Douglass's own photographic portraits might lead one to believe that Douglass was not a passive model before the photographer's gaze. Recent scholars emphasize Douglass's agency in his own image production. The formulaic quality of these photographs over decades of time, coupled with the fact that such similarity was produced within multiple studios, makes this interpretation likely, though it is just as plausible that various photographers collaborated or helped impose such visual standards of social propriety. Perhaps by jumping to the conclusion that Douglass's public persona was by and large self-consciously crafted, today's readers and viewers unintentionally mimic what Douglass did in his own lectures on pictures: ignore the social exchange at the sites of production and uncritically accept possessive individualism. These considerations of the role of the operator are indebted to Maurice Wallace's keen feedback to earlier drafts of this chapter.

47. Douglass, "Pictures and Progress," 454.

48. Ibid., 454, 456–57.

49. Ibid., 455.

50. Douglass, "Pictures and Progress," Frederick Douglass Papers at the Library of Congress, ms. page 19. For the argument that the earliest viewers understood photographs as absolute truth, see Alan Trachtenberg, "Illustrious Americans," *Reading American Photographs: Images as History, Mathew Brady to Walker Evans* (New York: Hill and Wang, 1989), 27.

51. Brian Wallis, "Black Bodies, White Science: Louis Agassiz's Slave Daguerreotypes," *American Art* 9, no. 2 (Summer 1995): 39–60. See also the chapter in this volume by Suzanne Schneider.

52. Douglass, "Pictures and Progress," 459.

53. Lindon W. Barrett, *Blackness and Value: Seeing Double* (Cambridge: Cambridge University Press, 1999), 71. For more on the black radical tradition that criticizes the equation of literacy and personhood, see Gregory S. Jay, "American Literature and the New Historicism: The Example of Frederick Douglass," *Boundary 2* 17, no. 1 (Spring 1990): 238–39; Fred Moten, *In the Break: The Aesthetics of the Black Radical Tradition* (Minneapolis: University of Minnesota Press, 2003), 6, 12; Valerie Smith, *Self-Discovery and Authority in Afro-American Narratives* (Cambridge: Harvard University Press, 1988), 3.

54. Douglass, "Pictures and Progress," Frederick Douglass Papers at the Library of Congress, ms. pages 12–13.

55. Ibid., and ms. page 17; Douglass, "Pictures and Progress," 462. Note that *savage* is left in the abstract, as if Douglass assumes his audience will automatically recall a certain image, time, and place.

56. Douglass, "Pictures and Progress," Frederick Douglass Papers at the Library of Congress, ms. pages 14–15; Douglass, "Pictures and Progress," 459.

57. Douglass, "Pictures and Progress," 460.

58. Frederick Douglass, "The Claims of the Negro Ethnologically Considered: An Address, Before the Literary Societies of Western Reserve College, at Commencement, July 12, 1854, Delivered in Hudson, Ohio," in *The Frederick Douglass Papers: Series One, Speeches, Debates, and Interviews; Volume Two, 1847-1854*, ed. John W. Blassingame (New Haven: Yale University Press, 1982), 497–525. As scientists, this school, allegedly most civilized because most learned and literate, sought a new text written upon the black body that only they could "properly" read. The compulsion to exhaustively categorize visible characteristics and link them to nonsomatic traits, thereby creating a new written script for social engagements, belies a certain anxiety of the writers and readers, not those who are written. In other words, they write themselves by writing upon others.

59. Douglass, "Pictures and Progress," 459.

60. The literary theorist Michael Chaney has also persuasively argued that Douglass was one of the first U.S. intellectuals to insist upon the social construction of visuality. See "Picturing the Mother, Claiming Egypt: *My Bondage and My Freedom* as Auto(bio)ethnography," *African American Review* 35, no. 3 (Autumn 2001): 391–408.

61. Frederick Douglass, "The Trials and Triumphs of Self-Made Men: An Address Delivered in Halifax, England, on 4 January, 1860," in *The Frederick Douglass Papers: Series One, Speeches, Debates, and Interviews; Volume Three*, ed. John W. Blassingame (New Haven: Yale University Press, 1985), 291. Similar thoughts are detailed in Douglass, "Age of Pictures," Frederick Douglass Papers at the Library of Congress: Speech, Article, and Book file, 1846–1894 and Undated; American Memory, Library of Congress Manuscript Division, available online at http://memory.loc .gov/ammem/doughtml/dougFolder5.html, ms. pages 40–41.

62. Frederick Douglass, "Age of Pictures," Frederick Douglass Papers at the Library of Congress, ms. pages 40–41. These examples are taken from the U.S. philosopher Thomas Cogswell Upham's *Elements of Mental Philosophy* (New York: Harper and Brothers, 1861), 69–70 and available online at http://name.umdl

.umich.edu/AJE5906.0001.001, which Douglass had in his library. See Frederick Douglass National Historic Site, FRDO 2134.

63. Lee, *Slavery, Philosophy, and American Literature, 1830–1860*, 103. Though Lee states that all of Douglass's early library was destroyed by fire in his Rochester home, some texts did indeed survive, including works by William Paley, Dugald Stewart, Thomas Upham, and Hugh Miller, all disseminating Scottish realist thought that averred the primacy of perceptions (see Frederick Douglass National Historic Site, FRDO 286, FRDO 580, FRDO 1110, and FRDO 2134; and Frederick Douglass, "It Moves," Frederick Douglass Papers at the Library of Congress, ms. page 8). Douglass's library also included selections of Emerson's lectures on transcendentalism that similarly tried to find a balance between Lockean empiricism and Kantian idealism. See Ralph Waldo Emerson, *Representative Men: Seven Lectures* (Boston: Phillips, Sampson, and Co., 1850), which was owned by Douglass (Frederick Douglass National Historic Site, FRDO 1156). On Emerson, see Lee, *Slavery, Philosophy, and American Literature, 1830–1860*, 7–9.

64. Frederick Douglass, "The Races," Frederick Douglass Papers at the Library of Congress: Speech, Article, and Book file, 1846–1894 and Undated; American Memory, Library of Congress Manuscript Division, available online at http://memory .loc.gov/ammem/doughtml/dougFolder5.html, ms. page 2 (emphasis added).

65. Frederick Douglass, "The Color Line," *North American Review* 132, no. 295 (June 1881): 567 (emphasis added). Available online through Jstor.

66. Frederick Douglass, "Age of Pictures," Frederick Douglass Papers at the Library of Congress, ms. page 42.

67. Douglass, "Pictures and Progress," 463.

68. "There is something in dress," *Frederick Douglass' Paper*, 8, no. 23 (May 25, 1855).

69. Douglass, "Pictures and Progress," 454–58.

70. Ibid., 458.

71. Ibid., 453.

72. Ibid., 462 (emphasis added).

73. A similar argument is made by Lee, *Slavery, Philosophy, and American Literature, 1830–1860*, 95.

74. Merleau-Ponty, *Phenomenology of Perception*, trans. Colin Smith (1962; London: Routledge Press, 1994), xvi; Douglass, "It Moves," Frederick Douglass Papers at the Library of Congress, ms. pages 13–16, 25.

75. Douglass, "It Moves," Frederick Douglass Papers at the Library of Congress, ms. page 23. This idea parallels Merleau-Ponty's distinctions of sensation and synthesis (*Phenomenology of Perception*, x–xi and xvi–xvii).

76. Merleau-Ponty, *Phenomenology of Perception*, xii.

77. Douglass, "Pictures and Progress," Frederick Douglass Papers at the Library of Congress, ms. pages 5–6 (emphasis added).

78. Douglass's narration goes even further to suggest that not only is the divide between self and other never fully discriminated, but that one also is not in full control of the divide between one's for-self and for-others. His companion reveals more of his for-himself than he realizes, and that this is picked up by Douglass and

shared with his audience suggests that the for-oneself and for-others are always fettered by the broader social world. Though there is a distinction, where that break is made is never fully known but pointed toward.

79. Notably, in a different version of "Pictures and Progress," Douglass utilized the same strategy to frame his topic. He foresaw his audience's impatience, explaining "it may seem almost an impertinence to ask your attention to a lecture on pictures" during "the all engrossing character of the war" and thus apologized for "this seeming transgression" (Frederick Douglass Papers at the Library of Congress, ms. pages 1 and 3). He initially called these ruminations on pictures a "relief from this intense, oppressive and heart aching attention to the . . . war" that "may be of service to all." The denouement of the lecture implies that these philosophic theories were seminal in understanding the concerns driving the war and its possible resolution, rather than an entertaining diversion.

80. In framing whiteness as race, and noting the speaker's unspoken centrality of his own racial identification, Douglass argues here for racial identification and reproduction in ways presciently akin to Richard Dyer's recent analyses in *White* (New York: Routledge Press, 1997).

81. Merleau-Ponty, *Phenomenology of Perception*, x.

82. Douglass, "Pictures and Progress," 461.

83. Ibid., 462.

84. Maurice Merleau-Ponty, "Eye and Mind," *The Primacy of Perception*, trans. Carleton Dallery (Evanston: Northwestern University Press, 1961), 165 (emphasis added).

85. Douglass, "Pictures and Progress," 459; Merleau-Ponty, "Eye and Mind," 164–65. For Merleau-Ponty, the imaginary is internal, something of the for-itself, that is simultaneously a prerequisite for acting in and with the world and is acted upon by the world. The imaginary is "the quasi presence and *imminent* visibility" because it moves toward a manifestation represented outside the body. The imaginary takes the world in and yet is not fully outside of the world; it "is *in* my body as a diagram for the life of the actual, with all its pulp and carnal obverse exposed to view for the first time" (164–65; emphasis added), an internal picture that "offers to our *sight*, so that it might join with them, the inward traces of vision" (165; emphasis in original).

86. Douglass, "It Moves," Frederick Douglass Papers at the Library of Congress, ms. page 6.

87. Merleau-Ponty, "Eye and Mind," 165 (emphasis added).

88. Ibid., 164. This does beg the question: does this only apply to objects made by an author for the sake of being seen?

89. In the various lectures on pictures, it does seem implicit, however, that photographs could be influenced by the visions of thought pictures. Whether such productive influence would emanate from the operator or sitter—or even a nosy patron not before or behind the camera—is left uninvestigated by Douglass.

90. Douglass, "Pictures and Progress," Frederick Douglass Papers at the Library of Congress, ms. page 20.

91. McFeely, *Frederick Douglass*, 186–200; Douglass, *The Life and Times of Frederick*

Douglass in His Own Words, 310–38; Philip S. Foner, "Douglass and John Brown," *The Life and Writings of Frederick Douglass: Vol. II, Pre-Civil War Decade, 1850–1860* (New York: International Publishers, 1950), 85–94; Frederick Douglass, "A Lecture on John Brown, Delivered at Harpers Ferry and Other Places," Folders 1 and 2, Frederick Douglass Papers at the Library of Congress: Speech, Article, and Book file, 1846–1894 and Undated; American Memory, Library of Congress Manuscript Division, available online at http://memory.loc.gov/ammem/doughtml/dougFolder5 .html; Frederick Douglass, "To my American Readers and Friends," in *Douglass' Monthly* (November 1859), in Foner, *The Life and Writings of Frederick Douglass*, 2: 463–67; Stauffer, *Black Hearts of Men*, 245–51.

92. Douglass, *The Life and Times of Frederick Douglass in His Own Words*, 312, 326–27 (emphasis in original).

93. McFeely, *Frederick Douglass*, 203.

94. Frederick Douglass, "John Brown and the Slaveholders' Insurrection: An Address Delivered in Edinburgh, Scotland, on 30 January 1860," in *The Frederick Douglass Papers: Series One, Speeches, Debates, and Interviews; Volume Two, 1847–1854*, ed. John W. Blassingame (New Haven: Yale University Press, 1985), 312–22; Stauffer, *Black Hearts of Men*, 250.

95. Douglass, *The Life and Times of Frederick Douglass in His Own Words*, 336.

96. This illustration was done by the young Winslow Homer ("Expulsion of Negroes and Abolitionists from Tremont Temple, Boston, Massachusetts, on December 3, 1860," *Harper's Weekly* [Dec. 15, 1860], 788, available at Library of Congress Online Catalogs, http://www.loc.gov/pictures/resource/cph.3c12670/.) See Peter H. Wood and Karen C. C. Dalton, *Winslow Homer's Images of Blacks: The Civil War and Reconstruction Years* (Austin: University of Texas Press, 1988), 21.

97. Douglass, "Pictures and Progress," 471.

98. Ibid., 453.

99. These include photographs of Brown, his sons, and wife, as well as a framed engraving hung in Douglass's office, illustrating the mythical tale of Brown, on his way to the gallows, stopping to bless a black child held by his mother. Though Brown is framed as the martyr, his Old Testament beard and impending death seem to suggest a passing not only of spiritual blessing but also of worldly leadership onto the young child.

100. Douglass, *The Life and Times of Frederick Douglass in His Own Words*, inserted after 276.

101. Cabinet cards, a larger version of cartes de visite, soon followed in 1862.

102. Andrea L. Volpe, "Cartes de Visite Portrait Photographs and the Culture of Class Formation," in *Looking for America: The Visual Production of Nation and People*, ed. Ardis Cameron (Malden: Blackwell Publishing, 2005), 43, 51; Hirsch, *Seizing the Light*, 78–83.

103. His bearded chin and streak of white in his hair help date the sitting to sometime during the early 1860s. See also the images at the Frederick Douglass National Site, FRDO 3924 and FRDO 4688. David W. Blight dates this image to sometime "shortly after the Civil War," in his edited version of *The Narrative of the Life of Frederick Douglass, An American Slave, Written by Himself* (1845; New York: Bedford

Books, 1993), 146. Christopher Densmore, the curator of Friends Historical Library of Swarthmore College, also suggests a date in the 1860s, personal correspondence, August 25, 2008. The connection between Hurn as telegraph operator and Douglass's escape of 1859 is related in James M. Gregory, *Frederick Douglass the Orator* (Springfield, MA: Willey and Co., 1893), 46–47. Special thanks to Mr. Densmore for bringing this source to my attention. Douglass names him as "Mr. John Horn, the telegraph operator" (*The Life and Times of Frederick Douglass in His Own Words*, 312).

104. Douglass, "Pictures and Progress," 460.

105. Douglass, "Pictures and Progress," Frederick Douglass Papers at the Library of Congress, ms. page 18.

106. It is of theoretical importance that Douglass chooses the example of seeing shapes in the clouds because it indicates the structure of the imagination. The child does not mistake the clouds for the objects he sees in them, but he endows the forms in the clouds with the sense of these other objects. The objects of the imagination are not present, and yet some impression of them is present in the sensible material of the clouds. These ideas are influenced by Jean-Paul Sartre, *The Imagination* (1940; London: Routledge, 2004), 5, 8–10, 12–13, and 23.

107. Douglass, "Pictures and Progress," 461; Douglass, "Pictures and Progress," Frederick Douglass Papers at the Library of Congress, ms. page 19.

108. Douglass, "Pictures and Progress," 460.

109. Douglass, "Pictures and Progress," Frederick Douglass Papers at the Library of Congress, ms. page 19.

110. Ibid., 22 (emphasis added).

111. Douglass, "It Moves," Frederick Douglass Papers at the Library of Congress, ms. page 23.

112. Douglass, "Pictures and Progress," 461 (emphasis added).

113. Moten, *In the Break*, 206.

THREE

Shadow and Substance

SOJOURNER TRUTH IN BLACK AND WHITE

Augusta Rohrbach

An illiterate former slave, Sojourner Truth left no written record of her own according to standard definitions of authorship. Yet, during her lifetime and beyond, Truth forged an iconic identity in a print-laden world through various "publications." Chief among them were the cartes de visite she sold, in various forms. Emblazoned with the slogan, "I Sell the Shadow to Support the Substance," Truth's photographs remain the most stable records of her efforts to intervene in a culture shifting from speech to writing and from image to text. Reading those pictures — and the variety of uses she put them to — offers us a glimpse into Truth's self-fashioning unlike any other record associated with her. The examples of what might seem to be ephemeral photographic evidence expose the hand of the "author" and reveal the deliberately unwritten story of Truth's greatest accomplishment: establishing herself as a historical entity and an international icon.

Before undertaking the careful construction of her image, however, Truth had already intervened in the conventions of print culture through another means. Though she published her own narrative in 1850, with the help of Olive Gilbert as amanuensis, her fame stems from a speech she made in 1851 at an Akron, Ohio, women's rights rally. Popularly known as the "Ar'n't I a Woman?" speech, the print history of this address epitomizes the difficulty scholars have had pinning down its charismatic speaker. Two versions of the speech exist, bearing little resemblance to each other, casting doubt on the record of this defining oration.[1]

In the case of both the speech in 1851 and the cartes de visite of 1864,

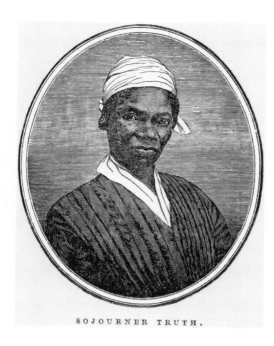

SOJOURNER TRUTH.

9. Author frontispiece,
Narrative of Sojourner
***Truth*, 1850.**

Used with permission of
Documenting the American
South, University of North
Carolina at Chapel Hill
Libraries.

timing is everything. Set into the context of her developing reputation, these acts function as reactions against and interventions in a dominant white culture's production of her image. Reviewing the archive with an emphasis on the conventions guiding speech and image, as opposed to those accorded to writing and print, affords us an important opportunity to reexamine basic ideas about authorship, replacing the notion of the stable, static, single-authored text with the idea of assemblage and collaboration suggested by the term *bricolage*.

The story of Sojourner Truth's refashioning of conventional print culture begins with her choice of a portrait rather than a photograph as the source for the frontispiece of her 1850 *Narrative of Sojourner Truth* (fig. 9). Unlike the photograph, the portrait makes no secret of its mediated state. The quality of the engraving, with its crosshatches and carefully impressed lines, calls attention to the artistic efforts responsible for the image, emphatically registering its status as made.[2] Looking closely at the portrait, Truth's use of iconography is conspicuous — and remarkably consistent with the fabulistic

impressions later popularized by publications of her "Ar'n't I a Woman?" speech. The white head wrap, for instance, became a characteristic part of her image, so much so that almost every description of her makes mention of it.[3] Through this article of clothing, Sojourner Truth references an African past and therefore, in the American literary context of the day, she calls attention to her connection to slavery. And it was precisely this connection that most made a difference in her market appeal. Similar to the exploitation of another icon of slavery in a published version of her speech—Southern dialect—the twang in Truth's voice and the head wrap both promoted and preserved the association with Southern plantation slavery as it was in her best interest marketwise: coded references to the South (either through apparel or diction) both identified her as a former slave and, by locating slavery in the South rather than the North, avoided offending Northern abolitionists. Using public signifiers to create the impression of the personal self, Truth managed her image without selling out to reigning conventions.

Truth's placement of the portrait is a good example of how she leverages the mid-nineteenth-century book culture convention of the frontispiece to suit her purposes. Under the cover of the convention, she greets her readers through a portrait at the start of the narrative of her life. According to this logic, the placement of the portrait emphasizes her presence, declaring Truth's commitment to orality and her radical resistance to literacy more generally.[4] By using a portrait rather than a photograph, Truth emphasizes the image as a mere approximation of her physical presence for readers. The image, like orality, endures through the representation of the body, but, as with a written text, it is transcribed and thus interpreted. This text, the use of the portrait seems to suggest, transcribes and interprets Sojourner Truth according to very specific rules of mediation inscribed by race, class, gender, and region. Using the portrait risks disqualifying Truth as a subject, because it radically reinforces her status as an object.

In Truth's preference for orality, she shows anxiety over the way written language accumulates meaning and, as Walter Ong has observed, restructures consciousness.[5] Insisting that children read to her from the Bible, she routinely turned down offers to read to her made by adults. With this choice, she wished to preserve the biblical passages in some idyllic (because less mediated) state of origin in the language. Her reasoning was simple: adults had a tendency to intermingle "ideas and suppositions of their own" with the sacred text as they read. These more mature readers threaten the authority of the text and risk distorting it. The *Narrative* uses this example

as "one among the many proofs of her energy and independence of character," but it also serves as evidence of her philosophy of language and its attendant narrative theory.[6]

Truth seems to believe that text is negotiated through the reader; the act of reading becomes a form of response that shapes the text in uncontrollable ways—and here she anticipates much of what reader-response criticism has contributed to our understanding of texts and their circulation. Favoring speech over writing, her views are closely linked to oral culture's anxiety about the way texts risk misapprehension. For Truth, speech and, as I suggest later, the photographic image allow the speaker and subject greater agency; both modes foreground presence as a requisite feature. As her amanuensis Olive Gilbert observes in the *Narrative*: "The impressions made by Isabella on her auditors, when moved by lofty or deep feeling, can never be transmitted to paper (to use the words of another) till by some Daguerrian art, we are enabled to transfer the look, the gesture, the tones of voice, in connection with the quaint, yet fit expressions used, and the spirit-stirring animation that, at such a time, pervades all she says."[7] Words, when they are printed, as this passage explains nicely, cannot render Sojourner Truth's message sufficiently. The fullness of her speech *as spoken* defies the codified representation that text relies upon.

At the same time, the *Narrative* calls attention to the mechanical—and intrinsically faulty—nature of writing. A "Note" facing the opening page cautions readers: "It is due to the lady by whom the following Narrative was kindly written, to state, that she has not been able to see a single proof-sheet of it; consequently, it is very possible that divers errors in printing may have occurred, (though it is hoped none materially affecting the sense) especially in regard to the names of individuals referred to therein. The name of Van Wagener should read Van Wagenen." Marking a clear distinction between the subject of the *Narrative*, its writing, and the printing, the note emphasizes just how slippery the process from speech to writing and subsequent publication is. What the note suggests is that the written text is what Jean Baudrillard has famously called "a simulation," so badly lacking a referent to the degree that its proper name may (or may not) be misspelled and thus misnamed.[8] So vivid is the note's indictment of writing and print that we can almost hear Sojourner Truth laughing as the note was read out to her.

Like the frontispiece, Harriet Beecher Stowe's article on Sojourner Truth, published in 1863, endorses the very same racial stereotypes that characterize this early image. Of course this piece would be especially valuable for Truth's self-promotion. Not only did Stowe write it, but she pub-

lished the article in one of the most important venues in the United States at the time, the *Atlantic Monthly*. Stowe casts Truth as the "Libyan Sibyl," whose oracular powers were both simple and astonishingly effective. Stowe sees Truth not as a modern-day Cassandra but rather as a down-home sage whose physical presence would be idealized in William Wetmore Story's statue of the same name.

As flattering as this portrait is in depicting Truth's larger-than-life personality, it does so by promoting several myths about Truth, including the notion that she was born in Africa.[9] Stowe uses the power of Truth's story, and her religious spirit in particular, to generalize about the "African race" repeatedly throughout the article. For instance, "The African seems to seize on the tropical fervor and luxuriance of Scripture imagery as something native; he appears to feel himself to be of the same blood with those old burning, simple souls, the patriarchs, prophets, and seers, whose impassioned words seem only grafted as foreign plants on the cooler stock of the occidental mind."[10] Stowe's central aim is in showing the dignity of the race from its darkest and most uneducated vantage point.[11] Standing in metonymically for the Southern plantation slave, the dark-complexioned, illiterate former slave Sojourner Truth fit the bill quite nicely. And these very same political purposes are served by Frances Gage's rendition of Sojourner Truth's Akron, Ohio, speech of 1851.

Readers familiar with Gage's transcription of the speech will notice that Truth is depicted as speaking a crude form of Southern dialect. The speech begins, "Well Chilern, whar dar is so much racket dar must be something out o' kilter. I tink dat 'twixt de niggers of de Souf and de women at de Norf all a talkin' bout rights, the men will be in a fix pretty soon."[12] This opening sentence is characteristic of what follows as it is littered with references to "de Souf," "de Norf" and "de niggers." Yet Truth was not from the South and did not speak Southern dialect. She spent her slavery years in Upstate New York and her first language was Dutch. Thus, the use of Southern dialect is meant to denote *racial* not regional affiliation. And then, of course, there's the flourish of the repeating rhetorical question, "Ar'n't I a Woman?" Scholars agree somewhat unanimously that this question is Gage's fabrication.[13] The question—like the dialect, then—seems to be an editorial flourish rather than a rhetorical one. Despite its inauthenticity, however, it is difficult to part with Gage's rendition. But we don't have to because Sojourner Truth decided to claim it for herself. In reprinting this version of the speech in the edition of her *Narrative* published in 1875, Truth claims these words as her own while once again baffling traditional definitions of authorship. But before adopting this rendition of her speech,

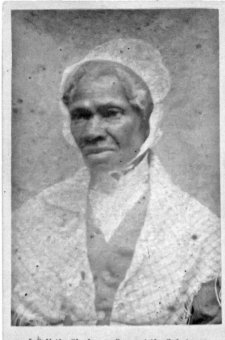

I Sell the Shadow to Support the Substance.
SOJOURNER TRUTH.

10. 1864 carte de visite with caption.

Courtesy of the Library of Congress.

Truth entered the interpretive fray created by Stowe and Gage to inflect her existing image.

In 1864, having already made a name for herself as a speaker among women's rights and abolitionist circles, Sojourner Truth branched out into another well-articulated and highly scripted line of business: cartes de visite. Dressed in the garb of Quaker womanhood, Sojourner Truth posed numerous times, arranging and perfecting her image according to many of the visual codes of the period (fig. 10). She put a lot into the cartes de visite as their sale — along with her speaking engagements where she also sold the printed narrative of her life — was a primary means of financial support for her. Branding it with her slogan, "I Sell the Shadow to Support the Substance," Truth sold her image throughout her lifetime — and beyond.[14]

Truth's personal favorite image is presented as figure 11. Very unlike the outspoken and uncouth speaker who exposed her breast to prove her identity as a woman at one listener's request, this photograph traffics in all the stereotypes of middle-class white womanhood.[15] Indeed, the knitting, book, and flowers are all the visual signifiers of nineteenth-century genteel

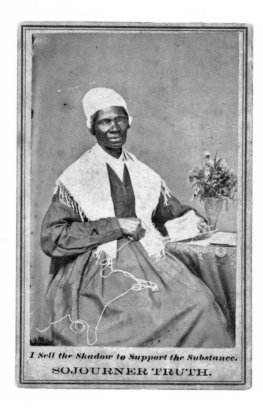

I Sell the Shadow to Support the Substance.
SOJOURNER TRUTH.

11. Sojourner Truth's favorite image, 1864 carte de visite with caption.
Courtesy of the Library of Congress.

and domestic femininity. One scholar even suggests that the light shawl against the dark homespun are choices made deliberately by Sojourner Truth to suppress clues that might aid in dating the photograph more precisely, thus extending the "shelf life" of the image's marketability.[16] As famous as this image is, however, little has been done to put it into the context of Truth's life and publication history.

Just prior to Truth's visit to the photographers James J. Randall and Croydon Chandler Randall in Detroit, Frances Dana Gage's fanciful rendition of what has come to be known as Truth's "Ar'n't I a Woman?" speech, initially delivered almost ten years earlier, and Harriet Beecher Stowe's publication of "The Libyan Sibyl" in the *Atlantic Monthly* had garnered her much public attention.[17] Like these publications, Truth, too, must have been riding the wave of renewed interest in things abolitionist put in motion by the Emancipation Proclamation. But perhaps more significantly, this set of photographs should be seen as Truth's active response to the solidification of her image happening all around her.

The success of her intervention relies on an idea about the relationship

between the subject and its photographic representation that was common to nineteenth-century viewers. Roland Barthes identifies the peculiar power of the photographic image, allowing that a photograph is "somehow co-natural with its referent"; it retains a level of presence not necessitated by other referential systems.[18] Indeed, as a signifier, the photograph documents "the necessarily real thing which has been placed before the lens."[19] The photograph allows Truth to preserve her presence long after her speech has ended, retaining a place in the imagination of her listeners as they return to the world of readers. Barthes's reflections resonate even more deeply when we recall how the limitations of the *Narrative* portrait frontispiece published in 1850 replicated the strictures placed on her authorial control of print conventions. Truth found a broader array of expressive techniques at her disposal in the conventions surrounding photography and the carte de visite form.

When it came to her cartes de visite, she used copyright conventions she probably learned from her experiences with print publication to protect her image and maximize profit. Typically, the photographer held copyright over images produced in the company studio. Truth subverted this system informally by printing her slogan on the front of the cartes de visite, thus calling attention to her ownership. Perhaps more significantly, however, she also utilized copyright laws designed for print publication, entering her image into copyright as early as 1864 in the Eastern District of Michigan under her own name.[20]

Truth aggressively marketed these images through the print organs—such as the *Anti-Slavery Bugle*—with which she had an ongoing relationship. These papers printed announcements provided by Sojourner Truth (through letters penned by her grandson) regarding availability, cost, and contact information for those interested in purchasing one of her images. Bringing this history to bear on Truth's command of her image through her active use of iconography, legal protection, and marketing exposes Truth in her various roles as artful purveyor, producer, and product.

All of these seemingly disparate elements of self-promotion come together as a form of self-production in the edition of Truth's *Narrative* published in 1875. Considered the closest thing we have to an "authorized biography" by Nell Painter, the edition of 1875 is the last edition Truth collaborated on before her death in 1883. Immediately upon opening the book, the reader encounters an important change. In place of the frontispiece found in the preceding editions of the *Narrative*, we find a lithograph based on one of the cartes de visite of 1864. We know of no fewer than seven separate versions of this photograph, suggesting a degree of

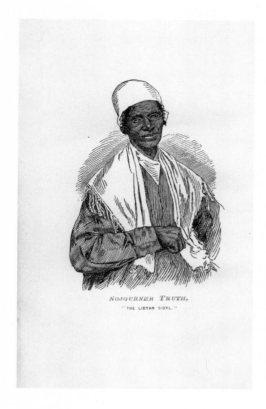

SOJOURNER TRUTH,
"THE LIBYAN SIBYL."

12. Author frontispiece,
Narrative of Sojourner
Truth, **1875.**

Used with permission of
Documenting the American
South, University of North
Carolina at Chapel Hill
Libraries.

intentional craft and artful manipulation that might be masked by what
may otherwise seem a stereotypical portrait of the era.[21] Indeed, part of
Sojourner Truth's success had to do with her use of various conventions
to ensure success.[22] She also routinely retooled convention to suit her pur-
poses.[23]

All of the existing photographs of Sojourner Truth—whether copy-
righted or not—resist the images of folksy slave life that both Gage and
Stowe put forward so baldly in their 1863 representations of Truth. Let us
turn, then, to the portrait she used for the frontispiece of the last edition of
the *Narrative* on which she collaborated (fig. 12). Based on the only image
of Sojourner Truth smiling, this image welcomes the reader with her re-
laxed pose. Like the earlier frontispiece, this portrait shows Truth looking
directly at the viewer. But this one seems to engage viewers with a friendly
smile, while the earlier portrait, with its rigid pose, suggests a more accu-
satory glance.

The frontispiece of 1875 "corrects" the earlier portrait through the clear
evocation of Quaker dress. And its provenance as being based on an actual

NARRATIVE

OF

SOJOURNER TRUTH;

A Bondswoman of Olden Time,

EMANCIPATED BY THE NEW YORK LEGISLATURE IN THE EARLY
PART OF THE PRESENT CENTURY;

WITH A HISTORY OF HER

Labors and Correspondence,

DRAWN FROM HER

"BOOK OF LIFE."

BOSTON:
PUBLISHED FOR THE AUTHOR.
1875.

13. **Title page,** *Narrative of Sojourner Truth*, **1875.**

Used with permission of Documenting the American South, University of North Carolina at Chapel Hill Libraries.

and known photograph also "corrects" the earlier frontispiece in its clear and direct reference to Sojourner Truth as having truly existed.[24] The headdress is transformed from a turban to a Quaker bonnet, an affiliation that is underscored by the shawl and homespun cloth of the simple gown. The frontispiece presents the author as dignified if not a little antique.

The image also picks up on changes made to the title page (fig. 13). Unlike the earlier editions, this one characterizes Truth as "A bondswoman of olden times" in a gothic font. Slavery, as it appears on the title page and as it is figured in the image accompanying it, is very much in the past. Indeed, like the gothic lettering, the terms *bondswoman* and *olden* emphasize a certain gentility that was categorically absent in the earlier editions. Previous editions pictured Truth in the garb of plantation slavery and referred to her as a "slave" explicitly using the same straightforward font of the entire title. Thus we see Truth's public persona revised here in image, text, and font.

Somewhat remarkably, Truth, with the help of her friend, sponsor, and manager Frances Titus, not only included Stowe's "Sojourner Truth: The Libyan Sibyl" in another new feature of the edition published in 1875, a

segment she called her "Book of Life," but also replaced what had become Truth's "trademark" phrase, "I Sell the Shadow to Support the Substance," with one taken from Stowe's title to announce her portrait. Captioning the frontispiece of 1875 with "Sojourner Truth: 'The Libyan Sibyl,'" she added still another layer of opacity to an already difficult to interpret case of agency (see fig. 12). Here it may be useful to return to one of the key distinctions that Truth has when put in the field with the other nineteenth-century African Americans who rose to prominence. Truth retained—even touted—her status as a member of an oral culture, making her living on speaking engagements at which she sold, more as a souvenir than as a "book," copies of her narrative working from one of oral culture's prime principles: you know what you remember.[25]

Truth did not abandon the earlier frontispiece (see fig. 9) entirely, however. She returned to the engraving and made use of it as the introductory image for the "Book of Life." Now acting as a frontispiece for a book within a book, the image introduces readers to a set of documents that sketch a more complex—if not multivalent—portrait of Sojourner Truth. Attentive viewers would notice a slight change in the details presenting the portrait, however. This time the caption reads: "A Picture taken in the days of her Physical Strength." Somewhat bizarrely, the engraving's alleged model—a photograph ("a picture taken")—never existed, leaving us to wonder how much agency we can assign to this image.[26] Should it, along with the Narrative and the "Book of Life," be dismissed from the archive as inauthentic or too deeply mediated by the agency of others? Might we, perhaps more boldly, simply dismiss it as a lie? Or might we consider the alleged photographic trace as still another example of Truth's canny manipulation of contemporary expectations? If so, the falseness of the reference to the portrait's photographic trace matters less than the suggested importance of the photographic image for Truth. Falsifying this reference, the image now has precisely the same liminal (and fabulistic) status as does Gage's version of Truth's speech and Stowe's portrayal of Truth as the Libyan Sibyl. Through the insistence of the reference, the image's status is being inserted as testimony much in the same way as are the other representations of Truth contained in the "Book of Life."

Certainly Gage's and Stowe's contributions might be dismissed as caricatures whose origins are rooted in American ideas about slaves. But rather than simply jettison these representations as false or too deeply mediated by the ideology of others, we should accept them as authorized witnesses—as opposed to textual acts of authorship—thanks to the publication history of Truth's Narrative.[27] Truth claimed these representations by reprinting them

14. A page of autographs,
Narrative of Sojourner Truth,
1875.

Used with permission of
Documenting the American
South, University of North
Carolina at Chapel Hill Libraries.

in the *Narrative* of 1875 to which she appended her "Book of Life"—a bricolage of materials that all "testify" to Sojourner Truth's cultural standing.

Placing emphasis on authorship as the construction of memory—rather than as a verifiable identity—Truth is free to utilize all manner of material and position it as testimony. She makes no secret of the communal act responsible for the construction of her memory. Indeed, the "endorsements" she receives are featured as "concluding" evidence of her worldwide reputation. In a section titled, "Autographs of Distinguished Persons, WHO HAVE BEFRIENDED SOJOURNER TRUTH BY WORDS OF SYMPATHY AND MATERIAL AID" readers become viewers of Sojourner Truth's scrapbook (fig. 14). These signatures—like her photographic image—establish human presence over the mechanical act of textual authorship as the ultimate measure of one's life and reputation. Making their hands hers, Truth transforms writing into image by reproducing actual signatures.

In a letter dated January 17, 1870, and also reprinted in the "Book of Life," Olive Gilbert writes, "I did not think you were laying the foundation of such an almost world-wide reputation when I wrote that little book

for you."[28] Clearly Truth's promotional efforts derive from her sophisticated sense of how to transfer key principles of orality—testimony, for instance—into a print-laden, commodity-driven evangelical culture. For, though she must have been proud of the prominence that she achieved thanks to Stowe's article, and therefore chose to reprint it in her "Book of Life," there was something very peculiar about this piece that might have argued against its inclusion—certainly in something she was calling her "Book of Life." Stowe spoke of Sojourner Truth as if she were dead. Rather than correct her rhetorical death,[29] however, Truth capitalized on her transformation from famous to *legendary*—indeed, this is the Sojourner Truth we remember today but don't *know* according to our own preferences for textual evidence over testimony. In appreciating her editorial control in manufacturing a public self, we must also realize what we don't have—insight into who Sojourner Truth really was. Instead we have the public identity she aggressively crafted with few clues as to what might lie behind that projection.

What sorts of conclusions might we draw from this barrage of seemingly contradictory evidence? For one thing, it might mean that Truth recognized a certain value in the more conventional portrait she used for the *Narrative* of 1875 as it encapsulates many of the racial and gender stereotypes of the day. Unlike the shifting signifier of the portrait used in the edition of 1850, this image refers to an actual photograph and thus capitulates to the convention that slave narratives use the frontispiece to prove racial identity. Like the reprinting of Gage's version of the Akron, Ohio, speech and Stowe's "Libyan Sibyl" article, the placement of this portrait also suggests that Truth turned to those stereotypes as one might to market conventions so as to help solidify her position in the literary marketplace—one largely defined by the moral consumerism of evangelical capitalism as defined by free labor sugar and cotton. Moving the portrait of 1850, which presents Truth in the guise of a slave, from the frontispiece into the middle of the volume, and using it to introduce the "Book of Life," Truth situates herself as the humble slave whose now legendary status has eclipsed many of the luminaries whose autographs are reproduced in the "autograph" section of the "Book of Life." This was, perhaps, Truth's way of heightening the irony between her "half-pint full" and the larger portions she had alluded to earlier when she assured her listeners at the Akron, Ohio, woman's

rights convention: "You need not be afraid to give us our rights for fear we will take too much, for we can't take more than our pint'll hold." As her "Book of Life" testifies, her pint held quite a bit. Regardless of the interpretation we accept, there is no denying that moving the portrait of 1850 from the frontispiece to the second half of the volume is a remarkable shift—and one that reverses the narrative history of the book as a composition.[30]

With all of this in mind, it is time to return to that vexed question of authorship. Remarking on the condition of Truth's legacy vis-à-vis the *Narrative*, Nell Painter observes, "with neither single author, coherent viewpoint, nor chronological order, . . . [the] editions of the *Narrative* present a fractured portrait."[31] From these fractures, through a close study of the many and various representations of Truth, we catch a glimpse at the degree to which authorship is constructed perhaps more blatantly than in other more "stable" examples that single-authored texts provide. What Truth has done is to call attention to the facts of composition that are part and parcel of representation. What seems clear is Truth understood the limits and gaps of print culture in ways that were both visceral and inevitable for a black woman living in mid-nineteenth-century America.

"I am a self-made woman," Sojourner Truth announced in the *Narrative* of 1875.[32] And in many ways, she's right. But it's important to weigh in not just that she made herself but how she made herself through concentrated efforts to engage marketplace conventions and demands. Of course, insofar as she *could* make herself. For while her example may seem refreshingly empowered, there are also some drawbacks to her story that we must not overlook. Asked why she looked so young late in life, she explained that she had two skins—a black one covering a white one. Her racial attitudes are troubling—I think especially within our political views about race in general today. Yet, here her internalized racism becomes a way for us to understand her conception of the world she was living in. She knew that race mattered and that as a dark-skinned black woman she needed to find ways to make race work to her advantage. Thus the turban in the author portrait of 1850 and the trappings of femininity in the photographs she sold to support herself later. When she says she sold the shadow to support the substance, we might understand shadow to mean "race" here and therefore recognize in Truth's catchy slogan another way in which she engaged in the race trade that compelled the market of the period.[33] Nonetheless, it's Sojourner Truth's *use* of the conventions of visual and print cultures not her collapsing to its rules that are most exemplary. Her story grants us an unusually illuminating look into the complexities of agency within the context of visual and print culture. Her example also shows us that these two

mediums are inextricably linked. Whether in image or text, Truth only lets her substance be seen from behind the shadow of the racist paradigms set for blacks who wished to use publication as a means to make a living. Converting the frontispiece from a racial marker into a visual clue to her complexity, privileging speech over writing, and remaining illiterate in a print-laden world while also laying claims to "authorship," are all examples of Truth's subtle repurposing of print culture's conventional norms. Truth's representations—in their various modes and appearances—challenge any and all of these representations as stable and authoritative narratives of self. Sojourner Truth plays with the idea of the photograph as an indexical sign marking the presence of the subject, demonstrating her awareness and manipulation of visual codes permeating nineteenth-century U.S. culture regarding race, gender, class, and region. In turn, her use of text and composition practices over the course of the many reprintings of the *Narrative* illuminates the pitfalls of photography as it lures us into a complacent acceptance of the pose as real. Taken together, her representational legacy braids two strands of theoretical thinking: one that has taken shape around visual culture and one that has focused on materiality and the history of the book. As Truth emphasizes the constructedness of the image we see she clearly understands that reproduced representations are assembled and therefore can be manipulated. She uses that knowledge to unsettle the authority of writing and print, even as she uses both to claim her own presence—selling the shadow to support the substance—while teaching those of us who are entrenched in a literacy-laden print culture to think outside the book.

Notes

1. The first version was transcribed by Marius Robinson, and appeared in the *Anti-Slavery Bugle*, June 21, 1851. The second was published by Frances Dana Gage in the *New York Independent*, April 23, 1863.

2. Although it was not uncommon for printed engravings to be based on photographs in 1850, it is unlikely that this portrait of Truth was based on a photographic image. As Nell Painter explains, photography was not yet invented during the years Truth dressed in this manner, as a farmworker. By 1839, the year photography was invented, Truth would have been over forty years old and living in New York City. Nell Irvin Painter, ed., *Narrative of Sojourner Truth* (New York: Penguin Books, 1998), 253n76.

3. Francis Dana Gage's description is probably the most often cited and therefore replicated. But Harriet Beecher Stowe's depiction of Truth in "The Libyan Sibyl" also includes the turban as part of the description.

4. Walter Ong in *Orality and Literacy: The Technologization of the Word* (New York: Routledge, 2002), 5, addresses the "persistent tendency, even among scholars, to think of writing as the basic form of language," and it is this tendency that has kept scholars from appreciating—and understanding—the important work that speech and image does for Sojourner Truth.

5. According to research Ong discusses at length, "Writing has to be personally interiorized to affect thinking processes" (*Orality and Literacy*, 56). Thus, though Truth had contact with literacy and even utilized many of its formations, she retained her independence from it by remaining illiterate. For further discussion of Ong's broader claim that writing restructures consciousness see *Orality and Literacy*, 77–114.

6. Painter, *Narrative of Sojourner Truth*, 74.

7. Painter, *Narrative of Sojourner Truth*, 30–31.

8. See Jean Baudrillard, *Simulacra and Simulation*, trans. Sheila Faria Glaser (Ann Arbor: University of Michigan Press, 1994).

9. Refuting this assertion, Truth remarked, "There is one place where she speaks of me as coming from Africa. My grandmother and my husband's mother came from Africa, but I did not." Sojourner Truth quoted in Nell Irvin Painter, *Sojourner Truth: A Life, A Symbol* (New York: W. W. Norton and Company, 1997), 163.

10. Harriet Beecher Stowe, "Sojourner Truth, The Libyan Sibyl," in Painter, *Narrative of Sojourner Truth*, 103–17, 114–15.

11. Harriet Beecher Stowe, "Sojourner Truth, The Libyan Sibyl," in Painter, *Narrative of Sojourner Truth*, 114–15. Further on in this passage, Stowe suggests that had Truth "the same culture" she might have "spoken words as eloquent and undying as those of the African Saint Augustine or Tertullian" (115). The slippage here is remarkable, as so many of the quotations in Stowe's piece show, Truth's spoken words are eloquent, but the record of them is not her own. She thus marks a distinction between testimony and textuality that is at the heart of my chapter on Truth in *Thinking Outside the Book* (forthcoming).

12. Gage, "Ar'n't I a Woman?," *New York Independent*, April 23, 1863.

13. Scholars have come to this conclusion based on a comparison with the earlier version of the speech published in the *Anti-Slavery Bugle*. For the sake of comparison, I reprint the earlier version here: "'May I say a few words?' Receiving an affirmative answer, she proceeded; 'I want to say a few words about this matter. I am a woman's rights. I have as much muscle as any man, and can do as much work as any man. I have plowed and reaped and husked and chopped and mowed, and can any man do more than that? I have heard much about the sexes being equal; I can carry as much as any man, and can eat as much too, if I can get it. I am as strong as any man that is now. As for intellect, all I can say is, if woman have a pint full and a man a quart—why can't she have her little pint full? You need not be afraid to give us our rights for fear we will take too much, for we can't take more than our pint'll hold. The poor men seem to be all in confusion, and don't know what to do. Why children, if you have woman's rights give it to her and you'll feel better. You will have your own rights, and they won't be so much trouble. I can't read, but I can hear. I have heard the bible and have learned that Eve caused man to sin.

Well if woman upset the world, do give her a chance to set it right side up again. The Lady has spoken about Jesus, how he never spurned woman from him, and she was right. When Lazarus died, Mary and Martha came to him with faith and love and besought him to raise their brother. And Jesus wept—and Lazarus came forth. And how came Jesus into the world? Through God who created him and woman who bore him. Man, where is your part? But the women are coming up, blessed be God, and a few of the men are coming with them. But man is in a tight place, the poor slave is on him, woman is coming on him, and he is surely between a hawk and a buzzard.'" Transcribed by Marius Robinson, *Anti-Slavery Bugle*, June 21, 1851.

14. After her death, the image was used by her tireless supporter—and promoter—Frances Titus to raise money for the Sojourner Truth memorial that was eventually erected outside of Northampton. See Kathleen Collins, "Shadow and Substance: Sojourner Truth," *History of Photography* 7, no. 3 (July–September 1983): 194.

15. Painter, *Sojourner Truth: A Life, a Symbol*, 139.

16. Collins, "Shadow and Substance: Sojourner Truth," 195.

17. The speech—and the several versions that have been published—is the subject of much debate. Once again, for the sake of comparison, see the two versions transcribed by Marius Robinson in *Anti-Slavery Bugle* on June 21, 1851, and published by Frances Gage in the *New York Independent* on April 23, 1863. "The Libyan Sibyl" appeared in *The Atlantic Monthly* on April 9, 1863.

18. Roland Barthes, *Camera Lucida*, trans. Richard Howard (New York: Hill and Wang, 1981), 76.

19. Barthes, *Camera Lucida*, 60.

20. Collins uses the copyright notice to help date the various photographs of Sojourner Truth. Those that do not bear the copyright stamp are believed to be taken prior to 1864 ("Shadow and Substance: Sojourner Truth," 189–90).

21. Andrea Volpe, "Collecting the Nation: Visions of the Nation in Two Civil-War Era Photograph Albums," in *Acts of Possession: Collecting in America*, ed. Leah Dilworth (New Brunswick: Rutgers University Press, 2003), 89–111.

22. Painter, *Sojourner Truth: A Life, a Symbol*, 189.

23. Famously, she was the first African American to file and win a slander suit.

24. I am glossing Barthes here: "Painting can feign reality without having seen it . . . in Photography I can never deny that the thing has been there" (*Camera Lucida*, 76).

25. Walter Ong, *Orality and Literacy*.

26. Once again, Nell Painter explains that it is unlikely this portrait was based on a photograph. Painter, *Narrative of Sojourner Truth*, 253n76.

27. Here again, understanding Truth's choices also requires that we think about them as within the practices of oral culture.

28. Painter, *Narrative of Sojourner Truth*, 187.

29. Truth did correct several errors about her life that Stowe promulgates in her *Atlantic Monthly* piece, among them the notion that Sojourner Truth was from Africa, as noted above. In correcting these errors, she de facto corrects the central error of the piece: that Truth is dead (Painter, *Sojourner Truth: A Life, a Symbol*, 160).

30. To explore the wisdom of Sojourner Truth's choices, we might turn to the literary history of Harriet Wilson's novel, *Our Nig*, and think of Wilson's experience as a cautionary tale. Published in 1859, Wilson violated convention by using the novel form instead of autobiography and focused on the tabooed subject of Northern slavery—features that Sojourner Truth studiously avoided. Known to us only thanks to Henry Louis Gates Jr.'s rediscovery of it (and here we might also recognize a more recent discovery of his: James Williams's novel that posed as an autobiography as well), the novel had moldered in obscurity. In stark contrast, Sojourner Truth's image and "words" are known the world over.

31. Painter, *Sojourner Truth: A Life, a Symbol*, 261.

32. Painter, *Narrative of Sojourner Truth*, 3. See also Jean Fagan Yellin, *Women and Sisters: The Antislavery Feminists in American Culture* (New Haven: Yale University Press, 1989).

33. There were other sacrifices as well. By adapting her message to the market for slave narratives for instance, her evangelical message was sometimes muffled by the noises of authorship. Yet, in this connection we should also consider the ending Truth/Gilbert chose for the *Narrative*—an homage to her former master for coming to see that slavery was evil. Hers is a decidedly evangelical ending in that she stresses the saving of his soul over the condemnation of slavery and its practitioners (see Painter, *Sojourner Truth: A Life, a Symbol*, 110).

Unredeemed Realities

AUGUSTUS WASHINGTON

Shawn Michelle Smith

The man's eyes rivet one's attention. Large and light and piercing they look directly out at the viewer from under the deep creases of a furrowed brow. The intensity of the man's expression is anchored by lips so thin they disappear in a straight line above his squared jaw. A wide expanse of forehead is topped by a thick shock of hair that stands straight up. Clad in a dark suit, standing straight and thin, the man steadies himself with one hand clasped to a flagpole as he lifts the other, palm turned out. With hand raised, and leveling his solemn stare at the viewer, the man seems to be swearing an oath, performing his pledge to abide an unspoken contract (fig. 15).

This image is Augustus Washington's daguerreotype portrait of the radical abolitionist John Brown, made in 1846 or 1847 in Washington's studio in Hartford, Connecticut. Like most early daguerreotypists, Washington came to his career in photography via a circuitous route. Born into freedom in Trenton, New Jersey, in 1820 or 1821, Washington grew up educated, and as a young man worked as a teacher. He enrolled at Dartmouth in the fall of 1843, as the college's only African American student, and in the winter of 1843 he took up daguerreotypy in the hopes of earning some quick money to pay for his education. His early experiments in photography were a success, but they were not lucrative enough to enable him to continue his studies at Dartmouth beyond the first year. Intending eventually to return to college, he taught in Hartford for two years and in 1846 took up daguerreotypy again, this time with sustained success. Washington operated a daguerrean studio in Hartford from 1846 to 1853, the year he

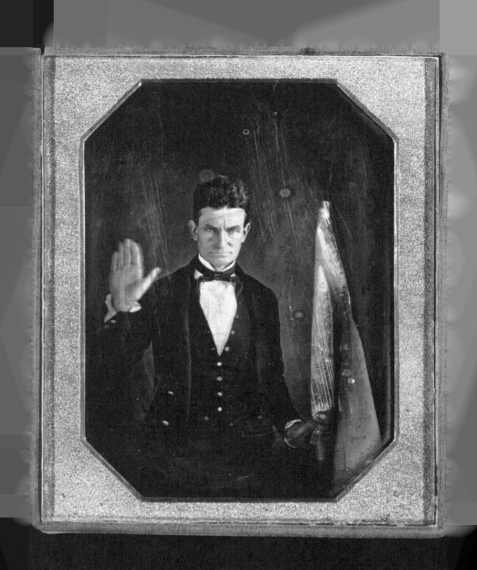

5. Augustus Washington, portrait of John Brown, daguerreotype circa 1846–1847.

emigrated to Liberia. He continued his photographic practice for several years in Africa, finally giving it up around 1858 as his agricultural pursuits flourished and he became a prominent figure in Liberian politics.[1]

While in Hartford, Washington ingeniously advertised his photographic services to a diverse clientele, offering daguerreotypes of different sizes, mounted in different frames, and ranging in price from fifty cents to ten dollars. In an advertisement of 1851 he noted that "in some instances, watches, jewelry and country produce will be received in exchange for Likenesses."[2] His services included portraiture, copying, daguerreotype jewelry, and postmortem images made at the deceased's home. He kept a separate ladies' dressing room and employed a female attendant to assist women as they prepared themselves for the camera.[3] It is unclear exactly how John Brown found his way to Washington's Hartford studio, but it is likely that their paths crossed in abolitionist circles, as Washington, like Brown, was an avid abolitionist and advertised his studio and photographic services in abolitionist newspapers.[4]

Both the photographer and his subject bear important and intriguing relationships to slavery and the nation. Neither could abide the United States' embrace of slavery, and both found it necessary to sever their bonds of allegiance with their birth country. Brown charted a path of violent rebellion, while Washington chose to leave the country altogether to found a new nation for African Americans in Africa. Washington determined to leave the United States after the Fugitive Slave Law of 1850 endangered all African Americans living in the North and deemed no territory in the country truly safe for African Americans. Although he abhorred the racist contingent of the American Colonization Society (ACS), which sought to purge free African Americans from American soil by sending them to Liberia, Washington could not find an alternative sanctuary. After Liberia formally gained its independence from the ACS (in 1847), and after the Fugitive Slave Law convinced Washington that there was no place for African Americans to remain in the United States, he decided that he would seek freedom and self-determination for himself and his family in Monrovia, the capital of Liberia.[5] He declared: "I have been unable to get rid of a conviction . . . that if the colored people of this country ever find a home on earth for the development of their manhood and intellect, it will first be in Liberia."[6] He and his family set sail in November of 1853.[7]

Soon after his arrival in Africa in December of 1853, Washington made striking daguerreotype portraits of Liberia's early leaders, including Vice President Beverly Page Yates (fig. 16), Senate chaplain Reverend Philip Coker, a number of senators, as well as the secretary, clerk, and ser-

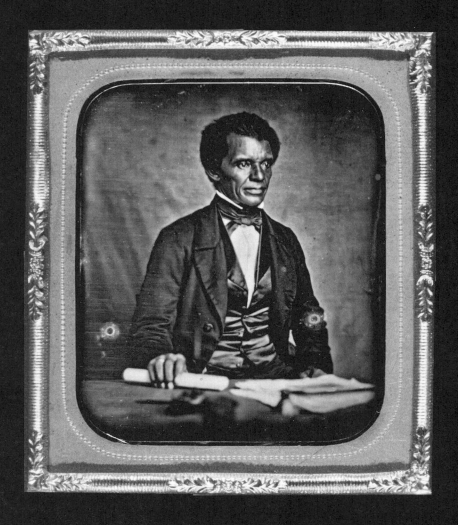

16. Augustus Washington, portrait of Beverly Page Yates,
vice president of Liberia, daguerreotype circa 1857.

Prints and Photographs Division, Library of Congress, Washington, D.C.

geant at arms of the Senate.[8] He also made landscape views of Monrovia, which were reproduced as engravings in the *Twenty-fourth Annual Report of the Board of Managers of the New-York Colonization Society* in 1856.[9] Washington's photographs of Liberia's dignified and leading men, both young and old, testify to the determination of the Liberians to demonstrate their capacity for self-government. Indeed, Washington's daguerreotype portraits of Liberian leaders challenged a host of scientific and popular pro-slavery arguments that proclaimed Africans and African Americans unfit to "master" themselves. In this way Washington's portraits of Liberia's leading men function as metonymic representations of the larger nation. The portraits reverberate with both the artistic and the political meanings of self-representation and suggest that the two are mutually constitutive. In Washington's portraits of Liberian government officials, one's ability to represent one's self photographically announces one's capacity for political self-representation.

Approximately ten years separate Washington's portrait of John Brown from his portraits of Liberian senators, and Washington's career as a daguerreotypist was essentially over by the time Brown made his raid on Harpers Ferry in October of 1859.[10] Indeed, on the day Brown entered Washington's studio and stood in front of the photographer's camera, many possible futures remained open to both men. Both had committed themselves to the cause of abolition, but both were still searching for plans of action. According to W. E. B. Du Bois, in 1839, in the presence of an African American preacher named Fayette, John Brown had pledged himself "to make active war on slavery," but at that time he was still "a nonresistant, hating war, and did not dream of Harpers Ferry."[11] Over the years, Brown slowly came to embrace violent means to his ends, and in 1856 he made his murderous attack in Kansas. In 1858 he made a raid into Missouri to free enslaved people, and the following year he made his most famous and final raid at Harpers Ferry. Brown's raid on Harpers Ferry ended in defeat, and Brown was captured, tried, and sentenced to death. He was hung in Charleston on December 2, 1859.

Although his final efforts failed, some have nevertheless credited John Brown with inciting the passions that would fuel the American Civil War.[12] Brown himself recognized that his execution might ultimately do more for the cause of radical abolition than any of his raids, and his premonition was realized as Union soldiers marched in 1861 to the song "John Brown's Body." As the lyrics of the song proclaim, even as "John Brown's body lies a-mouldering in the grave, / His soul is marching on!" The execution of John Brown symbolically liberated his soul for the continued struggle, and

the one-time pariah was transformed into a martyr and a powerful symbol in the fight for freedom.[13]

Washington's portrait of John Brown tells us nothing of this history. Indeed this daguerreotype, like all photographic images, provides only the most ambiguous kind of "evidence," only the strangest brush with the past. In Washington's portrait Brown's striking gaze portends a dramatic future. But in 1846 or 1847 it is still a future he has yet to imagine. At the moment Washington photographed Brown any number of subsequent paths were possible. And one might say this of all photographs. Although we tend to situate photographs within historical narratives as if the trajectories that have led from past to present were inevitable, those routes have never been preordained. It is extremely difficult to look at Brown's portrait today without a premonition of the important events to come, to engage his gaze without seeing in it a vision of the violent and heroic future that is now past, but at the moment the daguerreotype was made the future was unclear. If we take the photograph on its own terms, dissociating it from the history we have learned, it might give us access to that powerful indeterminacy.

Washington's portrait of Brown exemplifies one of the difficulties inherent in reading photographs. As Ulrich Baer has argued, viewers have a "virtually automatic predisposition to link particular sights to familiar historical contexts and narratives."[14] We look at Brown's portrait and cannot help but think of the events of Harpers Ferry. Nevertheless, according to Baer: "Photographs compel the imagination because they remain radically open-ended," and "every photograph is addressed to a beyond that remains undefined."[15] Part of the raw power of the photograph might be registered if one refuses the impulse to read it back through history or, rather, to read the historical record back to it. What would it mean to look into John Brown's eyes without seeing Harpers Ferry preordained? Without knowing that his efforts would fail and his life would end at the scaffold? What would it mean to let Brown's singular gesture, captured on a daguerreotype plate, remain unincorporated in the narrative of a history still to come? Such arrested narrative might return one to Brown's oath, to the power of the promise itself.

Writing in the wake of theorists such as Roland Barthes and Eduardo Cadava, who have focused on the melancholy nature of the photograph's record of a moment that has always already passed,[16] Baer proposes: "At the very least, our sorrowful realization that the photograph announces the future death of the subject should be paired with an equally poignant awareness of photography's promise of a reality that is yet, as Kracauer put

it, 'unredeemed.'"[17] The promise of the reality figured by John Brown's solemn oath is indeed a reality that has not yet been redeemed. Washington's daguerreotype of Brown's piercing eyes holds a radical vision of a future of racial justice that we have yet to see. Indeed, what Du Bois declared in his biography of Brown in 1909, and again in 1962, could be reiterated today: "Reverently listen again to-day to those words, as prophetic now as then." And those words, from the mouth of John Brown, are: "You may dispose of me very easily—I am nearly disposed of now; but this question is still to be settled—this Negro question, I mean. The end of that is not yet."[18] Gazing upon Washington's portrait of Brown, we might reject a historical narrative of past failures and reconsider the moment of our present failures. Looking into John Brown's eyes as they looked into Augustus Washington's camera, we might catch a glimpse of a radical vision, of a promise yet unredeemed.

Notes

1. Ann M. Shumard provides detailed biographic information about Augustus Washington in *A Durable Memento: Portraits by Augustus Washington, African American Daguerreotypist* (Washington, D.C.: National Portrait Gallery, Smithsonian Institution, 1999), 2–18. Shumard has begun the important work of bringing Augustus Washington's story to light with her exhibit of his work and informative catalogue. Other art historians and scholars, including Gwendolyn DuBois Shaw, Emily K. Shubert, Deborah Willis, and George Sullivan, have also marked Washington's importance in the history of photography, and Wilson Jeremiah Moses has collected Washington's published letters. See Gwendolyn DuBois Shaw, with contributions by Emily K. Shubert, *Portraits of a People: Picturing African Americans in the Nineteenth Century* (Andover, MA: Addison Gallery of American Art, Phillips Academy, 2006); Deborah Willis, *Reflections in Black: A History of Black Photographers 1840 to the Present* (New York: Norton, 2000); George Sullivan, *Black Artists in Photography, 1840–1940* (New York, Dutton: Cobblehill Books, 1996); Wilson Jeremiah Moses, ed., *Liberian Dreams: Back-to-Africa Narratives from the 1850s* (University Park: Pennsylvania State University Press, 1998).

2. Shumard, *A Durable Memento*, 7.

3. Ibid.

4. Ibid., 4.

5. Ibid., 6–8.

6. Augustus Washington, "Thoughts on the American Colonization Society, 1851," *African Repository* 27 (July 3, 1851): 259–65, reprinted in Moses, *Liberian Dreams*, 184–97, with the quoted material on page 185.

7. Wilson Jeremiah Moses, "Biographical Sketch of Augustus Washington," in *Liberian Dreams*, 181–83.

8. Shumard, *A Durable Memento*, 13.

9. Ibid., 15, 24.

10. Ibid., 14–15.

11. W. E. Burghardt Du Bois, *John Brown* (1909; repr. New York: International Publishers, 1962, second printing 1967), 92–93.

12. In the preface to the second edition of his biography of John Brown, W. E. B. Du Bois attributes the start of the Civil War to Brown, declaring: "A full century has passed since John Brown started in America the Civil War which abolished legal slavery in the United States and began the emancipation of the Negro race from the domination of white Europe and North America" (Du Bois, *John Brown*, 5).

13. Franny Nudelman, "The Blood of Millions: John Brown's Body, Public Violence, and Political Community," *John Brown's Body: Slavery, Violence, and the Culture of War* (Chapel Hill: University of North Carolina Press, 2004), 14–39.

14. Ulrich Baer, *Spectral Evidence: The Photography of Trauma* (Cambridge: MIT Press, 2002), 2.

15. Ibid., 24, 182.

16. Roland Barthes, *Camera Lucida: Reflections on Photography*, trans. Richard Howard (New York: Hill and Wang, 1981); Eduardo Cadava, *Words of Light: Theses on the Photography of History* (Princeton: Princeton University Press, 1997).

17. Baer, *Spectral Evidence*, 181–82.

18. Du Bois, *John Brown*, 403.

 FOUR

Mulatta Obscura

CAMERA TACTICS AND LINDA BRENT

Michael Chaney

Linda Brent, the narrator of Harriet Jacobs's *Incidents in the Life of a Slave Girl* (1861), postpones her status as a slave within the darkened space of her hideaway garret by becoming a seeing subject.[1] Conveyed through metaphors of the camera obscura and physically structured like one as well, the garret permits invisibility from plantation systems of optic domination while affording the viewer painfully ensconced within it an alternative version of optic power via a one-inch diameter peephole.[2] In this chapter I want to explore Jacobs's twinned thematics of visuality and embodiment, how domination through and retreat from visibility respond to historical entrapments of the raced and gendered body, and how liberatory possibilities for self-representation result from appropriative redomestications of technologies of seeing.

That visuality usually proved an inhospitable and unlikely domain of resistance for the antebellum slave is not surprising given the intensity with which sentimental, proslavery, and abolitionist discourses unanimously sought to associate physical violation with black embodiment. For Lindon Barrett, this association is crucial to the scopic logic of Western modernity, "in which racial whiteness ideally is read as the human, as the visible, and as the essential meaning of the human and the visual."[3] Monopolized in this way, the visual field as well as the perceptual, economic, and political values that organize it instantiate "a hostile realm of significance" for African Americans, the sight (site) of whose bodies invalidates their claims to value, which, according to Barrett, has led them to make compensatory

and strategic investments in "the less privileged sense-making medium of sound."[4] Debarred from participation in a visual economy of value predicated on racial whiteness, diasporic populations thus take refuge in the resistant potentiality of the auditory and its phonic affiliates (music, the singing voice, dance), which rely less upon abstraction and disembodiment than upon the routine materialization of abstraction, cultural forms that dramatize the embodiment of the concept. Fred Moten has theorized these forms as the effect of Western visuality's excision (or cut) of black humanity, reverberating thereafter in the acoustic aesthetics of black art. For Moten, the looking relations associated with this art preserve agencies of aurality, listening, and embodied response.[5] It is, after all, through such an embodied form of response that the contents of vision circumvent the terrain of the spectacle—which in the early nineteenth century, as Saidiya Hartman has shown, paraded the tortured black body as an inducement for the production of whiteness[6]—to arrive at the terrain of the encounter, a scene of viewing that does not ultimately reinforce through spectacularization the disembodied, abstractable, voyeuristic ontology of the viewer. As this chapter shows, just such an encounter structures Harriet Jacobs's representation of Linda Brent in a garret that conceptually coheres with the functioning of a camera obscura, save for its necessitation of the viewer's embodied response to what is seen simultaneously outside, through, and within it.

This chapter forestalls simple correlations between the artifactual properties of the daguerreotype and the power relations of seeing and being seen that underwrite those properties. For my purposes the relation of daguerreotype to camera obscura is one of synecdoche, a part to whole analogy that understands the mechanism of the daguerreotype in terms of its mechanics in the camera obscura. The latter encompasses the nexus of visual politics, racial history, and optic technology that produces the former. Thus, the presence of the camera obscura and the vicissitudes of its relation to the mulatta form the basis of my inquiry into Jacobs's characterization of the garret as a third space of representation, a material one that mirrors and revises the position of the conventional reader as well as reigning antebellum notions of vision, then under reconstruction in light of technological advancements in daguerreotypy.

And, as we shall see, the space actualized in the garret is never simply a condition of being nor an abstraction but a place of representation operating according to a particular and indeed peculiar mechanics. Trope as well as metric, the garret measures and records a crisis of relations exacerbated

by technologies of hidden surveillance. What Foucault says of the panopticon — that it renders power automatic and decentralized — easily extends to the functioning of the camera but applies to the mulatta only through potentializing analogy, whereby we begin to discern the inter-implication of vision and race with systems of law, love, and liberty.

Labors of Love: Historical Vision versus Sentimental Gazing

Incidents subverts the reader's affective recourse to a particular kind of sentimental reading, which overlooks material history, by denying the possibility of fellow feeling between narrator and reader. More than simple assertions of counteridentification, however, Jacobs facilitates during such authorial interventions a process that Judith Butler terms disidentification: "the experiences of misrecognition, this uneasy sense of standing under a sign to which one does and does not belong."[7] Rather than conceptualizing Jacobs as proponent of or opponent to the dominant ideologies of "true womanhood" ascribed to her readers, an emphasis on disidentification enables a critical sensitivity to the complicated ways in which Jacobs and her narrator highlight simultaneous relations of similarity and difference between the slave woman and her genteel reader. According to Butler, disidentification may be construed as a propitiatory narrational strategy because it proposes "a site of disarticulations" that breaks subjects free from oppressive social mechanisms demanding a repetition or miming of conventional codes of identification.[8] For Jacobs, several expressions of disidentification deal specifically with sentimental looking practices. For example, in a passage typical of the narrative's overall preoccupation with spectatorship, Jacobs courts but then checks her readers' reflexes of pleasure, suffusing a sight of loving connection between master and slave with bleak reminders of historical caste and economic exploitation: "I once saw two beautiful children playing together. One was a fair white child; the other was her slave, and also her sister. When I saw them embracing each other, and heard their joyous laughter, I turned sadly away from the lovely sight. I foresaw the inevitable blight that would fall on the little slave's heart. I knew how soon her laughter would be changed to sighs."[9] Beneath the superficial harmony of the girls' interaction, Brent glimpses an ensuing rift created by their asymmetrical relations to racial hierarchy. Hazel Carby astutely describes the materialist proclivities of Brent's narration, which "repeatedly emphasizes the overwhelming determination of material differences in structuring the lives of women, regardless of either biological

relation or emotional attachment."[10] Less clear in Carby's account, however, is the way in which these motifs of material difference are structured according to metaphors of vision and manifest in scenes of looking.

Through a preoccupation with looking relations, Jacobs critiques simple sentimentalisms that eliminate race and class. In this context, sentimentalism may be heuristically defined as a mode of literary discourse whose authority lies in evoking and transforming both the body's sensations as well as the political meanings attached to them, thereby identifying the body as a site of affective and political struggle.[11] According to Bruce Burgett, codes of literary sentimentalism pose an "intersubjective understanding of self-other relations [that] locates personal and political life as neither opposed along lines of private and public, nor identical to one another."[12] Yet Jacobs draws on this organizing gesture of sentimentalism as explained by Burgett—its partial fusion of the personal and the political—to indict an implicit racial divide separating black subjects from white readers. Rather than repudiate sentimentalism's mystification of the political and the affective, Jacobs highlights the fantasy of its material elision. In diverting the sentimental gaze from effacing social differences between pictured subjects, Jacobs redefines the way bodies come to have meaning in pictorial contexts and how they are constructed for public consumption. In this way, *Incidents* precludes a central effect of racist gazing—"abstraction of the body from its social environment."[13] Throughout this chapter, therefore, whenever discussing the particular form of sentimentalism denounced by Jacobs, I am neither referring to sentimentalism as a tradition nor as the discursive strategy commonly described by scholars of the genre, which seeks through affect the politicization of the body.[14] Rather, I use the term to describe what for Jacobs seems to encompass a strain of ahistorical false consciousness that depoliticizes bodies and imbues both proslavery and abolitionist ways of seeing slaves as centerpieces of affect—whether of suffering or of interracial harmony.

In her critique, Jacobs implicates everyday acts of looking as ideological. Instead of focusing on the photographic logic of the surface, that is, the fantasy of an immediate apprehension of the affections of the interracial playmates as mere image, Jacobs exercises a mode of seeing that synthesizes temporalities, bringing a discordant future to bear down upon the accords of the present. This sort of foresight is very much embedded in history, insofar as "history" denotes a record of material relations.[15] Applying historical vision to the scene becomes the antidote for the amnesia that sentimental pictures induce, particularly those that picture the mulatta in

scenes that stage her historical erasure and divert attention from the historical traumas and bodily violations that produce mulatta populations in the first place. However, it is with effort that the narrator disregards the affective force of the scene, particularly its mystification of social relations, melting them away in the heartwarming spectacle of interracial affection. The most effective means of demystification for Jacobs involves framing the scenes she observes with temporal simultaneity. From this critical vantage, the present joy of the interracial girls cannot account for their different relation to material history, nor can it obliterate the outcome of that difference. Nevertheless, the pull of affective sight is so strong that even the knowing observer denies its enthralling poignancy with difficulty. In turning "sadly away," Jacobs acknowledges the seductive power of pictures, that dangerous allure of seeing the girls' interaction detached from history. Yet simply restoring an occluded history does not always disable a picture's ahistorical effects.

It is in the narrative's treatment of the slave mistress that true womanhood, as a universal category available to women of the leisured classes, dissolves as a source from which principled historical vision may spring: "Mrs. Flint, like many southern women, was totally deficient in energy. She had not strength to superintend her household affairs; but her nerves were so strong, that she could sit in her easy chair and see a woman whipped, till the blood trickled from every stroke of the lash" (10). Instead of posing the mistress descriptively as an object of the reader's optical scrutiny, Jacobs's method of characterization concentrates on the mistress's visual practices: the dissonance between what the mistress sees unfeelingly and what she fails to see.[16] Although the mistress cannot oversee her household, she plays overseer to slave punishment. Two spaces of domesticity are thus counterpoised in this ironic commentary on the mistress's "nerve." On one level, there is the place of the house, which requires all of those facets of micromanagement that the languid mistress fails to satisfy—overseeing the cooking, cleaning, and maintenance of the main plantation house. On another level, there is the plantation or, more aptly, the extended plantation system. In this broader domestic space of authority, Jacobs asserts that the mistress satisfies her role entirely by dint of surveillance, presiding over the agony of slaves with merciless nonchalance. Powerlessness in the former kind of domestic space, Jacobs implies, does not entail powerlessness in the latter. Forasmuch as the mistress has nerve to oversee the oppression of her slaves and thus play manager of public authority, she lacks the nerve to manage the immediate, private demands of domesticity. Throughout *Inci-*

dents, Jacobs underscores a disturbing relationship between the enervated, sadistic spectator position of the mistress and the reader who takes no account of her privilege.

Typically, male-authored slave narratives dramatize a similar combination of voyeurism and sadism, but *Incidents* differently situates the slave viewer to the scene of slave abuse. In the whipping of Aunt Hester, for example, Douglass remains perceptually sensitive to but physically invisible within the scene of abuse that hails him into discursive being. Closeting himself in a nook so that he cannot be seen (a move that resonates with Jacobs's garret position and the mechanics of the camera obscura), Douglass voyeuristically takes part in a primal scene familiar to readers of the slave narrative, who occupy a parallel position of withdrawn scrutiny. Where Douglass's position departs from the classical model of withdrawn, disinterested gazing fetishized by the sovereign seeing subjects of the camera obscura is that his witnessing is anything but psychically or ontologically neutral. The dynamic he witnesses plays out between agents themselves transformed and blurred by the scene, between abusive father-master and abused aunt-mother-slave, which not only makes the young Douglass keenly aware of his position as a slave for the first time but also facilitates an identification more with the master than with the slave.[17] During Douglass's entry through "the blood-stained gate" of slavery's hell,[18] blackness is drawn in equivalence to feminine, abject corporeality and bodily subjection, while white masculinity denotes inviolable authority. Combined with the portrayal of other molested and battered women, such as Henrietta, Mary, and Henny, Aunt Hester's whipping sediments a general image—what Douglass calls "a most terrible spectacle"—of slave women as *abjective* correlatives of slavery's inhumanity.[19] Douglass emphasizes his role as eyewitness to brutality in order to martial literary authority, but as the narrative progresses this self-representation gradually shifts so that the older, emancipated Douglass recounts scenes of cruelty as "pure voice."[20]

Instead of inscribing Linda Brent solely as witness, Jacobs renders her narrator in *Incidents* as a voice of reportage. A quality of removal and distant witnessing more akin (at first glance) to the looking relations of the camera obscura imbues many of the scenes of slave torture recorded in Brent's life story, as seen here:

> Dr. Flint ordered him to be taken to the work house, and tied up to the joist, so that his feet would just escape the ground. In that situation he was to wait till the doctor had taken his tea. I shall never forget that night. Never before, in my life, had I heard hundreds of blows fall, in

succession, on a human being. His piteous groans, and his "O, pray don't, massa," rang in my ear for months afterwards. . . . I went into the work house next morning, and saw the cowhide still wet with blood, and the boards all covered with gore. (15)

In satisfying the genre's conventional representation of the slave body as a spectacle of abject victimization, this scene readjusts the narrator's (and thus the reader's) conventional relation to that spectacle. As in the opening account of William Wells Brown's *Narrative of William W. Brown*, Jacobs's text introduces the slave narrative trope of bodily mortification in a scene that exempts the narrator from having to be an eyewitness. As an alternative, Linda Brent becomes an earwitness to cruelty, but gives visual verification to the horror upon describing the blood-stained cowhide after its use. The "gore" on the boards makes palpable the abolitionist theme that the domestic spaces of slavery are saturated with immanent and immediate violence, creating an architecture that is literally buttressed with blood. Yet Jacobs's emphasis on hearing rather than seeing renders impossible any photographic logic of mimesis, diverting the reader's gaze from the surface of the subjected captive body and allowing the tortured slave a measure of humanity more commensurate with mind than body. The slave's words, detached from and instead of the image of his body, become the sole medium through which the narrator vicariously apprehends his anguish.

In Jacobs's scene of abuse, moreover, the instrument of torture is *removed* from the master's body. The sound of relentless flogging alone expresses the master's cruelty, punctuated only after the fact of the torture by a visual inspection of the cowhide and the blood. These post-spectacle signs visibly index the master's power as an immanent violence that circumscribes Linda. More than treating her narrator or others as victimized spectacles, Jacobs establishes abuse as a secondary but tangible peril, for which the eavesdropping slave—like the reader—feels pity without simultaneously viewing the subjected slave as pitiful. The aural priorities of Jacobs's rendering of torture proleptically metaphorize those tactics of covert observation that Brent will resort to while in the garret.

Unlike typical male slave narrators who begin with graphic punishments visited upon the bodies of slave women, Jacobs introduces her readers to slavery as an injustice not of torture but of hypocrisy, as a relation founded upon broken contractual obligations. Jacobs sardonically ventriloquizes plantation ideologies when explaining the attitudes of the master class toward her family members, culminating her dignifying bio-

graphical portraits of them with stark reminders that the grandmother amounts to nothing more than a "valuable piece of property" (9), or the father, though suddenly dead, need not be attended to—"he was merely a piece of property" (13). Brent experiences such hypocrisy when she is not set free as expected at the death of a mistress who was always kind to her and taught her to "love thy neighbor" because, as Brent reasons, "I was her slave, and I suppose she did not recognize me as her neighbor" (11). Such dismissals expose the slave system's perfunctory gesture of extending familial or foster status to the slave while ultimately subscribing to the slave's juridical status as merchandise, "for, according to Southern laws, a slave, *being* property, can *hold* no property" (10).

A central corollary to this principle of slave commodification in the face of empty or indeed rapacious intimacy between masters and slaves manifests in ocular valuations of slaves as things. From the perspective of the master class, the common link of Brent's grandmother's labor as nursemaid to children white and black does nothing to bridge the legal gap separating these children. A single source of maternal nourishment may connect the children of the plantation, but such labor is elided from the view of owners, who consequently see the slave nurse as a machine, indistinguishable from the very milk she provides: "These God-breathing machines are no more, in the sight of their masters, than the cotton they plant, or the horses they tend" (12). That the slave woman remains the milk machine for white and black children alike permits the white plantation mistress to escape being demoted to the product of her labor. As Mary Ann Doane has concluded with reference to modern technological experiments with human reproduction, while motherhood, broadly conceived, may be seen as that which loops femininity into scientific and mechanical discourse as a type of machinery, "it is also that which infuses the machine with the breath of human spirit."[21] In *Incidents*, the mechanization of slave women's labor is primarily an effect of the master class's optical orientation toward the slave as chattel. For white owners, seeing seems to be as much about a willed blindness toward the customary and secretive production of slave babies as it is about the marking of slave bodies.

Master Vision and the Mulatta

The tragic mulatta is considered by critics to be largely a construct of white female abolitionism, entering the popular consciousness often in sensational and negative relation to true woman ideals. The trope became a durable symbol throughout the nineteenth century and well into the

twentieth of a gendered status corrupted by a taint of admixture that nullifies the chastity available to white women. Moreover, the mulatta also signifies as a juridical and scientific touchstone of ambiguity, a figure whose indeterminacy menaces legal and rational discourses that seek to stabilize her vexing indecipherability. As a plot device, the mulatta is either a racist hero of white purity or degree zero racial fluidity. She is either victim, a sign of the oppressive practices that produce her and thereby complicit with them, or trickster, wreaking havoc upon the racial order by unraveling myths of white purity.

In *Incidents* Jacobs exposes how the slaveholder's ideological conceptualization of the slave as a familial asset coheres through public spectacles of generosity, which belie the slave's ultimate status in the public eye as a material asset. Negotiating this contradiction is shown to be a source of frustration for Dr. Flint as he is forced to conceal his private exploitation of slaves who have gained symbolic value within the white community as embodying that ideology of the extended family. Slaves who fall into this partial zone of public protection, such as Linda Brent's grandmother, must bargain for privileges by threatening to become exactly what they are—commodities—and thus arousing community interest by revealing the mitigating ideology of plantation familiarity as a sham. Brent's grandmother strategically utilizes the spectacle of the auction to flaunt her commodity status and thereby parade Dr. Flint's avarice to the community. This is how the vicissitudes of the mulatta's spectacularization in *Incidents* begins to invert the conventional scopic logics associated with putting black bodies on display. The auction does not solely rely on the grandmother's physicality for its effect but on the meaning of this exposure as a sign of her white master's degraded value. Instead of reifying the unassailable status of white male embodiment as the pinnacle of abstractable human value through a performative objectification of the raced and gendered body, the spectacle here becomes a weapon against the master's word, his logos. Wary of publicizing his double-dealing, Dr. Flint designs to sell the grandmother "at a private sale" (14), even though freedom was promised to her by a previous owner in exchange for upstanding service. As a countermeasure, the "very spirited" grandmother decides to willingly submit herself to the spectacle of the auction block, since, as Jacobs reports, "she was determined the public should know it" (14). When shocked onlookers exclaim "Shame! Shame! Who is going to sell *you*, aunt Marthy?" (14), her use of the commercial publicity inherent to her status as an exchangeable object succeeds in shaming Dr. Flint. It is precisely this model of turning around a plantation system of scopic control geared to objectify the tortured, raced,

and gendered body and making it function to indict and defy the master and his ocularcentric tactics of control that Brent will later use in the garret.

In Jacobs's narrative members of a master class in regulatory crisis are far more variegated than uniform in their treatment of slaves. There are those like Dr. Flint, who directly and cruelly abuse slaves and falsify contractual obligations; those like the grandmother's and Linda's prior mistresses, who position their slaves as intimate attendants; and then there is that ambiguous public to whom the grandmother's self-spectacle is addressed. The response of this public master class is characterized in aural rather than visual terms, as the "many voices" (14) who declaim her determined stance upon the auction block as "no place for *you*" (14). While the grandmother ascribes to this public a conscientious role to remember the slave's loyal service and to uphold verbally exchanged obligations between master and slave, Jacobs finally makes this public complicit in widespread acts of forgetting the slave's humanity in her recourse to unveil material relations covered over by systems of economic marginalization in both the North and South.

That the public is rendered as pure voice associates it with the disembodied subject position of the hypothetical reader or spectator, in whose view the external world becomes nothing more than an object of spectacle. The whites who assemble as spectators of the grandmother's slave auction, however, are not the only sort of public represented in *Incidents*. Jacobs alters the unmarked status of the viewing public when she includes within its abstract number the figure of the slave mother, who mediates sympathy for the slave while serving as a stand-in for the ideal, though impossible, reader-observer.

Describing the return of her escaped uncle bound in chains, Brent sets up a spectacle whose viewing public is neither unified nor disembodied, for it conceals the mother whose affective gaze unravels the male slave's fragile performance of masculinity: "I saw him led through the streets in chains, to jail. His face was ghastly pale, yet full of determination. He had begged one of the sailors to go to his mother's house and ask her not to meet him. He said the sight of her distress would take from him all self-control. She yearned to see him, and she went; but she screened herself in the crowd, that it might be as her child had said" (21). Rather than the general viewership of the text's reading audience or the specific perceiver embodied by Linda Brent, the concerned mother plays the role of the intimate observer, whose scrutiny, if consciously perceived by the slave, collapses his defiant relation to the scene in which he is made a spectacle. The sight of the

mother's sight, in other words, plays heckler to his enactment of masculine agency, and his compromise to become an exhibit of insurrection gives way as the maternal gaze, like the language of the paternal slaveholder, subsumes the discourse of power with that of the personal. In discussing Sawyer's hurt feelings over the escape of Jacobs's uncle, his beloved slave ("I trusted him as if he were my own brother") Lauren Berlant notes the tidy contrast between Sawyer's "language of personal ethics" and Jacobs's "language of power": "she looks to political solutions, while his privilege under the law makes its specific constraints irrelevant to him."[22] Subjects of privilege, in other words, require that the history of differential power be suppressed, while a consciousness of subjection requires such history to be made public.

Representations of slave abuse found in *Incidents* depend upon enlisting readers to play the role of screened-off mothers in the crowd, a sentimental viewing public that watches and feels for the slave as an object of cruel spectacle but which does not publicize its own acts of spectatorship. The gender dynamics of this rerouting of the terms of the spectacle, however, reveal an interesting complication. Repeatedly, the narrative foils the sentimental consumption of the male slave body by offering the woman, or the mother, as the site of the reader's identification. In such instances readers are constituted as a sympathetic public, containing so many screened-off mothers in its otherwise anonymous midst. And yet, the public's gaze is never suggested to be automatic proof against mistreatment, and Jacobs often demonstrates the great pains Linda takes to solicit the community's preventative scrutiny. For example, when she is assigned to carry out errands while aggressively pursued by Dr. Flint, Linda notes that temporary safety lies in the sight of the public: "By managing to keep within sight of people, as much as possible during the day time, I had hitherto succeeded in eluding my master, though a razor was often held to my throat to force me to change this line of policy" (29). Remaining within sight of anonymous others yields the same kind of defensive reassurance that publicity holds for the grandmother during the auction block scene. However, when that public becomes a crowd or mob—a cruel public—the prospect of tentative refuge is replaced by increased hostility.

In her description of a mob attack, Jacobs weaves together the text's threads of remote observation, auditory imagery, and criticism of mass public racism:

Towards evening the turbulence increased. The soldiers, stimulated by drink, committed still greater cruelties. Shrieks and shouts continually

rent the air. Not daring to go to the door, I peeped under the window curtain. I saw a mob dragging along a number of colored people, each white man, with his musket upraised, threatening instant death if they did not stop their shrieks. Among the prisoners was a respectable old colored minister. They had found a few parcels of shot in his house, which his wife had for years used to balance her scales. For this they were going to shoot him on Court House Green. What a spectacle was that for a civilized country! A rabble, staggering under intoxication, assuming to be the administrators of justice! (56)

Under the assumed rights of the military to intervene on civic affairs, the drunken soldiers take hostage innocent African Americans who are described by Jacobs primarily in auditory terms. Indeed, the "shrieks and shouts" of the assaulted blacks produce in the white soldiers an irritation that spurs the mob's desire to kill. Individuality in the mob is limited to designations of whiteness and weaponry. The phrase "each white man, with his musket upraised" is the only indication of specificity. Throughout, the soldiers are indistinct and plural, a "they" that agglutinates by the end of the passage into a "rabble." Although "colored people" initially comprise an undifferentiated series of discordant voices, biographical specificity arises with the "respectable old colored minister" and the exculpatory circumstances of his unjust arrest. Here again Jacobs narrates historical contingencies absent from the spectacle. Seeing the shot without knowing its innocuous purpose, the soldiers, we are led to presume, falsely impute insurrectionary motives to the minister and epitomize the superficial vision castigated throughout *Incidents*.

As in prior examples, Jacobs also presents Linda Brent as a secret observer of the mob. In contradistinction to the presumptive disinterest of the gaze, which however affected by what is perceived remains ontologically separate from the contents of vision (the central optical logic of the camera obscura), Jacobs's gaze is always a saturated, permeable, penetrated location of subjectivity. For example, even when parodying the scopic position of an omniscience Brent does as the screened mother in the crowd as well. The eye of God is a gaze Brent appropriates from the proslavery minister's litany, which uses the anaphoric refrain of "Although your masters may not find you out, God sees you; and he will punish you" (58) to discipline slaves, whose infractions are captured by an ever-watchful deity partial to the master. Jacobs turns this concept of the panoptic eye of judgment back around to inspect the injustices of white racism as a decidedly embodied spectator. Her position is embodied because of the physical em-

phasis of her peeping "under the window curtain" and, more importantly, because of the fear she admits to while spying. Linda's fear "to go to the door" underscores her own marked status, which mirrors that of the prisoners. Herein lies the narrative's embedded critique of the reader's position as spectator: if the reader takes up a disembodied, transcendent, empirical position in relation to the scenes Brent describes while huddled in fear behind doors or cramped and gasping for air in the garret, then a disturbing correlation arises between the comfort of the reader and the "nerve" of the master class. *Incidents* therefore requires that readers disassociate the technology of narrative from that of the camera obscura, which abstracts viewers from the scenes they survey.

Investing in and Divesting from the Camera Obscura Economy of Vision

A popular model for explaining and representing vision from the Renaissance to the early period of the nineteenth century, the camera obscura (fig. 17) typified bourgeois humanism. According to Jonathan Crary, it was the "dominant paradigm through which was described the status and possibilities of an observer."[23] It organized the act of vision so as to ensure that the observing subject could perceive the optical truth of an external world while remaining invisibly sheltered within the chamber of the camera. As Crary explains, "the camera obscura performs an operation of individuation; that is, it necessarily defines an observer as isolated, enclosed, and autonomous within its dark confines [and is thus] a figure for both the observer who is nominally a free sovereign individual and a privatized subject confined in a quasi-domestic space, cut off from a public exterior world."[24] With its ability to "decorporealize vision," the camera obscura facilitates perception not of the actual world but of a mechanically magnified reflection of it projected onto a screen within the camera. The figure inside the box does not see the exterior tower behind him, only its ambient reflection projected on the screen. In mediating vision the apparatus enhances perception, at least to an early modern worldview, since the perceiver remains cognizant of but not subject to the external world.

Jacobs undergoes a similar withdrawal from the observed external world as the camera obscura observer. Vision in the quasi-domestic garret is monocular, restricted by the one-inch diameter peephole in the wall. The hybrid space of the garret collapses categories of gender, as many critics of *Incidents* have noted, and allows Jacobs's narrator to fluctuate in her self-representation between the encumbered mother and dependent

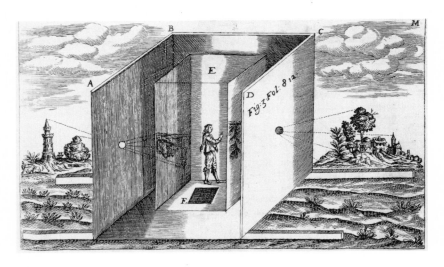

17. *Camera Obscura* from *Ars magna lucis et umbrae,* in *X. libros digesta* by **Athanasius Kircher, 1646.**

Courtesy Dartmouth College Library.

granddaughter, who is unable to physically escape the place of her subjection when it overlaps that of kinship, even as she becomes the embattled combatant of plantation authority. As Sidonie Smith, echoing others, puts it: "Jacobs/'Brent' eschews the representation of herself as the isolato, self-contained in her rebellion, figuring herself instead as dependent always on the support of family and friends, particularly her grandmother."[25] According to Smith, Jacobs's placeless vision enables *Incidents* to "probe, unconsciously and consciously, certain gaps in those conventions, certain disturbances in the surfaces of narrative."[26] The conventions to which Smith alludes are those that *Incidents* appropriates overtly, such as the seduction novel, domestic fiction, male slave narrative, biblical tropes, picaresque narratives, and the spiritual narrative. But I would add to this catalog those pseudoscientific and metaphysical narratives of vision invoked by the camera obscura, which Jacobs also seems to be unconsciously appropriating. Those narrative conventions having to do with sovereign seeing and withdrawn observation still linger in the antebellum imagination and their durability attests to the ways in which such obsolete models of transcendent subjectivity continued to promise some measure of resistance for marginal subjects.

As a revamped camera obscura, the garret allows Brent to remain invisible while surveying the landscape that grounds her social and juridical

subjection, and, as with the camera obscura observer, this invisibility becomes a precondition for an ideal type of viewing. For Jacobs, this ideal is a form of unseen viewing and it involves acknowledging legacies of defiance against the master class, particularly represented by the slave father. The correspondence between invisibility and black masculine confrontations with patriarchy derives from two consistently drawn associations in *Incidents*: the absence and thus unobservable character of fathers and the revolutionary spirit of black men, which gives rise to their absence whether through flight or extermination. The scene where Linda visits her parents' graves and decides to flee in order to protect her own children sheds light on these associations and their importance to understanding Jacobs's complex revision to Enlightenment practices of vision based on the camera obscura.

At the gravesite the narrative offers another proleptic metaphor of the garret, another moment of the mulatta's interjection into the machinery of a space of quasi-abstracted vision not unlike that of the camera obscura. "As I passed the wreck of the old meeting house," Linda Brent explains, "where, before Nat Turner's time, the slaves had been permitted to meet for worship, I seemed to hear my father's voice come from it, bidding me not to tarry till I reached freedom or the grave" (93). At this turning point Jacobs intervenes on a masculine tradition of slave rebellion by championing motherhood "as the source of courage and conviction," since the decision to flee is based on a consideration of "the doom that awaited [her] fair baby in slavery."[27] In this way Jacobs refocuses the female slave's relation to a legacy of a suppressed black paternal order.

The description of the meeting house implies that the legacy of the slave father is not something antithetical to that of the mother, but it is a related, albeit differently contextualized, strategy of defiance that can be operationalized within domestic structures. Although the meeting house has been abandoned, undoubtedly at the direction of white male authority figures terrified by the example of Nat Turner, Jacobs reanimates it, domesticating it as well as the famous slave rebel who personifies its reactionary aims by touching both with the presence of maternality—here articulated, in part, through the absent father. Jacobs's narrative so refurbishes this outwardly forlorn symbol of slave rebellion as to make it functionally operative: a successful meeting does takes place here, as the twin spirits of Nat Turner and Linda Brent's father impel her to escape. Adumbrating the situation of the garret, this scene imagines the father haunting an abandoned structure and wielding disembodied agency in the form of an auditory hallucination that imparts the will to defy slavocratic authority. Here,

Linda figuratively enjoys the disembodiment promised to the camera obscura spectator by identifying with her father, a mystified absence of revolution. As in the fugitive visions summoned forth by other slave narrators, the moment of re-fleshing in Jacobs instigates a reconstructive reordering of the visual field, as she decides to become, like the camera obscura operator, an unseen agent of vision and, like the father, one who battles invisibly with the master class.

To be sure, the combat of *Incidents* unfolds around scenes of looking, wherein an altered version of the camera obscura observer (the fugitive female slave) yields surprising reversals of the slave system by visually capturing her would-be captor.[28] Describing her "Loophole of Retreat" through martial metaphors, Jacobs characterizes her narrator as a vigilant sniper awaiting her public target from a secreted location: "Opposite my window was a pile of feather beds. On the top of these I could lie perfectly concealed, and command a view of the street through which Dr. Flint passed to his office. Anxious as I was, I felt a gleam of satisfaction when I saw him. Thus far I had outwitted him, and I triumphed over it. Who can blame slaves for being cunning? They are constantly compelled to resort to it. It is the only weapon of the weak and oppressed against the strength of their tyrants" (82). A common set of gendered binaries (private/public, domestic/market, fixed/open) comprises the spatial dynamics of Jacobs's loophole. The text portrays Linda's vantage point, with its featherbeds retooled to serve as an observation deck, as an undetectable domestic enclosure, and juxtaposes it against Dr. Flint's office, his public sphere headquarters in the marketplace. While Linda is rigidly circumscribed by and bound to her place of detection, the space associated with Dr. Flint is only the path leading to his office—not the structure itself. Turning the tables on the master, Jacobs reconfigures the spatial fixity associated with the feminine and the domestic to triumph over the master's seemingly unfettered mobility. The moment Linda experiences a "gleam of satisfaction" upon seeing the master from the loophole registers her awareness of the possibilities in a counteroffensive of seeing. It is here that she recognizes the power of a fugitive vision, one that reverses the expected social arrangements of race, property, and apperception in order to capture not just the master but the slave system as a perceived object removed from the seeing subject within the camera obscura.

Perhaps the most intriguing aspect of Jacobs's interrogation of vision is her infusion of the auditory onto the visual during key scenes of remote observation. Part of Jacobs's revamping of the camera obscura involves this transformation of the unseen lookout post into an auditorium

from which visual perception is impeded and thus superseded by listening. Such a transformation has gendered implications in that it shifts emphasis from autonomous, invasive watching to intersubjective, receptive listening. However, the acoustic veracity of Brent's perception is compromised by another "vision"—a sort of return of the repressed sentimental—as her anxieties regarding her children give rise to auditory delusions that finally manifest in visual terms. Commingling gothic motifs of eerie music and ghostly apparitions, the following passage elucidates how the aural dimensions of the "loophole of retreat" supplant the visual and cast suspicion upon the credibility of Brent's perceptual faculties:

> And now I will tell you something that happened to me; though you will, perhaps, think it illustrates the superstition of slaves. I sat in my usual place on the floor near the window, where I could hear much that was said in the street without being seen. The family had retired for the night, and all was still. I sat there thinking of my children, when I heard a low strain of music. A band of serenaders were under the window, playing "Home, sweet home." I listened till the sounds did not seem like music, but like the moaning of children. It seemed as if my heart would burst. I rose from my sitting posture, and knelt. A streak of moonlight was on the floor before me, and in the midst of it appeared the forms of my two children. They vanished; but I had seen them distinctly. Some will call it a dream, others a vision. I know not how to account for it, but it made a strong impression on my mind, and I felt certain something had happened to my little ones. (87)

This scene bears out Crary's claim that mid-nineteenth-century interest in anatomy so corporealized vision as to disqualify the credibility of disembodied vision. According to Crary, extensive antebellum interest in the physiology of optic sensation contributed to the demise of the camera obscura as the apotheosis of vision because the operations of the human eye were regarded as subject to chimerical deviations produced by a range of extra-perceptual factors like the emotional duress and sleepless worry overtaking Linda in the above passage.[29] As the ironic song permeates the garret it mutates into an aural chimera of precisely that which makes it ironic: the children without whom Linda cannot feel at home, the children whose existence under the constant threat of sale makes "no place" within slavery's domain "like home."

Jacobs's reference to the popular song seems intended to recapitulate a generic indictment of American hypocrisy found in many antebellum slave narratives.[30] It subtly questions the sentimental patriotism and regional at-

tachments fostered in nationally prized cultural texts or events—whether the Constitution, Fourth of July, or "Home, Sweet Home"—which exclude the alienations of the slave. The context of the song's intrusion upon Brent's vigilant post resonates with the song's maudlin lyrics: "An exile from home, splendor dazzles in vain, / Oh, give me my lowly thatched cottage again." Measuring the slave woman's unfathomable distance from a nationally espoused trope of "home," Jacobs subtly alienates her readers from any ahistorical appreciation of the lyric's seemingly neutral celebration of place.

The transformation of "Home, Sweet Home" into the moaning of children is not the only fantastic alteration that occurs in the scene. The acoustic illusion mutates again, transforming into a mirage within the chamber carried along a "streak of moonlight." Coupled with the music and Linda's heartrending anxiety for her children, the moonlight functions in a manner comparable to the screen of the camera obscura. It captures within the garret an image of an external reality not seen firsthand by the observer. This is a sophisticated revision of the classical model, however, as Jacobs disturbs the separation of vision from other perceptual faculties guaranteed by the camera obscura while craftily proving Crary's argument that the quirks of anatomy and emotion play havoc with the truth claims of vision. What Linda Brent thinks she sees in this moment no longer determines what can be known truthfully about the external world. Hence, Jacobs's appropriation of the camera obscura decouples the assumed relationship between knowledge and vision.

Conclusion: The Garret as an Obscurer Camera

Having engineered the hoax of a successful escape, Brent attains a supervisory command over the grounds of her life in slavery. In the garret she inspects slavery's physical demesne, political workings, and primary actors without breeching the limits of a space that blurs distinctions between confinement and sanctuary, womb and tomb. Neither one nor the other, nor even simply an in-between space, the garret becomes a third space of representation wherein the distinctiveness of the categories it mediates breaks down. There, notions of freedom and slavery are recontextualized, redefined according to different orders of knowledge. For instance, freedom for Brent in the garret is more than simply the opposite of slavery. Within the third space freedom never signifies anything so absolute as independence or opportunity but rather a complex of contradictory relationships involving sexual self-determination, maternal sovereignty, prox-

imity to ancestry, as well as surveillance despite invisibility and survival despite the most ascetic of privileges.

A crossing and recrossing of gender boundaries structures Brent's retreat, as she takes up a position commensurable to that of the absent father and, as I have made clear, engages in a form of combat with Dr. Flint. The letters deployed from this position, which would seem to make such masculine defiance possible, situate Linda—at least in the mind of Dr. Flint—at the same runaway boundary zone to which her brother and uncle once retreated. The very same escape that Jacobs inscribes in the earlier passages of the narrative as a possibility for male slaves hardened to abandon family members is finally achieved by the female slave but in a dramatically altered form. Indeed, it is only through a trick of representation, the deceit of the letters, that Brent occupies this escape zone. This is not to argue, however, that Brent's hybrid role as both masculine combatant and as entrenched female dependent leaves these original gender categories intact. One need only recall her later deception garbed as a male to recognize the way that the experience in the garret unhinges conventional gender and race markers.

As though mobilizing the garret into a portable prosthetic, Brent assumes the role of a fugitive passer. Costumed as a black male sailor, with her face deliberately made darker, the masquerading Linda Brent comes into contact with Mr. Sands, the father of her children, without so much as attracting the slightest notice from him. Now intermingling with those whom she had only been able to spy on from a hidden distance, Brent remains invisible—at least insofar as her identity as Linda Brent has been rendered unrecognizable by the costume. Blackface drag, in this context, reprises for Linda the security features of the garret without its insufferable fixity. The slave girl is just as enclosed within the faux skin of the black seaman as she was immured in her grandmother's garret. Her experience in the latter, we are led to believe, informs her decision to practice the former. To engage invisibly with the throng of the plantation thoroughfare, Brent decides to practice another form of self-enclosure, not within a domestic architecture so common that it escapes the notice of passersby but within a public, anthropomorphic equivalent: the black male laborer.[31]

While sentimentalism corrects the solipsism of the camera obscura's transcendent and disembodied form of vision by placing political emphasis on the body, in *Incidents* Harriet Jacobs refutes a very particular form of sentimental looking relations that does not, one that ironically takes on qualities that Crary aligns with the camera obscura. The conventions of sentimentalism that Jacobs attacks in *Incidents* rigidly define systems of

visual consumption, which produce observers, much like the camera obscura, "fitted for the task of 'spectacular' consumption."[32] But whereas this modern observer is mobile and able to consume an unending series of commodity-like images sundered from any point of fixed reference, Jacobs's is not. Modeled by Brent's confined and cyclopean vision while in the garret, Jacobs's observer is bound to politically charged physical spaces. In *Incidents* the picture sentimentally construed nullifies cultural and material difference. Jacobs situates her perspective in real space and in relation to systemic mappings of power. Her text organizes visual experience as potentially duplicitous in that it leaves out the body. In essence Jacobs recasts vision so that the private history of the captive body's subjection by and exclusion from dominant models of visualization—epitomized by sentimentalism's "lovely sights"—can be made public.

Yet just as the narratee of "lovely sights" is debarred from looking without simultaneously apprehending unruly material phenomena, so too does Jacobs reassert her position as observer as *part* of the exterior world represented in her observation through the peephole. Within the garret, she becomes part of what she sees without. The body is never fully abandoned in these garret acts of observation. Thus, the subsequent paradox of Jacobs's appropriation of the camera obscura is that she posits an embodied observer within a viewing context generally associated with detaching observation from the body, maintaining the objectivity of the sovereign observing subject and "escaping from the latent opacity of the human eye."[33]

Along with titillation and the promise of a prurient gaze of power that penetrates the concupiscent scene of the mulatta's conception, the trope of the mulatta, particularly when paired with that of the camera as seeing eye of judgment, also may have induced in audiences a phantasmatic sense of surveillance—a permanent social visibility that not even proof of whiteness can prove against. In this way the camera and the mulatta come together to form a composite machine for sustaining power relations through acts of seeing and being seen. Together they become a kind of "architectural apparatus," a panopticon, assuring the "automatic functioning of power" by instating acts of surveillance that are ultimately self-disciplining for all those who witness the permanent political effects of their social repositioning.[34]

Notes

1. Extending analyses focusing on Jacobs's use of literacy and feigned letters from the North, I pursue the concomitant effect of Jacobs's manipulation of the visual field in this chapter. For more on literacy and Jacobs, see Jean Fagan Yellin, "Written by Herself: Harriet Jacobs's Slave Narrative," *American Literature* 53, no. 3 (1981): 479–86; Lauren Berlant, "The Queen of America Goes to Washington City: Harriet Jacobs, Frances Harper, Anita Hill," *American Literature* 65, no. 3 (1993): 549–74; and Hazel Carby, *Reconstructing Womanhood: The Emergence of the Afro-American Woman Novelist* (Oxford: Oxford University Press, 1987).

2. The camera obscura is an optical device epitomizing the Renaissance ideal of disembodied observation that persisted well into the antebellum period.

3. Lindon Barrett, *Blackness and Value: Seeing Double* (New York: Cambridge University Press, 1999), 218.

4. Barrett, *Blackness and Value*, 217.

5. Fred Moten, *In the Break: The Aesthetics of the Black Radical Tradition* (Minneapolis: University of Minnesota Press, 2003), 183. See also Stephen Best's discussion of the evanescence of the human voice and its introduction into the law surrounding phonographic reproductions in *The Fugitive's Properties: Law and the Poetics of Possession* (Chicago: University of Chicago Press, 2004), 29–65.

6. See Saidiya Hartman, *Scenes of Subjection: Terror, Slavery, and Self-Making in Nineteenth-Century America* (New York: Oxford University Press, 1997), 3–7.

7. Judith Butler, *Bodies That Matter: On the Discursive Limits of "Sex"* (New York: Routledge, 1993), 219.

8. Butler, *Bodies That Matter*.

9. Harriet Jacobs, *Incidents in the Life of a Slave Girl*, ed. Nellie Y. McKay and Frances Smith Foster (1861; repr. New York: Norton, 2001), 28–29. Hereafter, citations to pages will be made parenthetically in the text.

10. Hazel V. Carby, "'Hear My Voice, Ye Careless Daughters': Narratives of Slave and Free Women before Emancipation," in *African American Autobiography: A Collection of Critical Essays*, ed. William L. Andrews (Upper Saddle River, NJ: Prentice Hall, 1993), 69.

11. *Incidents* emphatically isolates that tension inherent to sentimental looking relations between "feeling" and "code," which, according to Bruce Burgett, "was intended to sharpen the emotional effect on the sensitive reader who, presumably, experienced the same conflict within herself" (Bruce Burgett, *Sentimental Bodies: Sex, Gender, and Citizenship in the Early Republic* [Princeton: Princeton University Press, 1998], 16).

12. Burgett, *Sentimental Bodies*, 84.

13. Ibid., 16.

14. Perhaps the best-known argument that opposes Ann Douglass's claim that nineteenth-century sentimentalism merely sanctioned patriarchal minimizations of women and women's roles is Jane Tompkins's *Sensational Designs: The Cultural Work of American Fiction, 1790-1860* (New York: Oxford University Press, 1986). Post-Tompkins scholarly works that discuss sentimentalism's emphasis on the politics

of affect and the body, albeit according to a different ideological paradigm than male-authored discourse, are Nancy Armstrong, *Desire and Domestic Fiction: A Political History of the Novel* (New York: Oxford University Press, 1989); Herbert Ross Brown, *The Sentimental Novel in America, 1789-1865* (New York: Oxford University Press, 1989); Eva Cherniavsky, *That Pale Mother Rising: Sentimental Discourses and the Imitation of Motherhood in Nineteenth-Century America* (Bloomington: Indiana University Press, 1995); Nancy Cott, *The Bonds of Womanhood: "Woman's Sphere" in New England, 1780-1835* (New Haven: Yale University Press, 1977); Susan K. Harris, *19th-Century American Women's Novels: Interpretive Strategies* (Cambridge: Cambridge University Press, 1990); Mary Kelley, *Private Woman, Public Stage: Literary Domesticity in Nineteenth-Century America* (New York: Oxford University Press, 1984); Lori Merish, *Sentimental Materialism: Gender, Commodity Culture, and Nineteenth-Century American Literature* (Durham: Duke University Press, 2000); and Marianne Noble, *The Masochistic Pleasures of Sentimental Literature* (Princeton: Princeton University Press, 2000).

15. Jacobs's preoccupation with material history and the way that the past mediates observations of the present relates to Marxist conceptions of "fore-history." Walter Benjamin states that repetition does not exist for the material historian "because the moments in the course of history which matter most to [her] become moments of the present through their index as 'fore-history,' and change their characteristics according to the catastrophic or triumphant determination of that present" (Walter Benjamin, *The Arcades Project*, ed. Rolf Tidemann, trans. and intro. Howard Eiland and Kevin McLaughlin [Cambridge: Harvard University Press, 1999]).

16. Hazel Carby argues that Jacobs unmasks the contradictions of ideal womanhood when applying them to Southern mistresses, who invariably fall short of its dictates: "The qualities of delicacy of constitution and heightened sensitivity, attributes of the Southern lady, appear as a corrupt veneer that covers an underlying strength and power in cruelty and brutality" (Carby, "'Hear My Voice, Ye Careless Daughters,'" 70).

17. For more on Aunt Hester's whipping, see Gwen Bergner, "Myths of Masculinity: The Oedipus Complex and Douglass's 1845 Narrative," in *The Psychoanalysis of Race*, ed. Christopher Lane (New York: Columbia University Press, 1998), 241–60; and Deborah E. McDowell, "In the First Place: Making Frederick Douglass and the Afro-American Narrative Tradition," in *Critical Essays on Frederick Douglass*, ed. William L. Andrews (Boston: G. K. Hall and Company, 1971), 192–214.

18. Frederick Douglass, *Narrative of the Life of Frederick Douglass, An American Slave, Written by Himself*, ed. David Blight (Boston: Bedford / St. Martin's Press, 2003), 16.

19. Douglass, *Narrative of the Life of Frederick Douglass, An American Slave*, 16.

20. Jeannine DeLombard, "'Eye-Witness to the Cruelty': Southern Violence and Northern Testimony in Frederick Douglass's *Narrative*," *American Literature* 73, no. 2 (2001): 246.

21. Mary Ann Doane, "Technophilia: Technology, Representation and the Future," in *Body/Politics: Women and the Discourses of Science*, ed. Mary Jacobus, Evelyn Fox Keller, and Sally Shuttleworth (New York: Routledge, 1990), 166.

22. Berlant, "The Queen of America Goes to Washington City," 560.

23. Jonathan Crary, *Techniques of the Observer: On Vision and Modernity in the Nineteenth Century* (Cambridge: MIT Press, 1990), 27.

24. Crary, *Techniques of the Observer*, 38–39.

25. Smith, "Resisting the Gaze of Embodiment," 101; see also William Andrews, *To Tell a Free Story*, 253–58; Francis Smith Foster, "'In Respect to Females . . .': Differences in the Portrayals of Women by Male and Female Narrators," *Black American Literature Forum* 15 (1981): 66–70.

26. Smith, "Resisting the Gaze of Embodiment," 101.

27. Carby, "'Hear My Voice, Ye Careless Daughters,'" 75, 92.

28. Critics have argued that the garret metaphorizes Jacobs's struggle to find discursive as well as physical sanctuary in the antebellum United States. For Bruce Burgett, the martial connotations of the term "loophole of retreat" signify "that the boundary between public and private is a battleground that transects Jacobs's body. The garret becomes a strategic position in her struggle to publicize the structural asymmetries that both underlie *and* belie nineteenth-century liberalism as a political ideology" (Burgett, *Sentimental Bodies*, 138).

29. Crary argues that between 1810 and 1840 there occurs "an uprooting of vision from the stable and fixed relations incarnated in the camera obscura" (*Techniques of the Observer*, 14). While Crary argues that the new observer produced by this revolution in visuality becomes more mobile and exchangeable and is abstracted from any site or reference, Jacobs intervenes on this abstraction, grounding the viewers of her scenes in her own bodily experiences.

30. Originally written by the American John Payne to accompany the music of British composer Henry Bishop for the opera *Clari, or the Maid of Milan* in 1823, "Home, Sweet Home" quickly became one of the century's most renowned songs, sweeping America in printed song sheets and routinely performed by traveling minstrel troupes as well as the acclaimed Jenny Lind, who sang it for President Lincoln. Soon to be a favorite pastime for weary soldiers on both sides of the Civil War battlefield, the song takes on an eerily literal meaning for Brent in the garret, for whom there is no place like a home at all. For more on the history of "Home, Sweet Home," see Donald Clarke, *The Rise and Fall of Popular Music* (New York: St. Martin's Press, 1995).

31. As Lauren Berlant has argued, this passing critiques the gendered division of American citizenship: "He [Sands] has the right to forget and to not feel, while sensation and its memory are all she owns. This is the feeling of what we might call the slave's two bodies: sensual and public on the one hand; vulnerable, invisible, forgettable on the other" ("The Queen of America Goes to Washington City," 556).

32. Jonathan Crary, *Techniques of the Observer*, 19.

33. Ibid., 50.

34. Michel Foucault, *Discipline and Punish* (London: Penguin, 1977), 198–99.

 FIVE

Who's Your Mama?

"WHITE" MULATTA GENEALOGIES, EARLY

PHOTOGRAPHY, AND ANTI-PASSING NARRATIVES

OF SLAVERY AND FREEDOM

P. Gabrielle Foreman

Partus sequitur ventrem.
[The child follows the condition of the mother.]
—U.S. slave law and custom

If we shift from a politics of substance to a politics of optics, identity itself
no longer possesses the reassuring signs of ontological distinction
that we are accustomed to reading.
—Amy Robinson, "It Takes One to Know One:
Passing and Communities of Common Interest"

The right to see and be seen, in one's own way and under one's own terms,
has been the point of contention.
—Laura Wexler, *Tender Violence*

Passing For or Passing Through?

"Passing" for white and the representational strategies some phenotypically
indeterminate African American women used to claim privileges granted
to whites name phenomena as different as night and day. Examination of
the assumptions about racial aspirations that occupy the space between the
two illuminates how paradigms that trump expressed and expressive black
female will and agency circulate both in the nineteenth century and in
current literary criticism. Mulatto- and mulatta-ness as a representational

trope often designates a discursive mobility and simultaneity that can raise questions of racial epistemology, while it also functions as a juridical term that constrains citizenship by ante- and postbellum law and force. The women I examine in this chapter use their own bodies to challenge such constraints by expressing a desire, not for whiteness but for familial and juridical relations in which *partus sequitur ventrem* produces freedom rather than enslavement for African Americans, light and dark.

Many contemporary scholars, however, deploy *white mulatto* and *mulatta genealogies*, terms I use *not* to describe the lighter shades of a politically determined African American racial classification but to highlight an overemphasis on patrilineal descent and an identification with and projection of white desire that continually revisits the paternal and the patriarchal, the phallic and juridical Law of the (white) Father. Russ Castronovo offers one such configuration in *Fathering the Nation: American Genealogies of Slavery and Freedom* when he asserts "texts by ex-slaves prohibit the restoration of any genealogical line, suggesting that only in the discontinuity and disorder of bastard histories does remembering properly construct freedom"; he goes on to assert that "the slave's genealogy—both as personal history and as national critique—. . . recontextualizes freedom from plenitude and promise to a narrative of lack and deferral."[1] Others, like Lauren Berlant, offer considerations of undifferentiated "mulatta genealogies" that examine racial mixtures in unspecified and unsituated ways.[2] Eric Sundquist's important *To Wake the Nations: Race in the Making of American Literature* enacts a more explicit erasure of black female agency by offering a (masculinist) nationalist paradigm that enacts and encourages readings of race in the nineteenth century as if women did not have a voice.[3]

One might class these critical interventions with the misnamings Hortense Spillers has outlined in "Mama's Baby, Papa's Maybe" both as historical reflections *and* contemporary evocations of "the provisions of patriarchy, here exacerbated by the preponderant powers of an enslaving class declare Mother Right, by definition, a negating feature of human community."[4] Most readers of African American literary traditions, and certainly those familiar with the historically contextualized work of scholars like Barbara Christian, Ann duCille, Frances Smith Foster, and Carla Peterson, recognize that while light-skinned protagonists populate the literary work of African American women until well into the twentieth century, white mulatta genealogies nonetheless ignore the recognizable contours of a significant African American familial politics in slavery and its representation.[5] Moreover, any cursory glance at black female texts penned in the nineteenth century reveals that despite their differences, Harriet Jacobs,

Ellen Craft, Harriet Wilson, Lucy Delaney, and Louisa Picquet, as well as Frances E. W. Harper's and Pauline Hopkins's most famous protagonists, all work to steal away African American agency by recovering black female motive, will, and active desire, as well as by recuperating an economically, legally viable, and racially inflected motherhood.[6]

Critics who focus on white mulatta genealogies thus misrepresent many of the issues. They tend to assume, as Castronovo makes explicit, that "despite evidence of matriarchal resistance . . . the absence of a recognized patriarchy placed slaves within a genealogical void." The slave "issued forth not from a woman, but from a matrix of nonhistory, from a textual-sexual space that signified emptiness and absence, illegitimacy and silence."[7] Even a critic as sophisticated as Patricia Williams can assert that "instead of black motherhood as the generative source for black people, master-cloaked white manhood became the generative source."[8] Such contentions erase the historical, racial, and textual configurations of their subjects and ignore the very contextual framework that should inform our theorizing. Nineteenth-century black women's principal affiliation is expressed in their claim to and for maternal relations, which, under the law stating that children follow the condition of the mother, ties offspring, however light, to their often darker maternal ancestors. The desire to slip phenotypically white bodies over the border into a Fatherland of "whiteness" that promised (material) racial rewards, recognition, and inheritance is associated with white mulatta genealogies emphasizing the rise of the exceptional individual over the collective; the history of color-conscious communities that adhered to this kind of racism is well documented. Yet these practices should not be conflated with attempts to disrupt the binary racial meanings the women I address challenge—they press for more fluidity in the sets of signifiers assigned to the classifications of white and black in the United States and struggle for rights, recognition, and freedom not only for themselves but for their African American mothers, brothers, and sisters. "Narratives of miscegenation are not monolithic," as Jennifer DeVere Brody reminds us.[9] When addressing the literature that includes in its textual family works with distinctly situated racial explorations, we should differentiate passing narratives and white mulatta genealogies from *anti-passing* texts.

The semiotics of "passing" are hardly black or white; both the codes and the meanings of passing are situated and can be radically different. Louisa Picquet and Ellen Craft, two of the indeterminately colored enslaved women I examine here, often pass based on "similarity and contiguity"—they pass metonymically.[10] Craft, who transposes into a genteel

planter traveling North, passes purposefully with her unmistakably black husband, William, ostensibly her bondsman, in order to escape slavery. Yet neither actually passes *for* white. Rather, Craft passes *through* whiteness in order to endow her family (to be) with meanings of freedom and self-possession denied to slaves and to the "unowned" population of African Americans who were "free."[11] Once Ellen and William Craft reach the North, the narrative emphasizes her dramatic return both to her gendered and racial identities.

While "the literature of passing . . . has as its central concern the American mechanism for the cultural and genetic reproduction of whiteness," as Harryette Mullen suggests,[12] the women I address here again make efforts to identify with and recuperate blackness in a familial context, one which duCille and Claudia Tate have established is as radical a ground as more explicitly "political" arenas.[13] Indeed, Ellen Craft's reluctance to get married while still enslaved and her simultaneous desire for a legibly black man and legally and phenotypically black and free children are what precipitate the Crafts' attempt to escape. Likewise, though Picquet is encouraged to pass with her (even whiter) children, rather than abandoning race and family, she tours the country in 1860 trying to convince people that she is *black* so she can raise money to free her still enslaved mother and brother. If a person "becomes adeptly white" (what blacks do when they cross *over* the color line) when he or she "acquires a partner whose credentials are unquestionable and produces perceptibly white (not mulatto or mixed) offspring," then Picquet and Craft exhibit a racial will that defies identification with the Law of the (white) Father and the (patriarchally endowed) family that is often attributed to narratives in which mulattas appear.[14]

Examining eighteenth-century runaway advertisements, David Waldstreicher posits that "to get slaves or servants back into the role . . . owners had to describe what . . . attributes they possessed that might or might not help him or her pretend to be free."[15] If we exchange the phrase "back into the role" of slave with "back into the role of black" and describe the attributes that these women possessed that might help them "pretend to be" white, we underscore the concept of passing *through* whiteness rather than passing *over* and out of the race, of temporary appropriation that stops short of ontological identification. No one has to catch these women or "get" them "back into their racial role" in any literal sense. While dominant national consciousness conflates freedom with whiteness, these women are clear that they resist such associations and are working to cleave hierarchically fixed meanings from racial classifications.[16]

I focus on several nineteenth-century texts in which the connection

among (black) families, freedom, and race-based status are the principal concern of the subjects. A reading of the politics of color in Jacobs's *Incidents in the Life of a Slave Girl* (1861) and in Lauren Berlant's "The Queen of America Goes to Washington: Harriet Jacobs, Frances Harper, and Anita Hill" provides the bridge to in-depth examinations of the narratives of *Louisa Picquet, the Octoroon* (1861) and Craft's *Running a Thousand Miles for Freedom* (1860).[17] My central concern is to illuminate specific ways in which some mulatta bodies create a narrative crisis of knowing and seeing for those readers with racial power that can be quite disconnected from the subject's expressed racial will, even if that will is not constant or fully recoverable. What do we make of the anxiety phenotypically "white" bodies attract even as they are *not* attempting to pass? And, as images circulated in print media in ever-growing quantities, how did these shape readers' reception of bodies they couldn't easily identify? By revisiting the frontispiece and the opening passage of *The Octoroon*, we will also see how photography, introduced in 1839 and popularized as a truth-producing technology in the antebellum era, intersects with other representations of the enslaved—slave narratives and runaway advertisements, for example—to produce multiple "mulatta" meanings.

Fraudulent Relations: Berlant, Brent, and the Politics of Color

A persistent concern with (white) paternity continues to encourage the erasure of black women's maternal affiliation and racial agency in some contemporary critical readings of Jacobs's *Incidents in the Life of a Slave Girl*, arguably now the most famous of all writings by nineteenth-century black women. Recognized as essay of the year by *American Literature*, Berlant's "The Queen of America" smartly articulates some of the very issues of law, sexual vulnerability, and racial-sexual-national codings and representations to which critics such as Castronovo refer, issues that are central to some of the best work in the field. Yet as she introduces the term *mulatto genealogy*, she so destabilizes race that she facilitates the creation of a bodily category into which any Other can fit. Writing of the postbellum period in another essay, she contends that "the mulatta figure is the most abstract and artificial of embodied citizens. She gives lie to the dominant code of juridical representation by repressing the 'evidence' the law would seek—a parent, usually a mother—to determine whether the light-skinned body claimed a fraudulent relation to the privileges of whiteness."[18] Berlant refers to the trope of the "tragic mulatta," to the figure whose skin and will allows her to pass over the line into "whiteness" by repressing the dark mother. Yet again

one must note that in most nineteenth-century African American women's narratives, the captive or runaway of "mixed parentage" is characterized by the repression of the white *father*. In part, most narrators both elide and simultaneously express evidence of bodily violence, coercion, or "choice" as they recuperate rather than repress the enslaved mother.

Ultimately, Berlant creates in the figure of the mulatta an ahistorical and conflated amalgamation of Brent, Iola Leroy, and an "abstract national body" that projects Berlant herself into the resistant voice that in her own trajectory should belong to Anita Hill. Berlant links Jacobs's metaphorical use of the ear and discursive penetration to the Hill and Clarence Thomas Senate hearings as she describes her own fantasy to "enter a senator's body and to dominate it through an orifice he was incapable of fully closing, an ear or an eye. This intimate fantasy communication aimed to provoke sensations in him for which he was unprepared, those in that perverse space between empathy and pornography that . . . [are] constitutive of white Americans' interest in slaves, slave narratives, and other testimonials of the oppressed."[19] Tying the dynamics of the hearings, so to speak, to the representational erotics of slavery, Berlant consciously reproduces what is ultimately a desire to project white phallic power and voice, the Law of the Father that the senators embody, through a revised mulatta subjectivity. This example of a "phantasmic vehicle of identification" is unsettling,[20] especially since Berlant's rendition uses Hill as a proxy through which to speak to the powerful, while it extends Hill's inability to make herself heard by silencing her and erasing her body and the specificity of her (darkly) racialized experience. This is a double-edged empathy, for "in making the other's suffering one's own, this suffering is occluded by the other's obliteration."[21] Such "a recourse to fantasy reveals an anxiety about making [Hill's pain] legible; [and] this anxiety is historically determined by the denial of black sentience."[22] Moreover, Berlant elides the way color and desire are represented, rather than enacted, nationally; that is, Hill's supposed spurned woman fantasy projection and its ostensible self-evidence were both a legacy of black women's putative hypersexuality—they always want it—and a none-too-veiled commentary on her color: "Why would he want *her*," was the implication of some senators, "when he can have what's in the big house?" Full examination of these dynamics would actually link Hill's sexual predicament to the national negation of black female exploitation that Jacobs exposes. Yet in an example of what Saidiya Hartman calls the "violence of identification," Berlant instead makes Hill the last critical stop in a mulatta genealogy and displaces Hill with the critic's own phallogocentric imaginings.[23]

Berlant's grouping and her use of a white mulatta genealogy allow her to label Jacobs, whose parents were both "black," and Leroy, a phenotypical, juridical, and fictional quadroon, both and equally mulatta; it also fails to calibrate the difference between Jacobs's use of color as a stand-in for sexual and marital agency and Harper's patent, intentional use of the mulatta as trope.[24] While one might take Peterson's assertion that "Jacobs explicitly calls attention to the dominant culture's construction of Linda as a mulatta" to support Berlant's reading, it seems to me that Jacobs does not illustrate how the dominant culture constructs Linda as a mulatta per se; rather, Jacobs calls our attention to Linda's status as a sexually vulnerable and sentient slave girl *like all others* light and dark.[25] Flint's hissing "you have let your tongue run too far damn you," to a woman, his property, who like her enslaved husband was "black," while their child was very fair, is but one example.[26] Later, Jacobs emphasizes her situation as a culturally and legally determined black nursemaid or fugitive slave, when again, not gradations of color but binary distinctions and collective resistance determine treatment. Linda resolves "to stand up for my rights" and finally wins respectful treatment. Jacobs does not frame this as an individual triumph, even though she has just stressed that other nurses were "only one shade lighter in complexion." Rather, she urges collective resistance. "Let every colored man and woman do this," she avers, "and eventually we shall cease to be trampled under foot by our oppressors."[27]

Jacobs's description of the origin of her categorization as a "mulatta" distances her tale from any generational tragic mulatta story and points us to the possibility of her *grandmother's* rape (and hers as well); she also dismisses the possibility of her own personally ambiguous paternity.[28] Outlining her definitive nonwhite parentage, Jacobs comments, "in complexion, my parents were a light shade of brownish yellow and were termed mulattoes."[29] Her own direct genealogy contrasts with the unstable configuration of parental identity and categorization of and as property that the classic tragic mulatto tale embodies. That story also depends on the impossibility of bodily taxonomy, a consanguinity with the shades of whiteness that rarely, if ever, includes "light shades of brownish yellow."

Jacobs's mulatta story does not stand as a primary site of revision and resistance in *Incidents* unless we distinguish her specific use of color from tropes that refer to "whiteness" and its attendant and often-elusive meanings of freedom and protection. The "white" aristocrat turned "black property," Marie's mulatta-as-metaphor story in *Iola Leroy* (1892), for example, points both to the absurdity of racial constructions (a familiar national critique) and to the putative rewards of racial passing (a familiar individual

critique). It also recalls the begged, borrowed, and "what did I do to be so black and blue" tales included in *Clotel* (1853) and the beginning of the Craft narrative, just as it similarly recasts Cassie's move from madness to mother in *Uncle Tom's Cabin* (1852); none of these narrative paradigms echo the meanings attached to the mulatta's use in *Incidents*. With their emphases on freedom's contingency on finding families and (re)creating homes, these texts position mothers similarly but "mulattas" very differently.

Ma' Freedom or Maternal Framing in *Louisa Picquet, the Octoroon*

The Reverend Hiram Mattison's *Louisa Picquet, the Octoroon* (1861) is exemplary in revealing the tensions between nineteenth-century white patriarchal and black maternal mulatta genealogies. Mattison meets Picquet while she is traveling through Ohio en route to New York and soliciting subscriptions for the last of the funds she needs to free her mother and brother. Through a series of questions and answers that form the first half of the text, Picquet attempts to "control the narrative and position herself as its subject," using both her image and "resistant orality as self-defense and self-authorization."[30] When Picquet tries to tell the story of her family, Mattison leads her back to relating "white love adventures," as one chapter is incongruously titled. His concern is the continuous parade of "near white" or "very light" concubines that "pollute" Southern homes. Mattison quotes Picquet directly in the first half of the story (or represents himself as doing so) as she tells of her struggle as a fourteen-year-old against one master's sexual aggressions, which she evades, despite the beatings that ensue, although her mother cannot. Despite her ingenuity and the help she enlists, Louisa is sold and then raped by her new owner, an aging Mr. Williams, who soon after leaving the auction block explains "what he bought [her] for."[31] When he dies, as she had prayed for him to, he sets Louisa and her children by him free, insisting that they go North "and not let any one know who [she] was, or that [she] was colored."[32] Now "unowned," Picquet works to reconstruct her family according to her own will. Like the heroines she anticipates, she marries another "mulatto" man and spends eleven years raising money to free her mother and brother. While doing so, she continually works to convince people to read her physically indeterminate body as *black* rather than white.

The Octoroon echoes both the much-noted tensions between author and sponsor in slave narratives and the recognizable thematics of slave fiction and autobiography. Midway through the text, the growing friction between Mattison's subject and Picquet's subjectivity comes to a head as

her narrative freedom conflicts with his wish to maintain discursive mastery. Seemingly sick of his incessant, prurient questions about the ever-lightening color of enslaved women's and white men's "children," she describes her husband's daughter, who lives with them, as "the darkest one in the house" and "the smartest one we got too."[33] Like Picquet, the text has traveled away from the terrain Mattison wishes to map. When she starts to tell of the fugitives that they have housed in the North and her continued attempts to find her mother, Elizabeth Ramsey, and to convince Ramsey's owner to sell the rest of the family back to her, Mattison abruptly changes the narrative structure from oral transcriptions to his own third-person narrative, easing out both Picquet's voice and her story.

While Jacobs highlights the sexual threat so many enslaved women face without stressing their color, Mattison attempts to elevate the connection he envisions between sexual vulnerability and "whiteness" over Picquet's own emphasis on recuperating familial, particularly maternal, relations. Nevertheless, she has clearly dismissed her master's parting advice that she go North but not "marry any one but a mechanic" or, again, "let any one know who [she] was, or that [she] was colored."[34] She ignores his dying wish that she use her light skin to enact her new freedom. Neither her color nor his paternity of her children will overdetermine her racial affiliations in the North, as they hadn't in the South, where "the conditions of all subordination reserved for mulattos—no matter how well [they] may be dodged in particular circumstances—[were] identical to those reserved for unadulterated black bodies."[35]

The struggle over Picquet's and Mattison's construction of "white blackness" in conjunction with gendered sexuality is evident from the initial pages. The narrative opens with an engraving of Picquet (fig. 18). Using it, Mattison almost immediately establishes himself as an active evaluator rather than an unobtrusive narrative facilitator by announcing in an asterisked footnote that "the cut on the outside title page is a tolerable representation of the features of Mrs. P., though by no means a flattering picture."[36] The image is a staid representation that resists being construed as tantalizing even as it is at odds with the header on each page, *The Octoroon Slave and Concubine*. No stray locks escape, no bare flesh peeps through the thin and revealing clothing Mattison is so eager to have Picquet describe. As Barbara McCaskill notes, "when a face fair-of-skin peered from the page . . . the frontispiece engraving began the process of confronting white America with the terrible taboo of race mixing."[37] Mattison almost certainly solicited the "cut" from Picquet to bring home his concerns about "*the deep moral corruption*" white families experience "resulting from the in-

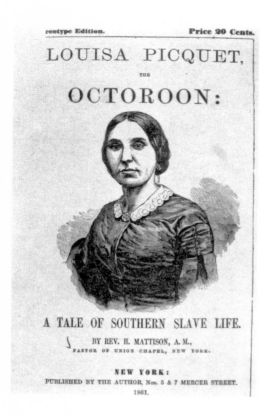

LOUISA PICQUET,

THE

OCTOROON:

A TALE OF SOUTHERN SLAVE LIFE.

BY REV. H. MATTISON, A. M.,

PASTOR OF UNION CHAPEL, NEW YORK.

NEW YORK:

PUBLISHED BY THE AUTHOR, Nos. 5 & 7 MERCER STREET.

1861.

18. Front cover, *Louisa Picquet, the Octoroon,* **1861.**

Photographs and Prints Division, Schomburg Center for Research in Black Culture, the New York Public Library, Astor, Lenox and Tilden Foundations.

stitution of slavery."[38] Considering his dissatisfaction, however, it is doubtful that he arranged the sitting. Letters reprinted in *The Octoroon* refer to daguerreotypes arranged by and exchanged between mother and daughter before Mattison and Picquet met.[39] We can surmise that by submitting the image used for the engraving, Picquet resists reenacting the fetishized presentation of the flushed, nubile, loose-haired young mulatta on the block popularized in *Uncle Tom's Cabin* when the slave mother Susan advises her daughter Emmeline to brush her hair back "smooth and neat and not havin' it flying about in curls; looks more respectable so" despite the girl's innocent remonstrance that she "don't nearly look so well that way."[40] Picquet recognizes that enslaved women are placed in front of viewers not only to be bought, as she explains to Mattison derisively, but as spectacle, "to be seen."[41] She stresses these dynamics of visual objectification, of women bought later to be recirculated (with resulting babe in arms) as erotic and economic promise to those in the actual audience or in the extended one made available by print culture's larger reach.

Picquet's image reproduces this tension between property, propriety,

and the fetishization of a familial tale of economic and bodily promise. It urges us to consider Bridget Cook's questions: "How are images of racialized spectacle . . . able to make successful interrogations of their own construction? In what ways can images of spectacle be used to support a reading that challenges the social order's dominant racial meaning?"[42] Picquet's iconographic resistance, her very unrevealing image, is paradigmatic, for "one convention of the nineteenth-century slave narrative was the inclusion of a frontispiece drawing or interior illustration that depicted the black author in garments symbolic of dignity, restraint, eloquence, reflection and cultivation."[43] Mattison's framing, however, elevates the national disgrace of miscegenation over any such presentation of black eloquence or agency. As Anthony Barthelemy puts it, Picquet is constrained in her expression of the "contrapuntal tale of filial dedication and maternal devotion" that characterizes this narrative, even though she tries to regulate the image that introduces her newly cast(e) story and to thwart Mattison's desire to offer a reproduction that "flatters," that situates Louisa once again as the commodified object of a sexual gaze.[44]

Carla Peterson contends that as the object of the white male gaze "the mulatta renders female sexuality available," legitimizing the act of seduction and rape. In literary representations "the libidinal surplus . . . is doubled by an economic surplus, and her story results from the convergence of two plots that produces the narrative crisis."[45] Mattison's story mirrors Louisa's mother's, among others; one passed on from mother to daughter as genealogical void, as Castronovo might put it. Picquet breaks the mold of rape, sale, and perpetual and pathetic servitude by stressing survival over slavery and power over pathos; by freeing her mother, she eventually transforms her from fungible public thing (her mother's master wants Picquet to pay $1,100 or "exchange Property of equal value") into a private and individual being.[46]

Mattison's and Picquet's divergent textual interests are underscored by his penultimate chapter "Conclusion and Moral of the Whole Story," a near endless chronology of "gentlemanly" misconduct resulting in everlighter offspring. Yet the resolution of neither Picquet's nor her mother's story, which he tags on, is necessary for Mattison's conclusion or moral. Though he claims he is Picquet's fiscal agent, she doesn't seem to even inform him of her success in freeing her mother. "Since the preceding was stereotyped," he admits, "the following has been sent us, marked in the *Cincinnati Daily Gazette* of October 15, 1860":

NOTICE—The undersigned takes this the first opportunity of expressing her thanks to those ladies and gentlemen . . . that have accomplished

through their kind aid the freedom of her mother, Elizabeth Ramsey, from slavery, by paying to her owner, Mr. A. C. Horton, of Texas, cash in hand, the sum of $900, collected by myself in small sums from different individuals . . .

I beg leave further to express my gratitude by thanking you all for your kindness, which will be engraved on my heart until death. My mother also desires to say that she is also most grateful to you all, and that if any of those friends who have assisted her to her freedom, feel disposed to call on her at my residence on Third Street near Race (No. 135) she will be happy to see them and thank them personally.

Very Respectfully, yours, etc. LOUISA PICQUET[47]

Picquet's announcement renders null and void her interest in the yet-to-be-published narrative and undermines Mattison's legitimacy as the freedom facilitator he purports to be, placing his other interests in fuller relief. Picquet reasserts her narrative authority by both resolving the narrative crises of "libidinal and economic surplus" (the convergence of his story of miscegenation and hers of motherhood) and by placing the end of her story offstage, so to speak. She thus both sidesteps and comments upon Mattison's self-placement as a middleman slave "buyer" of sorts and wrests her mother from public view as spectacle while she creates an alternative audience—one that has contributed to her cause and wants to see, quite literally, her mother free.

Had Picquet been able to redirect the context of reception, perhaps her mother's picture would grace the narrative, as Picquet might like it to appear on the subscription book she carried when she met Mattison. She might offer the much-discussed daguerreotype she receives of Ramsey and Picquet's younger brother John, "both taken on one plate." That image would mirror her mother's request to "have your ambrotype taken also your children and send them to me," for Ramsey "would give this world to see you and my sweet little children."[48] Such a sitting or setting of mother and child was quite popular; had Mattison been attuned to Picquet's agenda, he might have chosen it. Yet these images, requested for their own pleasure and perusal and not for others' voyeuristic gaze, would disrupt the explicitly sexual charge that fuels the sale of enslaved women for gentlemen's "own use." They would stress a maternal economics in addition to the concomitant patriarchal erotics often projected, romantically and artificially, onto the mulatta for sale and resituate Ramsey (and Picquet) in the ostensibly protected and private sphere of domestic sentiment that photos of mothers and children symbolized.

Mattison's textual framing of the frontispiece transfers the attempted dignity of Picquet's oppositional pose, the subject-granting meaning of the portrait-sitting context, into the realm of ethnography. Enwezor Okwui and Octavio Zaya's reading of Richard Avedon's photo *William Casby, Born a Slave*, the portrait reproduced in Roland Barthes's *Camera Lucida*, helps to clarify Mattison's process. They suggest that the "important linguistic signifier," the title *William Casby, Born a Slave*, clearly announces that this "is less a portrait than a sociological and anthropological study. The title points to the limitations of the photograph as a carrier of truth, for [it] needs the stabilizing factor of language employed not for clarification or as a source of knowledge but solely for the viewer's delectation."[49] Likewise, rather than presenting Picquet's face as a truth-telling icon on its own, Mattison surrounds the engraving with the title of the work and other linguistic markers meant to guide his readers and viewers back to his authority as the meaning maker of the text. For the reader or viewer who might find Picquet's bodily legibility hard to decipher, Mattison's title declares Picquet's racial status above the image itself, with *Octoroon* in the boldest and largest typescript on the page. The subtitle line "A Tale of Southern Slave Life" at the foot of the image reaffirms her previous subjugation; the "Price 20 Cents" in bold letters perched in the right corner announces her continued status as commodity. Finally, he reinforces the muting of Picquet's voice by displacing her story with his authorship; the book, "by Rev. H. Mattison, A. M.[,] pastor of Union Chapel, New York," is "published by the author."

Mattison announces himself as a self-generating subject located by geography, education, profession, and authorship. Yet his "Mrs. P." stands as a depersonalized variable and as a precursor to the dynamics critiqued by the contemporary (black Muslim) X.[50] When Mattison writes "the cut is a tolerable representation of Mrs. P," his truncation erases not her master's name but her husband's.[51] In this way, Mattison highlights the ways in which "legal enslavement removed the African-American male not so much from sight as from the *mimetic* view as a partner in the prevailing social fiction of the Father's name, the Father's Law."[52] Jutting "Mrs." against the symbolic *P* (Property, sexual Production, P***y) only places in relief Mattison's erection of (his own) white phallogocentric power over and above Picquet's will to choose a (black) partner and (new) name. Mattison's anthropological framing underscores that Picquet's genealogy is symbolized by a "matrix of nonhistory" that signifies "emptiness and absence, illegitimacy and silence," to recall Castronovo's characterization.

Looking Fly and Runaway Advertisements

Revisiting Mattison's opening pages also replicates the struggle over property, ownership, and narrative representation illustrated in descriptions of slaves that found wide audience—fugitive slave advertisements. The first chapter, "Louisa Picquet, the Octoroon Slave," opens: "Louisa Picquet . . . was born in Columbia, South Carolina, and is apparently about thirty-three years of age. She is a little above the medium height, easy and graceful in her manners, of fair complexion and rosy cheeks, with dark eyes, a flowing head of hair with no perceptible inclination to curl, and every appearance, at first view, of an accomplished white lady. No one, not apprised of the fact, would suspect that she had a drop of African blood in her veins; indeed, few will believe it, at first, even when told of it."[53] Mattison unveils the tension between enslaved people's desires to represent themselves freely and as free and their masters' desires to capture their likeness in language that recasts them as property.[54] His words overlap almost precisely with those in the broadside poster Dr. Flint uses when his slave girl runs away or that Dr. James Norcom, the "real" Dr. Flint, used in his advertisements in a Norfolk paper: "She is a light mulatto, 21 years of age, about 5 feet 4 inches high . . . having on her head a thick covering of black hair that curls naturally, but which can be easily combed straight. She speaks easily and fluently, and has an agreeable carriage and address. Being a good seamstress, she has been accustomed to dress well, and has a variety of very fine clothes, made in the prevailing fashion."[55] Norcom stresses some of Jacobs's "graceful manners," closely mirroring Mattison's language.

Other examples of the advertisements posted for women runaways are worth our attention, as they underscore the similarity of a core format that some of *The Octoroon*'s readers would find familiar. Yet another Harriet is "a light mulatto girl about 19 years old, and five feet high. She is stout built, has straight course hair, which she usually wears tucked up with a comb, large blue eyes and a flesh mole on her right cheek. . . . Her mother is living in NY, it is probable she will try to get to that place."[56] Another advertisement announces: "RUNAWAY from the subscriber . . . negro girl . . . HARRIET, belonging to John Davis—She is supposed to be lurking in the neighborhood where she has a mother living—she is a bright mulatto, 19 years old, of an audacious impudent temper, slothful and dirty habits—but notwithstanding all these qualities, a great favorite of some people who call themselves gentlemen."[57] John Davis, the former owner of one of the "slothful" favorites, offers subjective "qualities" instead of "objective" corporeal characteristics: telltale somatic signs that signify slavery. In *Stealing*

a *Little Freedom: Slave Runaways in North Carolina, 1775-1840* (1994), Freddie Parker notes that it is remarkable "that owners were so keenly aware of so many parts of their slaves' anatomy." Subtle features and "an awareness of the minute scars, bruises, and marks of all kinds in obscure places on their slaves' body reflected a desire that they be able to recognize their property if they ran away or were stolen."[58] Yet this familiarity also speaks to a desire for classification, an obsession with recognizing the body as the essential teller not only of racial status but of racial difference. As one legal critic notes, witnesses at trials where slaves tried to prove their free status by claiming whiteness "sought to certify their testimony as authoritative by asserting their longstanding observation of the 'negro' race with their ownership and mastery over enslaved 'negros.' In this manner, both lawyers and witnesses linked knowledge of racial identity, expertise and white men's identity as masters."[59] The enslaved body's availability and the ability to make it public demonstrate the power such masters possessed, just as privatizing how owners might gain such familiarity with the details of enslaved bodies illustrates the rights of privacy and protection (of reputation as much as of property) that owners enjoyed.

The latter two advertisements stress each runaway's maternal connections, even though maternity is not connected to sentimental affective desire—used to argue that slaves should be free—but as practical information, identifying markers, used to claim property rather than to proclaim humanity. Nonetheless, this locates us within the maternal nexus of a black mulatta genealogy. Despite blue eyes and hair that can be made straight, none of these women are presumed to be passing; rather, readers are exhorted to look for them at their (darker) mothers' homes. The signifying chain the slave owner John Davis strings together, linking "lurking" with "mother" and these with "impudent," "favorite," "slothful," and "gentlemen," only makes gendered sense if the racial signifier of his description is clearly "black." The inability of domestic sentiment's linkage of mothers and daughters in near-sacred union to disquiet the informational nature in these advertisements speaks to the difference race makes. If we give credence to their masters' instincts, these light-skinned runaways physically link black mothers—and not white "fathers"—with freedom.

Once identified, it is easy to align the formulaic language of runaway advertisements—age, height, color, manners—with Mattison's description of Picquet; this helps to disclose the tension between his interest in the great favorites of some people who call themselves gentlemen and hers in uniting with her mother. The details of physical appearances all point to anatomical concerns that mirror the bodily attention paid to persons as

property rather than the more spiritual character-driven descriptions of white women that omit age and close attention to the body in order to preserve their reputed delicacy. As Shawn Michelle Smith puts it, "as physical appearance was readily represented and circulated in the age of mechanical reproduction, interior essence was posed as an elite, sacred realm only accessible to (and perhaps only possessed by) members of the privileged middle classes."[60] Mattison's language, then, doesn't grant Picquet agency as an "accomplished white lady" but reasserts his and his privileged readers' ultimate authority to describe and proscribe. Her "easy and graceful manners," "fair complexion," and "rosy cheeks" don't align her with even objectified white womanhood; in the signifying chain Mattison constructs, these descriptors situate her not as a lady but as a symbolic fugitive slave.

For readers not familiar with the discursive topology of slave advertisements, Mattison's language poses as an explication of the image that opens the text and as an iconographic attempt to embody Picquet's story by offering a visual and textual bridge of identification and empathy to white readers. Even for those who have never seen a broadside, Mattison offers an ethnographic invitation to scrutinize and objectify in order to find the points of difference, the anthropological thing that is not like the others. When Mattison notes that Mrs. P. has "every appearance, *at first view*, of an accomplished white lady," he invites his readers to take a second look, to stop and stare. She has, he tells us, "a flowing head of hair with no perceptible inclination to curl." The adjective is telling; the distinction between "no inclination to curl" and "no *perceptible* inclination" is the liminal space ostensibly clarified by scientific racism (as popular in the North as in the South).

Mattison's more subtle assertion of his racial expertise allies him with nineteenth-century authors and scientists who, by "advertising the signs of deviance that were assumed to mark the body as a visual testament to abnormality, helped to instantiate an unreliable but pervasive optical model of identity" that Mattison will try to stabilize further.[61] Mattison as pseudo-anthropologist is akin to Dr. Latrobe in *Iola Leroy*, among others, whom Harper mocks for declaring, mistakenly, that to practiced eyes "there are tricks of blood which always betray" white niggers.[62] Like Mattison, Dion Boucicault's popular protagonist Zoe in *The Octoroon*, a play first staged in 1859, also avers that discerning eyes will recognize the somatic clues of a "poisoned" heritage: "Look at these fingers; do you see the nails are of a bluish tinge?" she moans, confessing her parentage to the white man who wants to marry her. "Look in my eyes; is not the same color in the white? . . . Could you see the roots of my hair you would see the same dark, fatal

mark," Zoe continues.[63] This belabored testimony is what delivers Zoe's blackness, as Brody contends, for in appearance, manner, and form she is not "black"; it must be written on her.[64] Mattison affirms the essential racial difference that Boucicault both reflects and further popularizes and that Harper will later challenge. As an "expert" at reading the hidden significations of the mulatta body, he also implies that he has seen in full flush what Picquet can only attempt to pull back in the cut she submits—and that by following his lead, readers too can uncover "true" racial meaning.

Laura Wexler suggests that the sentimental readers who also made up Mattison's audience were hungry for images as codifications of class and identity. Considering their fascination with photography, she argues that these images "repeatedly invoked the materiality of appearances to justify their claim to dominance and their every incursion into the private space of others. Anxious *for* separation, *for* a visible difference in display and deportment that could squelch any challenge to the distinctive privileges they claimed, middle-class people must have found in the very numbers of family photographs that filled their homes an assurance that real family life was coincident with the kind of families the photographs showed."[65] Critics including McCaskill have noted that the white skin of some slaves acted as a visibly clear symbol of the wrongs of slavery that in itself made the moral suasionist argument without displaying the scars of what Lerone Bennett calls the "Negro exhibit" of bodily exposure to abolitionist or potentially sympathetic audiences.[66] In addition to the erotic invitation of empathic connection and identification, for white readers and audiences the mulatta body is as often an invitation to reread and recuperate the essential signs of racial *difference* displayed in the penumbras, rather than epidermis, of the women on display.[67] Indeed, by announcing what his language suggests could be interpreted fraudulently as accomplished whiteness, Mattison offers to help readers recognize putatively authentic visual and racial codes. He thus invites them to identify not with Louisa but with the still safe and stable boundaries of their own racial status and classification.

Crafting Images of Race, Gender, and Desire
in *Running a Thousand Miles to Freedom*

Mattison framed the epidermal and epistemological uncertainty Picquet's image reproduced in an era when viewing (and classifying) unidentifiable bodies was all the rage. *Louisa Picquet, the Octoroon* appeared in the wake of Boucicault's hit play, *The Octoroon*, in the United States; it opened to

full houses in Great Britain in 1861, the year after Craft's *Running a Thousand Miles for Freedom* was published. Boucicault's wife, Agnes Robertson, a "white" woman, played the tragic Zoe on both continents. The transracial permeability of Robertson's performance echoes white stars' successes as Eliza in theatrical productions of *Uncle Tom's Cabin*; it also finds an analogy in Robertson's success in male "breeches" parts in other transcontinental hits.[68]

Craft and her husband also captivated the transatlantic public's attention. Newspapers throughout the United States and Great Britain described the details of the Crafts' escape, and some reveled in revealing details that "would stick in any southerner's craw."[69] The audacity, indeed élan, with which the couple staged their escape from the deep South in late 1848, and the public attention they garnered, infuriated the slavocracy. The Crafts executed their plan to pass over the Mason-Dixon Line by having Ellen dress as a "Mr. William Johnson," a wealthy, invalid, young planter, while her husband posed as his dedicated slave. As Mr. Johnson was a "most respectable looking gentleman," the two escaped on the overground railroad, quite literally, staying at the very best hotels as they rode first class to freedom. Abolitionists cheered; these were relatively well-situated slaves—William, a skilled craftsman, Ellen, a favored and protected house "servant"—who proved that slavery was insupportable in any state. And the Crafts continued to make that point, joining the abolitionist community in Boston and lecturing with antislavery societies in the United States and later throughout Great Britain, where Ellen was the first formerly enslaved woman to visit since Phillis Wheatley in 1772. In multiple mediums, abolitionists such as Lydia Maria Child, William Still, William Lloyd Garrison, William Wells Brown, and Colonel Thomas Wentworth Higginson continued to tell the Crafts' story, and Ellen's image as Mr. Johnson appeared everywhere.[70] Indeed, in 1857, a full eight years after their escape and six years after the Fugitive Slave Law forced them into exile in a case that again made them objects of national attention, the Leeds Anti-Slavery Society sold an illustrated youth edition of *Uncle Tom's Cabin* "on the same page as a notice for a shilling portrait of Ellen wearing masculine garments."[71] When a twelve-year fascination with their story culminated in publication, the frontispiece featured this startling if familiar image (fig. 19).

Situating Picquet's opening image in relation to representations of Ellen Craft further highlights how epidermal and epistemological uncertainty are wed to questions of mulatta genealogies and racial will. That in all of the literature on the Crafts there are no extant images of them *together* underscores the ways in which Ellen's body has been appropriated into

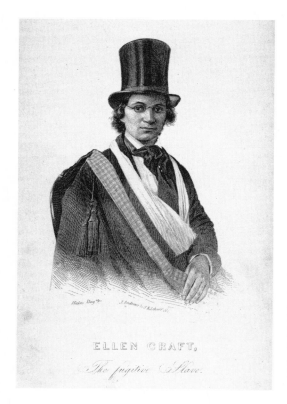

ELLEN CRAFT,

The fugitive Slave.

19. J. Andrews and S. A. Schoff, *Ellen Craft, the Fugitive Slave.*

Manuscripts, Archives, and Rare Books Division, Schomburg Center for Research in Black Culture, the New York Public Library, Astor, Lenox and Tilden Foundations.

a white mulatta genealogy, one that does not align her with the familial allegiances and racial critiques that cause them, quite explicitly, to run.[72] Their narrative is chock full of white bodies of various disjunctive genealogies and legal-racial standings that purposefully evoke the very epistemological and familial anxiety that Mattison seeks to master in *Louisa Picquet, the Octoroon.* The Crafts interweave their story with the stories of their (extended) families, their communities, and with the specter of their coming (slave or free?) children always haunting the text. Although family photographs and "portraits of couples," as they were titled, were popular in this era, the extensively reprinted engraving of "Mr. Johnson" abstracts Ellen from the filial context of parental responsibility that gave unwanted meaning to their marriage, just as it also excludes the couple from the visual circle of normative familial sentiment from which African Americans were barred. As Wexler puts it: "People outside of the magic circle of nineteenth-century domesticity . . . posed an interesting problem of exclusion in relation to such uses of photography . . . it is a problem that can be illuminated by examining the relation of these Others to the regime

of sentiment, taken as an aggressive, rather than a merely private, social practice."[73] William's absence from Ellen's side, sharing the frame, banishes them from the "magic" circle of normative domestic union, even as it simultaneously contains the threat of visually interracial (and/or) transgendered devotion. Seeing Ellen as Mr. Johnson alone, in or out of class, race, and gender drag, does not reference her desire for her husband at all.

A joint representation would symbolize what will become a paradigmatic literary rejection of white superiority and affirmation of racial loyalty by those who, despite their skin color, refuse to "walk on the side of the oppressor" and instead, "thank God" and are "with the oppressed," as Emily Garie in *The Garies and Their Friends* (1857) proclaims in a letter to her passing brother defending her marriage to the decidedly brown Charlie Ellis.[74] In 1861 Boucicault contended that "octoroon girls, proud of their white blood, revolt from union with the black and are unable to form marriages with the white."[75] Ellen Craft revises, indeed revolts against, this contention by asserting her desire to make such a union and by protesting her and William's inability to do so because of laws prohibiting their legal union as slaves. Picturing the Crafts together would underscore Ellen's rejection of the myth of racialized desire and also raise the specter of illicit sexuality in multiple senses, inviting "authentic" white women viewers not only to be shocked and outraged at the couple's (and Ellen's mother's) treatment under slavery but also to identify a bit too closely for (some's) comfort with Ellen and with her desire for an African American man. Indeed, in the absence of any representation of the Crafts as a couple, one way to read Mr. Johnson's visual popularity is to consider how race, gender, and class crossings that can be framed and contained do not constitute the threat that the image of the phenotypically "white" Ellen with her phenotypically "black" husband might pose. Passing (through), in Ellen's case, is a transgression that obtains curio status. The more threatening transgression, on the other hand, is the legitimate (visual) miscegenation whose absence speaks volumes about the story others wished to tell about the Crafts.

Even the engravings that most closely approximate the two Crafts together reveal their out-of-familial context (fig. 20). When these engravings were reprinted in William Still's *Underground Railroad* in 1872, Ellen and William appear side by side.[76] Yet, they are individual cameos; neither the Crafts nor the images actually touch or interact, and besides their size and arrangement there is no sign that they are related or together. Indeed, though both Ellen and William engage the viewer's gaze directly, it is impossible to meet one's eyes without excluding the other's. Seated as if they were sculpture busts, they look past each other to engage the viewer sepa-

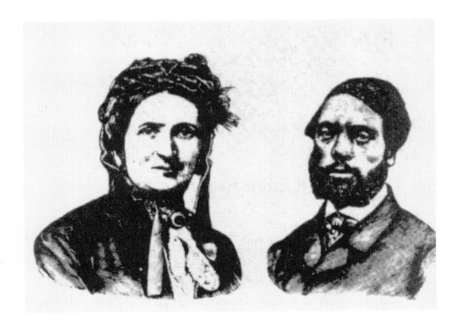

20. Illustration of William and Ellen Craft from William Still's
The Underground Railroad, **1872.**

Manuscripts, Archives, and Rare Books, Schomburg Center for Research in Black
Culture, the New York Public Library, Astor, Lenox and Tilden Foundations.

rately. Again, the visual representations of the Crafts reveal the cultural
limitations projected onto their agency that erase their racial and sexual
will.

To abolitionists like Stowe, photographs, "engravings or pictorial texts
authenticated Ellen's trauma."[77] While they certainly serve that purpose
for much of her audience, the body of Craft images also obfuscates Ellen's
personal trauma, grounding it in a familiar empathic arena based on super-
ficial phenotypical convergence with her white audience that she, herself,
pointedly rejects. Ellen is no "obliging octoroon," as Brody describes the
prototypical figure.[78] Indeed, despite her nearly universal acceptance on
both sides of the Atlantic by those of a wide range of castes and colors,
Ellen articulates her racial politics clearly. Finally over the Mason-Dixon
Line, when staying with Quakers she had assumed were light-skinned
blacks, she answers her husband's reassurance that "it is all right, these are
the same" by responding, "no, it's not all right, and I am not going to stop
here. I have no confidence whatever in white people."[79] When asked by
the *London Daily News*, "do you really think that the slaves are intelligent

enough to take care of themselves?," she is said to have retorted "at present, they take care of themselves and their masters too."[80] Moreover, she disdainfully rejects white prejudice—and the possibility of her own light-skinned privilege—by claiming her "black man—the *nigger?*" husband, as one amazed hotel clerk put it, at every public turn.[81]

Read outside of the context of a white mulatta genealogy, Ellen's trauma is not about the disjunction between (the assumptions that accompany) her skin tone and (the assumptions about) her experience as a slave—that is, it does not refer to the classic explanation of white audiences' response to light-skinned ex-slave women. Rather, her trauma is grounded in the constraints on her familial choices and freedom. It is the inability to extricate herself from the actualized mythological Southern "family" to make the transfer from being "one of the family" to having her own family that causes the couple to realize their challenges to racism, ownership, and slavery.[82] Ellen's trauma, then, cannot be represented in extant individual images. Rather, the images further isolate her from the actual cause of her distress: her inability to choose a (black) husband and parent their children in freedom.

Can I Get a Witness? Photography and the Eye of God

This era of celebrated and sometimes unrecognized passing reaffirmed obsessions with fixing racial identities that were actually mobile and diffuse. Amy Robinson suggests that "recognition typically serves as an accomplice to ontological truth-claims of identity in which claiming to *tell* who is or is not passing is inextricable from *knowing* the fixed contours of a pre-passing identity." Robinson's further interest in "the more subtle claim of telling in the absence of knowing," when the data of passing is "excavated from its epistemological certainty," is relevant here.[83] We can chart the connection between racial uncertainty and anxiety in *The Octoroon* and in *Running a Thousand Miles* because, though neither woman ever passes *over*, it is her will, not the dominant mastery of codes of racial legibility, that prevents it. Thus, the passing threat that stands in for the agency of putatively subordinate women like Craft and Picquet resonates throughout these texts as a (white) audience and author generated one just as surely as the success of the runaways to be a free black couple animates the visually repressed story in *Running a Thousand Miles*; likewise, the possible failure to gain release for Picquet's mother generates the principal narrative energy in Picquet's counternarrative. When it is possible for whites, in outrage and in error, to certify the whiteness of blacks (as the military officer who pre-

tends to know Mr. Johnson and his kin "like a book" when the Crafts need the miracle this man provides),[84] then one preoccupation of readers like Mattison, I'd contend, is to reassert the certainty of the connection between racial telling and knowing.[85]

For those who wished to codify racial difference, the technological innovation and popularity of antebellum photography offered a way to resolve tensions between ontology and epistemology. Garnering vast ideological influence, photography soon became so wildly popular as to be described as "daguerreotypomania."[86] Alan Trachtenberg notes that photography came into being "not just as a practice of picture-making but as a word, a linguistic practice. It was not very long before 'daguerreotype' became a common verb that meant telling the literal truth of things. . . . The very words photography and daguerreotype provided a way of expressing ideas about how the world can be known—about truth and falseness, appearance and reality, accuracy, exactitude, and impartiality."[87] By the late 1850s the era of the handheld, single-image daguerreotype was in decline, though its multiple meanings persisted as technology developed. That by this time engravings were based on photographs rather than drawings broadened the mass acceptance of the relationship between image and truth. Antebellum photographs were printed on wood blocks and "were in universal use as the standard" manner for illustration, making for much greater accuracy than had ever before been possible.[88] The final product was a woodcut; the popular abbreviation is the word Mattison uses when he laments that "the cut on the outside title page is a tolerable representation of the features of Mrs. P., though by no means a flattering picture."[89]

If antebellum photography was widely touted as an antidote to illusion in an increasingly unstable and unreadable midcentury America, it also heightened "the problem of racial discernment" the octoroon posed.[90] Images of women like Craft and Picquet simultaneously provided an ultimate proving ground for the form yet threatened to disrupt the very assumptions on which its authority was based. Photography offered a technological, popularized, but sacred counter to illusions of multiple kinds. It was widely considered the "eye of God" that provided an absolute truth, an idea that held sway even as voices offered other interpretive paradigms.

The picture of Ellen as "Mr. Johnson" symbolizes the theater of racial, status, and gender identity transposition. Yet the audience's ability to recognize this well-circulated image renders the play of the pass completely transparent and so nullifies the cultural threat to putative white purity. In this case the well-known story of Johnson's "authentic" identity delivers

racial authority rather than the ostensible transparency of the image itself. Ellen's face as Mr. Johnson was sufficiently well-known to convey racial meaning implicitly, without the linguistic markers offered by Avedon, for example, or by Mattison.[91] Most of the audience could identify the dissonance between the pictorial representation, a white planter, and its human referent, a runaway woman. In other words, the image is not passing at all. Robinson contends that the structure of passing is a triangular one in which "the passer, the dupe, and a representative of the in-group—enact a complex narrative scenario in which a successful pass is performed in the presence of a literate member of the in-group."[92] When the "visibility of the apparatus of passing, the machinery that enables the performance," was available, "Mr. Johnson's" viewers could choose between locations: those in the know or those outside of it. Those who chose to identify as literate members, "in-group" clairvoyants, unlike those duped in the narrative and during the escape, could reassert the connection between racial telling and knowing. It is the pleasure and power implicit in that racially reconstructive act, perhaps, that helped make the cut successful as a curio and commodity. Moreover, viewers could gain this literacy without giving up their racial locations, whether they were radically egalitarian or aligned with pseudoscientists like Harper's fictional Dr. Latrobe. Gazing at the engraving of Mr. Johnson, then, recalls the way the daguerreotype also functions as a looking glass, where the shifting optical focus allows "the viewer to see his or her own image [or in this case ideology] superimposed over the photographic one."[93] This cut can cut both ways; it can represent the "truth" of the mythology, or superiority, of racial difference.

The opening image of *The Octoroon* allows us to consider how reading and recognition, sin and sacredness intersect, as well as to consider how, seen through the lenses of a developing photographic discourse, a racially inflected religious context meets a legalistic one. One of Mattison's earlier publications, *Spirit-Rapping Unveiled!*, was an expose published in 1853.[94] He visited such unseemly subjects, he avers, "to vindicate the *Sacred writings* as *the only infallible standard of truth.*" He goes on to proclaim:

> In the progress of the expose, it has been thought best to cite numerous quotations from the writings of the spirit-rappers. . . . Many of these quotations, I am aware, are of the most pernicious character; and if found in any other book than a professed *unveiling* of a dark and iniquitous system, their repetition would be not only an offense against good taste, but a questionable antidote to error. But under the circumstance, I had no alternative but to leave the infidelity and licentious-

ness of the system to be admitted upon my bare assertion, or to support every charge by indubitable proof.[95]

Mattison's polemic against spirit rapping could be replicated, almost word for word, to justify his lascivious obsession with interracial sex and violence. By the time he published *The Octoroon*, photography had become one way to provide "indubitable proof," to pit the eye of God against the sinful illusions, the "infidelity and licentiousness," that practices like race mixing and spirit rapping symbolized.

In both *Spirit-Rapping Unveiled* and *The Octoroon*, Reverend Mattison justifies his penchant for exposing "inside views" by invoking sacred considerations. "Alas, for those telling mulatto, and quadroon, and octoroon faces," he declaims, after numbering no less than ten instances of miscegenous behavior in his "conclusion and moral of the whole story": "They stand out unimpeached, and still augmenting as God's testimony to the deep moral pollution of the Slave States."[96] In this context we can read his placement of Picquet's opening image as "God's testimony," infused with the authority of a new technology widely proclaimed to be the real Master's eye. Yet, for Mattison, this hybridity projects "a strategic taxonomy that constructs purity as a prior (fictive) ground."[97] Again, the telling "mulatto, quadroon, and octoroon faces" allow him to reemphasize the difference attached to key mitochondrial markers like Picquet's *seemingly* straight hair. Mattison manages the disruptive tension of Picquet's phenotypical "whiteness" as he had countered the radical gender equality that characterized spiritualism and spirit rapping;[98] he links his phallogocentric authority to multiple sources; he merges the scientific with the sacred, his eye/I and the I/eye of God.

Photography bridges the sacred and secular and finds itself in the discursive arena of the court insofar as it is able to give witness—to acquit or convict—on the basis of reliable evidence. "What we want in a witness," writes Reverend H. J. Morton in the *Philadelphia Photographer* (1864), is "capacity and opportunity for accurate observation and entire honesty. . . . We have abundant ocular delusions, but the camera is never under any hallucination. . . . The camera seeing with perfect accuracy and microscopic minuteness, and representing with absolute fidelity, is a witness on whose testimony the most certain conclusions may be confidently founded."[99] While Shawn Michelle Smith documents how discussions of criminal and racial passing dovetailed in the work of criminologists and eugenicists at the turn of the century and notes that "white anxiety over the perceived 'threat' of racial passing worked to encourage white surveillance over a

racialized social body," these overlapping arenas of middle-class monitoring are evident much earlier.[100] When antebellum racial witnessing is the issue, the language of science and law merge to create in photography a potentially more potent witness, for it can make what is within "outward, and even 'secret character,' unhappy truths disguised by outward appearance, will show through the mask."[101]

This technology is imputed to have the power to see through the material barrier separating the outside and the inside of the essentialized body; it can capture the "microscopic minuteness" of those small signs of telltale blackness that can bridge the inside and outside and cross the bodily border of internal and external: hair, nails, eyes.[102] As Brian Street suggests, "the nineteenth-century focus on the physical and visual features of cultural variety gave to photography a particular role in 'the formation of a particular discourse of race which was located in the conceptualization of the body as the object of anthropological knowledge.'"[103] The ways in which photography has been allied to anthropology are well documented, yet when the authority of photography, representation, and indeterminacy in the nineteenth century are at play, there is still much more to be said about its production and disruption of racial (and gendered) "truth." If "the field of vision is an implicit contest for the power of ownership," then questions of how those who were once owned negotiated multiple representational arenas surpass mere narrative tension to register personal and political resistance.[104]

The Contemporary Currency of Racial Taxonomy

I have examined the multiple valences of what I call white mulatta genealogies and differentiated them from the traditions generated in nineteenth-century African American narratives and fiction that tell the stories of once enslaved women such as Picquet and Craft. Like the writers Frances Smith Foster examines in her study of early African American authors, these women clearly affirm "their womanhood, their blackness, and their desire for full participation in American society"; they claim a rootedness and teleology that may be bodily indeterminate and epistemologically sophisticated but that are both juridically and maternally bound.[105] Examining the antebellum context of their iconographic representations underscores how perceived racial indeterminacy points to issues of reading rather than of being, as none of the phenotypically indeterminate women featured here wish to *claim* "whiteness." The inability to attach concrete meaning to ideologically inflected taxonomies of race and power provokes anxiety for

those whose ciphering ability the texts challenge, be they contemporaneous or contemporary viewers, readers, and critics or the original sponsors and amanuenses of the texts themselves.

Mulatta genealogies are the subject of this inquiry not only because "mulattas" are the African American women we've inherited as protagonists in much of nineteenth-century "race" literature and literary historiography but also because the term seems to be enjoying a vernacular and critical currency that, I fear, both expresses a current racial anxiety and reproduces the politics of exceptionalism.[106] Today, people ask their peers and professors, clients and customers, "are you a mulatto?" with little sense of meaning or manners, while publishers clamor for novels, autobiographies, and anthologies about living on the color line. Although the term *mulatto* etymologically hauls on its back the well-known nineteenth-century ethnological concepts that this crossbred, "weak" species would be unable—in the long term—to reproduce, the fascination with this line (of inquiry) has anything but died off.[107] The present currency of mixed-race subjects, as well meaning and seemingly innocuous as it may be, is *not* an acknowledgment that, as Albert Murray once put it, "American culture was, and continues to be, 'incontestably mulatto.'"[108] Murray's spectrum of racial categorization elucidates the difference between a person to whom such a designation is sometimes assigned and the complex cultural and national—rather than strictly "racial" or phenotypical—meanings it takes on in differently inflected literary and cultural economies. Rather than placing all Americans on a charcoal-to-chalk continuum, the contemporary investment that supports a formal or institutionalized "biracial" category, for example, seeks to separate putative "mulattos" from regular black folks, imagined essentialized Africans, without absorbing the "blackness" that "biracial" people carry into the still separate category of whiteness.[109] Simultaneously, the current racial vogue works as synecdoche, allowing liberal culture to express an interest in "race" without addressing or redressing the injustices and pain experienced by communities of color as they are being targeted by the politics of poverty, police violence, and prison. It is not the work per se but rather the contemporary cultural obsession with "light, bright, and damn near white" bodies that reproduces the very ideological and material abjection assigned to blackness that the women I examine here seek to challenge. This piece cannot help but to participate in the current vogue. Yet like its subjects, it has sought to disrupt the politics of racial desire that frame white mulatta genealogies, for these politics color our cultural obsessions and assumptions, our conception and reproduction of history and power, and the manner in which we

value citizens as part of the national family through ensuring equal access, resources, and representation.

Notes

1. Russ Castronovo, *Fathering the Nation: American Genealogies of Slavery and Freedom* (Berkeley: University of California Press, 1995), 193, 200.

2. Lauren Berlant, "The Queen of America Goes to Washington City: Harriet Jacobs, Frances Harper, Anita Hill," in *Subjects and Citizens: Nation, Race, and Gender from Oroonoko to Anita Hill*, ed. Michael Moon and Cathy Davidson (Durham: Duke University Press, 1995), 455–80.

3. Eric Sundquist, *To Wake the Nations: Race in the Making of American Literature* (Cambridge: Belknap, 1993). For a sustained reading of how masculinist critical paradigms lend to the erasure of foundational female figures, see Lora Romero, *Home Fronts: Domesticity and Its Critics in the Antebellum United States* (Durham: Duke University Press, 1997) 52–68, especially 52–55 for a consideration of *To Wake the Nations*.

4. Hortense Spillers, "Mama's Baby, Papa's Maybe: An American Grammar Book," *Diacritics: A Review of Contemporary Criticism* 17, no. 2 (1987): 65–81, 80. My work is aligned with Spillers's in our shared commitment to examining "the press of patronymnic, patrifocal, patrilineal, and patriarchal order" on captive women in the U.S. slavocracy ("Mama's Baby, Papa's Maybe," 79).

5. I name here only four of the most important books that address early black women's writing: Barbara Christian, *Black Women Novelists: The Development of a Tradition* (Westport: Greenwood Press, 1980); Ann duCille, *The Coupling Convention: Sex, Text, and Tradition in Black Women's Fiction* (New York: Oxford University Press, 1993); Frances Smith Foster, *Written by Herself: Literary Production by African American Women, 1746-1892* (Bloomington: Indiana University Press, 1993); Carla Peterson, *"Doers of the Word": African-American Women Speakers and Writers in the North, 1830-1880* (New York: Oxford University Press, 1995). Other important critics include Hazel Carby, Arlene Elder, and Jean Fagan Yellin, to name a few.

6. Spillers outlines the "theft of the body," which includes the "severing of the captive body from its motive will, its active desire." She argues that this ungenders the black captive body, which becomes "not at all gender-related, gender specific" (Spillers, "Mama's Baby, Papa's Maybe," 67). I'm interested in tracing the gendered specificity of black female desire, power, and naming.

7. Castronovo, *Fathering the Nation*, 201.

8. Patricia J. Williams, *The Alchemy of Race and Rights* (Cambridge: Harvard University Press, 1991), 163.

9. Jennifer DeVere Brody, *Impossible Purities: Blackness, Femininity, and Victorian Culture* (Durham: Duke University Press, 1998), 16.

10. Marjorie B. Garber, *Vested Interests: Cross-Dressing and Cultural Anxiety* (New York: Routledge, 1992), 282.

11. Williams, *The Alchemy of Race and Rights*, 21. Also see P. Gabrielle Foreman,

"Passing and Its Prepositions," in "Racial Recovery, Racial Death: An Introduction in Four Parts" (written with Cherene Sherrard-Johnson), in "Racial Identity, Indeterminacy and Identification in the Nineteenth Century," *Legacy: A Journal of American Women Writers* 24, no. 2 (2007).

12. Harryette Mullen, "Optic White: Blackness and the Production of Whiteness," *Diacritics: A Review of Contemporary Criticism* 24, nos. 2–3 (1994): 71–89, 73.

13. DuCille, *The Coupling Convention*, 7, 11; Claudia Tate, *Domestic Allegories of Political Desire: The Black Heroine's Text at the Turn of the Century* (New York: Oxford University Press, 1992), 4.

14. Mullen, "Optic White," 78–79.

15. David Waldstreicher, "Reading the Runaways: Self-Fashioning, Print Culture, and Confidence in Slavery in the Eighteenth-Century Mid-Atlantic," *William and Mary Quarterly* 56, no. 2 (April 1999): 243–73, 248.

16. *Hudgins V. Wright* (11 Va. 134), a case from 1806, complicates both the black/white and free/nonfree maternal paradigms. The enslaved women of Hannah Hudgins's family sued for their freedom, arguing that their mother was Indian. As Ian Haney Lopez points out, and unlike the women here examined, the Hudgins women "challenged their race, not the status ascribed to it" ("The Social Construction of Race," in *Critical Race Theory: The Cutting Edge*, ed. Richard Delgado [Philadelphia: Temple University Press, 1995], 191–203, 200).

17. While neither of these women penned their narratives, both provide enough information so that we may begin to gloss how their racial agency and desires might offer multiple and different readings than the generic ways in which their indeterminate bodies were often framed and received. Mattison writes in a question and answer format and suggests that he quotes Picquet directly; her irony is everywhere apparent. Craft left behind letters and a long history of commentary about herself. I'm not suggesting, of course, that we can recover some "pure" expression of will or agency from these texts, undistorted either by the politics of racial representation or hegemony; they remain "entangled with the politics of domination." I am not trying to, as Saidiya V. Hartman puts it, "liberate these documents from the context in which they were collected," but I am attempting to "exploit the surface of these accounts for contrary purposes to consider the form resistance assumes given this context" (*Scenes of Subjection: Terror, Slavery, and Self-Making in Nineteenth-Century America* [New York: Oxford University Press, 1997], 11). For more on Ellen Craft, see Dorothy Sterling, *Black Foremothers: Three Lives* (Old Westbury: Feminist Press, 1979); and Barbara McCaskill, "'Yours Very Truly': Ellen Craft—The Fugitive as Text and Artifact," *African American Review* 28, no. 4 (Winter 1994): 509–30.

18. Lauren Berlant, "National Brands/National Body: Imitation of Life," in *Comparative American Identities: Race, Sex, and Nationality in the Modern Text*, ed. Hortense Spillers (New York: Routledge, 1991), 110–40, 113.

19. Berlant, "The Queen of America Goes to Washington City," 475.

20. Hartman, *Scenes of Subjection*, 18.

21. Ibid., 18–19.

22. Ibid., 19.

23. Ibid., 20.

24. See P. Gabrielle Foreman, "'Reading Aright': White Slavery, Black Referents and the Strategy of Histotextuality in *Iola Leroy*," *Yale Journal of Criticism* 10, no. 2 (Fall 1997): 327–55.

25. Peterson, *"Doers of the Word,"* 570.

26. Harriet A. Jacobs, Lydia Maria Francis Child, and Jean Fagan Yellin, *Incidents in the Life of a Slave Girl: Written by Herself* (Cambridge: Harvard University Press, 1987), 13.

27. Jacobs, *Incidents in the Life of a Slave Girl*, 176–77.

28. See P. Gabrielle Foreman, "Manifest in Signs: The Politics of Sex and Representation in *Incidents in the Life of a Slave Girl*," in *Harriet Jacobs and Incidents in the Life of a Slave Girl: New Critical Essays*, ed. Deborah Garfield and Rafia Zafar (New York: Cambridge University Press, 1996), 76–99.

29. Jacobs, *Incidents in the Life of a Slave Girl*, 5.

30. DoVeanna Fulton, "Speak Sister, Speak: Oral Empowerment in *Lousia Picquet, the Octoroon*," *Legacy: A Journal of Women Writers* 15, no. 1 (1998): 98–103, 101.

31. Hiram Mattison, *Louisa Picquet, the Octoroon: A Tale of Southern Slave Life*, in *Collected Black Women's Narratives*, The Schomburg Library of Nineteenth-Century Black Women Writers, ed. Henry Louis Gates Jr. (New York: Oxford University Press, 1990), 20.

32. Mattison, *Louisa Picquet, the Octoroon*, 23.

33. Ibid., 27.

34. Ibid., 23.

35. Lindon Barrett, "African American Slave Narratives: Literacy, the Body, Authority," *American Literary History* 7, no. 3 (1995): 415–42, 429.

36. Mattison, *Louisa Picquet, the Octoroon*, 5.

37. McCaskill, "'Yours Very Truly,'" 516. For a fine reading of frontispiece conventions, see McCaskill, "'Yours Very Truly,'" 515–19.

38. Mattison, *Louisa Picquet, the Octoroon*, 50.

39. Ibid., 35. For an excellent reading of these photographic exchanges, see Laura Wexler, *Tender Violence: Domestic Visions in an Age of U.S. Imperialism* (Chapel Hill: University of North Carolina Press, 2000), 3–4.

40. Harriet Beecher Stowe, *Uncle Tom's Cabin: Or, Life among the Lowly* (1852; New York: Collier, 1962), 388–90. When Emmeline, the daughter, gets on the block "the blood flushes painfully in her otherwise colorless cheek, her eye has a feverish fire, and her mother groans to see that she looks more beautiful than she ever saw her before" as prices rise beyond that which households looking for "respectable" work might afford (Stowe, *Uncle Tom's Cabin*, 393).

41. Mattison, *Louisa Picquet, the Octoroon*, 17.

42. Bridget R. Cooks, "See Me Now," in "Black Women, Spectatorship and Visual Culture," special issue, *Camera Obscura* 36 (1995): 67–84, 70.

43. McCaskill, Barbara, "A Stamp on the Envelope Upside Down Means Love; or, Literature and Literacy in the Multicultural Classroom," in *Multicultural Literature and Literacies: Making Space for Difference*, ed. Suzanne M. Miller and Barbara McCaskill (Albany: SUNY Press, 1993), 81.

44. Anthony Barthelemy, "Introduction," *Collected Black Women's Narratives*, The Schomburg Library of Nineteenth-Century Black Women Writers, ed. Henry Louis Gates Jr. (New York: Oxford University Press, 1988), xl.

45. Carla Peterson, *"Doers of the Word,"* 155.

46. Mattison, *Louisa Picquet, the Octoroon*, 33.

47. Ibid., 53.

48. Ibid., 35, 31.

49. Enwezor Okwui and Octavio Zaya, "Colonial Imaginary, Tropes of Disruption: History, Culture, and Representation in the Works of African Photographers," in *In/Sight: African Photographers, 1940 to the Present* (New York: Solomon Guggenheim Foundation, 1996), 25. See also Roland Barthes, *Camera Lucida*, trans. Richard Howard (New York: Hill and Wang, 1982), 34–35.

50. The black Muslim *X* refers to African family names displaced during the middle passage and by the erasure of identity forced upon Africans in the New World. Of course, Louisa's husband's name was also, likely, a slave master's name, but it displaced *her* master's name, or her mother's master's, both of whom were rapists who gave their slaves names without any of the rights of inheritance or recognition names often signify. Of course, the politics of patriarchy and "choice" around naming are also problematic both in the Nation of Islam and more generally.

51. Mattison, *Louisa Picquet, the Octoroon*, 5.

52. Spillers, "Mama's Baby, Papa's Maybe," 80.

53. Mattison, *Louisa Picquet, the Octoroon*, 5.

54. See Waldstreicher, "Reading the Runaways," 243–72, for an excellent discussion of slave advertisements in the mid-eighteenth-century South.

55. Jacobs, *Incidents in the Life of a Slave Girl*, 215, 274n1.

56. Freddie L. Parker, *Stealing a Little Freedom: Advertisements for Slave Runaways in North Carolina, 1791–1840* (New York: Garland, 1994), 662.

57. Parker, *Stealing a Little Freedom*, 746.

58. Ibid., 93.

59. Ariela Gross, "Litigating Whiteness: Trials of Racial Determination in the Nineteenth-Century South," *Yale Law Journal* 108, no. 1 (1998): 109–88, 131.

60. Shawn Michelle Smith, *American Archives: Gender, Race, and Class in Visual Culture* (Princeton: Princeton University Press, 1999), 61.

61. Amy Robinson, "It Takes One to Know One: Passing and Communities of Common Interest," *Critical Inquiry* 20, no. 4 (1994): 715–36, 718.

62. Frances Harper, *Iola Leroy* (Boston: Beacon, 1987), 229.

63. Dion Boucicault, *The Octoroon*, in *The Longman Anthology of American Drama*, ed. Lee A. Jacobus (New York: Longman, 1982), 111.

64. Brody, *Impossible Purities*, 50.

65. Wexler, *Tender Violence*, 66–67.

66. Lerone Bennett, *Before the Mayflower* (Chicago: Johnson, 1969), 137.

67. For more on what is now critically accepted as the erotics of slavery, see, for example, Carla L. Peterson, "Capitalism, Black (under)Development, and the Production of the African American Novel in the 1850s," *American Literary History* 4,

no. 4 (1992): 559–83, 562; Karen Sánchez-Eppler, "Bodily Bonds: The Intersecting Rhetorics of Feminism and Abolition," *Representations* 24, no. 1 (1991): 28–59; and Houston Baker, *Workings of the Spirit* (Chicago: University of Chicago Press, 1991), 13–14.

68. This instability of bodily classification was underscored by the transcontinental popularity of Lord Byron's *Mazeppa* (1861). Its star, Adah Isaacs Menken, was exactly the kind of racial and gender chameleon that protectors of "whiteness" feared. For an excellent discussion of gender, performance, and specularity, see Daphne Brooks, "'The Deeds Done in My Body': Black Feminist Theory, Performance, and the Truth about Adah Isaacs Menken," in *Recovering the Black Female Body: Self-Representations by African American Women*, ed. Michael Bennett and Vanessa Dickerson (New Brunswick: Rutgers University Press, 2001).

69. Barbara McCaskill, *William and Ellen Craft in Transatlantic Literature and Life* (Athens: University of Georgia Press, 1999), 6.

70. William Craft describes his wife/master in this way when she first puts on her costume, see William Craft and Ellen Craft, *Running a Thousand Miles for Freedom*, in *Great Slave Narratives*, ed. Arna Bontemps (Boston: Beacon, 1969), 290.

71. Craft and Craft, *Running a Thousand Miles for Freedom*, 11.

72. McCaskill, "'Yours Very Truly,'" 510. These observations emerge as well from my conversations with McCaskill in the spring of 1999.

73. Wexler, *Tender Violence*, 67. Wexler goes on to assert "if the function of middle-class domestic photographs was . . . to precipitate a seemingly natural mirror image of the sentimental home out of the household, it would follow that the household, although it visibly and palpably sustained the home, *as well as heterogeneous images*, would need to be rendered functionally invisible" (*Tender Violence*, 67; emphasis added).

74. Frank Webb, *The Garies and Their Friends* (New York: Arno Press, 1969), 336. We'll see this gesture again and again, as when Iola's brother Harry assures his beautiful and ebony schoolteacher fiancée that his sister will certainly accept her as she abhors those who "can't be white but won't be black" (Harper, *Iola Leroy*, 278).

75. Brody, *Impossible Purities*, 47, quoted from an unpublished Boucicault manuscript. Nearly one hundred years later in 1952, in his chapter "The Woman of Color and the White Man," Frantz Fanon will echo Boucicault, querying "what indeed could be more illogical than a mulatto woman's acceptance of a Negro husband?" (Franz Fanon, *Black Skin, White Masks* [New York: Grove Press, 1967], 54).

76. The illicit visual possibilities of William and Ellen's partnering were disrupted again, when an interracial group, including the Crafts, promenaded through London's Great Exhibition of 1851 to view the popular sculpture *The Greek Slave* among nobility, members of Parliament, and Queen Victoria's party. Ellen made her appearance on the arm of an English officer of the National Reform Association, and William Wells Brown and William Craft accompanied the daughters of famous British abolitionist George Thompson (Sterling, *Black Foremothers*, 41). Despite the message of complete racial equality the party wished to deliver, choosing male and female and so (hetero)sexual pairings nonetheless divided the married Crafts again, thereby subverting the image of legitimate, though phenotypically

illicit, sexuality, while the Williams and Thompson couples' performance (only) gestured at the acceptability of such a possibility. Though the Thompson daughters' appearance on the arms of black abolitionists may have shocked some, light Ellen and her white partner's walk through the exhibition must have been noted only by its association with the other couples. Again, the arrangement erases Ellen and William's actual desire for, and choice of, each other, a choice that not only underscores their racial and sexual agency but visually flouts miscegenation taboos.

77. McCaskill, "'Yours Very Truly,'" 515.

78. Brody, *Impossible Purities*, 53. Mary Ellen Doyle makes this point, asserting that Ellen Craft is no tragic mulatto. See Mary Ellen Doyle, "Slave Narratives as Rhetorical Art," in *The Art of the Slave Narrative: Original Essays in Criticism and Theory*, ed. John Sekora and Darwin Turner (Macomb: Western Illinois University Press, 1982), 83–95, 86.

79. Craft and Craft, *Running a Thousand Miles for Freedom*, 316.

80. Sterling, *Black Foremothers*, 38.

81. Craft and Craft, *Running a Thousand Miles for Freedom*, 326, 328.

82. Note William Craft's comments: "My wife was torn from her mother's embrace in childhood, and taken to a distant part of the country. She had seen so many other children separated from their parents in this cruel manner, that the mere thought of her ever becoming a mother of a child, to linger out a miserable existence under the wretched system of American slavery, appeared to fill her very soul with horror; and as she had taken what I felt to be an important view of her condition, I did not, at first, press the marriage, but agreed to assist her in trying to devise some plan by which we might escape from our unhappy condition, and then be married" (Craft and Craft, *Running a Thousand Miles for Freedom*, 285).

83. Robinson, "It Takes One to Know One," 723.

84. A woman who accuses Louisa of being a racial imposter trying to impersonate *blackness* declares, "*You* a colored woman? You're no negro" (Mattison, *Louisa Picquet, the Octoroon*, 43).

85. Sterling, *Black Foremothers*, 17.

86. Cathy Davidson, quoted in Smith, *American Archives*, 13.

87. Alan Trachtenberg, "Photography: The Emergence of a Key Word," in *Photography in Nineteenth-Century America*, ed. Martha Sandweiss (Amon Carter Museum; New York: H. N. Abrams, 1991), 17.

88. William M. Ivins, *How Prints Look: Photographs with Commentary* (Boston: Beacon Press, 1987), 28, 35.

89. Mattison, *Louisa Picquet, the Octoroon*, 5.

90. Brody, *Impossible Purities*, 50.

91. Robinson argues that identity politics can be figured "as a skill of reading by African American and/or gay and lesbian spectators of the cultural performance of passing. . . . Disrupting the conventional dyad of passer and dupe with a third term—the *in-group clairvoyant*—the pass can be regarded as a triangular theater of identity" ("It Takes One to Know One," 716).

92. Robinson, "It Takes One to Know One," 723.

93. Trachtenberg, "Photography," 26.

94. Spirit rapping became popular in the 1850s and '60s and was practiced by abolitionists like Jacobs's good friend Amy Post and by Adah Isaacs Menken as part of the spiritualist movement.

95. Hiram Mattison, *Spirit-Rapping Unveiled! An Expose of the Origin, History, Theology, and Philosophy of Certain Alleged Communications from the Spirit World* (New York: Mason Brothers, 1853), 4 (emphasis in original).

96. Mattison, *Louisa Picquet, the Octoroon*, 51.

97. Brody, *Impossible Purities*, 12.

98. According to Anne Braude, "All Spiritualists advocated woman's rights, and women were in fact equal to men within Spiritualism practice, polity and ideology." They led the so-called ultraist wings of the movements for "the abolition of slavery, for the reform of marriage, for children's rights, and for religious freedom, and they actively supported socialism, labor reform, vegetarianism, dress reform, health reform, temperance, and anti-sabbatarianism" (*Radical Spirits: Spiritualism and Women's Rights in Nineteenth-Century America* [Boston: Beacon, 1989], 3).

99. Trachtenberg, "Photography," 18.

100. Smith, *American Archives*, 92.

101. Trachtenberg, "Photography," 24.

102. As Smith asserts, the middle class claimed photographic portraiture only for themselves as a transparent vehicle for "auratic" middle-class interiority (*American Archives*, 69).

103. Brian Street quoted in Okwui and Zaya, "Colonial Imaginary, Tropes of Disruption," 24.

104. Okwui and Zaya, "Colonial Imaginary, Tropes of Disruption," 21.

105. Foster, *Written by Herself*, 7.

106. Almost all of the protagonists in the fiction penned by black women from *Our Nig* (1859) through *Their Eyes Were Watching God* (1937) are light skinned. Lutie Johnson in *The Street* (1946) is the first dark-skinned protagonist in African American women's novels.

107. Just one example is the Georgia Supreme Court declaration of 1869: "The amalgamation of the races is not only unnatural, but is always productive of deplorable results, the offspring of these unnatural connections are generally sickly and effeminate, and they are inferior in physical development and strength, to the full-blood of either race" (qtd. in Peter Winthrop Bardagio, *Reconstructing the Household: Families, Sex, and the Law in the Nineteenth-Century South*, Studies in Legal History [Chapel Hill: University of North Carolina Press, 1995], 185).

108. Albert Murray, *Omni Americans* (New York: Vintage, 1983), 22. The national and critical resistance over accepting "black" claims that Thomas Jefferson fathered children with his slave Sally Hemings, and the generalized amazement that followed its confirmation, is just one example of this legacy of anxiety and the continued denial of black testimony.

109. I find the term *biracial* particularly inadequate because while attempting to recognize African American multiraciality, it undermines that very concept. The history of racial violence, intermixture, and race-based law assures that almost all people of black ancestry are multiracial. The term *biracial* separates those with im-

mediate nonblack ancestry from those with equally complex racial inheritances. It so affirms individual claims of difference over a collective history of racial admixture. Moreover, by claiming "blackness" for one immediate ancestor, a parent, the term *biracial* only defers by one generation the projection of absolute racial classification onto the black parent, thus replicating the very categorization the term is supposed to challenge.

 SIX

Out from Behind the Mask

PAUL LAURENCE DUNBAR, THE HAMPTON

INSTITUTE CAMERA CLUB, AND PHOTOGRAPHIC

PERFORMANCE OF IDENTITY

Ray Sapirstein

Almost annually from 1899 to 1906, the celebrated African American writer Paul Laurence Dunbar published a decorated volume of poetry in African American dialect illustrated with photographs, six books in all, made by faculty members of the Hampton Institute Camera Club, most of them well-connected white Northerners. These photo-texts almost completely excluded Dunbar's poems in standard English diction, a great percentage of his poetic work. Comprising half his output of published poetry, and among his most popular volumes, the illustrated editions represent more than 450 images dramatizing black life in rural Virginia at the turn of the twentieth century, making this series of works the largest discrete body of images of African Americans published to date.[1]

Although there are important exceptions, the volumes largely presented poems Dunbar had published previously, and they were assembled by the members of the Camera Club and later approved by Dunbar. It is unclear who actually selected poems for inclusion, whether Dunbar, his editors at Dodd, Mead, and Company, or the members of the Camera Club. More than likely, all parties contributed. In one documented case during the production of the first book in the series, *Poems of Cabin and Field*, Dunbar asserted editorial prerogative and cut one of the images made for the book, an image of an elderly African American man in close proximity to a young white woman hanging a Christmas garland in an elegant domestic interior.[2] Despite Dunbar's seemingly casual involvement, the works bear his name as author and were produced in a uniquely hybrid and richly

multivalent collaboration. Assigning primary authorship or a singular intention to these books seems futile and needlessly reductive. Selected by committee with images executed by up to thirty participating photographers initially, neither text nor image predominates; typically a stanza of poetry is accompanied by an image on the facing page, surrounded by decorative, hand-rendered framing devices and marginal illustrations executed by yet other credited collaborators. The last three books in the series were authored jointly by Dunbar and a member of the Camera Club who emerged as the lead photographer, Leigh Richmond Miner, the school's art teacher who would also be the school's official photographer for a generation.

The books are authored collectively; Dunbar rates as an "author" of the images as the photographers closely followed his narrative "script" when staging the images. Conversely, the photographers may be plausibly deemed "authors" of Dunbar's verse: because the books were produced over a long period as a regular feature of the poet's output, the early books would have contributed to and strengthened latent visual themes in Dunbar's poetry written thereafter. A writer from the urban North who traveled south on only a few occasions, the Camera Club's images likely helped Dunbar visualize the content and cultural landscape of his later work. Largely made in African American communities in the environs of Hampton, Virginia, the photographs' depictions of Southern folk culture lent Dunbar's work a further authenticity beyond that of his well-publicized racial identity.

Several factors contribute to the relative obscurity of the volumes today. In many ways, they seem to typify the post-Reconstruction era's romanticization of slavery with their commercial appeal, production by largely white photographers, rendering of African American dialect, and attractiveness to white audiences of the era. On first inspection, the photographs accompanying the poems would seem to reinforce a view of Dunbar as an author appealing strictly to white taste for quaint characters in the manner of Uncle Remus or the minstrel tradition, as picturesque exponents of homely folk wisdom. Further, despite the popularity of Dunbar's work among African American readers, several critics of the Harlem Renaissance publicly rejected Dunbar's dialect work in the 1920s. Dunbar's most prominent critic, his close friend James Weldon Johnson, suggested retrospectively that Dunbar's work hewed too closely to the plantation tradition, failing to explicitly elide the school of "humor and pathos" that had so defined nineteenth-century sentimental renderings of African Americans.[3] In a "standard" English poem, "The Poet," Dunbar himself seemed to deprecate his literary powers, deeming his art "a jingle in a broken tongue"

and voicing disillusionment with white preferences for dialect to the exclusion of his poems in "proper" English.[4] However, Dunbar's doubts as to the merit of his dialect literature seem a function of the limits he felt were imposed upon him because of his racial identity. Despite these factors, including Johnson's much-quoted critique, Dunbar's work in dialect was overwhelmingly celebrated and adopted by his successors, particularly Langston Hughes, also an Ohioan and a self-conscious inheritor of Dunbar's mantle. By the 1930s, Dunbar's use of vernacular language and the photo-text form would prove prescient, and today Dunbar's work has been accepted as a counterhegemonic validation of African American vernacular traditions, an important predecessor to the younger generation of poets of the Harlem Renaissance, and a monumental fount of inspiration in the twentieth-century African American literary tradition.

Dunbar's iconic status was furthered by his African American popular readership, rather than by modernist intellectuals seeking to position black art within the precincts of high culture. Despite their superficial similarity to works espousing white supremacy and waxing nostalgic on the paternalism of slavery, the Dunbar photo-texts represented a subtle effort to undermine existing representations and pictorial conventions describing so-called African American racial character. Dunbar's work, including his illustrated editions, remained popular among the black public throughout the twentieth century because of its authentic rendering of vernacular language, characters, and scenery and its well-couched and coded counterhegemonic subtleties. Although Dunbar's work was not sufficiently explicit in its counterhegemonic assertions for later twentieth-century critics, it did implicitly critique racial and cultural hierarchies from under cover within established forms. Similarly, the Hampton photographers voiced their opposition to racial hierarchy from within a "tight spot," as Houston Baker has phrased it, accompanying Dunbar in his tentative subversive forays without breaking cover.[5]

Well versed in the features of African American vernacular culture and the subtleties of its resistance to the brutalities of white supremacy, many of the members of the Camera Club were long-time faculty members at Hampton, and several were central members of the pioneering Hampton Folklore Society, the first local chapter of the American Folklore Society.[6] Folktales and idiosyncratic practices were largely collected by the

school's staff and widespread corresponding alumni from among their own far-flung communities and assembled and published in the "Folklore and Ethnology" section of the school's illustrated monthly magazine and publicity vehicle, the *Southern Workman*. Many Camera Club members also contributed photographs and articles, and several were editors and principal contributors of the *Southern Workman*. Undertaken as unofficial, leisure pursuits, the Camera Club photo-texts represent candid expressions of its members' interest in African American culture. The photo-texts both undermine and complement the now much-reproduced publicity images made for the school by the photojournalist Frances Benjamin Johnston as historical documents describing Hampton for posterity. Made at exactly the same time and place as Johnston's images, the Camera Club photographs provide substantially different insights into the school's program, as well as its underlying intentions, which often contradicted the school's official mission statements and philosophy. While Johnston's promotional images rendered Hampton's students and neighbors as uniformly righteous and industrious candidates for citizenship, they also presented them as standardized figures, limiting their humanity and depicting them as iconic exemplars. Johnston's images depicted individuals as representatives of the student body and their race as a whole, specifying little individuality, personality, or self-determination whatsoever. Scholars seeking to inquire into the character of education, racial philosophy, and the student body at Hampton ought to consult both bodies of images, triangulating Hampton's historical legacy from a broader range of contextual artifacts, venturing off the path of the official campus tour. Beyond their insight into the opacities of Dunbar and Hampton's legacies, the photo-texts themselves established a novel means of representing African Americans. They depicted people in theatrical play, putting on identities to enact fictional narratives, and serially in motion in time, suggesting the subjects' autonomous existence and potential beyond the pages of the books, mediating both sentimental imagery and evidentiary documentation that sought to characterize an entire collectivity of people into a singular, essential taxonomic identity. Because the images' cinematic fictions and composite nature are largely evident and unselfconscious, they are ironically more revealing documents than the promotional images Hampton used for publicity and fundraising.

In their most profound significance, the Dunbar photo-texts demonstrate the strategy of African American "masking," obscuring counterhegemonic prerogatives within the facade of acquiescence to white supremacy and social propriety, couching and reconciling black cultural forms within

dominant middle-class domestic ideals and behavioral norms. Responding to Dunbar's lead and implications, the Hampton photographers advocated the persistence of African American cultural identity alongside modern technologies, middle-class society, and U.S. citizenship, understanding black identity as a mindset, an ethnicity inhabiting standard American forms while maintaining its autonomy and distinction. This assertion of blackness as a legitimate cultural identity precedes its foremost proponent, Zora Neale Hurston, by nearly a generation and further underscores Dunbar's crucial stature in African American letters. While Hampton promoted middle-class standards, it was not necessarily advocating the abandonment of deeper cultural structures and in fact explicitly espoused the retention of positive cultural inheritances—its "gifts"—while abandoning the legacies and self-hatred of slavery.

Much of this conceptual model is manifested in the Dunbar photo-texts by their presentation of symbolic domestic spaces; like the doorways and thresholds they depicted, the books promised to be passages granting readers access to the interior of black homes, black "character," and an authentic black experience. Ultimately, however, the photo-texts delivered both racial and cultural blackness as a nominal difference rather than as an opposite cultural polarity to readers, demonstrating largely commonplace features and structures within the home and, symbolically, within the black psyche. The Hampton photographs promised to reveal exotic and forbidden interiors but largely conveyed the familiar iconography of the American domestic "folk" interior, depicting African American characters as a diversity of individuals rather than a countervailing cultural tradition, a pervasive cultural commonality and individual identity housed within the shell of a superficial racial and ethnic otherness.

Despite their nuances and distinction, few scholars have read into Dunbar's photo-texts. Scholars casually cite Dunbar's most important poem, "We Wear the Mask," as a crucial delineation of African American identity and comportment in everyday life. Reading the poem in the context of Dunbar's photo-texts, it additionally suggests not only photography's role as a medium conveying fictions but demonstrates subjects' self-invention and self-representation in photographs and ultimately their complicity in the content of an image.[7] The conjunction of masking and photography, implicit in the Dunbar photo-texts, undermines the concept of the dominance of the photographer and subject as subjugated subaltern, demonstrating the agency of the represented.[8]

The photo-texts are also largely unexamined in their significance to

Dunbar's own work. Because a great many people read Dunbar's dialect poems in the photo-text form, the content of the images helped determine the reception of Dunbar's texts. In one salient example, a Camera Club photograph actually makes explicit some of Dunbar's subtly subversive content. Demonstrating Dunbar's deep commitment to validating vernacular expression and language, "When Malindy Sings" pokes fun at a middle-class singer, Miss Lucy, who sings with an ostentatiously learned, technical prowess, which Dunbar suggests is inferior to the deeper, heartfelt expression of a vernacular singer, Malindy:

G'WAY an' quit dat noise, Miss Lucy—
Put dat music book away;
What's de use to keep on tryin'?
Ef you practise twell you're gray,
You cain't sta't no notes a-flyin'
Lak de ones dat rants and rings
F'om de kitchen to de big woods
When Malindy sings.
You ain't got de nachel o'gans
Fu' to make de soun' come right,
You ain't got de tu'ns an' twistin's
Fu' to make it sweet an' light.
Tell you one thing now, Miss Lucy,
An' I'm tellin' you fu' true,
When hit comes to raal right singin',
'T ain't no easy thing to do.

Easy 'nough fu' folks to hollah,
Lookin' at de lines an' dots,
When dey ain't no one kin sence it,
An' de chune comes in, in spots;
But fu' real melojous music,
Dat jes' strikes yo' hea't and clings,
Jes' you stan' an' listen wif me
When Malindy sings . . .⁹

The poem itself does not specify the racial identity of Miss Lucy and implies Malindy's African American identity by reciting her gospel repertoire, including the songs "Come to Jesus" and "Swing Low." As interpreted by the Hampton Camera Club in an illustrated edition, "Miss Lucy" is pictured, not as she could be, as a classically trained or "dicty" middle-

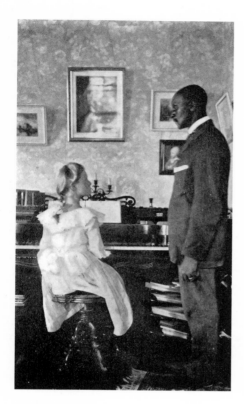

21. Unidentified Hampton Institute Camera Club photographer, from "When Malindy Sings," Paul Laurence Dunbar, *When Malindy Sings* (Dodd, Mead, and Co., 1903), 10.

class black singer, but imagined and inscribed by the photographers explicitly as a young white girl being addressed by the black narrator. The image overreaches a strict interpretation of Dunbar's poem, an interpretive leap that the influential posthumous collection of Dunbar's work reaffirmed for posterity with the same illustration in 1907, a subversive interpretation that has adhered to the poem ever since.[10] The illustration from the photo-text makes Dunbar's statement about the inferiority of Lucy's "nachel o'gans" far more racially explicit and transgressive. Dunbar's recent critics have upheld the poem as evidence of the poet's subtle subversions ever since.[11] In this specific instance, it was the Hampton photographers who were responsible for making Dunbar's subversive implications explicit, as well as depicting a young white girl in a domestic interior with a self-possessed, well-dressed (and married) young black man, potentially as social equals (fig. 21). Published in 1901, the tension and uncertainty on the models' faces also reveals the transgressive nature of their proximity. The headpiece of the poem depicts Malindy as a joyous singer in a homespun vernacular calico dress.

Despite Dunbar's approval of and benefit from the Camera Club photo-texts, they were produced largely as an extension of Hampton's formidable publicity and fundraising apparatus. One may speculate that they were appropriations of Dunbar's work to launch other careers and to divert his voice and stature to support a separate cause. Rather than identifying the club by its proper name as adopted in its charter—the Kiquotan Kamera Klub—the books credit the Hampton Institute Camera Club, implicitly strengthening Dunbar's connection to the school and perhaps promoting the misconception that Dunbar himself was a graduate or that the images were made by the school's predominantly African American students. Such associations might work to overstate the participation of African American image makers in the genesis of the works and suggest the same kind of authenticity that Dunbar's racial identity lent his dialect poetry. Like Frances Benjamin Johnston's concurrent publicity images commissioned by the school for the Paris Exposition of 1900 and Booker T. Washington's description of his formative years as a student at the school in his landmark autobiography of 1901, *Up from Slavery*, the Dunbar books represent a little-recognized major component of the school's prominence in the public eye during its heyday at the turn of the century. Each of these efforts testifies to the school's cagey and pioneering ability to shape a public image in the mass media to generate charitable income, balancing the concerns and agendas of several racial, regional, and politically disparate constituencies.

Dunbar also demonstrated a sustained commitment to supporting education at Hampton. Strengthened by his collaboration with the Camera Club, Dunbar maintained regular contact with members of the Hampton community. From 1899 until he neared his death in 1906, Dunbar published ten pieces of poetry and prose in the *Southern Workman*, including two illustrated by members of the Camera Club, "Fishin'" and "Possession."[12] The poet's wife, Alice Dunbar, a writer noted in her own right, contributed several stories to the magazine as well.[13] Dunbar's relationship to Hampton was further cemented when his mother traveled to the institute to vacation for the summer of 1899, evidently living at the school.[14] That summer, members of the Camera Club were in the process of collaborating with Dunbar on *Poems of Cabin and Field* and made Matilda Dunbar's acquaintance. In July 1901 Dunbar gave a recital on the Hampton campus and met those members of the Camera Club who lingered on campus during the

summer, only months after they had completed the illustrations for *Candle Lightin' Time*, the second book in the series.[15] Although some individual members may have met Dunbar previously, subsequently at fund-raisers, or both, this represented the only official face-to-face meeting between illustrators and author. Oddly and perhaps significantly, no image of Dunbar or his mother at Hampton has yet surfaced, and none of the Camera Club's members ever seemed to have photographed him. Neither appear in the photo-texts. Perhaps this is not surprising, however, given that throughout his life Dunbar had a tense relationship with the camera and disliked being photographed and giving out his portrait. He characteristically hemmed and hawed when women he courted sought his portrait, and he wrote apologetically to one love interest, "Apropos of your request for my picture—I have none. I have a most serious aversion to the camera—one which I cannot overcome sufficiently to have even a presentable likeness taken. I have had two sittings taken in my life and neither result looks anything like me."[16] Few portraits of the author show him soliciting the camera or meeting the viewer's gaze. Dunbar is stiff and uneasy in the majority of his portraits.

Dunbar's photo-texts served Hampton's interests and were initiated at the school, but Dunbar also participated in their production and had previously published his work with images. His first illustrated poem, "A Coquette Conquered," appeared in *Century* magazine in July 1896.[17] By the time the books appeared, photographic illustration of poetry was a well-established genre. James Whitcomb Riley, Dunbar's primary literary influence, a white poet who wrote intermittently in Indiana "Hoosier" diction and standardized English, published a similar edition in 1899, *Love Lyrics*, illustrated with photos by William B. Dyer, an art photographer of Alfred Steiglitz's circle. Many of Riley's published works appeared with illustration, and Dunbar would not have questioned the release of his own illustrated editions, given that his major professional role model had already set a precedent for him.

Prior to the publication of the photo-texts, Dunbar had demonstrated his interest in photography by authoring the poem, "The Photograph," first published in 1897 in Dodd, Mead, and Company's the *Bookman* magazine, which may have motivated the production of the illustrated books, in part.[18] The poem records the reaction of a vernacular narrator to seeing the image of a loved one and seems to be based upon Dunbar's courtship with Alice Moore, who would become his wife and whom he first "met" in a photograph.[19]

Written in 1897, the poem was published with a stock portrait of the author in June 1899 in the *Photographic Times*, prior to the release of the photography books, potentially another impetus for the Camera Club to illustrate his work photographically. Dunbar's take on photography was formulaic in this instance; it ranks among his most sentimental verse and depicts its African American narrator as a simple, technologically backward naif, as if viewing a photograph for the first time. The piece melds love, photographic fetishism, and black emotionalism, hardly the dignified description of African American characters that appear in most of his books. Dunbar recalls a man looking at a photograph of a woman; he is moved to tears and transported by her image:

See dis pictyah in my han'?
Dat's my gal;
Ain't she purty? goodness lan'!
Huh name Sal.
Dat's de very way she be—Kin' o' tickles me to see
Huh a-smilin' back at me.

She sont me dis photygraph
Jes' las' week;
An aldough hit made me laugh—My black cheek
Felt something a-runnin' queer;
Bless yo' soul, it was a tear
Jes' from wishin' she was here.

Often when I's all alone
Layin' here,
I git t'inkin' 'bout my own
Sallie dear;
How she say dat I's huh beau,
An' it tickles me to know
Dat de gal do love me so.

Some bright day I's goin' back,
Fo' de la!
An 'ez sho' 's my face is black,
Ax huh pa

Fu' de blessed little miss
Who's a smilin' out o' dis
Pictyah, lak she wanted a kiss![20]

Although the poem may have been a private reference to his wife, from whom he was often separated while on lecture tours, the work casts African Americans as particularly softhearted and lovable objects of sentimentality, an emotionalism seemingly performed for the reader. In itself it is an illustration of the manner in which photographs typically evinced black sentimentality, a media-borne convention the members of the Camera Club largely evaded. The photographer Leigh Richmond Miner depicts the narrator (fig. 22) in a far more candid and subtle manner (fig. 23) than did the poet, describing the contemplative profundity of an interaction with a photograph (fig. 24) and extending that sensitivity to an African American character. The model, an individual who looks as if he could walk through the door today, is seemingly a stand-in for Dunbar, a misconception the photographers may have welcomed, if not cultivated for the benefit of Hampton Institute. As was the case in "When Malindy Sings," Miner saw no contradiction between the man's thoroughly modern comportment and down-home diction, a nuanced vision presciently reconciling twentieth-century progress and the African American vernacular.

Although there is little archival evidence that establishes Dunbar's opinion of the photo-texts overall, circumstantial evidence indicates that at the very least he tacitly accepted them and likely enjoyed them.[21] Although Dunbar did not specifically initiate the production of the illustrated editions, photography was already among his subjects, suggesting his artistic interest in photographic illustration of his work. Remarking on illustrations made to accompany his works in periodicals, his correspondence indicates he appreciated "good" illustrations.[22] Finally, Dunbar grew to rely on the income the illustrated books generated in later years, working with difficulty because of his long, and ultimately fatal, struggle with tuberculosis. Toward the end of his short but remarkably productive life, the illustrated books dominated his published work, and the thousand dollars he received for each book helped cover his expenses as declining health prohibited public appearances.[23] Among their significances, the illustrated books helped Dunbar remain a professional writer when his contemporary Charles Chesnutt was unable to support himself by writing full time, finally adopting a career in law. Whether Dunbar explicitly approved of the manner in which the poems were illustrated remains unknown,[24] although the sheer number of books and the fact that they were illustrated by the same group indicates his pleasure with them. Dunbar died at thirty-three years old in 1906, publishing more than a dozen books of poetry, novels and short stories, and scores of essays and articles in a publishing career that lasted only thirteen years.

22–24. Leigh Richmond Miner, from "The Photograph," Paul Laurence Dunbar, *L'il Gal* (Dodd, Mead, and Co., 1904).

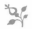

The Hampton Institute Camera Club was chartered in 1893 as the Kiquotan Kamera Klub and launched as an amateur leisure pastime in the fine-art pictorialist tradition, with an appropriately Germanic name and ostensibly facetious acronym. The thirty or so predominately white faculty members of the Hampton Camera Club began illustrating Dunbar's dialect poems as a means of providing a narrative structure to the many self-consciously artistic images some of the members had been making of the African American residents living near the school's grounds. Several nearby communities were established by African American squatters and contrabands during the American Civil War who settled the immediate area and who shortly after the war also provided the school with a great many students. Typical of the transatlantic camera club movement, illustrated verse provided discrete subject matter and an artistic mantle to be transferred to visual depictions. Subscribers to such photographic journals as *Camera Notes*, the *Photographic Times*, and *Camera Work*, the Hampton Camera Club sought to emulate the fine-art amateur pictorialism of the day and in turn demonstrate the artistic potential of photography by mimicking the formal appearance and subject matter of fine-art paintings.

Throughout the Dunbar books, the Camera Club executed images drawn directly from Dunbar's narrative, selecting phrases and images that lent themselves to visual representation. Almost weekly, judges selected the best images from among members' submissions in a group critique.[25] While many of the images present landscape scenes and depopulated interiors, the majority of the Camera Club's work for the Dunbar books was composed of portraits of African American subjects in domestic scenes, reminiscent of the quaint familiarity of painted rural genre scenes, although seemingly with more subtle allegories than those that genre paintings often evoked. Although much of the Camera Club's work was photographed in actual homes in surrounding communities, many of the club's images were set pieces staged among the homes and cottages on the Hampton campus, with costumed students and staff members standing in as characters embodying the personas mentioned in Dunbar's verse. More so than the many characters wearing the threadbare garb of quaint vernacular speakers, most of the younger characters dress neatly and in the style of the day. The Camera Club presents a population in transition, bridging the generation to have emerged from slavery and a generation of the near future, optimistically imagined ten years prior to the formation

of the NAACP in 1909, as civil and economic participants, bearing many of the social markers of middle-class status. Thus the images had a political intention, that of uplifting the race by positing African Americans as humble yet ordinary citizens capable—with the necessary intervention of technical and academic education—of bearing the rights and responsibilities of civic enfranchisement.

Following Dunbar's poetic narrative closely, the largely staged images describe African American domestic life situated about iconic cabins, photographed in a present but also evoking and simulating the iconography of the plantation tradition. Among a range of themes, a repetitive iconography emerges depicting scenes of wistful contemplation before hearths and individuals closely tethered to windows, doorways, and other thresholds. Like the traditions of genre painting and the cult of domesticity from which cabin iconography is derived, the Dunbar photo-texts subtly operate on an allegorical level. A parable employed extensively during the Jacksonian era to define the American "character," as Andrew Jackson touted his humble frontier cabin birth, Dunbar's repeated stress upon the cabin seems an effort, like Harriet Beecher Stowe's *Uncle Tom's Cabin*, to reveal the "character" or "heart" of the race through this symbolic device. The title of the book of poetry that established Dunbar's career, *Lyrics of Lowly Life* (1896), explicitly invoked Harriet Beecher Stowe's *Uncle Tom's Cabin*, subtitled *or, Life among the Lowly*. Dunbar specifically cast his work as a pendant to the famous work that established the cabin as the central locus and metaphor for African American vernacular culture and promised to reveal the essential "nature" of African American "character" within its precincts. The complexity and multiplicity of Dunbar and the Hampton Camera Club's photo-texts, however, subtly undermine any reduction of the characters depicted to an essential nature housed within the racial or architectural exterior. Ultimately the Dunbar photo-texts undermine the very practice of reading essential nature from exterior markers and question the notion of essential character altogether.

The photographs in the books were made, in part, as correctives to the ritualized abstractions of African American figures that predominated in the mass media of the time in magazines, literature, sheet music, theater, cinema, audio recordings, and advertising, as well as in popular illustrated books of African American dialect poetry by white authors. In his pref-

ace to *Lyrics of Lowly Life*, Dunbar's first nationally distributed volume of poetry, the editor and fellow Ohioan William Dean Howells prioritized the value of Dunbar's poems in African American dialect, employing the rhetoric of realism as a corrective to distortions of black language and intentions as rendered by white writers in the genre: "I do not know anyone else at present who could quite have written the dialect pieces. These are divinations and reports of what passes in the hearts and minds of a lowly people whose poetry had hitherto been inarticulately expressed in music, but now finds, for the first time in our tongue, literary interpretation of a very artistic completeness."[26] The Camera Club seems to have been similarly motivated to animate realistic visions of African American life and characters, perhaps with the encouragement of Dunbar, a friend and protégé of Frederick Douglass and his family in the 1890s. In the pages of the *Southern Workman*, members of the Hampton community repeatedly and specifically condemned caricatures by the cartoonist Edward Windsor Kemble, the illustrator of several books of Dunbar's short stories. An anonymous reviewer, likely a member of the Camera Club, commented in the magazine in 1900, regarding his work for Dunbar, "It is regretted that the illustrations have not received more sympathetic treatment at the hands of Mr. Kemble. . . . The sketches are caricatures and must seem unsatisfactory to both author and reader."[27] A subsequent review read, "It is possible that the illustrations, most of which are in Mr. Kemble's usual style of caricature, help to give the impression that the writer is out of sympathy with [its African American characters]."[28] A specialist in renderings of African American folk characters, Kemble had acquired a national reputation in 1884 as the illustrator of the first edition of Mark Twain's *Adventures of Huckleberry Finn*. A year prior to the publication of the first of the photographic books, in 1898, Kemble illustrated both Dunbar's *Folks from Dixie* and released a book of derisive and violent caricatures, *A Coon Alphabet*, likely executing images for the two works concurrently.[29] Kemble released several other books of verse and illustration during the years prior to the turn of the century, and before his contributions to Dunbar's works, some of which depict violence inflicted on children as a comic topic. His titles, *Kemble's Coons, Comical Coons, Coontown's 400, Kemble's Sketchbook, Kemble's Pickaninnies*, and *The Billy Goat* appear to have been intended as reading material marketed specifically to children. A reviewer of one of the Dunbar books in *Southern Workman* lauded the Camera Club's work as a corrective to Kemble's distortions, indicating that the photographers concertedly sought to use photography as a means of reforming representations of African Americans by contradicting and repudiating such con-

ventions: "Any effort to substitute scenes from life for the caricatures that are generally used in illustrating Negro dialect stories and poems is to be welcomed."[30] The Hampton photographs undermined not only malicious essentialisms of incapacity for self-restraint, lascivious criminality, and intellectual inferiority but evidently also latent essentialisms perpetuated by benevolent but patronizing portrayals of African Americans prostrating themselves as deferential objects of reformist pity and charity. This was a goal congruent with the emphasis upon autonomy, agency, and African American self-determination promoted both by Dunbar and at Hampton.

The members of the Camera Club were initiated in the intricacies of African American resistance to white authority and social dominance, and their approach to photography was informed by the Hampton Folklore Society's attention to the racial dynamics of documentary practices. Robert Russa Moton, one of two African American members of the Camera Club to contribute to the Dunbar books, had been a leading figure in the Hampton Folklore Society, as was the case with several members of the Camera Club.[31] Moton was the school's disciplinarian and commandant of cadets, and he was later Booker T. Washington's successor as principal of Tuskegee Institute, Hampton's offspring institution.[32] Moton contributed all the images for "A Hunting Song" in *Poems of Cabin and Field*, ostensibly depicting several African American men treeing a raccoon or opossum with dogs.

Collection of folklore among the Hampton workers was not merely a retrospective elegy or entertainment for a curious, sentimental public. Writing in the school's widely distributed magazine, the Folklore Society's founder, Alice Mabel Bacon, addressed this issue explicitly, asserting the society's commitment to rigorous documentation and realism:

> We hope that the readers of the *Workman* bear in mind as they look over the folklore department of this paper, that the work we are trying to do in it is not to afford popular or entertaining reading, nor is it to depict an ideal of any kind for the attainment or education of our pupils or graduates, but it is an effort to give with as absolute accuracy as we can secure, the stories, superstitions, sayings and songs of the illiterate Negroes, in the hope that we may all in this way learn a little more about their lives and ways of looking at things.[33]

Because of the complications presented by the racial divide, the Hampton Folklore Society's original call for study of African American folklore warily implied in 1895 that only black interviewers could accurately collect folklore from African American informants, a consideration many later folklorists failed to heed, including many of the writers working for

the federal government's Works Progress Administration in the 1930s: "It would be possible for any educated colored man or woman living in a community of less cultivated persons of his own race to collect a great deal of material along these lines which would be of great scientific value, not only to students of folklore, but to the future historians of the Negro race in America."[34] Bacon's hope for the significance of the work of African American collectors of folklore was ultimately fulfilled. The folklorists Elsie Clews Parsons, Alan Dundes, Mason Brewer, and Bruce Jackson used Hampton materials extensively in their work, as did Laurence Levine in *Black Culture and Black Consciousness* (1978), Newbell Niles Puckett in his monumental study *Folk Beliefs of the Southern Negro* (1926), and Donald J. Waters (1983) in his study and compilation of folklore material from Hampton's *Southern Workman*.[35]

The trickster figure, popularized by Joel Chandler Harris in the figure of Brer Rabbit and derived from African and African American animal tales, uses subterfuge, indirection, and ingenuity to overcome his disadvantage in power to succeed within a system controlled by mighty predators. In derivative tales depicting the manner in which an archetypal slave, John, hoodwinks his master, tricksterism is revealed as the primary tactic by which African Americans may resist the hegemony of white supremacy. John utilizes racist conceptions of black intellectual inferiority as camouflage, which he uses with strategic advantage to secure plum assignments and fringe benefits, but not without risk and sometimes with hazardous consequences. Although hardly liberatory, Dunbar's poem "We Wear the Mask," published in 1896, is an exposition of African American resistance to the White gaze, an evasive, counterhegemonic dissemblance and withholding performed for white onlookers, contesting the transparent, putatively essential, comic nature of African American character.

Dunbar's poem, however, hardly celebrates the comic or strategic aspects of the mask, emphasizing instead its tragic aspects. Dunbar's poem insists on the disjunction between projected external visual markers and reserved internal character, discrediting visuality as the means of perceiving inner truths, highlighting the disjunction between surface appearance and inner self, between seeing and knowing, emphasizing explicitly that viewers "only *see* us," dispelling the underlying logic of racial essentialism, as well as photographic realism. Dunbar's poem is a plea for recogni-

tion and acknowledgment of the invisible humanity obscured by the mask of racialized identity. The architectural symbolism of the Camera Club's images in the Dunbar photo-texts seems appropriate visual accompaniment to Dunbar's landmark poem.

While it dispelled the comic nature of African Americans, "We Wear the Mask" posited and reinforced sentimental archetypes of African American emotionalism and victimhood that underlay reformist representations of black characters even long before *Uncle Tom's Cabin*, images that the Camera Club seemingly also sought to dispel.

We wear the mask that grins and lies,
It hides our cheeks and shades our eyes, —
This debt we pay to human guile;
With torn and bleeding hearts we smile,
And mouth with myriad subtleties.

Why should the world be over-wise,
In counting all our tears and sighs?
Nay let them only see us, while
We wear the mask.

We smile, but O great Christ, our cries
To thee from tortured souls arise.
We sing, but oh the clay is vile
Beneath our feet and long the mile;
But let the world dream otherwise,
We wear the *mask*![36]

"We Wear the Mask" might promote a vision in which African American individuals seem restricted within a singular, assigned stock identity, souls tortured and contained *by* the mask assigned them. Here then the mask might serve as a conceptual predecessor to his friend W. E. B. Du Bois's later notions of racialized vision as a "veil" and "double consciousness," as one's own experience juxtaposed with the iconic vision society at large has prescribed for one's social group, an identity assigned and overlaid, coloring one's sense of self.[37]

Given Hampton's educational mission, as well as Dunbar's own racial politics and identity, it is therefore unlikely the photographers are suggesting that the characters are bound to the domestic sphere by their own inherent racial defects or limitations. One may interpret that the books' authors envisioned African Americans upon a threshold, incarcerated by social practice and perception, conventionally masked and assigned an essen-

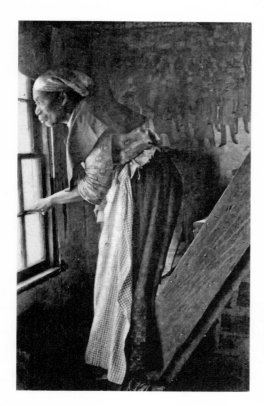

25. Leigh Richmond Miner, from "The Christmas Basket," Paul Laurence Dunbar, *Joggin' Erlong* (Dodd, Mead, and Co., 1906), 68.

tial identity. They are also "framed" by their domestic context, and rather than enjoying the strategic advantage afforded by obscurity, they articulate a second aspect of hidden watching, inhabiting spaces analogous to Plato's cave, experiencing secondhand (fig. 25). A corollary to Dunbar's own song of the caged bird, incarceration within identity was an allusion with which Miner and the Hampton photographers would also likely have been familiar, given public awareness of Dunbar's previous occupation as an elevator operator, caged in a downtown Dayton office building.[38]

The dual nature of domestic passages, as entries and exits, is exemplified by the Roman deity Janus, a figure with two faces who sees into the past and future. The god's name derived from the Latin word for doorway, *ianua*; he is the god of beginnings (and ends), recognized in the name of the first month of the year, a temporal threshold, and in the word *janitor*, one who maintains and guards doors. Janus's duality of character represents dialectic and interchange itself, a simultaneous existence in two worlds, and his image is installed over thresholds to guard the passage, an iconography shared with Saint Peter, guardian of heaven, and syncretically

with several African and diasporic societies, the pagan European counterpart to the Yoruban trickster spirit Esu and his New World derivations, Legba and Elegua. Janus's two-faced nature is figurative as well as literal; he is endowed with double consciousness and a penchant for dissemblance, misleading viewers with misrepresentations of his internal state, hence the iconic Janus symbolizes the concurrent mirth and tragedy, freedom and constraint of theatrical role-playing. Subjects at thresholds are both sheltered from surveillance and self-limiting and self-referential, expressive and worldly, but exposed to others' scrutiny and preconceptions and simultaneously claustrophobic and agoraphobic, deep and superficial.[39]

One observes in the Camera Club's photographs that while thresholds are passages from exterior to interior, they are also passages from interior to exterior, and subjects often face outward. The threshold potentially represents a thwarted escape, from incarceration and slavery into freedom and citizenship, from ignorance and superstition to civilization, from the shadows into the open, from the past to the future. Given the subjects' seeming confinement, the threshold figure is an unlikely parable for the Hampton mission or an allegory for the turn of the century itself, the passage from the nineteenth to the twentieth century, as Booker T. Washington would have it in a volume of photographic portraits of illustrious African Americans titled *A New Negro for a New Century*.[40] By regularly anchoring African Americans within the threshold and in the context of the domestic cabin, Dunbar and the Camera Club seem to suggest the proscriptions against African Americans fully joining society, passing into the public sphere. Established in Dunbar's text and visualized by the Hampton photographers, one might then interpret the prevalence of thresholds in text and images as expressions of political desire and resistance, pointing out the irony of African American freedom and the continuing injustice of disfranchisement and half-citizenship, as the nation stood upon the doorstep of the twentieth century. If Reconstruction brought African Americans out of slavery into civilization and citizenship in the public sphere, the post-Reconstruction years relegated them to liminal status, neither slaves nor citizens.[41]

Dunbar's "We Wear the Mask" appealed to white viewers by simulating a shared confidence with the reader, luring them through their desire for solidarity, sympathy, and awareness of the reality of black life in America,

an imagined bond with the black subject, a status relished by the white viewer that he or she is an insider initiated in the rituals of authentic blackness. The poem also recalls the subject's response to a specific photographic practice: reformist social documentary photography, which typically casts its subjects figuratively as sentimental objects of pity, a genre that depicts the needy and unfortunate to elicit paternalistic, quasi-missionary remediation, social activism, and charitable contribution. Such sentimental subjects provoke a viewer's sorrowful temporary glance downward, confirming that they are allied with righteousness, met by the subject's appreciative glance, figuratively upward as if in helpless pleading for divine intervention, legitimating incursions into the private spaces of social subalterns.

Dunbar's presentation of the mask clarifies and asserts the photographic subject's complicity in creating the image, especially so in the case of African American subjects. Like the sitter for a formal portrait, the subjects of the images in the Hampton photographs are willing collaborators in the final outcome and meaning of the image. In the photographs in which we as viewers are most accustomed to participating, a subject's influence over the outcome of an image often supercedes a photographer's input and control over the meaning of the image. A portrait photographer exerts control over the technical variables of framing, exposure, lens type, shutter speed, the selection of props and background, and the exact instant in which to trip the shutter. However, as the ultimate producer of the image, the subject of the photo controls powerful subtleties of meaning in facial expression, dress, and final image selection—editing both the image itself and selecting the photographer and context in which the image appears. Based upon their control of gesture and expression, sitters exude practiced mirth, cultivated respectability or sympathetic charm, coy sexuality, or ironic satire of the conventions of the medium itself, as in mugging for the camera. In her vernacular practices, in studio photographs or family snapshots, the photographer functions only as camera operator, and/or as set designer, while the subject of the image asserts the prerogatives of director and producer, wardrobe designer, and picture editor. In any case, the many powerful forces at work in the meaning or impact of a photograph often seem beyond a photographer's intent or influence, and the power of meaning resides instead in a subject or photographer's desire to conform to or modify social and or pictorial conventions. Given Dunbar's editorial prerogative, scripting of the photographic scenarios, and the photographers' initiation into the nuances of black vernacular culture, we might consider the photographs to be more rhetorically black than the vast ma-

jority of images of African Americans made at the time. If we apply Dunbar's mask poem to refer to photography, it asserts that subjects largely represent themselves, contradicting Dunbar's assessment of the medium's transparency in his earlier poem, "The Photograph": "Dat's de very way she be—."

Subjects occupying thresholds telegraph subtle resistance to the photographers' acquisition of their image, adopting a conditioned, reflexive response to white parody and voyeurism. The photographic exchanges at the threshold are wary visual articulations of Dunbar's "We Wear the Mask," his exposition of coded African American self-expression as a means of articulating subjecthood and resisting the scrutinizing and regulating gaze of racial determinism.[42] Dunbar's figure of the mask suffuses the phototexts in their architectural iconography, of interior and exterior and in the manifold thresholds that mark the boundaries. The dynamic spatial negotiations represented by the photographic encounter in Dunbar's books, the conflict between white desire for entry and African American resistance, manifests itself in both the literal making of the photograph and in an architectural subtext, recalling the push and pull of the exposé, a missionary impulse to access the interior of the African American mask, home, and psyche, to probe beneath the public façade of the structure into the private sphere to mitigate unhealthy or antisocial tendencies. Some of the work for the Dunbar books seems to whet the desire of the white audience to access traditions, identities, and private spaces that they knew were obscured from them, potentially a manifestation of the Progressive desire to regulate, "uplift," and civilize pitiable objects, employing the rationale of domestic sentimentality, a parental license for incursions into the domestic space of others, figured as children. African American subjects occupy doorways and other thresholds defensively in part, displaying a reticence to be photographed, pulling back from the photographers and viewers who push forward to get their image. Thresholds, however, also exist as organic sites of interaction between photographer and subject. Although Dunbar's text established the scene in many cases, the prevalence of the device seems largely determined by the requirements of available light for photography and the Southern climate prior to air conditioning, encouraging the use of the front yard and stoop as an exterior parlor; the lack of a proper parlor a marker of region and class as much as race.

Staged and constructed deliberately to follow Dunbar's imaginative texts closely, the Hampton photos, however, are patently not documentary images, although they had a reformist intent in part, as correctives to media-borne images essentializing African American racial character. To

advance their social agenda, the Hampton photographers simulated documentary practice, promising a candid vision of a racialized interior obscured from public view, granting readers access within the mask of racialized difference, a rhetorically "truthful" exposé of the features of black life and African American "character." The images thus stage an exposé of African American interiors for public consumption, yet they deliver no interior truth of African American character, despite their promise of an insider's access into African American life. Although they appropriated Stowe's iconography, the bondage from which they delivered the inhabitants of cabins and masks was that of racial essentialism.

The figure underlying the Hampton images, "We Wear the Mask" also suggests the subject's agency to represent his- or herself, performing identity, and voluntarily permitting or denying access to the interior self. Although images and text repeat stock figures, several of the Camera Club's subjects demonstrate resistance and defiance through the course of the books, appearing resentful of the imposition of the camera, seemingly cynical with the condescending sentimentality and voyeurism they expected from white interlopers, and calling attention to the camera and photographers' presence in the scene and eroding the theatrical and cinematic "fourth wall."

Although figure 26 accompanied Dunbar's comic narrative of a woman's displeasure with her man's overdue arrival from the saloon, the actual person in the image appears authentically protective of the child and skeptical of the prospect of being photographed. Despite its associated text, the image demonstrates an unpicturesque reality, hardly a sentimental vision, and the woman's seeming resistance to conforming to a predictable racial narrative. In figure 27, a woman projects self-possession with a note of bemused cynicism, complicating oversimplification of her character and psyche, invisible to the camera's lens. Frequently the images provide exactly this manner of counternarrative, elaborating upon and diverting readers from Dunbar's lyric and not quite conforming to the textual narrative.

Intentionally or otherwise, the images demonstrate a great deal more subtlety and vitality than the overwhelming majority of stock images of rural African American "humor and pathos" of the era, as James Weldon Johnson later articulated it, a testament to the intractable, "wild" nature of the photographic image, especially when employed, often somewhat tentatively, by amateur practitioners.[43] Note for instance, the cat peering out from under the house in the lower left-hand corner of the photograph of the woman in the doorway in figure 28. Roland Barthes asserts this kind of unpredictable element as the governing character of the photo-

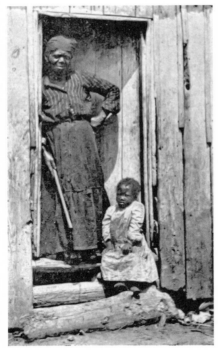
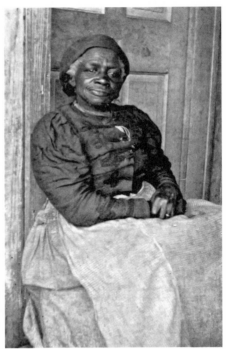

26. Leigh Richmond Miner, from "De Way T'ings Come," Paul Laurence Dunbar, *Howdy Honey, Howdy* (Dodd, Mead, and Co., 1905), n.p.

27. Leigh Richmond Miner, from "The Old Cabin," Paul Laurence Dunbar, *Howdy Honey, Howdy* (Dodd, Mead, and Co., 1905), n.p.

graphic image, its elusive resistance to reductive representation by virtue of its surfeit of uncontrollable details, "messages without a code," "wild," third-order subjective signifiers without fixed meaning.[44] We might see these lapses as holes in the mask, thresholds through which an underlying reality of the past or the Other can be discerned from the present and that clarifies the process of image making, identifying photographers' additions and omissions and their ideological framework and cultural point of view.

"We Wear the Mask" projects agency on the part of wearers of the "mask," a singular identity performed for "those who only see us," and hardly liberatory in the manner that Dunbar presents the practice. As numerous critics have figured it, African Americans utilize the dissembling

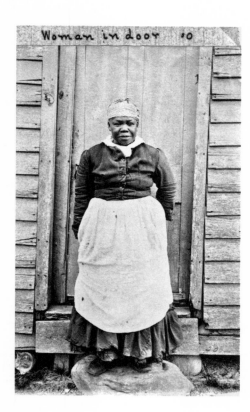

Woman in door #0

28. Unidentified Camera
Club Photographer, *Woman in
Door*, cyanotype mounted in
Camera Club Album, Camera
Club Collection.

Courtesy of Hampton University
Archives.

mask to reserve a space of agency, privacy, and occlusion within an ex-
pressionistic, self-validating work, an assertion of subjecthood, even when
subjected to the surveying gaze of racial outsiders. Masked African Ameri-
can self-expression asserts sentience and through indirection and coded
signifiers to insiders maintains autonomy rather than pandering to the sen-
timental taste for spectacles of black abjection or buffoonery.[45] What Dun-
bar's mask poem accomplishes, it seems, is in informing outsiders they are
witnessing a diversion, and they have only limited access to the reality
within the psychic or cultural interior. The photo-texts, however, dem-
onstrate that masking and photography offered the possibility of escape
and psychic mobility still largely out of reach for individuals such as Dun-
bar, trapped within essentialisms and sentimentalities dictated by external
traits such as race and habits of perception but offering an expression of
individuality governed by more nuanced expressions of identity. Given
Dunbar's multiple poetic homages to James Whitcomb Riley, whose "We
Are Not Always Glad When We Smile" does not make specific mention of

any mask, Dunbar's poem is not merely a statement of generic social dissemblance. Undoubtedly because of Dunbar's suggestion of "guile" and "mouthed subtleties," scholars have overwhelmingly interpreted Dunbar's poem categorically as a parable of African American agency and indirection rather than incarceration within an identity assigned them by others.[46]

The photo-texts most profoundly alter the reading of Dunbar's mask poem by introducing the liberatory possibilities of masking and role-playing. Paul Laurence Dunbar's image of the mask as a performed identity had another important precedent, one that specifically linked the figure to the practice of photography. Walt Whitman's "Out from Behind this Mask" is a meditation on the interrelation of photography and identity. The poem first appeared in Whitman's *Two Rivulets* (1876), and Whitman published it with slight modification in subsequent editions of *Leaves of Grass* from the 1880s onward. Erudite and exceedingly self-conscious of his predecessors, Dunbar would likely have read one or both of these volumes.[47] Undermining the nineteenth century's notion of morality suffusing a fixed, singular "character," Whitman outlined an important conceptual precedent to the notion of the composite and mutable nature of identity. Whitman's "Out from Behind the Mask" reads,

1

OUT from behind this bending, rough-cut Mask,
(All straighter, liker Masks rejected—this preferr'd,)
This common curtain of the face, contain'd in me for me, in you for
 you, in each for each,

(Tragedies, sorrows, laughter, tears—O heaven!
The passionate, teeming plays this curtain hid!)
This glaze of God's serenest, purest sky,
This film of Satan's seething pit,
This heart's geography's map—this limitless small continent—this
 soundless sea;
Out from the convolutions of this globe,
This subtler astronomic orb than sun or moon—than Jupiter, Venus,
 Mars;
This condensation of the Universe—(nay, here the only Universe,
 Here the IDEA—all in this mystic handful wrapt;)
These burin'd eyes, flashing to you, to pass to future time,
To launch and spin through space revolving, sideling—from these to
 emanate,
To You, whoe'er you are—a Look.

A Traveler of thoughts and years—of peace and war,
Of youth long sped, and middle age declining,
(As the first volume of a tale perused and laid away, and this the
 second,
Songs, ventures, speculations, presently to close,)
Lingering a moment, here and now, to You I opposite turn, As on the
 road, or at some crevice door, by chance, or open'd window,
Pausing, inclining, baring my head, You specially I greet, To draw and
 clench your Soul, for once, inseparably with mine,
Then travel, travel on.[48]

"Out from Behind the Mask" reasserts the photograph's transcendental and fetishistic capacity to convey the spirit for posterity through time and space, his "flashing" eyes meeting and directly addressing those of the viewer, evidently without mediation of the photographer, the image a "crevice door" or "open'd window," a threshold separating subject and viewer. Like Dunbar, Whitman categorically demonstrates the subject's authorship of the photograph, projecting a performed and mutable identity. Whitman's poem also complicates this visible reality, asserting that photographs capture only a consciously constructed evident façade that conceals an elusive and complex composite individual identity within. Whitman's model of the psyche seems a presciently modern composite of contradictory and fragmentary impulses, both "seething" and "serene," godly and satanic, the image simplifying the self as a sign for public consumption. Unlike Dunbar's mask, however, Whitman speaks of identity unbound, the orb of the head a universe unto itself, of limitless identities to be performed, of the infinitely complex and multivalent nature of the human psyche. Unattributed by scholars previously, Whitman's antecedent to Dunbar's poem strengthens the relevance of photography to "We Wear the Mask." Whitman's poem invokes the performative and self-validating nature of the subject of the portrait photograph explicitly and demonstrates the liberatory possibilities of performed identity only implicit in Dunbar's poem but that scholars have overwhelmingly read there, using "masking" as a shorthand for trickerism.

Read in the context of photography, Dunbar's "We Wear the Mask" reminds us that portraits are sites that complicate, rather than reveal, inner character read from external features; the process of photography encourages theatrical dissemblance, a site in which one broadcasts a self-willed identity outward, an identity often cultivated privately, much as a perfor-

mance of identity rehearsed before a mirror. It is the complexity of the face and photography's capacity to render the nuances of expression and multiple, serial visions of the individual subject in time that gives it its capacity to convey the human aura, to assert subjecthood and autonomy, to see the medium and through it into the complexity of the original context. This then must be the standard for photographing an other: an image the viewer can imagine as an image projected outward rather than captured; a representation of the self with which subjects might plausibly have chosen to portray themselves. Would a subject choose this identity, would one have hung this image over his or her own mantel?[49]

Like his mentor, Frederick Douglass, Dunbar belongs to the canon of writers on photography for his extensive use of photography in his publications, for his poetry explicitly about photography, and for his perception of the camera's nature as a threshold, a point of contact and opening in the mask, as a means of self-invention, and affirming one's identity to one's self. In addition, the content of the photographs accompanying the text suggests Dunbar's use of architecture as a metaphor for identity and as an allegory of political desire and self-invention, subtle insights into the work that are not immediately obvious from a purely textual rendering.[50]

While tempting readers with a potentially sensational depiction, the Camera Club photographers explicitly instilled a new representational standard to the American public, undermining any singular, essential vision of racial "character" but publishing hundreds of visions of individual *characters* endowed with agency, autonomy, and self-determination, a complicated multiplicity of identities rather than a low-resolution racial archetype, building upon the content of Dunbar's "We Wear the Mask." Like Dunbar's poem, the images are staged poses (fig. 29) that reserve an interiority for their sitters (fig. 30), while they demonstrate the mutability of identity (fig. 31).

Dunbar's photographic illustrators, effectively but likely unintentionally, further articulated the self-fashioning and serial nature of photographic portraiture by using models repeatedly, such as "Uncle Step," who appears in figures 30 and 31 here and throughout the photo-texts' run over the seven years they were published.[51] Several other individuals appear throughout the books, demonstrating the photographers' continuity with their subjects and the subjects' willing participation in the fashioning of

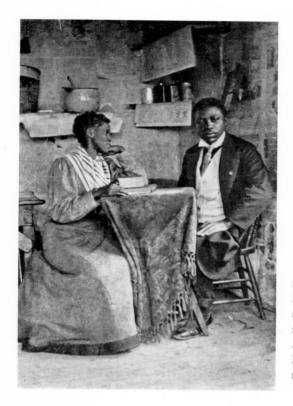

29. Leigh Richmond
Miner, from "Encour-
agement," Paul Lau-
rence Dunbar, *Howdy
Honey, Howdy* (Dodd,
Mead, and Co., 1905),
n.p.

their images. Multiple images of specific individuals often undercut Dun-
bar's narratives, giving sitters a complexity in time, space, and identity that
single photographs rarely provide, a counternarrative and subtext through-
out the books that makes the images excellent documentary vehicles, re-
vealing their constructed nature and the complexity of individual person-
alities, factors entirely outside the scope of Dunbar's text.

A great percentage of these people, given the context of "We Wear the
Mask," have represented themselves, exposing but one or more of their
manifold, fragmentary, or potential selves, in whatever mood they happen
to be in, and many fill in repeatedly in various character roles, on seemingly
friendly terms with cameras and photographers over a long period of time.
Even in the most theatrical, staged images, few of these actors perform per-
sonas seamlessly, except in rare cases, and if so, they perform for the camera
with a tendency to overact. The books do present visions of bodies used
up and spirits tested and of sporadic, recognizable expressions of resistance,
depression, and cynicism, but the picture we get of the aftermath of slavery
and Reconstruction is of meditation and self-determination rather than

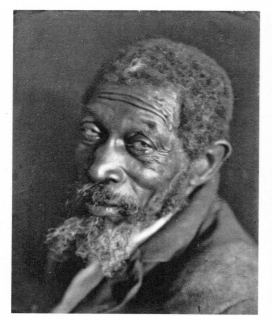

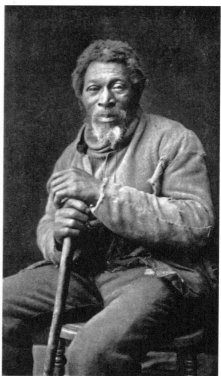

**30. Leigh Richmond Miner, Uncle Step, frontispiece, "A Cabin Tale,"
Paul Laurence Dunbar, *Joggin' Erlong* (Dodd, Mead, and Co., 1905), 94.**

From an original print in the Sarah S. Heath Collection.

**31. Leigh Richmond Miner, Uncle Step, from "Noddin' By the Fire,"
Paul Laurence Dunbar, *When Malindy Sings* (Dodd, Mead, and Co., 1905),
84, and cover, *Joggin' Erlong*.**

the subservient effusion and passive victimization of documentary practice
that often reinscribes the hierarchies of race and class.

As portrayed in the photo-texts, the "character" of the race turns out
to be a composite of individual characters, a limited, optimistic portrait of
black life at the turn of the century to be sure. As a compendium of rural
black life at the turn of the century, the books have a great many omis-
sions: of brutal truths and thwarted human potential, of lynchings and in-
numerable civil injustices, a totalizing hegemony to which Americans of
all stripes, including many African Americans, tacitly acquiesced, and that a

vanguard of agitators and leaders of the time resisted bravely and ably, both overtly and subversively. Despite these lapses, and perhaps because of them too, the books were popular among black audiences. They presented a fair likeness of rural black life at the time and a corrective to the dominant, sentimental vision of black abjection. The vision in the Dunbar books was a vision of black life that had been neglected and purposefully underrepresented: it portrayed African Americans visible as individuals, conducting everyday life in the present rather than pictorially recreating the conditions of slavery, and for once not as iconic, undifferentiated representatives of an entire people. The photographs were directed by Dunbar's text and the visions of predominantly white image makers who seemed to have sporadically forgotten they were depicting African Americans, who saw and represented people (and allowed people to represent themselves) in their manifold expressions of individuality.

The photographic vision of the Dunbar books suggests a vision that looked beyond race as an essential signifier, a vision sounded expressively in an African American voice, a desperate, coded attempt to influence an alternative future, a vision of race as ethnicity rather than a totalizing identity, a self-validating vision, even if just readable by an audience of insiders.[52] In the manner they depict the mutability of identity, the manner in which photographic subjects could theatrically adopt and shed personas, the Dunbar photo-texts presented a vision in which one's African Americanness could be merely a part of one's identity. This change indicates an early phase of modern identity, in which individual selfhood was conceived as a composite of factors and a matter of selection and self-invention rather than being bound and determined by race and inheritance, familial background, region, and birthplace. Rather than fixing identity, the Dunbar photo-texts demonstrated individual motion, reinvention, and possibility, motivations shared by the millions who migrated northward and cityward to reinvent themselves and begin to ignore the limitations of race that had been taught them previously. Above all, the Dunbar books seemed to have loosened the fixity of identity that blackness implied, and they position Dunbar as a twentieth-century modernist author, highly attuned to the performance of racial identities.[53]

Notes

1. The photo-texts were all published by Dodd, Mead, and Company: *Poems of Cabin and Field* (1899), *Candle Lightin' Time* (1901), *When Malindy Sings* (1903), *L'il Gal* (1904), *Howdy, Honey, Howdy* (1905), *and Joggin' Erlong* (1906). The series certainly

vies with the number of published images produced by the much higher-profile Farm Security Administration for this distinction. The first three books were illustrated collectively by the Hampton Camera Club, the last three individually by Leigh Richmond Miner, who emerged as the lead photographer of the books.

2. An illustration in a prototype mockup of *Poems of Camera and Field* in the Hampton University Archives reads, "Mr. Dunbar says *no* to first print." I have reproduced the image and recount the process by which the Camera Club worked with the poet in my article in the *African American Review*, "Picturing Dunbar's Lyrics" 41, no. 2 (Summer 2007): 331–32.

3. James Weldon Johnson, "Preface," *The Book of Negro Poetry, Chosen and Edited with an Essay on the Negro's Creative Genius* (New York: Harcourt, Brace, 1922), xl.

4. Paul Laurence Dunbar, "The Poet," *Lyrics of Love and Laughter* (New York: Dodd, Mead, and Company, 1903), republished in Joanne Braxton, ed., *The Collected Poetry of Paul Laurence Dunbar* (Charlottesville: University Press of Virginia, 1993), 191.

5. Houston Baker, *Turning South Again: Re-thinking Modernism / Re-thinking Booker T.* (Durham: Duke University Press, 2001), 69. Baker in turn cites Ralph Ellison's phrase and allusion, which originates in a depiction of stereotypical rural Southern squalor in *Invisible Man*, an episode in which the narrator carelessly guides the white patron of a Southern industrial institute off the straight-and-narrow path into contact with the abject poverty adjoining the school. The narrator is humiliated verbally for carelessly revealing too much detail by the school's principal, likely modeled on Robert Russa Moton, the principal of Tuskegee at the time Ellison attended the school. Prior to arriving at Tuskegee after the death of Booker T. Washington in 1915, Moton had been a prominent member of the Hampton Folklore Society and Camera Club and a key African American contributor to the Dunbar photo-texts.

6. While professional ethnography was hardly free from racist ideology, several members of the Camera Club corresponded regularly with Franz Boas, suggesting their introduction to the notion of cultural relativism. Boas was a contributor to Hampton's *Southern Workman* magazine and enrolled one of its Indian graduates, William Jones, in graduate school at Columbia University and as his assistant at the American Museum of Natural History. As an indigenous ethnographer, Jones represents the pattern for Boas's later students, Ella DeLoria and Zora Neale Hurston. The white Camera Club member Caroline Andrus was engaged to Jones at the time of his murder by Ilongot Philippino natives in 1909. This model of insider collection of ethnographic data was ultimately a Hampton innovation, an influence on the development of the technique of participant observation.

7. Dunbar's poem was patterned after a work by the Indiana poet James Whitcomb Riley, a generic statement of social dissemblance, "We Are Not Always Glad When We Smile." Among the most popular poets in the United States and a leading practitioner of local dialect poetry, the first of Riley's three stanzas reads, "We are not always glad when we smile: /Though we wear a fair face and are gay, / And the world we deceive / May not ever believe / We could laugh in a happier way.— / Yet, down in the deeps of the soul, / Ofttimes, with our faces aglow, /

There's an ache and a moan / That we know of alone, / And as only the hopeless may know" (*Riley's Complete Works, Volume 1* [New York: Harper Brothers, 1916], 238). According to an early biographer, Riley's "Not Always Glad" was composed in 1877; see Marcus Dickey, *The Youth of James Whitcomb Riley* (Indianapolis: Bobbs-Merrill, 1919), 403–4; see also Nadia Nurhussein, "Paul Laurence Dunbar's Performances and The Epistolary Dialect Poem," *African American Review* 41, no. 2 (Summer 2007): 233. Dunbar's "We Wear the Mask," however, might equally respond to Walt Whitman's poem "Out From Behind the Mask," a statement of self-determination and limitless invention of identity, explicitly citing the theatrics of photographic posing.

8. Complicated by my reading of the photo-texts, the notion of photographic "objectification" held sway for nearly a generation, largely inaugurated by Susan Sontag's groundbreaking collection *On Photography* (New York: Noonday Press, 1977). Responding to years of naive celebration of the reformism of the photographic exposé, Sontag sought to rhetorically skewer uncritical acceptance of photography's benevolence, highlighting its implicit aggression and powerful naturalization of cultural prejudices.

9. Dunbar, *When Malindy Sings* (New York: Dodd, Mead, and Company, 1903), 9–14.

10. Lida Keck Wiggins, *The Life and Works of Paul Laurence Dunbar* (Napierville: J. L. Nichols and Co., 1907), n.p., illustration insert.

11. Dunbar's most influential interpreter, Joanne Braxton, for instance, highlights the poem as such in her introduction to the definitive (unillustrated) collection of Dunbar's verse. See Joanne Braxton, "Introduction," *The Collected Poetry of Paul Laurence Dunbar* (Charlottesville: University Press of Virginia, 1993), xxvi–xxvii.

12. Paul Laurence Dunbar, "Fishin,'" *Southern Workman*, January 1901, 761; "Possession," *Southern Workman*, 1899, 468.

13. Born Alice Ruth Moore, she became Alice Moore Dunbar and after remarrying, Alice Moore Dunbar-Nelson. Both Dunbar, his wife, and several intimates in his circle appear on a mailing list of regular outside contributors to the *Southern Workman*. H. B. Frissell, "Letters to *Southern Workman* Contributors," January 18, 1899, H. B. Frissell Letterbook, p. 700, Hampton University Archives.

14. Paul Laurence Dunbar to Matilda Dunbar, June 22, 1899–August 9, 1899, Paul Laurence Dunbar Papers, Microfilm edition (Columbus: Ohio Historical Society, 1972), roll 2, frames 91–106.

15. Paul Laurence Dunbar obituary, *Southern Workman*, March 1906, 137.

16. Paul Laurence Dunbar to Rebekah Baldwin, n.d., Paul Laurence Dunbar Papers, Microfilm edition (Columbus: Ohio Historical Society, 1972), roll 1, frame 137. See also Baldwin to Paul Laurence Dunbar, August 17, 1895, frame 273; and Alice Ruth Moore to Paul Laurence Dunbar, April 28, 1896, roll 1, frame 300.

17. Nancy McGhee, "Portraits in Black: Illustrated Poems of Paul Laurence Dunbar," in *Stony the Road; Chapters in the History of Hampton Institute*, ed. Keith L. Schall (Charlottesville: University of Virginia Press, 1977), 77.

18. E. W. Metcalf, *Paul Laurence Dunbar: A Bibliography* (Metuchen: Scarecrow

Press, 1975), 34. The poem was also published in the *Photographic Times*, June 1899, 286; and in *Lyrics of the Hearthside* before the appearance of the first illustrated volume.

19. Details of the unhappy relationship between Dunbar and his wife are most thoroughly recorded in Eleanor Alexander's somewhat speculative *Lyrics of Sunshine and Shadow: The Tragic Courtship and Marriage of Paul Laurence Dunbar and Alice Ruth Moore* (New York: New York University Press, 2001).

20. Paul Laurence Dunbar, *L'il Gal* (New York: Dodd, Mead, and Company, 1904), 109–13.

21. Dunbar made few direct statements concerning the content of the illustrations in his books. More accurately, little remains *readable*, at least by me. Much of Dunbar's later letters, written as he was weakened by tuberculosis, including some addressed directly to the Camera Club and his editors while the books were in production, were dictated to a secretary who recorded them in Pitman shorthand, an archaic British form. Despite my earnest efforts, I have been unable to decipher the cryptic letters. George Bernard Shaw scholars may find another scholarly application for literacy in Pitman shorthand. Stenographer's Notebooks, Paul Laurence Dunbar Papers, Microfilm edition (Columbus: Ohio Historical Society, 1972).

22. Paul Laurence Dunbar to Alice Dunbar, April 8, 1901, published in Jay Martin and Gossie H. Hudson, ed., *The Paul Laurence Dunbar Reader: A Selection of the Best of Paul Laurence Dunbar's Poetry and Prose, Including Writings Never Before Available in Book Form* (New York: Dodd, Mead, and Company, 1975), 455. In one instance, Dunbar did propose a photographically illustrated children's book, which was never realized. He had initiated the project and had gone as far as writing Theodore Roosevelt for permission to publish a poem, "Boy Time," which he had privately written at the behest of the president's son, Kermit. Paul Laurence Dunbar to Edward H. Dodd, undated, from Stenographer's Notebook, Paul Laurence Dunbar Papers, Microfilm edition (Columbus: Ohio Historical Society, 1972), reel 1, frames 729 and 733.

23. Edward H. Dodd, Dodd, Mead, and Company to Paul Laurence Dunbar, April 20, 1903, Paul Laurence Dunbar Papers, Microfilm edition (Columbus: Ohio Historical Society, 1972), reel 1, frame 466.

24. The only extant copies of much of Dunbar's correspondence are in a letter book at the Ohio Historical Society. As noted above, Dunbar's later correspondence, including much with his publishers, was recorded by a stenographer in Pitman shorthand that scholars have yet been unable to decipher, myself included.

25. Camera Club Minutes Book, Camera Club Collection, Hampton University Archives.

26. William Dean Howells, "Introduction," in Dunbar, *Lyrics of Lowly Life* (1896, rpt: New York: Citadel, 1984), xix.

27. "Book Review: *The Strength of Gideon and Other Stories*," *Southern Workman*, 1900, 487.

28. "Book Review: *The Heart of Happy Hollow*," *Southern Workman*, December 1904, 693.

29. Beverly R. David and Ray Sapirstein, "Reading the Illustrations in *Adventures*

of Huckleberry Finn," in *The Oxford Mark Twain: Adventures of Huckleberry Finn* (New York: Oxford University Press, 1996), 29.

30. "Book Review: When Malindy Sings," *Southern Workman,* December 1903, 631.

31. Donald J. Waters, *Strange Ways and Sweet Dreams: Afro-American Folklore from the Hampton Institute* (Boston: G. K. Hall and Co., 1983), 37.

32. Images in a prototype mock-up of *Poems of Cabin and Field,* housed in the Hampton University Archives, were initialed, identifying makers of individual images in many cases.

33. Alice M. Bacon, "Editorial—Folklore Department," *Southern Workman,* June 1899, 201. Republished in Waters, *Strange Ways and Sweet Dreams,* 338.

34. Alice M. Bacon, "Folklore and Ethnology," *Southern Workman,* September 1895, 154.

35. Waters, *Strange Ways and Sweet Dreams,* 338.

36. Paul Laurence Dunbar, "We Wear the Mask," *Lyrics of Lowly Life* (New York: Dodd, Mead, and Company, 1896), republished in Braxton, *The Collected Poetry of Paul Laurence Dunbar.*

37. David Levering Lewis, *W.E.B. Du Bois, Biography of a Race* (New York: Henry Holt and Company, 1993), 175–76.

38. Dunbar's poem "Sympathy" begins with the line, "I Know Why the Caged Bird Sings," largely made famous as the title of the autobiography of Maya Angelou. "Sympathy" was never rendered by the Camera Club.

39. Jane F. Gardner, *Roman Myths* (Austin: British Museum / University of Texas Press, 1993), 10, 20, 32, 52.

40. Booker T. Washington, *A New Negro for a New Century* (Chicago: American Publishing House, n.d. [ca. 1899]). Several critics interpret the threshold in such a manner in Gertrude Kasebier's *Blessed Art Thou Among Women,* also an image made circa 1900. The girl, dressed in street clothes, emerges; the mother, in a dressing gown remains bound to the interior of the domestic space. See Barbara L. Michaels, *Gertrude Kasebier: Photographer and Her Photographs* (New York: Harry Abrams, 1992). See also Mary Ann Tighe, "Gertrude Kasebier, Lost and Found," *Art in America,* March 1977, 96.

41. This is the standard reading of the final scene of *Adventures of Huckleberry Finn,* Twain's allegory of the post-Reconstruction South, in which Tom Sawyer incarcerates Jim in a cabin gratuitously, despite his having been freed previously, although unbeknownst to the slave himself.

42. Fred Moten's study, *In the Break: The Aesthetics of the Black Radical Tradition* (Minneapolis: University of Minnesota Press, 2003), articulates the African American domestic and psychic interior as a womblike space, a refuge from white racialist surveillance and expectations. His model is seemingly derived indirectly from Dunbar via Ralph Ellison's underground *Invisible Man* and Richard Wright's *Native Son.* At some level, each of these writers refer to the specificities of blackness and to the larger dialectic between individual and society at large, adapting models from such literary precedents as Dostoevsky's *Notes from the Underground* and Henry Roth's *Call It Sleep.*

43. James Weldon Johnson, "Preface," *The Book of Negro Poetry*, xl.

44. Roland Barthes, "The Photographic Message" and "The Third Meaning," in *Image Music Text*, trans. Stephen Heath (New York: Noonday Press, 1977); this idea is developed further in *Camera Lucida: Reflections on Photography* (New York: Hill and Wang, 1981).

45. Fred Moten, *In the Break*, 26–31 and passim.

46. See Henry Louis Gates Jr., "Dis and Dat: Dialect and the Descent," in *Figures in Black: Words, Signs, and the "Racial" Self* (New York: Oxford University Press, 1987); Charles T. Davis, "Paul Laurence Dunbar," in *Black Is the Color of the Cosmos: Essays on African American Literature and Culture, 1942-1981*, ed. Henry Louis Gates Jr. (New York: Garland Publishing, 1982); Eric Sundquist, *To Wake the Nations: Race in the Making of American Literature* (Cambridge: Harvard University Press, 1993), 274; Gavin Jones, *Strange Talk: The Politics of Dialect Literature in Gilded Age America* (Berkeley: University of California Press, 1999); Houston Baker, *Modernism and the Harlem Renaissance* (Chicago: University of Chicago Press, 1987); and Paul Gilroy, *The Black Atlantic: Modernity and Double Consciousness* (Cambridge: Harvard University Press, 1993). Many scholars casually use the term *wearing the mask* to imply tricksterdom and African American dissemblance, and although it wasn't Dunbar's original usage, it is a logical extrapolation.

47. "Out from Behind the Mask" appears in *Leaves of Grass* in the subsection, "Autumn Rivulets," Book 24 of the 1881, 1891, and 1900 editions.

48. Walt Whitman, *Two Rivulets, Including Democratic Vistas, Centennial Songs, Passage to India* (Camden: Author's Edition, 1876), 24. In subsequent editions, Whitman emended the second line to read, "These lights and shades, this drama of the whole . . ."

49. I owe several scholars credit for complicating my thought on this topic, whom I have not yet cited, including Renato Rosaldo's chapter titled "Imperialist Nostalgia" in *Culture and Truth: The Remaking of Social Analysis* (Boston: Beacon Press, 1993); Laura Wexler's *Tender Violence: Domestic Visions in an Age of U.S. Imperialism* (Chapel Hill: University of North Carolina Press, 2000); and Lora Romero, *Home Fronts: Domesticity and Its Critics in the Antebellum United States* (Durham: Duke University Press, 1997).

50. Claudia Tate demonstrates that sentimental domestic novels signify differently in an African American context, as allegories of subjecthood, fulfillment, and civil rights. See Claudia Tate, *Domestic Allegories of Political Desire* (New York: Oxford University Press, 1992).

51. Uncle Step appears in nearly all the books, apparently a favorite subject of Leigh Miner. Uncle Step was also photographed by F. Holland Day during his visit to the Hampton campus in 1905. See Barbara L. Michaels, "New Light on F. Holland Day's Photographs of African Americans," *History of Photography* 18, no. 4 (Winter 1994): 334–47. One of Day's most famous African American images depicted Miner's model, a persona already recorded previously in the Dunbar books.

52. In the poem, "Sympathy (I Know Why the Caged Bird Sings)," Dunbar's bird voices his song to the ears of God to elide the spectacle of black abjection, much as he does in "We Wear the Mask," addressing his last stanza, a spontaneous

upwelling of sentiment to "O Great Christ." By directing the expression of abjection skyward rather than to the audience, the black artist avoids inviting the audience to downward condescending sympathy and intervention.

53. My definition of modernity here, as individuality and self-determination, is derived from that of Werner Sollors, *Beyond Ethnicity: Consent and Descent in American Culture* (New York: Oxford University Press, 1986).

 Snapshot 2

Reproducing Black Masculinity

THOMAS ASKEW

Shawn Michelle Smith

The photograph is striking in large part because the young men are so striking (fig. 32). They sit and stand in suits, wearing high-collared, elegant white shirts, individually patterned and styled ties, and boutonnieres. Their parted hair is carefully coiffed; one wears tight curls, another carefully ironed ripples, and others soft, full waves. One young man, a bit older than the rest, sports a full mustache; his younger colleague, seated to his left, bears the hint of his own stylish facial hair. Each man holds a string instrument. Two seem to engage the camera directly, as the others look off at different angles just outside the photographic frame. Despite individual differences in grooming and clothing, most of the men look remarkably alike one another. Indeed, five of the six are siblings, sons of the photographer who made this image, Thomas Askew.

Thomas Askew was a very successful photographer in Atlanta at the turn of the century. He catered to Atlanta's African American elite and made beautiful portraits of prominent men, women, and children. Beginning in 1896, and until his death in 1914, he operated a studio out of his home at 114 Summit Avenue, near the fashionable Auburn Avenue district. Tragically, most of Askew's work was lost in Atlanta's Great Fire of 1917, which destroyed his home and studio, including all of his photographic equipment and plates. Today, his extant work remains in Atlanta archives such as the Auburn Avenue Research Center, the Atlanta History Center, and the collection of Herman "Skip" Mason Jr.[1] Other images, such as Askew's photograph of his sons in the Summit Avenue Ensemble, have been preserved in

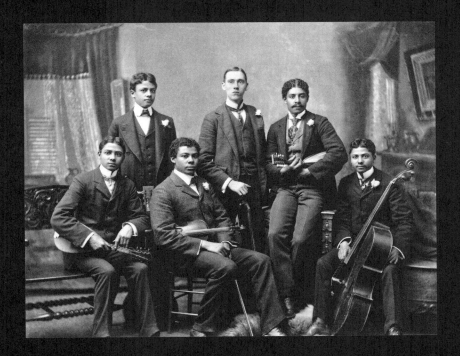

32. Thomas E. Askew, *The Summit Avenue Ensemble,* **from** *Negro Life in Georgia, U.S.A.,* **compiled by W. E. B. Du Bois, 1900.**

Daniel Murray Collection, Library of Congress, Washington, D.C.

albums that W. E. B. Du Bois compiled for the American Negro Exhibit at the Paris Exposition of 1900. Askew's beautiful portraits of Atlanta's elite were fitting representatives of Du Bois's Talented Tenth, and Askew provided many (if not all) of the 363 images Du Bois presented in *Types of American Negroes, Georgia, U.S.A.* (1900) (volumes I–III) and *Negro Life in Georgia, U.S.A.* (1900). As part of the American Negro Exhibit, Askew's photographs were displayed for the world at the Paris Exposition of 1900, the Buffalo Pan-American Exposition of 1901, and the Charleston South Carolina Interstate and West Indian Exposition of 1901–1902.[2] Today the photographs, still in Du Bois's albums, are held in the Daniel Murray Collection at the Library of Congress.

Askew presented himself in Du Bois's albums in a half-figure cabinet card portrait. In the image Askew sits with his body facing front, his head turned somewhat sharply to look out the left side of the frame (fig. 33). The photographer wears a fine woven suit with subtle decorative piping and a patterned tie that shines like silk. His hair is carefully styled, laying straight out from a clearly defined part and ending in curls on his forehead. His striking facial hair is rather flamboyant; a full mustache curves up at the ends on his upper lip, and a long goatee descends from his chin. Askew wears the suit of a respectable and successful businessman and the somewhat eccentric facial hair of the bohemian artist. Around his goatee, the fullness of a slight double chin signals the prosperity of a man just entering middle age.

In his photograph of the Summit Avenue Ensemble, Askew's sons are dressed and groomed with the same careful attention to self-presentation their father displays in his own portrait. An ensemble is, of course, a group of musicians who perform together, but it is also a well-put-together outfit. Askew's wife, Mary, was a seamstress, and as Deborah Willis has argued, "it is likely that Mrs. Askew's profession inspired her husband to focus his attention not only on the faces of his subjects but also their dress."[3] Clothing was one of the visible accoutrements of class status,[4] and it was not uncommon for photographers to keep garments and jewelry for clients in their studios. As the Askew sons helped to advertise their father's profession by posing for his camera, they also helped to promote their mother's profession by wearing impeccably sewn and pressed clothing.

In addition to their fine suits, string instruments distinguish Askew's sons from the men represented in another musical group, namely a marching band in Du Bois's albums (fig. 34). The string instruments connote refined European music to be performed for an intimate, elite group, whereas the big drums and brass instruments of the marching band announce the

33. Portrait of Thomas E. Askew, from *Types of American Negroes, Georgia, U.S.A.*, compiled by W. E. B. Du Bois, 1900.

Daniel Murray Collection, Library of Congress, Washington, D.C.

34. Marching band, from *Negro Life in Georgia, U.S.A.*, compiled by W. E. B. Du Bois, 1900.

Daniel Murray Collection, Library of Congress, Washington, D.C.

more raucous and military music of outdoor festivities such as ballgames and parades, with their larger and more anonymous crowds. The marching band represents an institution, and all of the men are dressed in uniforms, whereas the members of the string ensemble wear the trappings of the middle class. The marching band is photographed outside, a large group posed on the steps of what appears to be a church, whereas the ensemble is photographed in a middle-class parlor, likely the familiar site of its performances. The band may demonstrate discipline in its playing and precise phalanx, but given the circumstances of its performance it probably cannot achieve the subtlety and sophistication of the string ensemble. Thus, in their attire as well as the instruments and music they have chosen, Askew's sons represent an elite class of African American men. Their "place" is in the parlor in which Askew has photographed them, reinforcing their middle-class status.

At the time of Askew's success, photography was celebrated as a uniquely reproducible medium. Indeed, Askew's clients could order countless copies of his cabinet card photographs to share with family and friends. As one of his advertisements proclaimed, they could secure "1 Doz. Cabinets for $2.75."[5] The circulation of images exploded as identical copies of the same photograph could be easily and inexpensively procured. Years later Walter Benjamin famously recognized the photograph's reproducibility as a revolution in artistic production. The advent of reproducible photography heralded the age of the copy—no longer would art be subordinate to the unique original. "Mechanical reproduction" unsettled the very idea of the original, for in photography no single image could be isolated as distinct from other copies. Identical prints made from the same negative were all copies without an original.[6]

As one gazes at Askew's portrait of his many handsome sons in the Summit Avenue Ensemble, *reproduction* begins to take on multiple meanings. Clearly, Askew's sons are not copies of one another (even though two are twins) or of himself, but their similar appearance suggests familial, biological reproduction captured via mechanical reproduction. Indeed, the photograph would seem to represent a male fantasy of reproduction in which the father is sole progenitor of an entirely male family. Despite the discomfort such a fantasy might create for feminist viewers, Askew's claiming of reproductive privilege and display of male virility gains pointed political import when considered within the context of the assault on black masculinity at the turn of the century.

Part of the misrepresentation or "frame-up" that has figured black manhood in the United States is a discourse of faulty fatherhood.[7] Although

not crystallized until later in the twentieth century, with studies such as E. Franklin Frasier's *The Negro Family in the United States* (1939) and the Moynihan Report, *The Negro Family: The Case for National Action* (1965), the idea of absent or ambiguous black fathers has pervaded racist representations of the African American family.[8] During slavery, for example, the legally unrecognized black husband was unable to protect his wife from the attack of the white slave master. At the turn of the century, when Askew was photographing, the discourses that sought to legitimize lynching depicted black male sexuality as dangerously out of control and detached from the discipline of the family. The fantasy of the black male rapist perpetuated by the lynch mob imagined black men as the reckless and unwanted fathers of children to white mothers. In this way, fears of miscegenation buttressed white anxieties about black male sexuality. In the discourses surrounding lynching, the legacy of white men raping black women, "fathering" children as slaves, came back to haunt a white patriarchy in the inverted fantasy of the black male rapist of white women.

Viewed within this context, Askew's photograph of his sons acquires political meaning. In an era in which black male virility was so often vilified by white supremacists as a threat to the sanctity of white women and the white family, Askew announces his own reproductive powers through the photographic display of his many handsome sons. Here is black masculinity literally and figuratively reproducing itself, reveling in biological and artistic reproduction. The photograph is an assertion of black fatherhood, and it is doubly reproductive, for it announces paternal reproduction through mechanical reproduction. Ultimately, *The Summit Avenue Ensemble* presents Thomas Askew's doubled performance of black masculine reproduction.

Notes

1. Shawn Michelle Smith, *Photography on the Color Line: W. E. B. Du Bois, Race, and Visual Culture* (Durham: Duke University Press, 2004), 164–65n14. Deborah Willis, *Reflections in Black: A History of Black Photographers 1840 to the Present* (New York: Norton, 2000). Herman "Skip" Mason Jr., *Hidden Treasures: African American Photographers in Atlanta, 1870–1970* (Atlanta: African American Family History Association, 1991).

2. Shawn Michelle Smith, *Photography on the Color Line*, 12.

3. Deborah Willis, "The Sociologist's Eye: W. E. B. Du Bois and the Paris Exposition," in *A Small Nation of People: W. E. B. Du Bois and African American Portraits of Progress* (Washington, DC: The Library of Congress, 2003), 51–78, 59.

4. For more on "conspicuous consumption," see Thorstein Veblen, *The Theory*

of the Leisure Class: An Economic Study of Institutions (1899; repr. New York: Modern Library, 1931).

5. Askew's advertisement ran in the *Voice of the Negro*, December 1904.

6. Walter Benjamin, "The Work of Art in the Age of Mechanical Reproduction," in *Illuminations*, ed. Hannah Arendt, trans. Harry Zohn (New York: Schocken, 1969), 217–52.

7. On the enframement of black men, see Maurice O. Wallace, *Constructing the Black Masculine: Identity and Ideality in African American Men's Literature and Culture, 1775-1995* (Durham: Duke University Press, 2002), 8, 30, 44.

8. See David Marriott, chapter 5, "Father Stories," in *On Black Men* (New York: Columbia University Press, 2000), 95–116.

 SEVEN

Louis Agassiz and the American School of Ethnoeroticism

POLYGENESIS, PORNOGRAPHY, AND

OTHER "PERFIDIOUS INFLUENCES"

Suzanne Schneider

I see in and through them. I view them from unusual points of vantage. . . . I see these souls undressed and from the back and side. I see the workings of their entrails. I know their thoughts and they know that I know. This knowledge makes them now embarrassed, now furious! . . . And yet as they preach and strut and shout and threaten, crouching as they clutch at rags of facts and fancies to hide their nakedness, they go twisting, flying by my tired eyes and I see them ever stripped—ugly, human.
—W. E. B. Du Bois, "The Souls of White Folk"

Like a car accident, in which, in the last moments before impact, the occupants of each vehicle simply close their eyes and give themselves over to the force of physics, the explosive event that the camera flash records represents an instant of mechanical collision with the world. It is a collision that, while it may for all intents and purposes encapsulate a real occasion in time, is nevertheless a moment, some would say of crisis, that exists only through the interpretation of the result—the "real" has been lost somewhere in those seconds of the shutter's snap. Thus, in the same way that in order to speak of the "truth" of the crash that was to bring two automobiles and individual worlds into violent contact, we must begin by piecing together the story that preceded proximity in order to get to the "truth" that the photograph synthesizes, we need first ask what came before—a before that necessarily includes not only the person(s) driving the cam-

era to that shape-shifting, earth-shattering *click* but also the forces that steered the individual(s) to this instant of impact. With a nod, then, to Laura Wexler's wonderfully evocative notion of *anekphrasis*, "an active and selective refusal to read photography — its graphic labor, its social spaces — even while, at the same time, one is busy textualizing all other kinds of cultural documents,"[1] I would like to begin my present discussion, one that hopes to make sense of the moment that would bring the scientist Louis Agassiz into charged collision with the black bodies of five slaves (three men and two women), with the assertion that any and all labors toward the contextualization of the cultural documents I shall examine require both active and studied detection of photography's "graphic labor" and candid inspection of its "social spaces." The discussion that follows is, therefore, as much concerned with the histo-material reconstruction of a specific time period as the deduction of the eroto-personal proclivities that would synthesize themselves in Agassiz's slave daguerreotypes. Moreover, I wish to urge forward an interrogation of the ways in which our contemporary critical reading practices, in all their laudatory deconstructiveness, often serve as screens themselves, shielding us from the subjective rather than objective "truths" of a history that many actively and selectively view as "not damned, but innocent; not a blind accident of evolution, but a progressive fulfillment of destiny," to take a page from Toni Morrison.[2]

My epigraph from Du Bois staging its own moment of collision — one in which the head-on returned gaze of the racial Other at once exposes, eviscerates, and penetrates the bodies and machinations of those who would make him the object of conventionally "disinterested" scientific scrutiny — is meant to enact a similarly violent rupture of discourses, to lay bare a well-worn plotline that, in conflating the gaze of the scientist with the gaze *of science* and allowing the cloaking powers of empirical objectivism to pass unremarked, also serves to naturalize science's narrative of progressive cultural and technological advance. It is this narrative that ignores the extent to which the "advances" made by early Western science in particular can be said to have been directly inflected by and intended to cater to the very distinctive demands and desires of a minority segment of the population: the white, privileged, and learned men who comprised science's early circles. If we ignore this aspect of the story, a story that is far from innocent in its far-reaching implications, if we close our eyes and let ourselves be drawn along by the force of a now-established cultural physics that, like photography itself, "generates images which are coercive to the extent that they are able to mobilize powerful modes of social behaviour and appearances according to which the major divisions [and hierarchies]

of age, race, class and sex are made to appear natural and desirable,"[3] then we are damned to keep crashing in the same car.

I say, therefore, that while the author of the slave daguerreotypes may be dead, his biography is as much a valid cultural document as the documentations of cultural Otherness he left behind at the crash site where personal drives bumped up against the demands of his larger social world. Taking my reading of Agassiz's slave daguerreotypes as a sort of salvage job, these two texts — the photographs and Agassiz's biography — simply cannot be disentangled from one another. It is said that Agassiz's life in science was marked by a tendency to "stud[y] nature more subjectively than anyone realized."[4] What my interlocutions (or interlopings) into this life hope to reveal, in fact, is that Agassiz's decision to move from his initial "subjective" focus on the study of fossil fish to still more "subjective," prurient study of the black male penis had both everything and nothing to do with an actual commitment on the scientist's part to the doctrines of racial difference. To approach Agassiz's slave daguerreotypes as the obvious and expected, if alarming, end products of this Swiss émigré's enthusiastic adoption of polygenesist beliefs upon arrival in America is to both utterly *mis*interpret the import of these images *and* to read them exactly according to plan. No one having yet attempted to unpack that "something more" sensed in the official account of Agassiz's "sudden conversion" from standard creationism to a polyvalenced racism,[5] there is something more to be said as well of the "naturalism" that preceded this moment of uncanny crisis. Indeed, my discussion of Agassiz's life, both in, out of, and prior to early American ethnography will reveal the polygenesist project that would result in the daguerreotyping of five stripped Africans as a studied and sublimating sleight of hand on Agassiz's part. His attention to the dusky derrieres of two men, in particular, made use of difference even while indulging desires rooted in a masculine sameness that permitted the Swiss-born and scandal-plagued scientist to continue the sorts of homosocial exchanges that he had grown accustomed to prior to his arrival in the States. In short, and once viewed from "unusual points of vantage," the "rags of facts and fancies" to be found at this inquest site are to reveal that the "truth" behind the *visual* apparatus produced by Agassiz and American racial science is that the "essentially lascivious black [male] body was . . . not born but made"[6]: made in America, in the mid-1800s, and inaugurated specifically to prop up certain institutionalized systems of white male dominance while masking forms of white male deviance that threatened the same. If this has yet to be read in these images . . . crash, boom, bang, "I see in and through them," I say.

The visual representation of male bodies and sexualities within modern regimes of corporeal and sexual knowledge cannot be separated from the erotic pleasures of the look that are usually disavowed so categorically by empirical science. . . . The microscope is also a peepshow.

—Thomas Waugh, *Hard to Imagine: Gay Male Eroticism in Pornography and Film from Their Beginnings to Stonewall*

Let us begin to address, then, the series of shots before us, the infamous slave daguerreotypes of scientist Louis Agassiz (figs. 35–43). Commissioned in 1850, these haunting images were meant as ocular evidence to support a polygenesist project that held that "the races of mankind had been separately created as distinct and [inherently] unequal species."[7] It will not require much effort on my part to establish that the "proofs" that these pictures offer tend to indict their white author (and intended viewing audience) much more than they do the slaves forced to strip down for "science." If a first-glance perusal does not immediately suggest the "foul play" afoot, then I offer this final remarkable fact: as I alluded to earlier, the more familiar torso shots reprinted above do not comprise the entire study. Carefully crèched in the same velvet-lined, ornamentally gilded framings as these representative images are the five physique shots that complete this series. Presenting front (*full* frontal), side angle, and rear views of three denuded and fully grown black men, these photos reveal the true gems (and focal points) of Agassiz's scientific survey. Yet these images have been kept almost wholly hidden from view.

The complete series of fifteen daguerreotypes were first published in 1995, and Harvard's Peabody Museum, an institution founded by none other than Agassiz himself, had since imposed a fairly stringent ban on allowing the most graphic of these daguerreotypes to be publicly exhibited.[8] And while previous staffers at the "Agassiz Museum," as it is often called, offered several reasons for this official censure, I would hold that chief among these would have been the unacknowledged fact that the scientific "cover story" meant to veil the shocking nakedness of these black "specimens" collapses beneath the very least scrutiny and points to a much more troubling collapse of the distinctions that would delimit taxonomer from voyeur, empirics from erotics, and Agassiz as ethnographer from Agassiz as pornographer.

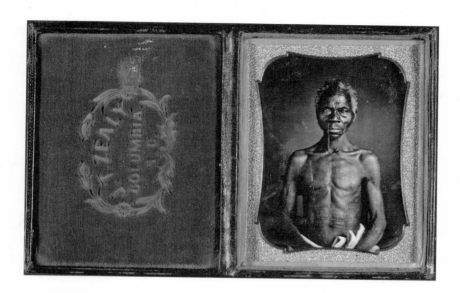

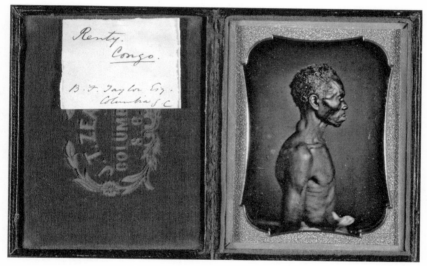

35. Louis Agassiz, *Daguerreotype, Renty, Frontal*.

Courtesy of the Peabody Museum of Archaeology and Ethnology, Harvard University.

36. Louis Agassiz, *Daguerreotype, Renty, Profile*.

Courtesy of the Peabody Museum of Archaeology and Ethnology, Harvard University.

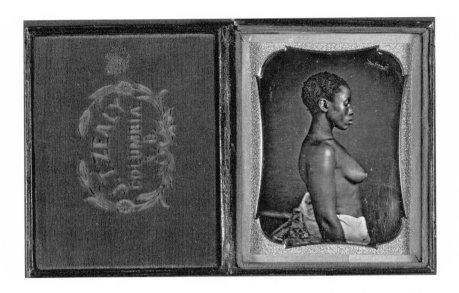

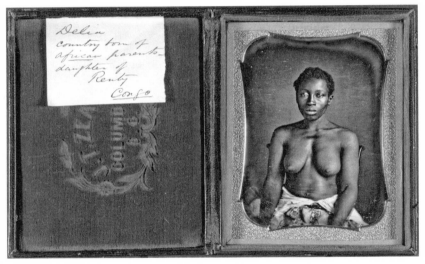

37. Louis Agassiz, *Daguerreotype, Delia, Profile.*

Courtesy of the Peabody Museum of Archaeology and Ethnology, Harvard University.

38. Louis Agassiz, *Daguerreotype, Delia, Frontal.*

Courtesy of the Peabody Museum of Archaeology and Ethnology, Harvard University.

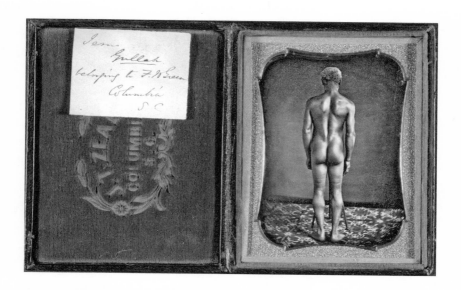

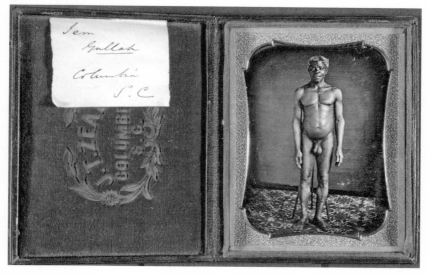

39. Louis Agassiz, *Daguerreotype, Jem, Full Back.*

Courtesy of the Peabody Museum of Archaeology and Ethnology, Harvard University.

40. Louis Agassiz, *Daguerreotype, Jem, Full Frontal.*

Courtesy of the Peabody Museum of Archaeology and Ethnology, Harvard University.

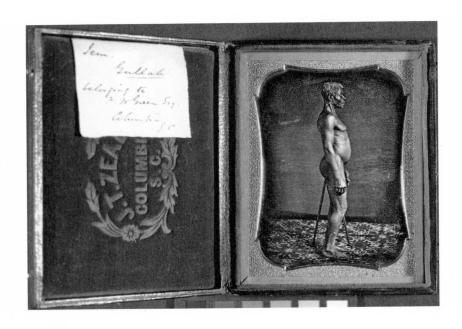

41. Louis Agassiz, *Daguerreotype, Jem, Full Profile.*
Courtesy of the Peabody Museum of Archaeology and Ethnology, Harvard University.

The fact of these images' ornate keepsake casing and parlor setting may be explained away as the inevitable detritus of the professional daguerreotypist's studio in which these photos were conceived. One might forgive these fetishistic and commodified trappings as the unintentional excesses of a fledgling practice of medico-scientific photographic documentation that had not yet produced its own technicians or established specialized guidelines for presenting the subject of the scientific gaze. (Early practitioners in the field were forced to rely upon the services of the still rather limited crop of individuals instructed in both the aesthetic and technical mechanics of this emergent art-archival form. That the earliest photographic documentations of the human body as site of scientific and medical study should follow the classical and artistic conventions of the portrait study in which these professional practitioners were trained is not astonishing.) One might also attempt to ascribe the sense of voyeuristic delight that overhangs images somehow "too familiar, too personal for our eyes," and that stands in direct contrast to the clinically detached perspective of later medico-scientific records of "anonymous patients shot against plain backgrounds," to the caprices of an untrained eye: the photographer, J. T.

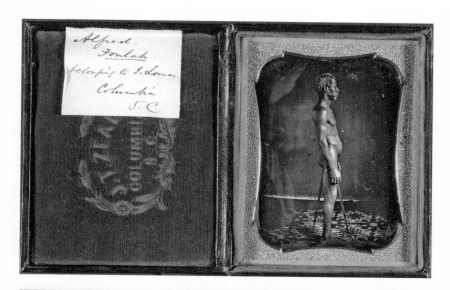

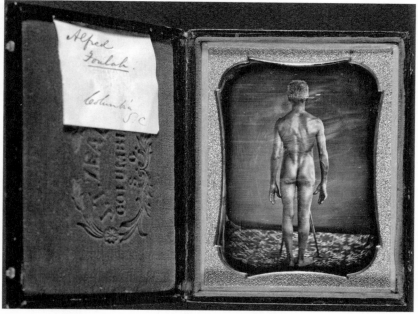

42. Louis Agassiz, *Daguerreotype, Alfred, Full Profile.*

Courtesy of the Peabody Museum of Archaeology and Ethnology, Harvard University.

43. Louis Agassiz, *Daguerreotype, Alfred, Full Back.*

Courtesy of the Peabody Museum of Archaeology and Ethnology, Harvard University.

Zealy, unable to deny the illicit pleasure accompanying upclose and personal access to the bared bodies of subjected strangers and not yet versed in the performance of the various subterfuges meant to mask subjective investments in objectified bodies.[9] But trace evidence refutes all such alibis and levels culpability not at Zealy, as simple accomplice, but rather upon the mastermind at work behind the scenes; in short, it is not to be forgotten that the Agassiz photos were *commissioned* works, and although the scientist himself was not present at their execution it is evident that he left rather explicit instructions as to the manner in which he wanted his subjects to be "taken."

The division between the two series of images was obviously instituted at the scientist's behest, the first set of full-body poses casting a *physiognomic* gaze upon the body's "shape, proportions, and posture," the second series of upper body shots following the tenets of the then wildly popular science of *phrenology* and "emphasizing the character and shape of the head."[10] Agassiz would also have had to specify that the subjects were to be photographed nude and have requested the enregistration of multiple shots taken from various angles, both requests ostensibly meant to provide the penetrating eye of the empiricist with the detailed evidence of these bodies' anatomical peculiarities. While these specifications might not seem, in and of themselves, out of the ordinary range of practices of scientific discernment—the rather untoward fact of these slaves' unprecedented nudity raising the only red flags for contemporary critics of these photos—it takes little detective work to construct a string of inquiries that might illuminate the truth behind a storyline that "obscure[s] its embedded contradictions by drawing attention to the evocative logic of its emplotment."[11]

The first question that should be asked of Agassiz's scientific master narrative seems to me quite obvious but has been generally ignored by many critics reading/acknowledging only the "evocative logic" of these photos. If these images are meant to stand as visual testimonies to the postulate that blacks and whites are the offspring of separate creations, what are the polygenetic "proofs" that they evidence? What exactly are we supposed to be looking at here: Physiognomically and phrenologically what is it that we are intended to see? Were the differences between black and white so obvious to a nineteenth-century audience that attention need not be directed toward the bodily sites on which they were supposed to be so distinctly written? Do *no* scientific notations need to be appended to these visual testimonies?

While the series of headshots might conceivably be conceded to speak

for themselves, could the same be said of the full-body sequences? It has generally been held by contemporary critics that in these images we are meant to note racial differences in "size of limbs and configurations of muscles,"[12] yet with no verification of this fact offered by Agassiz (available correspondence provides no such précis), we cannot assume this to be the case; nor do any clear deviations present themselves between the limbs, muscles, and rather unremarkable bodies of Jem and Alfred, the men in the full-length shots, and their absent white counterparts who if subjected to endless hours of plantation toil would presumably exhibit a sinewy musculature comparable to that of these two men. And *what of* the counterparts to whom these men are to be contrasted? Lacking a similar series of images that center on white male bodies—a series that Agassiz would have been hard-pressed to procure on this side of the Atlantic—the very notion that these photos are meant to stand as scientific studies of comparative anatomy becomes suspect at best. Such skepticism is increased by Agassiz's failure to request, or include, any information that would make quantitative assessments of these representative Africans' physiognomic features possible if such a comparative survey were to be fabricated at a later date. Content with the most minimal, and often extraneous, of statistical information on his subjects—name, tribal affiliation, plantation origin, and, occasionally, specialized métier—Agassiz, a man renowned for his standardization of scientific cataloging techniques, appears to have neglected to request that any actual measurements be made of the subjects of his taxonomic inquiry. In these photos' failure to provide even the most rudimentary of indicators of scale no such appraisements could even be hypothesized.

To be interrogated in these images as well would be the necessity of extending a shot meant to focus upon the characteristics of the face and head to include the full, and fully denuded, torsos of the subjects of phrenological scrutiny. Skull size, facial angles, and "racially distinct" features aside, let us cast aside euphemism as well. These images should be apprehended for what they are: titty shots. The women pictured being, for the most part, extraneous to this study, the inclusion of their naked breasts surely would have provided ample pleasure for many among Agassiz's potential viewing audience, as would have the vague implications of incest provoked by a rather taboo proximity between naked daughters and their equally denuded fathers. This said, it is nevertheless quite apparent that for Agassiz these women's mammillae were not intended as the main attraction of this work, as the next subject for scrutiny should begin to make prominently clear.

Ironically, the inclusion of varied angles of inspection being just about the only standardly anthropometric element of these photos, it is the appearance of an *extra* angle in the physiognomic series focusing on Jem and Alfred, that should be considered one of the most definitive markers clueing observers into the fact that this is primarily a *sexual*, rather than a scientific, study. While the frontal and profile depictions of the two men, like the vaguely mug-shot images of the remaining sitters, do, at least in terms of angle, conform to then established modes of scientific representation, the rear shot is actually an anomaly. The majority of scientists seem to have come to a general consensus concerning the back of the body's inability to offer any information of value to those who wished to uncover evidence of the physiological differences that existed among men. The main arena in which the discussion did, in fact, move rearward was in specific relation to the sexual and sexualized anatomy of women. One thinks, in particular, of Sander Gilman's well-known essay on the celebrated buttocks of Saartjie Baartman—a young woman of the "Hottentot" (Khoi khoi or Bushman) tribe of Southern Africa whose naked body was displayed in England and France for more than five years until her death in 1815. No such precedent existed for the empirical study of the male bum, black, white, or otherwise.

The anomaly of the focus on the black male's backside in the Agassiz daguerreotypes, then, would have signaled to a nineteenth-century audience that the bodies placed before them were so positioned for sexual inspection—and, subtextually, homosexual gratification—an understanding buttressed by the very fact that this study depicted *male bodies* at all. While women's bodies and sex organs had long been the subjects of scientific and salacious scrutiny, early materialist taxonomies had almost exclusively limited their comparisons between men to the region above the neck. As Allan Sekula notes, "the lower regions [being] shaded off into varieties of animality and pathology," inquiries into the essential characteristics of *man* were "discourses *of* the head *for* the head."[13] In fact, up to this point, men of color, although consistently animalized and pathologized within both social and scientific discourses, might still be said to have been considered, at least within the official annals of natural science, men of reason and contrasted against whites primarily along the scale of an Enlightenment-inspired hierarchy of intellect rather than at the "base" level of the body.

The naturalist scientist Louis Agassiz's unofficial study, therefore, was actually among the first such endeavors to turn the empirical regard away from the contours of the head of man and to redirect this gaze toward the head of the (black man's) penis. Indeed, it is the protestingly present fact of

the black penises of Jem and Alfred, the men "taken" in the full-body shots, as well as the penises that lay beneath the head shots of the other three men in this survey, that stand as the essential and originating locus of the racial difference that Agassiz wishes to explore and exploit. Look at this study any way you like, at bottom you will find the same information: it is the black man's sex and sex with the black man that are at once the subtext and the *hyper*text of this "scientific" typology.

This said, and perhaps taking his cues from his much-beloved mentor, George Cuvier—the French zoologist credited with having not only performed the autopsy of the "Hottentot Venus," Saartjie Baartman, but having also prepared her dissected body for museum exhibit (in such a way, of course, that her celebrated "posteriors" were preserved and positioned so that they might be clearly viewed for all posterity)[14]—Agassiz clearly had his finger on the pulse of *this* nation's pornographic pulsations. The titillation, the *scopophilic* pleasure, that these photographs and the black bodies captured therein would have occasioned, not just in Agassiz but in the public to whom they were to have been displayed at a time when the full-frontal nudity that they portrayed was *absolutely* unheard-of, should be obvious. What is entirely remarkable about these photographs—America's first scientifically sanctioned black nudie shots—however, is not only that they were the first of their kind to be produced in America but, most importantly, that they figure the African American *male* as the main subject of their sexual spectacle. Taking a step forward, then, from Brian Wallis's apt summation, "The case of the Hottentot Venus marked the collapse of scientific investigations of the racial other into the realm of the pornographic,"[15] I would like to depart from this pronouncement, as well as from Sander Gilman's influential early analysis that designated the body of the black *woman* as the principal star of nineteenth-century racial science's empirical investigations and sexual exploitations, and propose instead a vision of our nation's 1800s that marks this era as *the* moment in American history in which the black male body comes to the fore: when Hottentot Venus turns *Hot-to-trot Penis*.

While Agassiz is to be credited, not single-handedly but surely most significantly, with putting midcentury America on the map as a legitimate center for ethnographic study, he can also be credited with having both transplanted and transformed the vision of Europe's great naturalist masters in a thoroughly of the moment, if not actually "modern," way. Playing to the particular geographies that mapped the desires of his new American masters, his pornographic aestheticization of the black man would come to rival even Cuvier's earlier takes on the "Black Venus." Agassiz's

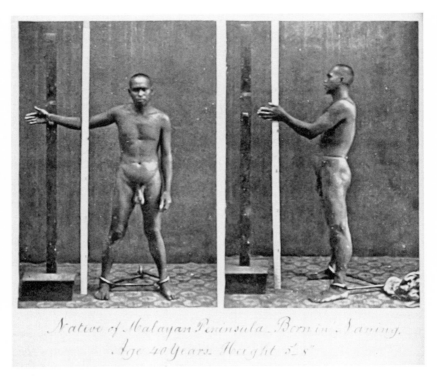

Native of Malayan Peninsula. Born in Naning.
Age 40 Years. Height 5' 5"

44. Anon., *Native of Malayan Peninsula,* **born in Naning, circa 1870.**
Reproduced by permission of Taylor and Francis Books, UK.

images proved inspirational for other like-minded scientists in the field. Later shots, one the byproduct of a search set up by the London Ethnographic Society in 1870 (fig. 44), the other an anonymous "anthropological" shot from approximately the same era (fig. 45), bear a striking resemblance. They also inaugurate an immediate epoch in midcentury America's mass culture during which similar, and similarly pornotroped, visions of black masculinity would take center stage. These popular images grounding themselves and their erotic ethos in this initially advanced and authoritative take on the black male body as both sexual exhibition and sexual intermediary—it was also a moment in which this body became stand-in for and representative of *all* deviant bodies—became the Other par excellence. Not only sexual beast but sexual aberration (genderbender/homosexual projection), not only nature's freak but the sideshow's as well, the black male body, always seductive and always repulsive, fetishized, codi-

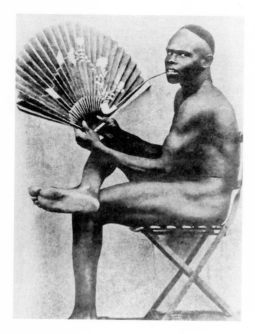

45. Anon, *Le Nègre à L'éventail,*
circa 1900, Algeria.

Reproduced by permission of Taylor
and Francis Books, UK.

fied, *Uncle Tom*ified, and commodified, was, from the 1850 publication of
the Agassiz daguerreotypes onward, repeatedly set before the nineteenth-
century public's eye for voyeuristic dissection and delectation.

What does it mean to say pornography and ethnography share a discourse of domi-
nation? For one thing, they represent impulses born of desire: the desire to know
and possess, to "know" by possessing and possess by knowing.
—Christian Hansen, Catherine Needham, and Bill Nichols,
"Pornography, Ethnography, and the Discourses of Power"

More intriguing than the colonized, the colonizer; more intriguing than the
object of scholarship, its subject.
—Mieke Bal, "The Politics of Citation"

But this is not the end of the story. If the images that sprang from Agas-
siz's lascivious lens, and the various iterations of the eroticized black mas-
culine that were to follow, were to escape official censure while ensuring

public pleasure, it was because, for all their pornographic transgressions, they might still be seen, finally and ultimately, as working within the service of the state. As I would hope to make clear, the official sanction given during this era to these frenzied fixations on black male corporeality had everything to do with the phobic magnitude of his figure as this dark being appeared poised to be set loose upon the body politic and the body of the white woman in a nation on the verge of both the modern era and the American Civil War. The libidinal is thus put in service of the political, and voyeurism is recast as "vigilance," even as the black man threatened to emerge up from slavery and out from under the policing eye of the plantation overseer—a proto-Pavlovian association of this figure with the pornographic promised to make a culturally enforced system of racial surveillance *pleasurable* for those who were to perform this "civic duty."

Furthermore, if racial science was to render its captured subjects *hypervisible*, it was by the very act of forwarding these revelatory distinctions that the scientists responsible for these optical incarcerations might themselves be rendered *invisible*. In an essay by Laura Dassow Walls that explores Louis Agassiz's thoroughly "modern" approach to nineteenth-century science, one sees the taxonomist credited with a mode of inquiry that attempted to erase the body of the scientist from the empirical equation and to produce instead a vision of "the scientific seer [as] a pure vessel for the transmission of truth from nature to humanity."[16] The renunciation of what Jonathan Crary has called the "carnal density" of the seeing subject—the role of the flesh in determining one's sight (and the manipulability of such) and the effect that one's embeddedness in Merleau-Ponty's "flesh of the world" has on the same[17]—was in many ways necessary in order to (re)consolidate a notion of an ordered "reality" based in "natural" and "eternal" truths during a moment in which white men's dominance over this increasingly *destabilizing* natural order was being called into question. The fact that *desire itself* was somehow seen to be at the base of all the current chaos required, if the white man was to maintain ascendancy, a denial of his fleshly investments, as well as a supposed "de-eroticization" of the white man's look. And Agassiz's look, in particular, was certainly being called into question.

A brief overview of Agassiz's early life, both in and out of science, clearly reveals the extent to which the personal and the professional seem to have been intertwined for the naturalist. As his choice of vocation and his professional success both depended heavily upon the young scientist's fondness for the social company of men, as well as his inclination to form the most intimate attachments to his male confreres, it seems that the pursuit, and the exchange, of scientific knowledge was, for Agassiz, always

"an impulse born of desire"—science, and its circles, serving for the young licentiate as both mediator and *mask* for the exchange of otherwise unsanctioned desires for and among men. The tale of Agassiz's private history thus far told only in ellipses—its "meatier" bits relegated to the same blank spots that encompass Jem and Alfred's dark flesh—there is no time here to provide a full blow-by-blow account of Agassiz's formative European years and the intensely intimate relationships he would eventually share with many of the great scientists the Continent had produced. Suffice it to say for now, paraphrasing Alexander Doty, that there was clearly something queer there—actually, quite a few things. From the rather bizarre account of Agassiz's early "adoption" by a gentleman stranger met on the highway home from college who was so taken with the dashing young student that he immediately petitioned Agassiz's parents to personally take over all of their son's upkeep and educational expenses, to the triangularly homosocial system of exchange that was to leave Agassiz and his two most cherished school chums entangled by an arrangement in which the sisters of one comrade had been promised in marriage to the other two (the three men, hence, to be forever wedded to one another), very few sentences need be finished or elliptical leads followed to recognize that by all accounts the existing documentation we have of Agassiz's early years suggests a portrait of the empiricist as burgeoning potentate in a utopian homosocial sphere.[18]

The fraternal society that the scientific community constituted in the early decades of the nineteenth century offered Agassiz a domain in which, with the privilege of membership, one might also be afforded certain male-male affectional opportunities that remained beyond the pale of those allowed among the ordinary citizenry. Membership in scientific circles also had its rules of engagement, many of which Agassiz was to learn in his association with the famous naturalist Alexander von Humboldt. The well-weathered and well-respected older gentleman serving the eager apprentice as a guide in matters more worldly than scientific ("things he could not have learned from former teachers and only dimly understood from his short acquaintance with Cuvier"), Humboldt offered Agassiz a crash course in what might, euphemistically, be called "cosmopolitanism." "By personal example and intimate advice," he taught the youth how to become a "man of the sort" that he, and presumably Cuvier, were to be recognized as. It was, in fact, the studied sophisticate who was known to have passed along the following bit of advice to a young Agassiz: "It is not enough to be praised and recognized as a great and profound naturalist; to this one must add domestic happiness as well."[19]

Agassiz followed Humboldt's advice at least as far as it involved taking a wife. But he would fail at maintaining the surface veneer of a happy heterosexual home. In fact, Agassiz would eventually throw his household into ultimate disorder due to his long-term relationship with Edward Desor, who, from the beginnings of his association with the scientist, was considered by both Agassiz's wife and extended family to "exert an unwholesome" and "perfidious influence" over the naturalist and his affairs,[20] and who was later said to have established a dynamic in the men's volatile relationship in which the young apprentice hired as Agassiz's personal secretary and servant "had subtly become his master."[21] It was with increasing gossip in Continental circles concerning his relations with Desor and the influence of such on the dissolution of his marriage, as well as the widely publicized failure of his scientific publishing house—both circumstances threatening to unmount the career and the public persona that Agassiz had worked so arduously to construct—that Agassiz turned to America, where he hoped he would be able to regain professional and public esteem.

One would presume that having *run*, not come, to America Agassiz would go to great measures to keep his checkered past well behind him. Instead, and within three years of his arrival in the States in 1846, Agassiz found himself courting opprobrium yet again, this time following a very ugly public breakup with Desor, who had, at the time of the falling out, been maintaining a Boston residence with him since 1847. The scorned secretary quickly commenced a smear campaign in which the plaints forwarded against his former mentor ranged from the charge that Agassiz had cared little for the wife he had left behind in Europe to the more serious allegations that the naturalist had falsely taken professional credit for scientific research undertaken by his secretary and had failed to provide monetary compensations owed his assistant as well. Finally, Desor topped all off with the most damaging of recriminations: "that Agassiz had enjoyed an 'improper connection' with Jane, a servant in the East Boston home."[22]

With news of the explosive falling out quickly spreading, and followed even faster by lurid insider accounts of the private proclivities enjoyed by one of the city's most prominent men, Desor's allegations, as well as innuendo concerning Agassiz and his secretary's intimate relations, were soon the talk of the town, as one contemporaneous exchange between the scientists Charles Henry Davis and Alexander Dallas Bache makes clear. Davis writes: "These quarrels are, as you intimate, truly wonderful. I could . . . 'moralize' this spectacle for a month to come. 'Tis passing strange and wondrous pitiful.' But *as it takes all sorts of men to make a world, so it takes all sorts of dispositions to make a man*. Of one thing I feel certain, that in this quarrel

. . . [Agassiz] must be right; this is an opinion fire would not melt out of me. . . . The sincere admiration inspired by his character carries me with him without inquiry."[23] Bad enough that the public was now involved in his personal business, but finding that, unlike Davis and Bache, many of his professional associates *had* given ear to his secretary's stories and sided against him, Agassiz decided that some equally public yet less publicized action must be taken if he was to clear his now besmirched name. Calling together a panel of arbitrators, consisting of John Amory Lowell, D. Humphreys Storer, and Thomas B. Curtis, private deliberations were arranged in which Desor's charges, as well as Agassiz's counterclaims, would be evaluated and any guilt on either side adjudicated. Importantly, the specificities of the recriminations made, as well as the evidence introduced in the proceedings, were to remain sealed to outsiders, the dirt mongering and sensation driven public was to learn, at least from these judges, only the end result of the inquest. And even now, I, without fairly extensive research, would never have located the transcripts to these private proceedings, secreted away as they were, very much like Agassiz's slave daguerreotypes, in Harvard's dusty vaults.

The suit of *Desor v. Agassiz* was clearly one in which the professional controversies—most importantly, the charge of false authorship the assistant had made against his employer—that were supposedly the basis of the action were of little consequence to the referees. Of a twenty-one-page handwritten transcript of the proceedings only four are specifically addressed to this aspect of the dispute. What was on trial, rather, was the established scientist's sexuality and whether or not it could be established that Agassiz's sexual proclivities, if dispositionally out of the ordinary, were to categorically position the man outside of the protective parameters of white male mastery, no matter how much "sincere admiration" he might inspire among many of his professional friends. That Desor's base accusations against Agassiz have been variously described as placing a "shadow" over the scientist, "tarnishing [his] standing in the community," and threatening to "blacken his reputation in Boston,"[24] colorfully delimit the stakes of a contest in which the (hyperembodying) mark of "immorality" is to be pitted against the unadulterated "invisibility" of racial and class-based ascendancy.

Following the trial's end in February of 1849, a triumphant but still publicly compromised Agassiz retreated to Charleston, South Carolina, only to emerge several months later freshly engaged to one of Boston's most respected ladies, Elizabeth Cabot Cary (formerly courted by the U.S. statesman Charles Sumner), his children in the process of being sent over from

Europe, a series of articles about to be published in the *Christian Examiner* in which the naturalist would make markedly and publicly clear his views on the separate origins of the species, and his sequence of slave daguerreotypes well in the works. Agassiz's hasty move to take a new wife, as well as the immediate arrangement for the importation of his offspring, clearly indicating the scientist's pressing need for new "beards," should finally help to convey both the import and inevitability of "the accused's" determination, in the wake of a scandal that had so spectacularly placed his dark privatedoings and privateperson in the full-public eye, to pronouncedly associate himself with American ethnography and the elutriating ascendancy promised through membership therein.

Given Agassiz's sexual proclivities and, by extension, his racial positioning "on the block," it is not surprising that he should realize that Jem, Alfred, and their dark privates might be sold out instead. As Dana Nelson, like Tagg, Sekula, and others before her, has held, "As 'other' bodies were investigated, inventoried, and invested with particularized materiality, scientific authority located the Observing Subject in . . . 'an artificial space of evacuated materiality.'"[25] And, indeed, it was to be through Agassiz's publicized adoption of the doctrines of polygenesis and his admission into what Nelson has called the "puritivizing" sphere of the leading men of racial science, behind whose study walls the sanctity of the radiantly whitened racial scientist's body, mind, and affectional excesses could be protected, that the stigmatized naturalist was finally able to shake the taints, both real and implied, that were to momentarily mark him as darkly desiring subject.

In brief, and very much like the other race-baiting Barnum's that comprised his classmates in the American School of Ethnography, immensely popular lecturers whose "magic shows" had tugged on the heart and purse strings of a very large portion of the nation's populace, Agassiz had also become a master of the scientific sleight of hand. His "queerness" calling into question his individual class, and racial, affiliations, he aligned himself with a group that not only "promise[d] privileged access to a pure world cordoned off from abrasive encounters with 'otherness,'"[26] but also, through the dissemination of their doctrinal teachings, held out to *all* (white) men the reassurance that racial (and class) distinctions were both primordial and immutable. If much had been made of Agassiz's secretary's plan, through close association with his mentor to raise himself up to an equal level and to "share . . . glory" with the man whom he then hoped to permanently overtake as "master," Agassiz and American ethnology offered to the nation

theories that held that close association of unequal castes (intermarriage) results not in elevation but degeneration and death. They doctored, as well, a picture of an ancient and enduring eminence, in which from the beginning of time "the social position of Negroes had been the same as it was in the nineteenth century, that of servants and slaves."[27] When Agassiz and Desor's dramatic falling out had called the private dark doings of the great man into public account, the scientist would respond with a discovery that might prove much more titillating and distracting to popular audiences: he enters, for the first time, the dark privates of the black man into America's photographic/pornographic annals.

Acknowledging the contagion of colonialism rather than repressing it so that it will inevitably return is to my mind the route to remedy. An unproblematic emphasis on the difference of the colonial past is a sure way to keep it alive in an unacknowledged present—hence the paradoxical conclusion that is, in fact, close to the first rule of psychoanalysis as a practice: insight alone is not enough; we have to live through our past traumas again, not looking at them from a false distance but immersing ourselves in them.
—Mieke Bal, "The Politics of Citation"

Jules Marcou offers the following image of a posttrial (and positively repositioned) Agassiz enjoying a round of postrepast repartee with the members of his "Saturday Club," a rotating group of dining distingués that included the likes of Oliver Wendell Holmes, Henry Wadsworth Longfellow, and Ralph Waldo Emerson, among others:

> With a lighted cigar in each hand, [Agassiz] would force the attention of every one around him. . . . Then would come one of his made-up stories—a mixture of dream and science. He knew perfectly well that it was a fiction, and the first time he told it he hesitated a little. If he thought anyone in the company was doubting its truth, he would look at him with a dumb request not to betray him. On the next occasion he would repeat the same story without any hesitation; and the third time he told it, he was sure that it had really happened and was true. Agassiz would have been very truthful, if he had less fire and brilliancy in his imagination, always too easily excited. In principle he was honest, because he believed all that he said. For him the Italian proverb, "si non e

vero e ben trovato," was an article of the code of conversation . . . among witty gentlemen.[28]

If the theories of Agassiz and others concerning natural repugnance and the sterility and degeneration of "hybrids" were betrayed by both the reality of these "mongrels'" continued existence as well as by scientists' compulsive fascination with interracial reproduction, and if Agassiz's interest in the origins of the different species betrayed a perverse fascination with the black man's organs of generation that bespoke an obsession with contact rather than separation,[29] then *si non e vero e ben travato*. Alternately translated: "if it isn't true, it ought to be" and "if it isn't true, it's well invented," this Italian proverb proved to be an article and code of both early racial science and standard white supremacy. Although the arguments and "evidence" produced by Agassiz in particular were more fiction than reality, more dream than science, they did much to enregister an understanding of inherent racial differences that while helping to resolve the inherent contradictions of America's republican credo also helped to fix a view on the black male body that was meant to check the potentially disruptive effects of white desire for this Other even while allowing for the pursuit of endless, if unspoken, pleasure in adopting the liberties of such a look.

Which is to say that if the project of Agassiz and his white empiricist peers was to justify, through the designation of separate realms of creation for blacks and whites, separate realms of social fraternization and participation, lurking behind this imperative was of course the terror, distinguished by longing, that the black male body might possess a "manhood" that might not be so easily denied nor distanced. It was this fear, then, and its disavowal that necessitated both the constant surveillance of the black male body and black male sexuality, as well as the denial of the personal (and imperialistic) interests that were invested in that (sexually charged) moment of looking. That the same look that was to purify the white man and the "innocence of his eye"[30] was to petrify the black man within a representational framework dedicated to what is best defined by Ann Laura Stoler as "the pornographic aestheticization of race" is to prove Foucault's point that it was only through "systematic blindnesses" that the nineteenth-century's scientific seers were able to construct "around and apropos of sex an immense apparatus for producing truth, even if this truth was to be masked at the last moment."[31] Which is to say, and as I have been trying to make explicit, that what was really at stake in Agassiz's moves to secure membership in American racial science's private and privatizing scientific community—one in which authoritative and financial power over

fellow professionals and one's fellowman was at once hard won and practically purchased through the "scientific" display and social disciplining of white women and people of color—was that such membership would make Agassiz both ultimately invisible and practically *untouchable*. Firmly ensconced within the elite of American ethnography, a discipline that posited its practitioners as forerunners in the battle to ensure the reproduction of white male patriarchal power systems, Agassiz had also found a niche in which he was to prove so invaluable that even the potential homoeroticism that might adhere to the sorts of homosociality he relished, rather than unmanning or leaving him open to a fully embodied racial re-signification, could be effectively incorporated into a definitive narrative of (abstracted) white male dominance.

Given the reading of the Agassiz images and the Agassizian vision I have just offered, I remain fascinated by not only the fairly limited attention that his slave daguerreotypes have received but also, and even more so, by what clearly seems, in contemporary engagements with these "portraits," evidence of an inherited set of systematic blindnesses around and apropos of addressing the very real and hardly innocent sexual pulsions encountered within them. How do we read what appears to be a fairly deliberate refusal on the part of those few critics who have attempted to tackle the subject of these slave daguerreotypes to acknowledge the machinations of desire at work within the frames of these images?[32] How is it that these contemporary critics, trained in the most intensive and often unmerciful procedures, have so readily accepted Agassiz's empirical alibi, accepted that his penetrating scrutinies fall simply on the side of science (albeit "bad" science, racist science) rather than within the realm of flat-out prurience? Finally, and most importantly, how is it that the black male bodies and penises that are the central locus of this study (and the objects of such disavowed desire for its author and contemporaneous audiences) continue to be essentially overlooked and elided by this current-day critical gaze?

Toward offering an explanation, I'd like to up the ante on Wexler's *anekphrasis* and draw upon a term recently introduced into the arena of black masculinity studies by Maurice O. Wallace, *spectragraphia*, which "names a chronic syndrome of inscripted misrecognition." Wallace explains further, "What racialists see gazing at the black male body, is a '*virtual image*,' at once seen and unseen, spectacular and spectral, to their socially conditioned eyes," eyes that "see black men half-blindly as a blank/black page onto which the identity theme of American whiteness, with its distinguishing terrors and longings, imprints itself as onto a photographic negative."[33] Thus, just as the scientific master narrative offered by Agassiz acts

as a veil shielding the sex that these black men signify, while at the same time allowing the naturalist unlimited and ultimately licensed access to the black bodies that lie behind the veil, we see in the interventions of the cultural inheritors of this "scientific" archive a tendency to produce critical narratives concerning these captured images that in many ways mirror the late scientist's own responses to the stimuli before him.

As such, and despite contemporary claims to transcendent liberal humanism, as well as frequently reiterated desires to acknowledge and celebrate what is at base the essential humanity shared with these "naked bodies, male and female, of persons dispossessed of themselves,"[34] to quote Alan Trachtenberg, this recognition is often accomplished only at the expense of these same bodies and through a process of dissimulation meant to disavow the erotics that obviously adhere to the event of critical confrontation. We therefore see again and again in these theoretical interventions, as we saw in Agassiz's own early encounters with the African in America, an insistence that it is in fact the innermost essences of these slaves upon which critical focus is actually leveled rather than on the bodies of beings whose black skin is not the least of the eroticized external organs that might draw the attention, and whet the libido, of their critical or empirical interlocutors. To turn again to Trachtenberg as representative study:

> Stripped of everything deemed intrinsic to selfhood and "character" if not humanness itself, they are simply themselves—what we see . . . black slaves constrained to perform the role of specimen before the camera. . . . By stripping these figures of all but their bodies (and eyes), the pictures depict the base degradation of such relations. They also encompass the possibility of imaginative liberation, for if we reciprocate the look, we have acknowledged what the pictures most overtly deny: the universal humanness we share with them. Their gaze in our eyes, we can say, frees them. And frees the viewer as well.[35]

Similar to early racial science's empirical claims to the ability to read the internal character traits of the racial subject through the study of their external physical characteristics ("the material form is the cover of the spirit"),[36] central to Trachtenberg's analysis is a resolute faith in his own powers as critical medium and imaginary emancipationist to *really* see into the deepest recesses of these black slaves' souls. Even if what the critic eventually spies there is humanity, the erotics of mastery being played out are, nevertheless, undeniable. Trachtenberg, investing himself with an all-seeing, all-knowing empirical gaze that is able to completely penetrate the material before him (people possessed in picture form) and allowing him

to return to share the innermost secrets of these men and women with his audience,[37] is just one of many to overlook the fact that it is the "basely degraded" black *male* body specifically that this probing gaze must go to the greatest of lengths to revest.

Admittedly, it is not Trachtenberg alone who wishes to keep the captive and captivating bodies (and penises) of the subjects of Agassiz's full frontal shots under wraps. References to these men's nudity appear rarely, if at all, in the majority of critical discussions of these enslaved daguerrean subjects, and in Trachtenberg's own critique, although acknowledging the photos' inclusion of "genitalia,"[38] Jem and Alfred receive no mention. In fact, Trachtenberg limits his acknowledgments to "Jack the Driver and Renty, . . . Delia and Drana [Jack's daughter]," at one point further reducing this recognition to "Delia and *the others*."[39] I'd like to suggest, therefore, that the blind spots that exist in the analyses of these images offered by otherwise adept cultural critics, as well as the holes/blank spots to which the black male subjects of the Agassiz daguerreotypes have been relegated, coincide with the black man's phantastical and fetishistic positioning within the darkest regions of the national imaginary and the mind's eye.

Lost in the raptures (and ruptures) of a phantasy of absolute identification with these long dead specimens of the "base degradation" of America's "peculiar institution," these contemporary critical interventions end by specularly reproducing the speculative (in both its conjectural and contemplative senses) logics of the ideological systems that were institutionalized so as to structure and support this same unequal social arrangement. That these theoretical dreams of access to, as well as the exchange of, "universal humanness" with these slaves must take place at the expense of these blacks' distinctive bodies—the corruption and darkness of which must be transcended in order to achieve enfranchisement ("imaginative liberation")—only further naturalizes the position of the disembodied (white) subject as rightful heir to the privileges granted those not made manifest by destiny, especially as it is the critical detachment of the critic's own disembodied gaze that legitimates his or her position as the interpreter and bestower of meaning on enslaved subjects over whom they wield the power of emancipation *and* imaginative *re*incarnation. Naturalized and revitalized, also, are the dynamics of a desire that have doomed these subjects to perpetual service in the panoptic prison house of sexual signification in that attempts to "contain" the erotics invoked at the sight/site of the nude black (male) body actually serve only to check their dissipation.

Repeatedly clothing these black nudes in humanity, insisting that that which is "base" in these images be veiled from vision, these theorists' de-

nial of that which is right before their eyes renders that lying inside their discursive blind spots that much more pronounced. Although critics appear determined to see only the racist "science" at work in these pictures, rather than acknowledging the interracial (homo)sexual desire also clearly evoked (insisting that that which is seen is not seen, that that which is desired is not desired), the penises of Jem and Alfred continue to be wholly discernible even when obscured by critical readings that posit themselves as a *reverse* striptease, maintaining that they are looking into the eyes of "Delia and the others" though their every perspective leads elsewhere. That Trachtenberg and others are capable of constructing such a discourse, and able to see it as a way out of "a system of representation" in which Agassiz's "illustrations are trapped . . . as firmly as the sitters,"[40] indicates just how firmly entrenched this system is. Capable of ventriloquizing themselves through the bodies of intermediaries who, thanks to the seductive logics of this system, are allowed to imagine themselves as uncaptured within its frameworks, representative ideologies display the power to turn would-be agitators into nothing more than mechanisms (like the chemical agitators used by mass-market photographers) that guarantee that such enregistrations are distinctly reproduced.

In keeping, then, with the Mieke Bal quote I introduced above, the impetus of the rather extended critique offered of contemporary critical mis(sed)readings of the Agassiz slave daguerreotypes emerges from the conviction that in order to ultimately conceptualize and contextualize the prodigious *work* that these images did for and to the nineteenth-century viewership for whom they were destined, it is crucial that we critically examine their effect on our own twentieth- and twenty-first-century workings: analytical, ideological, *and* physical. Rather than attempt to explain away the "bad" erotic feelings that arise in response to the Agassiz photos, it is imperative that we own up to and initiate lively explorations of the pornographic excesses of these images and the dynamics of the desire that they produce in order to understand the cultural mechanics behind the proliferation and reproduction of these dark fantasies; especially as the precondition of desire is that it must never be fully *realized* ("Desire . . . is sustained only by want"[41]).

Furthermore, I agree with Robyn Wiegman's assertion that "if rethinking the historical contours of Western racial discourse matters as a political project, it is not as a manifestation of an other truth that has previously been denied, but as a vehicle for shifting the frame of reference in such a way that the present can emerge as somehow less familiar, less natural in its categories, its political delineations, and its epistemological foun-

dations."[42] I'd like to insist therefore, extending Wiegman's logic, that if Agassiz's personal story matters it is because the alternative narrative of race in America that it suggests reveals that, like the "fairy's wing" upon which the rock of Fitzgerald's Gatsby's world was founded, the vision of the black male's ontological essence that has been passed down from this mid-nineteenth-century world may have been grounded in little less than something both as simple and as complex as one man's socially transgressive and class-crossing love for his male secretary. And, if so, how embarrassing and how infuriating for us all. To discover, after all of this time, that, as epistemological inheritors of this Agassizian vision, our own empirical drive toward the chimera of critical objectivism has done little more than render us, à la Du Bois, "bone of [his] thought and [flesh] of his language," when we might long ago have denaturalized this worldview, seems twistedly tragic, indeed.

In closing, I ask again, then, if pornography is, according to Baudrillard, a love affair with the very notion of the "real"—with its constant promise to reveal the truth of the body, the truth of sex, the truth of pleasure— if it is a real that is emptied of any erotic promise as in giving too much, might we not see the desire to ignore the possibility of new "truths" as a desire to sustain the erotic promise that lies in existing fabrications? If the theoretical "striptease" just performed in the revelation of Louis Agassiz's naked, "ugly, human" self seemed somehow anathema to many readers— too much, too close, too uncritical—yet his images of stripped slaves continue to be regarded as epistemologically valid, if disturbing, *scientific* artifacts, I ask only that we ask ourselves *why*? (I ask also that my readers ask themselves if, in the pornographic exercise above, they are willing to admit to those moments, even in the midst of critiquing the pleasure *I* was obviously taking in my position as provocateur—the fun with which I dispatched of the "dirt"—when the more staid instances of my critical method were quickly passed by in search of subsequent titillations.) If, ultimately, my revelation of the incredibly subjective urges that underwrote Agassiz's now infamous slave daguerreotypes is to leave us not with a lasting image of "black slaves constrained to perform the role of specimen before the camera,"[43] but rather forced to see their white author in every aspect and angle of the camera's perspective, might we be resisting this "unusual point of vantage" because it would deny us the unusual and endlessly erotic pleasures that we have long ago grown accustomed to taking in the spectragraphic/phantasmagoric spectacle of black male sexuality on display?

To end with a quote from Slavoj Žižek, whose critical theorem frames the pornographic studies that I am both producing and reproducing in this

project, "Contrary to the commonplace according to which, in pornography, the other (the person shown on the screen) is degraded to an object of voyeuristic pleasure, we must stress that it is the spectator himself who effectively occupies the position of the object. The real subjects are the actors on the screen trying to rouse us sexually, while we, the spectators are reduced to a paralyzed object-gaze."[44] Recalling Trachtenberg's own enjoinder for a look that would reciprocate that of the sitters spectrally enslaved by the daguerrean eye (a reciprocity inconceivable in that, powerless to shield themselves from scrutiny, the "look" of Jem, Alfred, Delia, and the others can never truly counter that of those who, disembodied, "gaze" upon them), according to Žižek, it is the pornographic gaze that gives as good as it gets. If the on-screen object of pornography is to be "reduced" to the corporeal, so is the spectator off-screen, whose visceral, or, more accurately, whose *genital*, responses to the sexualized subjects of their gaze entraps them in their bodies just as surely as these Others are entrapped: both become slaves to erotic drives, both are penetrated by the look of the other. The pornographic spectator equally becomes a subject for sexual scrutiny.

This is the fungible look that I would like to extend to the subjects of Agassiz's slave daguerreotypes. Recognizing the naiveté of the fantasy of liberating them from the debasement they must endure within the realm of representation—no simple denial of the rules of this game will disqualify them, or myself, from participation in it, just as the denial of the erotics that circulate around their images has in no way checked their propagation—one *can*, however, muck things up a bit. By giving as good as one gets, by turning the tables on this spectacular system, by turning our attentions upon ourselves as well as the others holding stakes/at stake in this visual match, perhaps we might, at the very least, disturb the "fixity" of its outcomes, denaturalize and render less transparent the workings of power. Exposing *all* bodies (our own included) as marked (if only by the taint of desire), perhaps the body of the Other will cease to be the quintessential victim, the *ur-mark* of the vicissitudes of visuality.

Notes

1. Laura Wexler, *Tender Violence: Domestic Visions in an Age of U.S. Imperialism* (Chapel Hill: University of North Carolina Press, 2000), 58.

2. Toni Morrison, *Playing in the Dark: Whiteness in the Literary Imagination* (New York: Vintage Books, 1992), 52.

3. Wexler, *Tender Violence*, 4–5.

4. Edward Lurie, *Louis Agassiz: A Life in Science* (Chicago: University of Chicago Press, 1960), 155.

5. In a now infamous letter to his mother, composed in the wake of his first encounter with black men in America, a near hysterical Agassiz proclaims, "I hardly dare tell you the painful impression I received, so much are the feelings they [Negroes] gave me contrary to all our ideas of the brotherhood of man and unique origin of our species" (qtd. in Lurie, *Louis Agassiz*, 257). This letter taken as marking the naturalist's first turns toward polygenesist beliefs, it is oft-quoted (and variously translated) in a series of different articles and texts. See, for example, Brian Wallis, "Black Bodies, White Science: Louis Agassiz's Slave Daguerreotypes," *American Art* 9, no. 2 (1995): 42–43. Also rather striking about this bit of correspondence is the evidence that it gives of what seems to be a spontaneously generated phobia in Agassiz: a hypersexualization of the black male body that borders on the pathological.

6. Cynthia J. Davis, "Speaking the Body's Pain: Harriet Wilson's *Our Nig*," *African American Review* 27, no. 3 (1993): 395. Davis's focus here lies, fairly exclusively, on the early exploitation of African American women—a common critical tack that further indicates how well the production of black *male* lasciviousness has been well hidden.

7. Wallis, "Black Bodies, White Science," 40.

8. For years, Wallis's article "Black Bodies, White Science" (1995) remained the only source that could be found in which Agassiz's fifteen images were offered in their entirety. Interestingly, a subsequent reprint of this article in *Only Skin Deep: Changing Visions of the American Self*, ed. Wallis and Coco Fusco (New York: Harry N. Abrams, 2003), included only six of the shots. No explanation was given for the conspicuous omission of the full-body poses, nor are reasons given for the general reduction in images. I have personally been working with the Agassiz daguerreotypes since 2000 and had previously been denied permission for public display. My *deepest* thanks and most sincere respect to the current staff of the Peabody Museum for the magnanimity (and speed!) with which they honored my present request to include these controversial pictures in this piece.

9. Melissa Banta, "Daguerreotyping Disease: Inside Dr. Bigelow's Pathology Files," in *A Curious and Ingenious Art: Reflections on Daguerreotypes at Harvard* (Iowa City: University of Iowa Press, 2000), 63. In her "Framed: The Slave Portraits of Louis Agassiz," published in the same book, Banta also offers some insights into the life of Joseph T. Zealy, a well-known and well-respected South Carolinian photographer renowned for his portraits of high-bred local families and celebrities. Zealy's services were procured for Agassiz by the plantation owner, physician, and friend of Samuel Morton, Dr. Robert W. Gibbes.

10. Wallis, "Black Bodies, White Science," 45–46.

11. Laura Briggs, "The Race of Hysteria: 'Overcivilization' and the 'Savage' Woman in Late Nineteenth-Century Obstetrics and Gynecology," *American Quarterly* 52, no. 2 (June 2000): 266. Briggs employs Wahneema Lubiano's idea of the "cover story" to think about the ways in which nineteenth-century medical dis-

courses shaped women's bodies (both white and of color) and sexuality, alternately inscribed as either excessive or lacking, and the ways in which these discourses were intricately linked to a need to police and maintain the bounds of whiteness. Quoting Lubiano directly, her text continues, "Cover stories cover or mask what they make invisible with an alternative presence; a presence that redirects our attention, that covers or makes absent what has to remain unseen" (Briggs, "The Race of Hysteria," 263). For more on the "cover story," see Wahneema Lubiano, "Black Ladies, Welfare Queens, and State Minstrels: Ideological War by Narrative Means," in *Race-ing Justice, En-gendering Power: Essays on Anita Hill, Clarence Thomas, and the Construction of Social Reality*, ed. Toni Morrison (New York: Pantheon Books, 1992). Clearly Lubiano's "cover story" can be tied to Maurice O. Wallace's "spectra-graphia" (mentioned later in this chapter), both concepts speaking directly to the substitutive dynamics I'd like to suggest are involved in Louis Agassiz's frenzied focalizations on the black male body.

12. Alan Trachtenberg, *Reading American Photographs: Images as History, Mathew Brady to Walker Evans* (New York: Hill and Wang, 1989), 53.

13. Allan Sekula, "The Body and the Archive," *October* 39 (1986): 12.

14. Until 1974, Baartman's skeleton and preserved brain and genitals were conspicuously displayed at the Musee de l'Homme in Paris.

15. Wallis, "Black Bodies, White Science," 54.

16. Laura Dassow Walls, "Textbooks and Texts from the Brooks; Inventing Scientific Authority in America," *American Quarterly* 49, no. 1 (March 1997): 3.

17. Jonathan Crary, "Modernizing Vision," in *Vision and Visuality*, ed. Hal Foster (New York: New Press, 1999), 43. It is Martin Jay, who, in his chapter "Scopic Regimes of Modernity," also found in *Vision and Visuality*, speaks of Merleau-Ponty's "dream of meaning laden imbrication of the viewer and the viewed in the flesh of the world" (18).

18. The best Agassiz biography that I have found is Edward Lurie's. Jules Marcou's, *Life, Letters, and Works of Louis Agassiz* (New York: Macmillan and Co., 1896), although blasted by Lurie—"Jules Marcou's [text] was based in large degree on Mrs. Agassiz's *Life*. Where Marcou departed from this account, the results are often strange and misleading. Certain discussions, as for example those regarding glacial theory, are excellent; others, as in the case of the evolution controversy, are entirely unreliable" (Lurie, *Louis Agassiz*, 422)—is actually *most* interesting in the moments where it departs from "reliability" and starts to dish some absolutely *fantastic* gossip concerning Agassiz's personal life and relations. There is also the, obviously biased, Elizabeth Cary Agassiz, ed., *Louis Agassiz, His Life and Correspondence*, 2 vols. (Boston: Houghton Mifflin Co., 1886), 590–617.

19. Laurie, *Louis Agassiz*, 66, 78.

20. Ibid., 112. I also offer below an extended excerpt from a missive of 1846 in which Rose Agassiz expresses a mother's sincere desire that her errant (and erring) son should finally, in America, free himself from the "perfidious influences" that had corrupted him in his past life. Hitherto buried in the Harvard archives—much like Agassiz's slave daguerreotypes, not discovered until 1976 and not reproduced in their entirety until nearly twenty years later—this document, referenced

but never fully quoted in Lurie's biography, is to see light for the first time only now, almost forty-eight years since its last citation. Agassiz's mother expatiates at length: "I will, with the frankness of a mother, whose anxiety is well known to you, unbosom myself upon the matter. . . . You have shut your eyes, but mine have remained open, & without communicating to you my observations, I have watched. . . . Desor . . . has become your master; with much shrewdness he has taken his position; not succeeding, as [he] had planned, in separating you from your own caste, in bringing you down to [his] own level, he has perceived that the best thing for him was to share your glory, at the same time that he should deny himself none of the indulgences that his tastes required. . . . Abusing your confidence, he has possessed himself of all of your most intimate secrets; if they are known, & have reached me, it is through him. I have burned the letters he wrote to me; they have remained unanswered. It would have been too hard a task for me to break the chains that bound you to this man. He was too superior to me in means; the struggle would have been too unequal. I therefore left things as you had arranged them. But now that you are separated for a season, that you have each to enter in new careers, that it is in your power to provide for him advantageously in America, I beg, nay I entreat you to ponder this matter deeply. At forty years of age, it is time to provide for yourself a better future, live according to your necessities & your tastes & in your return to your native land, form to yourself a home happier, with God's blessing, than your former one. I have always hoped that an amiable wife would one day be your portion. To this end, M. Desor must no longer partake your labours & reenter your house as master. No woman will submit to his dominations & you will be once more between the hammer and the anvil. Louis! My dear child, my best loved son, do not reject the counsels of your mother." The letter of November 1846 was later introduced as evidence in "Process Verbal of the Case of Desor vs. Agassiz" (21), Agassiz Papers, Houghton Library, Harvard University.

21. Lurie, *Louis Agassiz*, 113.

22. Ibid., 155.

23. Ibid., 156 (emphasis added).

24. Ibid., 158, 153, and 155.

25. Dana D. Nelson, *National Manhood: Capitalist Citizenship and the Imagined Fraternity of White Men* (Durham: Duke University Press, 1998), 124.

26. Nelson, *National Manhood*, 195.

27. William Stanton, *"The Leopard's Spots": Scientific Attitudes toward Race in America, 1815–59* (Chicago: University of Chicago Press, 1960), 51.

28. Marcou, *Life, Letters, and Works of Louis Agassiz*, 133. For more on Agassiz's "Saturday Club," see Lurie, *Louis Agassiz*, 194 and 202–3.

29. One might similarly read the scientist's *conversion* of the fear of (and desire for) "unnatural" male-male sexual interaction across racial lines into the obsession with the repugnancy of racial interbreeding/amalgamation as a sort of *reaction-formation* meant to mask, for both scientist and audience, preoccupations that most surely ran contrary to both "cultivated tastes" and heteronormative reproductive imperatives.

30. Crary, "Modernizing Vision," 41, quotes John Ruskin who "proposed reclaiming 'the innocence of the eye.'"

31. Ann Laura Stoler, *Race and the Education of Desire: Foucault's 'History of Sexuality' and the Colonial Order of Things* (Durham: Duke University Press, 1995), 184; Michel Foucault, *The History of Sexuality: An Introduction*, vol. 1 (New York: Vintage Books, 1990), 55, 56.

32. Brian Wallis, who does indeed make gestures toward rooting out that which should be labeled "porno" in the graphic representations of these stripped African subjects, is the exception here. Even in the face of increasing acknowledgement within the academy, however, Agassiz's daguerreotypes remain little touched within published works. Following is a list of the best known texts that make mention of these images: Trachtenberg, *Reading American Photographs*; Martha A. Sandweiss, ed., *Photography in Nineteenth-Century America* (Fort Worth: Amon Carter Museum, 1991); Vicki Goldberg, *The Power of Photography: How Photographs Changed Our Lives* (New York: Abbeville, 1991); Andrea Kirsch and Susan Fischer Sterling, eds., *Carrie Mae Weems* (Washington, D.C.: National Museum of Women in the Arts, 1994); Weems, an African American female artist produced an art installation that incorporated (and recontextualized) Agassiz's daguerreotypes; Brian Wallis, "Black Bodies, White Science"; Laura Wexler, "Seeing Sentiment: Photography, Race, and the Innocent Eye," in *Female Subjects in Black and White: Race, Psychoanalysis, Feminism*, ed. Elizabeth Abel, Barbara Christian, and Helene Moglen (Berkeley: University of California Press, 1997); a revised and expanded version of the Wexler essay appears as chapter 2 in Wexler, *Tender Violence*; and in the original and expanded discussions of the Agassiz prints, Wexler cites Harryette Mullen's reading of these works in "'Indelicate Subjects': African American Women's Subjugated Subjectivity," in *Sub/versions: Feminist Studies* (Santa Cruz: University of California Press, 1991). See also, Banta's *A Curious and Ingenious Art*; and most recently, Molly Rogers's *Delia's Tears: Race, Science, and Photography in Nineteenth-Century America* (New Haven: Yale University Press, 2010).

33. Maurice O. Wallace, *Constructing the Black Masculine: Identity and Ideality in African American Men's Literature and Culture, 1775-1995* (Durham: Duke University Press, 2002), 30, 32.

34. Trachtenberg, *Reading American Photographs*, 56.

35. Ibid., 59–60.

36. Agassiz quoted in Wallis, "Black Bodies, White Science," 49.

37. It should be noted, also, that Trachtenberg seems to evidence in the quotation cited in note 34 an inability, despite his appeals to a "brotherhood of man," to view these black slaves as anything other than alterior and formed so very far away from his own conceptions of Self; hence his capacity to connect with them only after he has imposed an image of himself in the whites of/in their eyes.

38. In light of the current conversation, I think that it is important to take this opportunity to turn to a particularly telling moment in Trachtenberg's work in which he refers to "the social convention which ranks blacks as inferior beings, which violates civilized decorum, which strips men and women of the right to cover their genitalia" (*Reading American Photographs*, 56). Drana and Delia's genitalia

are never pictured in the Agassiz photos, his study of these women's bodies is limited to the chest and head. Thus, Trachtenberg is not really addressing the bodies of *both* men and women here; in actuality he can *only* be referring to Agassiz's male subjects.

39. Trachtenberg, *Reading American Photographs*, 56 (emphasis added).

40. Ibid.

41. Jean Baudrillard, *Seduction*, trans. Brian Singer (New York: St. Martin's Press, 1990), 5.

42. Robyn Wiegman, *American Anatomies: Theorizing Race and Gender* (Durham: Duke University Press, 1995), 35.

43. Wexler, *Tender Violence*, 311n69.

44. Slavoj Žižek, *Looking Awry: An Introduction to Jacques Lacan through Popular Culture* (Cambridge: MIT Press, 1998), 110.

 # EIGHT

Framing the Black Soldier

IMAGE, UPLIFT, AND THE DUPLICITY OF PICTURES

Maurice O. Wallace

> Let me . . . unpack some of the issues that constitute, for me, the heart of the cultural analysis of photography. That heart involves the photograph's simultaneous investments in the preciously private and the vulgarly public domains; hence, the way it deconstructs the flawed, illusionary, opposition, or even the distinction, between those two. Here lies the photograph's power, and here lies its power to lie, deceive, seduce, and manipulate: its political, militant, even military agency.
> —Mieke Bal, "Light Writing: Portraiture in a Post-Traumatic Age"

> What is certain is that . . . we need to treat the photographic image as an occasion for skepticism and questioning.
> —Victor Burgin, "Art, Common Sense and Photography"

Walter Benjamin once declared that, "All efforts to render politics aesthetic culminate in one thing: war."[1] The Armageddon of the Second World War just three years off, Benjamin's pronouncement proved prophetic. However prescient his view, though, it would seem to have been a presciently biconditional one as well. That is, the logic of Benjamin's belief in an aesthetic accountability for war also runs in the opposite direction. Inasmuch as the aestheticization of war as a technical and political renaissance event (think, "the New American Century" or "the post-9/11 world")[2] may be just as likely the *outcome* as much the *cause* of those discrepancies between a society's technical advances and its insufficient markets (those discrepancies Benjamin believed directly provoked war), war's aestheticization

also impinges circularly upon the postwar politics of state reconstitution following inevitably *in* and *as* war's terrible aftermath. While the temptation is great to publicly contemplate how the archive of political orations and Orientalist images representing the recent wars in Iraq and Afghanistan have exploited a Western aesthetic sensibility expressly to justify its designs to "mobilize all of today's technical resources," as Benjamin says, "while maintaining"—indeed expanding—"the [traditional] property system,"[3] I feel an imperative toward a set of notes more far-reaching in time, argument, and implication. No less material to the political reality than Benjamin's thesis on the problem of aesthetics and Fascism, I shall argue for a political utility in early photographic production serving the racially inflected expansionist interests of the American Civil War specifically. Although we have already seen how photography pictured war (owing to such prominent researchers as William A. Frassanito, William C. Davis, and Alan Trachtenberg), I want to show how war, in turn, pictured photography as an instrument of the national fantasy.[4]

While conflicts in Iraq and Afghanistan provide ample evidence of the appropriation of photography to deadly expansionist ends—one has only to recall those aerial photographs purported to show the mobile production facilities for biological agents that then-Secretary of State Colin Powell alleged in his address before the United Nations Security Council in 2003 calling for an invasion of Iraq—I want to return nearly 150 years earlier to the American Civil War and postwar periods where, I argue, the labor of photography may be seen aiding the country's political efforts (including the war itself) to navigate the problems of slavery and freedom. Early photographic forms—the daguerreotype, tintype, carte de visite, and ambrotype—came near achieving the United States's post-emancipation dreams of radical reconstructionism precisely by formalizing for the public imagination the picturable prospect of a new national subject, one fully assimilable into the imagined body politic: namely, the African American male as soldier and, thus, would-be citizen.

To be sure, the iconicity of the African American soldier has not gone unnoted in Civil War and Reconstruction discourse. Although African Americans as distinguished as Frederick Douglass, William Wells Brown, Susie Taylor King, and Joseph T. Wilson drew early and laudatory attention to the military service of black troops in the Civil War, they were much

overlooked in the official records.[5] After a full century's neglect by white historians, Benjamin Quarles's *The Negro in the Civil War* (1968) and James McPherson's two volumes, *The Negro's Civil War: How American Negroes Felt and Acted During the War for the Union* (1965) and *Marching toward Freedom: The Negro in the Civil War, 1861–1865* (1968), finally established the black soldier as a historical agent of his own emancipation within academic Civil War history. Many more years later, new scholarship on the black Civil War soldier advanced Quarles's and McPherson's pioneering illuminations. Appearing in 1982, Ira Berlin's magisterial *The Black Military Experience* from *Freedom: A Documentary History of Emancipation, 1861–1867* seemed to spur a small explosion of works foregrounding the Civil War's black troops that were to follow in its wake: Hondon Hargrove's *Black Union Soldiers in the Civil War* (1988); Joseph T. Glatthaar's *Forged in Battle: The Civil War Alliance of Black Soldiers and White Officers* (1990); Edwin S. Redkey's *A Grand Army of Black Men: Letters from African-American Soldiers in the Union Army, 1861–1865* (1992); William Gladstone's *Men of Color* (1993); Noah Trudeau's *Like Men of War: Black Troops in the Civil War, 1862–1865* (1998); John David Smith's *Black Soldiers in Blue: African American Troops in the Civil War Era* (2002); Keith Wilson's *Campfires of Freedom: The Camp Life of Black Soldiers during the Civil War* (2002); and David W. Blight's *Race and Reunion: The Civil War in American Memory* (2001) and *Beyond the Battle Field: Race, Memory, and the American Civil War* (2002) compose a short catalog of other important texts, most of them fairly recently written, devoted to the black Civil War rank and file.

Still, too few volumes of the regimental histories of the Civil War are concerned to point out the fight and society of black units, illuminating as the works above have been. Although upwards of 164 colored regiments fought in approximately 449 engagements over the course of the war, the regimental profiles of black troops remain comparatively few.[6] For the student of race and America's great rebellion, the relatively meager numbers of black regimental histories are a monumental irony. For as Steven Hahn has written, "to the extent that [black soldiering] redefined the relationship between African American men and the federal government," and "tied as it was to emancipation," black soldiering cannot be viewed as other than altogether "integral to the building of a new nation."[7] As the political contours of the reconstituted nation had still to be decided decades after the close of the war, in fact, black soldiers played an essential part in "testing and reshaping them," as Hahn points out.

Moreover, the importance of this part was to endure long past the withdrawal of Federal troops from South Carolina, Louisiana, and Florida in 1877. Both in their person and in their symbolism, black soldiers would

continue to help refashion the nation (and refashion blackness, moreover) throughout the period ending with the so-called Indian Wars, the closing of the Western frontier, and the Spanish-American War of 1898. That is, while the greater part of the black troops who fought in the Civil War were mustered out of service soon after Lee's surrender at Appomattox, a few black units were kept in service, mainly in the South. Congress reorganized the U.S. Army in 1866, and out of the remnant of black units still standing, it raised six new regiments. These six regiments, soon to be recombined into two cavalry and two infantry divisions, helped advance U.S. interests west and further south, "testing and reshaping" the national fantasy past prior borders.

More than the importance of the black soldier (and, as we shall see, the black convict) to the American reformation following the Civil War, I want to make the further and more precise claim that between the government's authorization of blacks' enlistment in July 1862[8] and the "winning" of the West at Wounded Knee in 1890, photography, in the popularity and proliferation of the black soldier portrait, participated in nothing less than the genesis of African American manhood as a coherent category of civil identity and experience in the postbellum political imaginary. Put another way, Reconstruction witnessed the emergence of *a new national manhood*, one inscribed for the first time into constitutional legitimacy, a national *black* manhood that traded on the countercondition of the black convict and the mostly invisible, undocumented, unpaid exploitation of black women's labor.

Whereas the terms *black* and *man* could hardly create a politically meaningful syntax together before emancipation, the black soldier portrait envisaged the possibility of a spectacular new grammar and social logic. If slavery realized the unmaking of the African subject by "social negation" as Orlando Patterson put it in *Slavery and Social Death*, the photograph of the "colored soldier" realized the imaginability of his incorporative American remaking. This is to say, in other words, that the full force of Lincoln's Emancipation Proclamation could hardly have been felt, or realized, without the imagined picturability of the idea of black civilization, free black personhood, and the economic assimilation of the ex-slave into an as yet uncertain, but propitiously industrial, future. The traffic in black soldier portraits might be said, then, to have amounted to, in Benjaminian parlance, an aestheticization of a new black proletariat. Their photographing gave "these masses . . . a chance to express themselves" *inscriptively* without, however, fundamentally altering the material conditions of black disinheritance and the property structures that the war, Lincoln's Emancipa-

tion Proclamation, and the earnestness of black recruitment had pretended to want to eliminate.[9] From the time of its mass appeal in daguerreotypy, early photography was pressed into the preservation of state interests *despite* (but also precisely *by means of*) its radically democratic availability.

Just as surely as the novelistic imagination in the early republic helped distill the idea of America by its fictional reflections upon a range of national themes coextensive with the novel's late eighteenth-century popularization, the invention and swift commercialization of the daguerreotype only a few decades later helped to further shape the nation's idea of itself. In fact, by the time of the rise of photography among the lower castes, those Americans who were cut off by class and capital from the unerringly bourgeois arts of painting and sculpture, the photographic image had so completely suffused American life that, according to one historian, it was "on par with the printed word" in its ordinariness and reflective function.[10] In following the bourgeoisie that had looked to painting to render on canvas the imaginary relation of the bourgeois subject to the conditions of his existence — or, in other words, to the differential relations of production obtaining between him and the other classes — the lower castes appropriated to themselves the social significations of portraiture's immortalizing and, thus, historical function. At the same time, their pictures idealized middle-class domesticity, in effect mobilizing photography to Jacksonian aspirations of self-made manhood and middle-class footing. Two scenes from the William Dean Howells's novel of 1885, *The Rise of Silas Lapham*, illustrate photography's competing claim on portraiture as the sign and the visual production of American uplift. Howells's novel puts the elevating power of photography's new aesthetic instrumentality in vivid relief.

Although the plot of *The Rise of Silas Lapham* proceeds against the backdrop of a venture in mineral paints that rises and fatefully falls into irrecoverable ruin, the novel puts the technology of industrial paint production in tension with the history and application of painting in the beaux arts, symbolically opposing the industrialist parvenu Silas Lapham to Bromfield Corey, the old-money dilettante who previously studied art in Rome. Shunning the entrepreneurial legacy of his father and grandfather, Corey "might have made himself a name as a painter of portraits if he had not had so much money."[11] His aversion to "the notion of a man [like Lapham] . . .

rival[ing] the hues of nature in her wildest haunts with the tints of his mineral paint" (67) betrays an artistic temperament in Corey inimical to the mechanical reproducibility of nature's hues by the fiction of "tints" that, *un*naturally of course, "will stand like the everlasting hills" (11). But the opposition of art to industry, of Corey to Lapham, exists along but one axis of cultural conflict on display in *The Rise of Silas Lapham*. Intersecting with it is a second axis on which the painted portrait is set in dialectical relation to the photographic one, their opposition showing signs of a contestation in which the vulgarities of photography's proletarianization appear to encroach upon, and subvert, the auratic merit of painted portraiture. Whereas Corey's home is decorated by a painted portrait of his father hung over the mantel in his room, and by a series of other such portraits, Mrs. Corey's kinsmen, "more or less darkling on the walls" (196), Lapham still "mean[s] to have pictures" (205)—portrait photographs—to decorate his much newer home. *His* people, "clustered in an irregular group in front of an old farm-house" (8), are captured on a "large warped, unframed photograph" (7) nearly lost in the dusty neglect of papers atop his desk. The photographer's carelessness not to hide "the instrument of torture which [professionals] call a head-rest under their occiputs" (8) exposed the constructedness of the class conceit that the Lapham clan was after in the image but that, pictured against a background "whose ugliness had been smartened up with a coat of Lapham's own paint and heightened with an incongruous piazza" (8), served only to highlight the diminished distinction of the art of portraiture in the age of mechanical reproduction. There was beauty about them, to be sure, but the posing protocols "put them into awkward and constrained attitudes" (8)—which is to say, into looks of strained gentility—giving way to a play of blurred faces and "wavering shadows" (8) that fairly pleased Lapham. Not in spite of them, I aver; because of them. Taken ironically, the family photograph in *The Rise of Silas Lapham* is the middle-class's parodic revenge on the equally constructed performativity of visual aristocracy in centuries of painted portraiture.

That photography helped to revolutionize class in the nineteenth century is clearly then a phenomenon that *The Rise of Silas Lapham* does not neglect to recall. As the novel intimates, photography took up the specifically visual productions of caste, culture, and early capitalism literally *head on*. It is a history that precedes Howells by forty years. According to Allan Sekula, photography became "practical and profitable in the period of the continental European revolutions of 1848, the period in which class struggle first took the clear form of an explosive political confrontation

between the bourgeoisie and urban proletariat."[12] This European struggle had its closest parallel (if not its natural protraction) in the United States in the economic arguments that pressed the Civil War forward. Inasmuch as some of the expansion of the Northern industrial interests during the war was owed, tautologically, to the technical demands of modern fighting methods, it is not an exaggeration to say that photographic technology and the burgeoning business in it, a business made wildly profitable by its wartime demand, helped the urban industrial North overthrow the stubbornly feudal planter aristocracy of the South. That is, as the Civil War settled into the long drawn out conflict it was, photography became one of its most significant tactical technologies: "The Federal government and, to a lesser extent, the Confederate government utilized photography for military intelligence, documentation, map copying, medical recording and other purposes. 'Official' and semi-official photographers accompanying armies and troop units produced a great variety of scenic images. Further, independent photographers, many of them camp followers, took uncountable numbers of pictures."[13] If photography's militarization during the Civil War involved it in an explosive economic battle radically reshaping the contours of American class identification, this is not to say that the pictorialization of the military science and personnel were uniquely separate from the photophilia of the public sphere. Although it exploited the technology's tactical uses, in other words, Civil War photography was never wholly removed from the social appeal of portraiture in civilian life. In 1862 a writer for the *Scientific American* magazine made this observation vividly: "In all the popular galleries in [this] city, crowds of persons are constantly waiting for their turns [to sit for a photograph], and the proprietors are reaping a rich harvest. The same prosperity is enjoyed by the profession in other places, and from the receipt of some of the little pictures from officers beyond the Potomac [River], we discover that traveling photographers are visiting the army for the purpose of enabling the soldiers to comply with the all-prevailing fashion."[14] The "all-prevailing" vogue disinterestedly observed here should not to be taken for its "mere" fashionableness, however. For insofar as the photographers once called "traveling-army-portrait-makers"[15] made portraits of *black* soldiers, the photographic fashion was also a movement, one that literally witnessed to an abolitionist will, black and white, intent upon the sociopolitical transfiguration of the black serf into his own autonomous lordship.

Black portraiture raced the revolution of photography against the aura of the elite class by the spectacularity of the slave's elevation. As nominal

freed people, the former slaves quite naturally "wanted to appear more attractive than they had as ragged slaves. They cast off the slave clothing of degraded drudges," as Nell Painter has said, "and adorned themselves as handsomely as possible."[16] If the new world of the ex-slave's freedom, incomplete though it was (having only crossed into the vestibularity of Union benefaction), was signified in the appearance, then the visual and sartorial rhetoric beneath the historian Steven Hahn's Duboisian view of emancipation may demand a second glance. A "rebellion-turned-revolution" according to Hahn, the Civil War produced many spectacle results, though none more powerful "than *the sights to be seen* in parts of the Union-occupied South."[17] There, Hahn writes, the slaves "*fashioned* their own interpretation of the . . . conflict and . . . in great numbers rebelled against their owners at the first opportunity" by running off or refusing to flee with their fleeing masters.[18] In full view of so many cameras employed by the business of war, the barely free—and the colored recruit, in particular—did literally enact a fashioning of freedom within photographic frames.

In other words, I want to argue, from a more clearly epistemological vantage point, one very probably issuing from sympathies bearing faith in historical materialism, that the first possibility of an imagined national black manhood was constructed by the technological and commercial means of Civil War photography foremost, not constitutional rhetoric, in the nineteenth-century American mind. Very powerfully, photography made visible—to the point of near advertisement—black male bodies no longer outside of the law as ciphers to its civil and human rights but directly beneath its custodial thumb. In the American Civil War archive is a class of photographic portraiture visually approximating the verbal chiasmus, and its underlying logic of binary opposition, made famous in African American abolitionist discourse by Frederick Douglass, a figure not at all untutored in what W. J. T. Mitchell has called "picture theory."

Few images in the whole American Civil War archive display the urgency of the black soldier portrait so dramatically as the before and after portraits of Private Hubbard Pryor of the Forty-fourth U.S. Colored Troops Infantry (fig. 46). Pryor's carte de visite portraits[19] "illustrate and body forth" (Douglass's phrase) a new phase of history, unfulfilled but propitious, in which, according to Douglass, "slavery hitherto paramount and priceless may be less valuable than an army . . . [and] the negro . . . more useful as a soldier than as a slave."[20] If Douglass made chiasmus the central trope of the slave narrative, as Henry Louis Gates Jr. has famously argued,

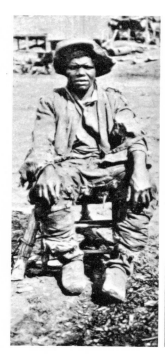
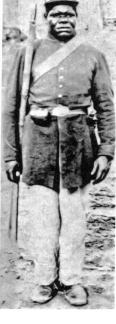

46. Hubbard Pryor, 44th U.S. Colored Troops Infantry.

Enclosed in Col. R. D. Mussey to Major C. W. Foster, October 10, 1864, M-750 1864, Letter Received, Ser. 360, Colored Troops Division RG 94 [B-468].

then the oft-copied Pryor portraits, taken on April 7, 1864,[21] by the photographer A. S. Morse of Nashville,[22] display chiasmus as an important trope in early African American visuality too.

"All contrasts are juxtapositions," decreed the photographer and theorist Victor Burgin, "but not all juxtapositions are contrasts."[23] Although Hubbard Pryor's two looks enact a deliberate contrast, their contrast does not obtain naturally ("not all juxtapositions are contrasts"). Rather, the meaning of their difference is conveyed by a chiastic manipulation of form and content, one reproducing the very rhetorical structure of Burgin's heuristic pronouncement in a visual grammar. Sartorial signs and a visual logic of substitution and surprise, old and new, appropriated from the exhibition culture of midcentury work together to communicate the photographic message of *enslavement* and *freedom*. The intelligibility of Pryor's "before" condition and his "after" image over time, in other words, has been owed to a historical rhetorical practice only apocryphally photographic.

Although the desire of abolitionist audiences to hear the horrors of slavery firsthand was clearly in the interest of authenticating abolitionist claims about the wretchedness of life under the peculiar institution, the call for abolitionists to produce a "real" slave to give evidence of slavery's inhumanity was also of a piece with the exhibition culture of freaks, missing links, and other human oddities put on view in circus and carnival sideshows. "The public have itching ears to hear a colored man speak, and particularly *a slave*," stressed one abolitionist to the more famous William Lloyd Garrsion: "Multitudes will flock to hear one of this class speak."[24] In *My Bondage and My Freedom*, Frederick Douglass's autobiography published in 1855, Douglass delineated his role in the early days of his apprenticeship under Garrison in clear carnival language: "Much interest was awakened—large meetings assembled. Many came, no doubt, from curiosity to hear what a Negro could say in his own cause. I was generally introduced as a '*chattel*'—a '*thing*'—a piece of southern '*property*'—the chairman assuring the audience that *it* could speak. Fugitive slaves, at that time, were not so plentiful as now; and as a fugitive slave lecturer, I had the advantage of being a '*brand new fact*.'"[25] Recalled the same year P. T. Barnum's *The Life of P. T. Barnum, Written by Himself* was published, Douglass's memory of the spectacle event that initiated his public career does not fail to reflect the circus's sensational designs. A "curiosity" and "brand new fact," Douglass was no less an attraction than Barnum's Tom Thumb or Fiji mermaid.[26] In this atmosphere, Douglass's presentation to new audiences by abolitionists accrued ever-wider appeal. Garrison's introduction in particular seemed to encourage the illusion of Douglass's oddity. When Terry Baxter refers to Garrison as Douglass's "de facto carnival barker," the phrase is more suited to mimesis than metaphor.[27]

To make the case more vividly, one witness reported that Garrison "had the habit of 'observing that [Douglass] was one, who, by the laws of the South, had been *a chattel* but who was now, by his own intrepid spirit and the laws of God, *a man*.'"[28] Possessed of charms of speech matched only by a later Douglass, Garrison moved new audiences to excitements far more common to mass entertainment. Part reformer, part showman, Garrison made rapt spectators feel "as though they had witnessed a drama where a beast had become a man before their eyes."[29] That one half of the structure of the chiasmus (antimetabole) for which Douglass is renowned—"You have seen how a man was made a slave; you shall see how a slave was made a man"[30]—is clearly indebted to Garrison's dialectic of the two historically incompatible conditions of black life, chattel and man, underscores more than Garrison's rhetorical influence on Douglass (an influence Garrison

cleverly called attention to in his ironically self-serving preface to Douglass's 1845 *Narrative*);[31] this debt also surfaces the too easily neglected subject of Douglass's self-conscious submission to Garrison's exhibition designs. Though he claims to have desired resisting their efforts to make him "talk like a slave, look like a slave . . . act like a slave,"[32] Douglass nevertheless indulged in his own spectacle condition. I disagree with the biographer William S. McFeely. Douglass was not speaking "disingenuously" but frankly and in harmony with abolitionism's exhibition ambitions, when he allowed that, notwithstanding the well-worn opinion of "some of [his] colored friends . . . [who] thought very badly of [his] wisdom for thus . . . degrading [him]self," he was, he'd later confess, "*willing to be regarded as a curiosity*, if [he] may thereby aid the high and holy cause of the slave's emancipation."[33] Who knows but that the more obscure figure of Hubbard Pryor was similarly disposed, in commensurately problematic ways, to share Douglass's chiastic will to visible personhood and power?

To link Pryor and Douglass in this way is not to insist upon any reflexive or calculated readiness by black subjects to capitulate to the doubly exoticizing and domesticating effects of their spectacle exhibition exactly; rather, it is to posit a more ambivalent, if still yet everyday, relation of black male subjects to the photographic gaze, both mechanical and social, in the nineteenth century. Even as photographs like those visualizing the chiastic transformation of African American soldiers from slaves to virtual citizens attempt to picture black men like Hubbard Pryor as new national subjects, the exhibition conventions by which photography rendered "the new" spectacular during the age of tent revivals and traveling sideshows left black enlisted men, in particular, doubly "framed" in the aftermath and sold, as it were, a false bill of visual goods. Pryor is a vivid case in point.

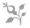

Born in Polk County, Georgia, Hubbard Pryor escaped the Haden M. Prior plantation in northwest Georgia to Federal lines in Tennessee sometime before April 1864,[34] and he enlisted in Company A of the Forty-fourth U.S. Colored Troops Regiment. Although his service records show he was twenty-two at the time of enlistment, this may not be a reliable accounting since a Georgia census conducted in 1880 indicated that Pryor was sixty in that year, not thirty-eight as he should have been sixteen years after enlistment. As slaves "seldom come nearer to [knowing their dates of birth] than planting-time, harvest-time, cherry-time spring-time or fall-time,"[35]

to quote Douglass, twenty-two might well have been the conjecture of an enlisting officer or the deceit of a recruiter financially motivated to fill the ranks as expeditiously as possible. Besides the uncertainty of his age at enlistment, Pryor's legal status upon reaching Chattanooga was also uncertain. While it would have been natural for him, like thousands of black runaways, to presume his freedom once he crossed Federal lines, his legal standing was as ambiguous as his age and anything but settled.

Until March 1862 it was U.S. Army policy to abide by the conventions of the Fugitive Slave Law and remand runaway slaves into the hands of their masters. Afterward, Congress prohibited the runaways' re-enslavement, declaring them "contrabands of war" instead. Since Pryor's service records show him to have enlisted well *after* March 1862, and on exactly the date that the U.S. Army raised the Forty-fourth U.S. Colored Troops Infantry, April 7, 1864,[36] Pryor probably spent several days, if not weeks, in Chattanooga's contraband camp awaiting the Forty-fourth's authorization, the War Department having recently issued (February 25) its General Order No. 75 declaring "all able-bodied male colored persons between ages 20–45, residents of the United States" eligible for service.[37] No longer fugitive behind Union lines, nor yet free in the contraband camp, Pryor existed in categorical suspension.

Although those African Americans who managed to pass into Union lines at Chattanooga, "were, for all intents and purposes, declared free men and women," as the historian James Martin writes, in point of fact the contraband camps were a limbo space between slavery and freedom, architectures of purgatory that masked a plantation-days changing same behind rations, wages, and freedom-speak. Confiscated as Confederate property (just as the government might seize caches of Confederate weapons, say), contrabands, both fugitives and impressed Confederate laborers, were settled into such camps by their would-be deliverers in the hope that a systematic management of these refugees' relief could be achieved and the many thousands gone from the plantation kept from overwhelming Northern cities and taxing Northern sympathies. However expedient the camps were to the conundrum presented by the sudden independence of so many black slaves, in most cases the deprivations endured in the camps rivaled those of their enslaved past. Not only did the eventual decision by Congress to cease appropriations for contraband medical care devastate camp objectives, many army quartermasters discovered that the black market value of camp rations and supplies was high enough to forsake the nobler purpose assigned to their hands. Not surprisingly, then, black life in the contraband camps hardly recommended freedom.

By the winter of 1862–1863 contraband camps had been established all across the Union-occupied South. Camps at Corinth, Mississippi; Lake Providence, Louisiana; and Memphis, Lagrange, Bolivar, Grand Junction, and Jackson, Tennessee, were in especially desperate straits. A questionnaire in early 1863 sent by Chaplain John Eaton Jr., general superintendent of contrabands in the Army of the Tennessee, to the local superintendents of each camp—chaplains all—revealed the misery of camp life for the contrabands, overwhelmingly women and children. Respondents reported to Eaton that the clothing of the contrabands was "very poor; many of them having hardly enough to cover their nakedness," "in nearly every instance, very destitute." Their shelter included "old tents," "deserted houses," and "in some cases no shelter" at all. Some brought property into the camps: "Horses, mules, wagons, cotton, oxen, &c." came with the contrabands at Corinth where an estimated three thousand dollars in goods was "all turned over [to] the Quartermaster" there. In Memphis, Bolivar, and Lake Providence, as well, the quartermasters seized whatever property entered the camps with the contrabands, usually for "employing and caring for contrabands, as per order." In Grand Junction, the vulnerable refugees lost their effects to unscrupulous white soldiers. "The freedmen suffered robbery and all manner of violence dictated by the passions of the abandoned among the soldiery," the Grand Junction chaplain related to Eaton. Worse still, pneumonia, typhoid, congestive fevers, measles, gangrene, smallpox, and diarrhea were all too common infirmities among the contrabands. Common ailments that might have been easily treated outside of the camps were frequently fatal within them because of the "difficulty in obtaining surgeons and medicines," as the Lake Providence respondent put it.

Adequate housing in the camps seemed a chronic impossibility. Months before the squeeze was put on the contraband budget by Congress, the future U.S. president Andrew Johnson, then military governor of Tennessee, denied tents to some camps, believing that such assistance would encourage black dependency. The consequences were severe. To say though that the inevitable overcrowding of tobacco barns, sod huts, and abandoned houses that followed "took a heavy toll"[38] is to understate the effects of such official deprivation. In Memphis, the mortality rate in the camp exceeded 25 percent in 1863–1864. It neared 50 percent in Natchez, Mississippi, where contrabands were also pressed, sometimes as many as six families at a time, into one- and two-room tents and lean-to's. Not all of those deaths were health related, however; some were violent ones.

In August 1864 Colonel Reuben D. Mussey, commissioner for the Or-

ganization of Black Troops in Middle and East Tennessee,[39] wrote to two fellow commissioners objecting to "several cases of enormous and flagrant abuses, of colored men and women" by white citizens and soldiers that remained uninvestigated by the army.[40] He reported that despite a now two-year-old policy against it, contrabands in a number of camps had been surrendered to their masters by army officers with "pro-slavery tendencies."[41] More than a few were whipped and shot to death in punishment.

Given the depth and degree of so many physical perils faced by contrabands in camp, it is just short of miraculous that twenty thousand outwardly able-bodied contrabands survived the camps to enlist. Indeed, one Colonel Smith of Kentucky had already complained to Mussey, "I have picked up and got the names of all male negroes of all ages at this place. . . . They number One hundred twenty five (125). . . . I do not think there is more than 15 or so of this number able bodied."[42] Evidently, the contraband camps produced as much disability as hidden Union labor, much more in women and children as they languished there in the wake of the government's colored recruiting campaign. The production of disability in the double portrait of Hubbard Pryor belies that notion at first blush, however. And the indenture of black women's work to the essential support and daily maintenance of the war machine (and its clearly gendered promises), Pryor's portrait evades altogether. Taken at Colonel Mussey's orders and enclosed in his report of October 1864 to the War Department on the progress of colored recruiting, Mussey offers up the very picture of how a slave was made a man; how a contraband was transformed into a soldier and citizen. A picture of pictures, to be precise, Mussey's chiastic enclosure to the report to Major Foster succeeded in concealing so much disability by the illusion of its *third effect*. The *third effect*, of course, is the name given to two separate photographs when, by their manipulated pairing, they are taken to be seen together.

While singly the photograph picturing Hubbard Pryor as a slave might only have impressed upon the assistant adjutant general who received it the acuteness of the contraband problem mounting at Chattanooga, or caused doubt in the War Department that slaves could be made fit soldiers at all, its apposition to the picture of Pryor uniformed and at attention, an image that on *its* own might only have confirmed to Washington (perhaps in self-congratulation) that the recruitment of colored troops was proceeding apace, alters their individual content dramatically. Far apart from merely illustrating an arbitrary point, the third effect of their visual conjunction serves up an ideological argument in its appositional excess. Burgin has shown most clearly how this is achieved. He explains how a

photograph of a baby nursing at the breast of a woman in Switzerland that is positioned alongside a second photograph of another infant feeding at *her* mother's breast in rural India comes to convey an ideological half-truth about motherhood's universal sameness, imprecisely obscuring the differential conditions of health, wealth, mortality, and society worrying the smug equivalency the photographic juxtaposition intends. Burgin's point is that the formal juxtaposition of these two photographs constructs out of an ideological will a photographic trompe l'oeil "in such clarity and with all the immediacy of an observed natural truth."[43] Of course, nothing is natural about this third effect at all, and the "truth" it strains to convey is only ever an exaggeration of observable details misrepresenting the material reality from which they are extricated out of time and put "*in the service of specific vested interests.*"[44] The actual world of slavery, warfare, and freedom that was Hubbard Pryor's in 1864 reveals that those interests, relative to Pryor's pictorial utility to the Union campaign, were so profoundly racialist in effect (if not in intent) that it might be said, reasonably, that a consolidated whiteness, achieved across enemy lines and at the visually avowed expense of the full enfranchisement of the emancipated slaves, helped bring the Southern states back to the Union, the Northern states selling out to de facto slavery myriad contrabands, refugees, fugitives, and freedmen even before the war was yet won.

The magic of the third effect produced by the designs of Mussey needn't be made to seem entirely elusive. The dramatic compositional difference between the two likenesses of Pryor and the marked elevation of the subject signified by his cardboard pose, brass buckle, and order arms in the second image disclose that picture in particular as displaying what Christopher Looby has called an "aesthetic production of military spectacle." As with the more famous First South Carolina Volunteers whom Looby avers "had as one of its most important missions a symbolic or expressive one"; namely, "to display, before . . . skeptical [white] eyes . . . a model of perfect military valor,"[45] Pryor's pictures were visual propaganda. The spectacularity of his new condition (an ironic spectacularity given the severely disciplinary operations of camera, uniform, and mechanical pose) hid not only the bodily violence of slavery and its unexpected extension into Union lines (a violence fully exposed in the second of three genre images of Private Gordon of Baton Rouge)[46] but, more subtly, the political and legal disorder around the status of ex-slaves turned soldiers.[47] The more brutal reality of black soldiers' exploitive pay, black women's indenture, their same ambiguous contraband status, worrisome conscription laws, the army's paltry provisions of clothes, and these deprivations' uncoverings of

both the material injury and enduring vulnerability of "free" black bodies are made by a will to ideality and display to disappear into the black soldier's brass buttons and Union cap. Who knows, after all, but that Pryor was conscripted into military service, an indulgence of the War Department to answer the impatience of some states with freedmen willfully idle in their cities. So common was this practice that the possibility Pryor was impressed into uniform,[48] especially if enlistment amounted to no less drudgery than slavery, is hardly improbable as his countenance here has already betrayed his "conscription" into the staging of these photos. Pryor's is "coerced agency" and "simulated contentment" in these portraits.[49] And what manner but idleness is the "before" Pryor made to signify parked languidly on his buttocks alongside his ennobled "after" image, erect and at armed attention?

If the visual dialectic of Hubbard's opposing portraits constructs a photographic typology for other visual narratives of how a slave once was made man, or his natural condition improved by the goodwill of whites, then the oft-reproduced group portrait of the Fourth U.S. Colored Troops Infantry visualizes the guarantee of that event's safety to the nation for the wider, mass production of a national black manhood through early military means (fig. 47). Close to the barracks, far from the field, hands choking the mouths of rifles pushed down against the earth like shovels, Company E may look like men (of war) but caught as they are between the properly manly pose of attention and the impassive look of at ease, between their digging down into the trenches fighting and their digging out of trenches for white others, they are hardly *ideal* types, assuring that role will be reserved for white men like Mussey under whose command and surveillance they go on devotedly soldiering into an industrious, not dangerous or dependent, freedom. The Fourth U.S. Colored Troops Infantry, then, is but a more positively rendered portrait of the uniform discipline, so clearly impressed into the service of state interests, in Thomas Lindsay's *Stripes but No Stars*.

Although taken fully apart from each other, at separate times and distinct places, juxtaposed, the photograph of Company E and Lindsay's *Stripes but No Stars* also form a dialectic of before and after, yet another visual chiasmus, not unlike the one consciously detectable in the Hubbard portraits. Only in this instance, the military portrait is the historical before image of black American manhood at the first possibility of gender as a significant category of free black national life. Opposing it, *Stripes but No Stars* represents the tragic after image of the military experiment in black manhood (fig. 48). Appearing in a special section of the photographer's catalog

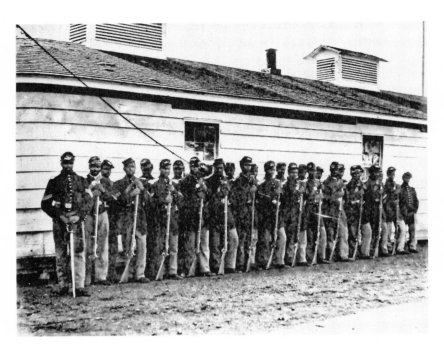

47. Company E, 4th U.S. Colored Troops.

Library of Congress, no. B817–7890.

designated for "all kinds of characters and comic subjects," *Stripes but No Stars* highlights that other familiar uniform signifying the more properly historical, tragic condition of black manhood in America that the military portrait conceals but never escapes.[50] After the Civil War, the Thirteenth Amendment officially abolished slavery for all people except those convicted of a crime, providing for the slave system's revivification under another name. The door was thus open for the mass criminalization of black men particularly whose freedom would be disciplined by hook or crook into an old order with a new face. Hartman calls this "the entanglements of slavery and freedom."[51] "Notwithstanding the nugatory power of the Thirteenth Amendment, racial slavery," she wrote, "was transformed rather than annulled."[52] The prison camp became one of its most effectual surrogates.

In October 1864, just three days following Colonel Mussey's report on the colored troops containing the chiastic photos of Hubbard Pryor, the Forty-fourth U.S. Colored Troops Infantry, recently removed to Dalton, Georgia, surrendered to General John Bell Hood's Confederate Armies.

SCENES IN WESTERN NORTH CAROLINA.

VIEWS OF WESTERN NORTH CAROLINA.

48. Thomas H. Lindsay, *Stripes but No Stars*.

Wm. B. Becker Collection/PhotographyMuseum.com. © MMX The American
Photography Museum, Inc.

The rebels immediately released the unit's white officers and, though
the Confederacy did not recognize blacks as prisoners of war until many
months later, Pryor and 350 members of the Forty-fourth were confined
in a Confederate prison camp more desperate than the contraband camps
most started in. Here Pryor and approximately 124 of his comrades spent
the rest of the war working on Confederate railroads in Alabama, Mis-
sissippi, and Georgia. When the Confederate Armies finally surrendered
at war's end, Pryor and his cohort were abandoned near Griffin, Geor-
gia. Pryor's service record, file 80679 of the Colored Troops Bureau now
housed at the National Archives, reports Pryor having been discovered "in
a sick broken down naked and starved condition."[53] Hubbard ultimately
survived the ordeal but kept his Federal service a secret. For Pryor ended
up only a few short hours from the Polk County plantation he escaped
from two years earlier. For fear of his life, apparently, Hubbard did not file
for any of the Federal restitution to which he was entitled. Nor did he make
any claims to the Bureau of Refugees, Freedmen, and Abandoned Lands
(later, the Freedmen's Bureau) for the other benefits owed to him as a vet-
eran. If the original photographs of Pryor were intended to display how a
slave was made a man, then the rest of Pryor's story suggests that his end
may have been in his beginning, that the congratulating picture of "how

a slave was made a man" might be more truthfully reversed to reflect the irony of war's material outcome. Because of Frederick Douglass, we have seen how a slave was made a man. But because of Hubbard Pryor and a North Carolina chain gang, we can see with more sober eyes how often a man is made a slave.

Notes

1. Walter Benjamin, "The Work of Art in the Age of Mechanical Reproduction," in *Illuminations*, ed. Hannah Arendt, trans. Harry Zohn (New York: Schocken, 1969), 241.

2. That these artful phrases gained currency in the wake of two U.S. invasions of Iraq in 1991 and 2003, respectively, is no surprise under Benjamin's logic.

3. Benjamin, "The Work of Art in the Age of Mechanical Reproduction," 243.

4. See William A. Frassanito, *Antietam: The Photographic Legacy of America's Bloodiest Day* (New York: Scribner, 1978); *Gettysburg: A Journey in Time* (New York: Scribner, 1975); *Grant and Lee: The Virginia Campaigns, 1864-1865* (New York: Scribner, 1983); William C. Davis, ed., *Shadows of the Storm: Volume One of The Image of War, 1861-1865* (Garden City: Doubleday and Co., 1981); *Touched by Fire: A National Historical Society Photographic History of the Civil War, Vol. 1* (Boston: Little, Brown, 1985); Alan Trachtenberg, *Reading American Photographs: Images as History, Mathew Brady to Walker Evans* (New York: Hill and Wang, 1989). I take "national fantasy" from Lauren Berlant, *The Anatomy of National Fantasy: Hawthorne, Utopia, and Everyday Life* (Chicago: University of Chicago Press, 1991). There she writes: "there is always an official story about what the nation means, and how it works: not only in the way propaganda enacts a systematic fraud on citizen-readers, but also in the power of law to construct policy and produce commentary that governs the dominant cultural discussion of what constitutes national identity" (11). In this chapter, photography serves a vague "propaganda" function by constructing the literal picture of national identity in the portrait photograph of the Civil War soldier. Pictured in *his* uniform, the black Civil War soldier, specifically, enacts "a fantasy of national integration" (21), which Berlant shows has long since been a construction of the nationalist utility of utopian discourse.

5. In 1864 the U.S. War Department began a collection of official orders, reports, maps, diagrams, letters, and eyewitness accounts of the war's transactions. By this writer's survey, *The Official Records of the War of Rebellion* neither relies upon nor mentions the work of any of these documentarians.

6. Save for the first-person varieties of Thomas Wentworth Higginson's *Army Life in a Black Regiment* (1869; rprt. East Lansing: Michigan State University Press, 1961) and Susie King Taylor's *Reminiscences of My Life in Camp with the 33d United States Colored Troops Late 1st S.C. Volunteers* (1902; rprt. Athens: University of Georgia Press, 2006), both works spotlighting the First South Carolina Volunteers, black regimental histories are so little-known as to elude the notice of all but a precious few of the most exacting historians. After Higginson and Taylor, Luis F. Emilio's

A Brave Black Regiment: History of the Fifty-Fourth Regiment of Massachusetts Volunteer Infantry, 1863–1865 (1891; rprt. Shmegma: De Capo Press, 1995) is another key work in black regimental history, having informed the Academy Award–winning film *Glory* in 1988. Other works include Agness Kane Callum, *Colored Volunteers of Maryland Civil War: 7th Regiment United States Colored Troops, 1863–1866* (Baltimore: Mullac Publishers, 1990); William H. Chenery, *The Fourteenth Regiment Rhode Island Heavy Artillery (Colored) in the War to Preserve the Union, 1861–1865* (Providence: Snow and Farnham, 1898); Agnes Kane Callum, *9th. Regiment United States Colored Troops Volunteers of Maryland Civil War, 1863–1866* (Baltimore: Mullac Publishers, 1999); James M. Paradis, *Strike the Blow for Freedom: The 6th United States Colored Infantry in the Civil War* (Shippensburg: White Mane, 2000); John Raymond Gourdin, *Voices from the Past: 104th Infantry Regiment—USCT, Colored Civil War Soldiers from South Carolina* (Westminster: Heritage Books, 2007); and Charles B. Fox, *Record of the Service of the 55th Regiment of Massachusetts Volunteer Infantry* (Cambridge: Press of J. Wilson and Son, 1868).

7. Steven Hahn, *A Nation under Our Feet: Black Political Struggles in the Rural South from Slavery to the Great Migration* (Cambridge: Harvard University Press, 2003), 94.

8. Achieved by the Second Confiscation Act, Section 11, July 17, 1862, and the Militia Act, Sections 12, 13, 1 and 15, July 17, 1862.

9. Benjamin, "The Work of Art in the Age of Mechanical Reproduction," 241. By the "inscriptive" expressions of the proletarian masses, I mean to evoke Paul Connerton's definitions of "inscriptive" and "incorporative" practices. Inscriptive practices aid social memory by formal storage of information in media such as photographs, cinema, sound, and of course print culture. Incorporative practices are embodied and involve body posture, facial expressions, gesture, physical movement, and so on as sites and sources of social memory. Inasmuch as their subjects evince a body consciousness in their poses before the camera, black soldier portraits represent black masculinity inscriptively and incorporatively. See Paul Connerton, *How Societies Remember* (New York: Cambridge University Press, 1989).

10. William C. Darrah, *Cartes de Visite in Nineteenth Century Photography* (Gettysburg, PA: W. C. Darrah, 1981), 1.

11. William Dean Howells, *The Rise of Silas Lapham* (New York: Penguin Classics, 1986), 70. All subsequent references shall be to this edition and indicated in parentheticals in the text.

12. Allan Sekula, "The Traffic in Photographs," in *Only Skin Deep: Changing Visions of the American Self*, ed. Coco Fusco and Brian Wallis (New York: Harry N. Abrams, Inc., 2003).

13. Sekula, "The Traffic in Photographs."

14. "Photograph Albums," *Scientific American* 4, no. 14 (1862).

15. *New York Tribune*, August 20, 1862, quoted in Josephine Cobb, "Photographers of the Civil War," *Military Affairs* 26, no. 3 (Autumn 1962): 128.

16. Nell Irvin Painter, *Creating Black Americans: African American History and Its Meanings, 1619 to the Present* (New York: Oxford University Press, 2006), 131.

17. Hahn, *A Nation under Our Feet*, 82 (emphasis added).

18. Ibid. (emphasis added).

19. The original images are kept secured at the National Archives and are available to researchers only in photocopy. Since the National Archives has not cataloged the original images by type of photograph, this writer surmises their carte de visite format by the evidence of only one other Morse image (incorrectly identified as by the Morris Gallery of the Cumberland) he has been able to locate, *Portrait of a Boy Soldier*, in the Civil War Reference File at the Library of Congress. Notes on the image disclose that a "copy photo made by LC in 1961 of carte de visite." Ambrotype and tintype are also possible forms of the Pryor photographs.

20. Frederick Douglass, "Pictures and Progress," Frederick Douglass Papers at the Library of Congress: Speech, Article, and Book file, 1846–1894 and Undated; American Memory, Library of Congress Manuscript Division, available online at http://memory.loc.gov/ammem/doughtml/dougFolder5.html, ms. page 3.

21. Presumably this date is accurate. The pretense of the before picture is that it is a reflection of Pryor before coming under Union protection and care and therefore is presumed to have been taken on or near April 7, 1864. If one assumes that a Union uniform was immediately available for Pryor (or one provided for the dress-up of all photographed recruits), then it is reasonable that the second (i.e., "after") image was taken on the same day. It is possible, however, that Pryor's "before" picture, while intended to depict his slave past, might reflect his condition behind Union lines up to the October 1864 date Colonel Reuben D. Mussey sent these photographs to his superior at the War Department. Whenever the "before" photograph was taken, the "after" image need not have been taken on the same day since its taking depended upon the availability of a uniform to dress Pryor in. What seems certain, in any case, is the before and after designs of the photographer (or commanding officer, as the case may be).

22. George F. Witham's *Catalogue of Civil War Photographers, 1861–1865* (Memphis: George F. Witham, 1988) lists a "Morse's Gallery of the Cumberland" and a "Morse & Peaslee, 'Gallery of the Cumberland'" in Nashville, Tennessee (both at 25 Cedar St.); a "Morse's Gallery" in Huntsville, Alabama; and a "Morse and Peaslee, Army Photographers" at the Department of the Cumberland. It is very likely that A. S. Morse operated by all of these designations, having studios, like the more famous Oliver and McPherson company, in at least two states.

23. Victor Burgin, "Art, Common Sense and Photography," in *Visual Culture: The Reader*, ed. Jessica Evans and Stuart Hall (London: Sage Publications, 1999), 45.

24. John A. Collins to William Lloyd Garrison, January 18, 1842, in *Liberator*, January 21, 1842.

25. Frederick Douglass, *My Bondage and My Freedom* (1855; rprt. New York: Dover, 1969), 360–61 (emphasis in original).

26. Tom Thumb was the stage name of Charles Sherwood Stratton, a dwarf performer made international celebrity by Barnum's traveling circus. Barnum also popularized the Fiji mermaid, a curiosity purporting to be the mummified remains of a creature half mammal, half fish. In reality, the Fiji mermaid was the head and torso of a baby monkey attached to the body of a fish.

27. Terry Baxter, *Frederick Douglass's Curious Audiences: Ethos in the Age of the Consumable Subject* (New York: Routledge, 2004), 148.

28. *National Anti-Slavery Standard*, May 22, 1845, quoted in John W. Blassingame, ed., *The Frederick Douglass Papers: Series One, Speeches, Debates, and Interviews; Vol. 1* (New Haven: Yale University Press, 1979), 28.

29. Baxter, *Frederick Douglass's Curious Audiences*, 89.

30. Frederick Douglass, *Narrative of the Life of Frederick Douglass, an American Slave, Written by Himself*, ed. David Blight, 2nd ed. (Boston: Bedford/St. Martin's Press), 84.

31. See chapter one of Robert Stepto, *From Behind the Veil: A Study of Afro-American Narrative*, 2nd ed. (Urbana: University of Illinois Press, 1991) for a reading of Garrison's self-referential habit in the Douglass "Preface."

32. Douglass, *My Bondage and My Freedom*, 362.

33. Frederick Douglass to J. Miller McKim, September 5, 1844, qtd. in William S. McFeely, *Frederick Douglass* (New York: W. W. Norton, 1991), 114 (emphasis added).

34. Although the Forty-fourth U.S. Colored Troops Infantry moved to Rome, Georgia, in July 1864, just twenty miles from Pryor's Polk County, and to Dalton, Georgia, in October, approximately thirty miles from Chattanooga, Pryor's enlistment in April 1864 suggests, contra Robert Scott Davis Jr., that he had already escaped the more than ninety miles to Chattanooga when he enlisted and did not join the "wagon trains of black and white recruiting parties [that] fanned out across the countryside [nearby his native Polk County] in search of enlistees" (Robert Scott Davis Jr., "A Soldier's Story: Records of Hubbard Pryor, 44th United States Colored Troops," *Prologue* [Winter 1999]: 269).

35. Douglass, *Narrative of the Life of Frederick Douglass*, 41.

36. See William A. Gladstone, *Men of Color* (Gettysburg: Thomas Publications, 1993), 215, and Davis Jr., "A Soldier's Story," 268, 272n13.

37. Quoted in Gladstone, *Men of Color*, 105.

38. James Alan Marten, *Civil War America: Voices from the Home Front* (Santa Barbara, CA: ABC-CLIO, 2003), 209, 214.

39. Joseph T. Glatthaar, *Forged in Battle: The Civil War Alliance of Black Soldiers and White Officers* (New York: The Free Press, 1990), 55.

40. Colonel Reuben D. Mussey to Mssrs. Hood and Bostwick, August 15, 1864, reprinted in Ira Berlin et al., ed., *Freedom: A Documentary History of Emancipation, 1861–1867; Series 1, Volume 1: The Destruction of Slavery* (Cambridge: Cambridge University Press, 1985), 324.

41. U.S. Senate, "Report of the Commissioners of Investigation of Colored Refugees in Kentucky, Tennessee, and Alabama," Senate Executive Documents, 38th Congress, 2nd Sess., No. 28, quoted in Berlin et al., *Freedom*, 325.

42. Quoted in Colonel Reuben D. Mussey to Major C. W. Foster, in Berlin et al., *Freedom*, 604.

43. Burgin, "Art, Common Sense and Photography," 43.

44. Ibid.

45. Christopher Loobey, "A Literary Colonel," *The Complete Civil War Journal and Selected Letters of Thomas Wentworth Higginson* (Chicago: University of Chicago Press, 2000), 4. The First South Carolina Volunteers later became the Thirty-third U.S. Colored Troops.

46. According to Gladstone, three illustrations of the fugitive slave named Gordon accompanied the article "A Typical Negro" in *Harper's Weekly*, July 4, 1863. As photographs were not yet reproducible in periodical print, the illustrations, "Gordon as he entered our lines," "Gordon Under Medical Inspection," and "Gordon in uniform as a US Soldier," copied three original photographs of Gordon taken by Baton Rouge photographers, McPherson and Oliver. I have not yet located the two other photographs accompanying "Gordon Under Medical Inspection."

47. The status of blacks involved in the war effort was irregular and ambiguous. They were, by turns, contraband, volunteers, conscripted men, substitutes, armed combatants, enlisted noncombatants.

48. Gladstone writes, "The general order [No. 75] also referred to the drafting of slaves of loyal masters, making the slave free and giving the bounty of $100.00 to the master. A slave master in each of the slave states represented in Congress was to receive up to $300.00 compensation for each black volunteer. The volunteer was then made free" (*Men of Color*, 105).

49. Saidiya Hartman, *Scenes of Subjection: Terror, Slavery and Self-Making in Nineteenth-Century America* (New York: Oxford University Press, 1997), 7.

50. The prisoners' stripes might also recall those bloody ones carved directly onto the flesh by the lash since Douglass connected the stripes of the American flag, parodied by the title of the picture capturing black convicts, to precisely this wounding. In his "Farewell Speech to the British People" in 1847, he held forth: "United States! Your banner wears / Two emblems, one of fame; / Alas! the other that it bears / Reminds us of your shame, / The white man's liberty in types / Stands blazoned on your stars; / But what's the meaning of your stripes? / They mean your Negroes' scars" (Frederick Douglass, "Farewell Speech to British People," in *Life and Writings of Frederick Douglass: Vol. 1, Early Years 1817-1849*, ed. Philip Foner [New York: International Publishers, 1950], 227).

51. Hartman, *Scenes of Subjection*, 7.

52. Ibid., 10.

53. Quoted in Davis Jr., "A Soldier's Story," 270.

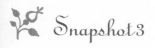 Snapshot 3

Unfixing the Frame(-up)

A. P. BEDOU

Shawn Michelle Smith

In a memorable photograph, Booker T. Washington stands on a platform looking amiably down into the crowd of people gathered around him (fig. 49). He is framed nearly in the center of the image, his body turned away from the photographer who observes him from behind. It appears as though something has attracted his attention in the crowd, and as he looks down, the camera captures his face in profile, a smile beginning to curve his lips and light up his eyes. He leans slightly forward, as if fully engaged by the crowd that engulfs him. We look at him from behind two rows of seated listeners and see the seemingly endless rows of people that extend up and out of the frame on the other side of his narrow platform. He is literally encircled by admirers. The crowd is registered in a soft focus that makes individual faces nearly indiscernible, blending bodies into a mass of black and white at the outer edges of the frame. The only figure rendered in sharp focus, Booker T. Washington stands out from the indefinite masses, drawing the eyes of later viewers to his arresting presence, just as he commanded the attention of his immediate audience.

In the image the orator is still, his mouth closed. But the effects of his speech are still rippling through the audience, brightening the indistinct faces with smiles. It appears that Washington is enjoying the effect his speech has made on the crowd, listening to the echoes and stirrings of laughter and appreciation sent back to him. It is as though a current of energy swirls around him, as if motion rather than depth of field has made the crowd blurry, and Washington stands splendidly still in the middle of

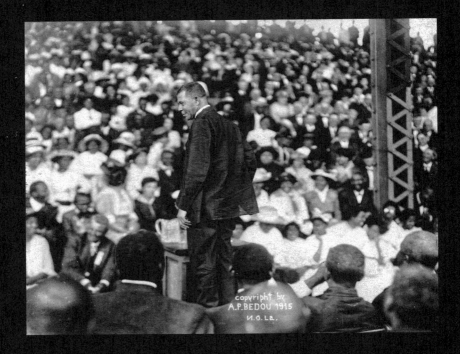

49. A. P. Bedou, photograph of Booker T. Washington.

Courtesy of Xavier Archives, New Orleans, LA.

it all, the source and receiver of this energy, snapped into sharp focus. Fred Moten has taught us to listen for the sound of the photograph, to hear its shattering shout and moan. And while the sound of this photograph is not the deep cry of anguish Moten hears, not the sound that ruptures the image, this sound registers the shout of a call and response.[1] The sound of this photograph is the crackle of an electric energy generated by the famous orator, delivered to his audience, and circulated back again.

Arthur P. Bedou took this photograph of Booker T. Washington in 1915, during Washington's last tour of Louisiana. Bedou knew his subject well, for he was Washington's private photographer and traveled with the elder statesman to document his lecture tours from 1908 to 1915, the year of Washington's death. Born in New Orleans in 1882, Bedou was a well-known and successful photographer for over six decades.[2] In an early self-portrait, he presents himself in an elegant tuxedo (fig. 50). His dark jacket reveals the deep V of a crisp white shirt, high collar, and white tie. On his right hand he wears a striking white glove accented with dark piping, and in it he clutches the glove removed from his left hand. Though formally and even stiffly dressed, he leans slightly forward in his chair in a relaxed pose and gazes directly out at the camera. Light touches the right side of his face, revealing the contours of his forehead, cheek and chin, as the left side recedes into softer shadow. Both eyes sparkle as they look out into the camera.

Bedou's self portrait is by no means the best-known image of the photographer. In his more famous likeness, Bedou has placed his camera in the center of the frame, amidst a large crowd of densely packed people (fig. 51).[3] Standing on its tripod in the middle of the crowd, body and lens raised almost to head and eye level, the camera appears animated, as if it is another viewing subject among many. The men and women standing shoulder to shoulder with Bedou's camera look back at another camera, at the one that has captured this image. Some in the crowd look quizzical, others curious, a couple confused. Only one man's face beams back at the maker of this image and at us, riveting our gaze with his twinkling eyes. Standing several feet behind the camera, head raised slightly above the crowd, this man's crisp white shirt and white tie mark a deep V against his dark jacket. Smiling back at the photographer, this man is A. P. Bedou himself.

In this photograph, Bedou has situated himself and his camera amidst "the people." The photographer and his instrument share the same space of the crowd, and although they stand out slightly from it, they are clearly "of it." The photograph suggests that Bedou makes his photographs from the "people's" perspective; he sees his subject, Booker T. Washington, the

50. A. P. Bedou, self-portrait.
Courtesy of Xavier Archives, New Orleans, LA.

51. A. P. Bedou in the crowd.
Reproduced with permission. Photographs and Prints Division, Schomburg Center for Research in Black Culture, the New York Public Library, Astor, Lenox and Tilden Foundations.

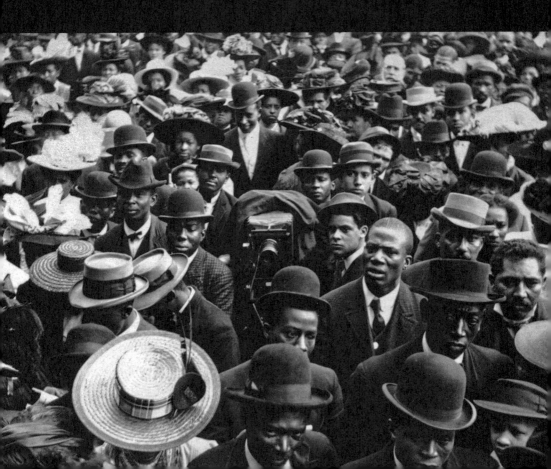

famous orator, as they do. But the image also clearly announces Bedou's understanding of his role as a picture maker within the crowd. His photographs will frame the crowd and its views for posterity, and they will also delineate the view for years to come. In this photograph, Bedou has turned the camera back on himself as photographer, highlighting his self-conscious understanding of his role as a maker of images.

This photograph of Bedou was made around 1910, and judging from the size of the crowd, it was most likely made on one of Booker T. Washington's speaking tours. The identity of the photographer who made the image remains unknown, but given its unusual perspective, looking down at heads and hats pressed close, it was almost certainly made from the raised vantage of the speaker's platform. Indeed, the photograph might have been made by Booker T. Washington himself. But regardless of whether or not Washington actually made the image, the photograph can be said to have been taken from his perspective and to represent his point of view, as it was made from the place on the platform he so singularly inhabited. Whether or not it directly reproduces a specific set of relations, then, the photograph enables one to imagine an exchange of gazes between orator and photographer, a playful reversal of roles in which the photographer becomes subject and the subject becomes photographer, and both collude in the knowledge of their image making.

The image of Bedou with his camera calls photography itself into view, drawing attention to the processes through which images are made and circulated and consumed and viewed. Highlighting the literal framing of the subject through the camera's lens, this photograph also evokes the cultural frames and filters that shape and inform seeing. As Maurice Wallace has powerfully demonstrated, such cultural frames are particularly fixed and focused when the black male subject is brought into view. "Black men tend to be seen photographically in white eyes, looked on as one looks on a snapshot or some other objectified, arrested image."[4] White racialist ways of seeing enframe or "frame(-up)" black masculinity, transforming images of black men into fetishes that make the black male body both overly visible and invisible, a spectacle and a specter.[5] Bedou's photograph of photography calls attention to this broader notion of the frame at the same time that it troubles the privilege of a white gaze. Highlighting the frame, the photograph disrupts the frame(-up). For this image represents a circuit of black looks in which Bedou sees Booker T. Washington, Booker T. Washington sees Bedou, and both see the large crowd of African American men and women looking at Booker T. Washington.

The image of the photographer in the crowd emphasizes African Ameri-

can looking. It represents Booker T. Washington's proximate and present viewers, highlighting their vision of the man. Both Bedou and Washington know, and indeed hope, that Bedou's photographs will circulate widely, beyond the sphere of Washington's African American admirers, into the popular cultural domain of the racist frame(-up). By self-consciously calling attention to the looking relations embedded within them, Bedou's photographs remind later viewers that the frame(-up) is always a reframing of African American men. Indeed, Bedou's photographs declare that the frame(-up) won't be the first or the last view of Washington.

If the photograph of Bedou in the crowd resists the frame(-up) by underscoring African American looking relations, his photograph of Washington enjoying his effect on the crowd resists the frame(-up) by infusing sight with sound. As the latter image demonstrates, the audience has gathered not only to see Washington but also to hear him. Indeed, if the photograph of Bedou, the photographer, emphasizes looking, the photograph of Washington, the orator, emphasizes listening. Bedou's photograph of Washington represents the force of Washington's word, the partially disembodied power of his speech. Registering the response of his audience, the effect of his oration, the photograph does not contain Washington in his image. Bedou's photograph refuses to see Washington only photographically, to limit him to an objectified vision of his body. Focusing on the sound of the image, the photograph registers Washington's effect within and beyond the image. Together Bedou's photographs work to unfix the frame(-up), encouraging us not only to see Washington but also to hear him.

Notes

1. Fred Moten, *In the Break: The Aesthetics of the Black Radical Tradition* (Minneapolis: University of Minnesota Press, 2003), 192–211.

2. Deborah Willis-Thomas, *Black Photographers, 1840–1940: An Illustrated Bio-Bibliography* (New York: Garland, 1985), 13–14; Deborah Willis, *Reflections in Black: A History of Black Photographers, 1840 to the Present* (New York: Norton, 2000), 39–40; *The New Orleans Tribune: The Way We Were, Our Family Album* 4, no. 6 (July 1988): 14; Xavier University Archives and Special Collections, A. P. Bedou Collection, Series IV; Newspaper obituaries, Xavier University Archives and Special Collections, A. P. Bedou Collection, Series I; Michael Bieze, *Booker T. Washington and the Art of Self-Representation* (New York: Peter Lang, 2008), describes the contest between A. P. Bedou and C. M. Battey to be Washington's official photographer (69–82). To document his tours, Washington wanted "snapshots" of himself in action that could then be assembled into narrative form in albums. Bedou complained of the difficulty of making such action shots but nevertheless complied (78), lobby-

ing Tuskegee for a camera with a faster shutter speed. Bedou also made postcards of Washington and Tuskegee, as well as photograph albums (182, 211, 214).

3. Deborah Willis chose this image for the striking cover of her groundbreaking book on African American photographers, *Reflections in Black*.

4. Maurice O. Wallace, *Constructing the Black Masculine: Identity and Ideality in African American Men's Literature and Culture, 1775–1995* (Durham: Duke University Press, 2002), 82.

5. Wallace, *Constructing the Black Masculine*, 8, 30, 44.

 NINE

"Looking at One's Self
through the Eyes of Others"

W. E. B. DU BOIS'S PHOTOGRAPHS FOR

THE PARIS EXPOSITION OF 1900

Shawn Michelle Smith

In *The Souls of Black Folk*, W. E. B. Du Bois describes double conscious-
ness as the "sense of always *looking at one's self through the eyes of others*" and
thereby draws upon a *visual* paradigm to articulate "the strange meaning of
being black" in the Jim Crow United States.[1] For Du Bois, African Ameri-
can subjectivity is mediated by a "white supremacist gaze"[2] and therefore
divided by contending images of blackness—those produced by a domi-
nant white culture, and those maintained by African American individu-
als within African American communities. It is the negotiation of these
violently disparate images of blackness that produces the "twoness" of Du
Bois's double consciousness, the psychological and social burden of at-
tempting to assuage "two souls, two thoughts, two unreconciled strivings;
two warring ideals."[3]

Recognizing the visual paradigms that inform Du Bois's conception of
double consciousness can help one to understand a remarkable collection
of photographs he assembled for the American Negro Exhibit at the Paris
Exposition of 1900. These images appear at first enigmatic, but when read
against the late nineteenth-century "race" archives they originally engaged,
we can see how the photographs emblematize the complicated visual dy-
namics of double consciousness. Du Bois's American Negro photographs
disrupt the images of African Americans produced "through the eyes of
others" by simultaneously recalling and supplanting those images with a
different vision of the American Negro. Specifically, Du Bois's photographs
contest the discourses and images of an imagined "Negro criminality" that

were evoked to legitimize the crime of lynching. Considering the images in this light restores a key text to the visual archives of U.S. race relations and also underscores the importance of W. E. B. Du Bois as a *visual* theorist of "race."

Du Bois's collection of American Negro photographs includes 363 images of people and places. The photographers who made the images are not noted, but I have identified Thomas Askew as the producer of a number of striking photographs included in the series.[4] Du Bois organized the photographs into four volumes and presented them in three separate albums titled *Types of American Negroes, Georgia, U.S.A.* (volumes 1–3) and *Negro Life in Georgia, U.S.A.* The albums constituted one of three displays Du Bois supervised for the American Negro Exhibit, including a series of charts and graphs documenting the social and economic progress of African Americans since the American Civil War and a three-volume set containing the Georgia legal code pertaining to African Americans.[5] These displays joined other exhibits celebrating work in African American education and African American literary production, which together were organized under the direction of Thomas J. Calloway for the exposition.[6] The American Negro Exhibit was housed in the Palace of Social Economy, and it won an exposition grand prize.[7]

The photograph albums that Du Bois assembled for the American Negro Exhibit contain a variety of images, but by far the most numerous and notable are the hundreds of paired portraits that almost fill volumes one and two. In examining these portraits, I would like to suggest that Du Bois was not simply offering up images of African Americans for perusal but was critically engaging viewers in the visual and psychological dynamics of race at the turn of the century. In 1900 Du Bois declared, "The problem of the Twentieth Century is the problem of the color line,"[8] and with his American Negro photographs for the Paris Exposition of 1900, he asked viewers to consider their places in relation to that color line.

Du Bois's American Negro portraits are disturbing, even shocking, in the way they mirror turn of the century criminal mug shots. Indeed, the images appear uncannily doubled, connoting both middle-class portraits and criminal mug shots simultaneously. Drawing upon Henry Louis Gates Jr.'s theory of "signifyin(g)" in order to tease out the *doubled* signifying registers the photographs evoke,[9] I argue that by replicating the formal characteristics of both the middle-class portrait and the criminal mug shot, Du Bois's American Negro photographs subvert the visual registers and cultural discourses that consolidated white middle-class privilege against an image of "Negro criminality" at the turn of the century.

Interrogating both middle-class identity and whiteness, Du Bois's images signify across the multivalent boundaries that divide the "normal" from the "deviant," challenging not only the images of African Americans produced "through the eyes of others" but also the discursive binaries of privilege that maintain those images. Through a process of visual doubling, Du Bois's American Negro portraits engender a disruptive critical commentary that troubles the visual and discursive foundations of white middle-class dominance by destabilizing their oppositional paradigms.

Repetition with a Difference

In an essay titled "In Our Glory: Photography and Black Life," bell hooks proposes: "The camera was the central instrument by which blacks could disprove representations of us created by white folks."[10] It is in this resistant spirit that I think one should read the photographs Du Bois collected for display at the Paris Exposition of 1900. The portraits arranged in *Types of American Negroes, Georgia, U.S.A.* work against dominant, white-supremacist images of African Americans perpetuated both discursively and in visual media at the turn of the century. Certainly the images differ dramatically from the racist caricatures of Sambo, Zip Coon, and Jim Crow, stereotypes that fueled white fantasies of racial superiority. As Du Bois himself said of the Paris Exposition photographs, they "hardly square with conventional American ideas."[11] More importantly, however, the photographs problematize the images of "Negro criminality" that worked to consolidate a vision of white middle-class privilege at the turn of the century.

Du Bois was well aware that challenging the discourses and images of "Negro criminality" was a particularly important political necessity for African Americans. Increasingly over the course of the late nineteenth century, white Americans evoked the imagined "new Negro crime" of raping white women in order to legitimize violence upon African American bodies.[12] White lynch mobs called forth an image of the black male rapist in order to justify the torture and mutilation of black men. As Ida B. Wells observed in the 1890s, lynching served as a form of economic terrorism, as a racialized class warfare translated into the terms of sexual purity and transgression.[13] Many whites argued that African American criminal behavior had increased dramatically during the postbellum era and suggested that newly emancipated blacks were reverting to their "natural" state of inferiority without the guidance of their former masters. In "The Negro Problem and the New Negro Crime," one writer for *Harper's Weekly* contended that "such outrages are sporadic indications of a lapse of the

Southern negro into a state of barbarism or savagery, in which the grati-
fication of the brutish instincts is no longer subjected to the restraints of
civilization."[14] A *Harper's* correspondent concurred: "In slavery negroes
learned how to obey, and obedience means self-control." Lamenting the
demise of "discipline" under slavery, the same writer proposed that "a sub-
stitute must be found" to ensure the "mental and moral discipline" of the
African American.[15] In this way, some white Americans fabricated dis-
courses of "Negro criminality" to evoke the imagined inferiority of Afri-
can Americans and to justify increasing social surveillance, segregation,
and violence.

Du Bois explicitly challenged pervasive and extreme white perceptions
of "Negro criminality," particularly the tenets that "the Negro element is
the most criminal in our population," and that "the Negro is much more
criminal as a free man than he was as a slave," in his edited volume *Notes on
Negro Crime, Particularly in Georgia*.[16] In this text Du Bois argues that slavery
was not a check on supposed criminal tendencies; it was instead an insti-
tution that encouraged criminal behavior. Although he fails to critique
the very idea of "Negro criminality," he does attempt to denaturalize it,
discussing crime as the result of social, historical, and economic factors,
not as an innate or inherent racial tendency. Addressing what he deems
the "faults of the Negroes" in the "causes of Negro crime," Du Bois con-
siders "loose ideas of property" and "sexual looseness," and quotes Sidney
Olivier, who states: "All these faults are real and important causes of Negro
crime. They are not racial traits but due to perfectly evident historic causes:
slavery could not survive as an institution and teach thrift; and its great
evil in the United States was its low sexual morals; emancipation meant
for the Negroes poverty and a great stress of life due to sudden change.
These and other considerations explain Negro crime."[17] In delineating the
"faults of the whites" in producing "Negro criminality," Du Bois notes "a
double standard of justice in the courts," "enforcing a caste system in such
a way as to humiliate Negroes and kill their self-respect," and "peonage
and debt-slavery."[18] In *Notes on Negro Crime* Du Bois demonstrates how dis-
courses of innate "Negro criminality" directed public attention away from
the material circumstances of extreme poverty and racism under which
many "free" African Americans struggled to survive by sharecropping in
the post-Reconstruction South.

Du Bois, like Ida B. Wells, knew that many whites viewed African
American economic success as a threat to white cultural dominance, as a
privilege "stolen" from white possessors. Indeed, many whites linked an
imagined "Negro criminality" to "talk of social equality."[19] Du Bois exam-

ines this position in *The Souls of Black Folk* in a chapter titled "The Coming of John." In his fictional depiction of an encounter between a white judge and an educated African American teacher in the postbellum South, Du Bois demonstrates how white anxiety over social and economic equality with African Americans was intertwined with white violence upon the black body in turn of the century U.S. culture. Du Bois's white judge proclaims:

> Now I like the colored people, and sympathize with all their reasonable aspirations; but you and I both know, John, that in this country the Negro must remain subordinate, and can never expect to be the equal of white men. In their place, your people can be honest and respectful; and God knows, I'll do what I can to help them. But when they want to reverse nature, and rule white men, and marry white women, and sit in my parlor, then, by God! we'll hold them under if we have to lynch every Nigger in the land.[20]

The immediacy with which the white judge moves from an imagined social equality to the desire to lynch is both terrifying and telling. In Du Bois's depiction the middle-class African American man is, in and of himself, a source of white rage. Further, Du Bois's story marks the dependence of white conceptions of African American "honesty" on a system of racial subordination. In Du Bois's rendition of the African American image produced "through the eyes of [white] others," African Americans "can be honest" only when they remain "in their [subordinate] place," a position well outside the bounds of the white middle-class parlor. Du Bois knew that examples of African American economic success circulated under white eyes waiting to proclaim "usurper," "liar," "thief." For many whites, the image of the successful African American was also an image of one who had stolen cultural privilege from its "rightful" owners. In other words, when projected through the eyes of white others, the image of the middle-class African American individual often transmuted into the mug shot of a "Negro criminal." It is precisely this transformation of the black image in the eyes of white beholders (a transformation from middle-class portrait into criminal mug shot) that Du Bois's American Negro portraits unmask.

In Du Bois's albums the first images displayed (which frame a reading of later images) replicate with striking precision the formal style of the criminal mug shot (fig. 52). Adapting Henry Louis Gates Jr.'s theory of "signifyin(g)" to visual texts enables one to see how Du Bois's portraits "signify on" the formal visual codes of criminological photography. While

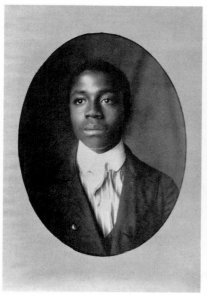
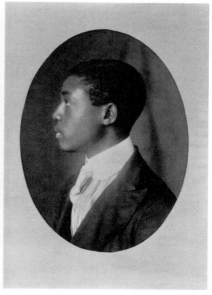

**52. From *Types of American Negroes, Georgia, U.S.A.*, compiled by
W. E. B. Du Bois, 1900.**

Daniel Murray Collection, Library of Congress, Washington, D.C.

Gates defines "signifyin(g)" as an African American manipulation of signs
that applies primarily to verbal and musical texts, I propose that one can
also use this theoretical tool in reading visual media.[21] Certainly one can
identify a wide store of "received" images in U.S. culture, and one might
also delineate a set of tropes or styles specific to different kinds of visual
signification.[22] While the assumed link between photographic signifier
and signified may prove more tenacious than the visually arbitrary linguis-
tic signifier, it is still possible to repeat visual codes "with a difference"[23]
and thereby trouble the assumed naturalness of photographic representa-
tion. Indeed, to mention one well-known example, the artist Cindy Sher-
man has reproduced iconic images from Hollywood films in order to show
how meaning can be manipulated by repeating images within different
interpretive frames. Sherman's "stills" problematize Hollywood's gendered
visual strategies by over-naturalizing them, thereby destabilizing the nor-
mative power of the images she imitates. Also, her repetitions work not
only to undermine representational strategies but also to disrupt the posi-
tion of passive observers; her images critique dominant visual codes and

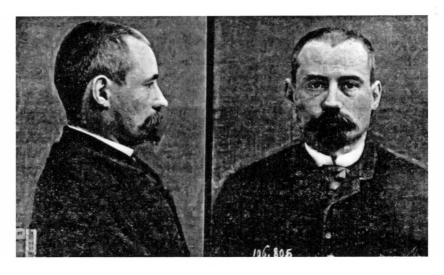

53. From Alphonse Bertillon, *Identification anthropométrique, instructions signalétiques,* **new edition (Melun: Imprimerie Administrative, 1893).**

Courtesy of Manuscripts, Archives, and Special Collections, Washington State University Libraries, Pullman.

engender critical viewers.[24] It is this doubly critical strategy, of denaturalizing both images and viewing positions, that signifying on dominant representations can effect.

In Gates's terms, Du Bois's photographs repeat the visual tropes of the criminal mug shot "with a difference," directing reading of the images by "indirection," and thereby inverting the dominant signification of these particular photographic signs.[25] The initial portraits show expressionless subjects photographed from the shoulders up, both head on and in right-angle profile, replicating uncannily the full face and profile headshots of the prison record. Further, the photographs depict subjects posed against a plain gray background, devoid of props and frills, and reminiscent of the institutionalized walls against which legal offenders are posed. In short, the images in Du Bois's albums repeat the formal signifiers of the criminal mug shots institutionalized in U.S. prisons and police archives in the late nineteenth century.

In replicating the formal attributes of the criminal mug shot, Du Bois was signifying on a pervasive cultural icon. "Rogues' galleries" showcasing criminal mug shots for public perusal grew alongside middle-class portrait galleries from the very inception of photography (fig. 53). As early as 1859, the *American Journal of Photography* ran an article that proclaimed:

"As soon as a rascal becomes dangerous to the public, he is taken to the Rogues' Gallery, and is compelled to leave his likeness there, and from that time on he may be known to any one."[26] Popular criminal archives encouraged middle-class citizens to survey the population for social deviants and criminal intruders, those who might attempt to steal the property upon which middle-class cultural privilege depended. Specifically, such archives trained middle-class individuals to scrutinize the bodies of their acquaintances for telltale markers that would reveal them to be criminals in disguise. In his published rogues' gallery of 1886, *Professional Criminals of America*, the New York City chief police detective Thomas Byrnes proposes: "There is not a portrait here but has some marked characteristic by which you can identify the man who sat for it. That is what has to be studied in the Rogues' Gallery—detail."[27] The scrutiny of physical detail encouraged by rogues' galleries promulgated the myth of a successful surveillant society.

The desire to look for outward signs of hidden criminality resonated powerfully with attempts to delineate the mythological "signs of blackness" by which anxious whites hoped to identify racial passers and thereby to reinforce the exclusive bounds of white privilege. Indeed, the systems of surveillance established by popular rogues' galleries in order to stop what was deemed "criminal passing" coincided with nearly hysterical discourses of racial passing in the United States at the turn of the century. In a culture characterized both by a legacy of forced racial mixing and by heightened racial segregation, many whites viewed racial passing as a threat to their cultural privilege. The laws that equated "one drop" of "African blood" with blackness encouraged those who believed themselves to be white to scrutinize other white-looking bodies for the imagined signs of hidden blackness. If discovered passing (wittingly or unwittingly), a white person legally defined as African American could instantly fall not only beyond the pale of white society but also into the terrain of ("Negro") criminality, as one who defied the jurisdiction of "whites only."

By playing on the formal characteristics of the criminal mug shot, Du Bois's photographs signify on the surveillance under which African Americans lived in the United States. More importantly, the images work to trouble the power of that surveillance. Du Bois's photographs begin to disrupt the authority of white observers by collapsing the distance between viewers and objects under view that generally is held to empower observers. Specifically, the photographs trouble that distance through a process of doubling. They replicate a misrepresentation "with a difference," functioning in much the same way as the "double-voiced" word that

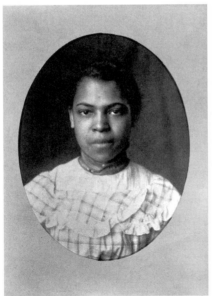

**54. From *Types of American Negroes, Georgia, U.S.A.*, compiled by
W. E. B. Du Bois, 1900.**

Daniel Murray Collection, Library of Congress, Washington, D.C.

Gates, following Bakhtin, describes as one mode of signifying.[28] The first
few images in the albums present portraits of African Americans *as* mug
shots; indeed, the images appear to be doubled, signifying simultaneously
as middle-class portraits and as criminal mug shots. The careful grooming
of the subjects suggests a premeditated desire to be photographed typical
of the middle-class portrait, while the visual patterns of close-cropped,
expressionless frontal and profile poses replicate the tropes of the criminal
mug shot (fig. 54). Through one lens the images portray middle-class sub-
jects, and through another they portray criminal offenders.

 Du Bois's initial images suggest that for some white viewers the por-
trait of an African American connotes the mug shot of a criminal. Making
explicit the discursive assumptions that situate African Americans beyond
the pale of white society, and behind a "veil" where they are invisible to
white eyes blinded by racist stereotypes, these portraits *as* mug shots make
explicit the "shadow meanings" of white-supremacist images of African
Americans.[29] However, after this introduction, inaugurated by images that
repeat so closely the formal style of criminal mug shots, Du Bois's albums
gradually come to resemble middle-class family albums. As viewers con-

55. Photograph by Thomas E. Askew, from *Types of American Negroes, Georgia, U.S.A.*, compiled by W. E. B. Du Bois, 1900.

Daniel Murray Collection, Library of Congress, Washington, D.C.

tinue to page through the albums, they find portraits made by Askew, with subjects posed in three-quarter turn, rather than in profile. Gradually more and more of the body is represented, and subjects are supported by the stuffed chairs, patterned carpets, books, lamps, and lace draperies that signify middle-class parlors. Thus, as one moves through Du Bois's albums, one finds that the stark mug shot gradually fades into the middle-class portrait (fig. 55).

In situating these visual poles of identity in such close proximity, Du Bois's albums expose and trouble the dependence of middle-class identification on the counterimage of a criminal other. Indeed, Du Bois's photographs are unsettling because they signify at the limits of middle-class photographic portraiture. The images inhabit the very boundary that separates authorized identities from those the state deems in need of careful surveillance and discipline. As Allan Sekula has argued in "The Body and the Archive," the photographic portrait became the site of middle-class self-recognition precisely as the rogues' gallery came to signify the boundary of respectable middle-class inclusion in the late nineteenth century. In

many ways, the rogues' gallery functioned as a public counterexample to the middle-class portrait gallery; analogously, the criminal offender served as a point of distinction against which middle-class citizens could identify themselves. According to Sekula, "To the extent that bourgeois order depends upon the systematic defense of social relations based on private property, to the extent that the legal basis of the self lies in the model of property rights, in what has been termed 'possessive individualism,' every proper portrait has its lurking, objectifying inverse in the files of the police."[30] Du Bois's photographic portraits signify across the binary that stabilizes white middle-class identity, resembling in formal pose the mug shot while also reproducing the accoutrements of the middle-class portrait.

Du Bois's photographs highlight the disturbing resemblance that links the middle-class photographic portrait to the criminal mug shot and the middle-class citizen to the criminal body (fig. 56). The images draw out the correspondence Thomas Byrnes suggests in his description of the rogues' gallery. Through the voice of a fictional detective Byrnes states, "Look through the pictures in the Rogues' Gallery and see how many rascals you find there who resemble the best people in the country. Why, you can find some of them, I dare say, sufficiently like personal acquaintances to admit of mistaking one for the other." Linking the criminal's middle-class appearance to a middle-class lifestyle, Byrnes declares: "Remember that nearly all the great criminals of the country are men who lead double lives. Strange as it may appear, it is the fact that some of the most unscrupulous rascals who ever cracked a safe or turned out a counterfeit were at home model husbands and fathers."[31] The imagined "double lives" of criminals passing for middle-class citizens generated an anxiety that rattled the oppositional paradigm upon which middle-class identity was established and encouraged the surveillance discussed above. Du Bois's doubled portraits similarly disturb the assumptions upon which middle-class identity is founded by blurring the distinctions between middle class and criminal. As we have seen, Du Bois's photographs point toward the "doubled meanings" the African American portrait may have held for white viewers trained to distrust middle-class African Americans as usurpers of cultural privilege (that is, as always already criminals). Further, Du Bois's images pose a critical cultural position, a place from which African Americans can gaze back at white beholders. As bell hooks reminds one in "Representations of Whiteness in the Black Imagination," despite the historical prohibition against the black gaze, African Americans have observed white people with "a critical, 'ethnographic' gaze."[32] Indeed, the eyes that look out from the

56. From Thomas Byrnes, *Professional Criminals of America* (New York: Cassell, 1886).

frontal portraits in Du Bois's albums may witness the doubled lives of some of their viewers, namely of those who were both white middle-class citizens and criminal racial terrorists at the turn of the century.

As Du Bois's photographs disrupt the binary dividing criminal from middle-class, they also challenge the opposition that maintains a stable white center in relation to a black margin. If the middle classes consolidated their cultural legitimacy against the othered images of criminals who questioned their property rights, the *white* middle classes also consolidated their cultural privilege in relation to racial others. In these overlapping paradigms, an image of "Negro criminality" provided a boundary that contained the cultural legitimacy of the white middle classes. Once again, it is precisely that doubled boundary that Du Bois's photographs contest.

Reflecting on Whiteness

As Du Bois aesthetically merges the opposing positions of criminal and middle-class subject in his albums, he also closes the divide that distinguishes images of "whiteness" from images of "blackness." Du Bois's portraits signify on the rogues' gallery to connote the proximity between authorized middle-class selves and criminal others, and some of the images also register a visual proximity between racially authorized "white" viewers and "black" objects under view. Du Bois's portraits of white-looking African Americans contest a racial taxonomy of identifiable (because visible) difference, and in so doing they highlight a closeness that troubles the imagined autonomy of the white viewer.

Askew's images of a young, blond, very pale African American child challenge white investments in separating the races by signaling an undeniable history of physical union between them (fig. 57). In Du Bois's visual archive, these images create a space "for an exploration and expression of what was increasingly socially proscribed" at the turn of the century, namely social and sexual contact between racial groups.[33] As Robert J. C. Young has argued in *Colonial Desire: Hybridity in Theory, Culture, and Race*, "The ideology of race . . . from the 1840s onwards necessarily worked according to a doubled logic, according to which it both enforced and policed the differences between the whites and the non-whites, but at the same time focused fetishistically upon the product of the contacts between them."[34] White hysteria over the "threat" of racial passing both spurred an increased fervor in racial surveillance at the turn of the century and marked the extent to which a long history of forced racial mixing during slavery had blurred the color line of privilege in a postslavery world.[35]

57. Photograph by Thomas E. Askew, from *Types of American Negroes, Georgia, U.S.A.*, compiled by W. E. B. Du Bois, 1900.

Daniel Murray Collection, Library of Congress, Washington, D.C.

By the end of the nineteenth century several states had laws that deemed one thirty-second African or African American ancestry the key that distinguished "black" from "white," a distinction so narrow as to make explicit the invisibility of "blackness" and "whiteness" as racial categories. As Mary Ann Doane has argued, the individual of mixed ancestry, "whose looks and ontology do not coincide, poses a threat to . . . the very idea of racial categorization." According to Doane, the physical appearance of the person of mixed ancestry "always signifies a potential confusion of racial categories and the epistemological impotency of vision."[36] Individuals of mixed racial ancestry challenge visual codes of racial distinction, showing a racial taxonomy founded in visual paradigms of recognition to be a fiction, albeit a powerful one.

As Du Bois's images of white-looking African Americans trouble the veracity of nineteenth-century scientific racial taxonomies, they also problematize nineteenth-century literary representations of men and women of mixed racial ancestry. The photographs "hardly square" with the conventional literary figure of the "tragic mulatto." As Hortense J. Spillers has

argued, "Mulatto-ness, is not, fortunately, a figure of self-referentiality." The term *mulatto* signifies "the *appropriation* of the interracial child by genocidal forces of dominance," and the power of this misrepresentation lies in its ability to steal the "dynamic principle of living" from the historical subject it objectifies. In other words, the term derives its force from its capacity to objectify and to reify a historical agent. As an image produced "through the eyes of others," the "mulatto" masks the presence of men and women of mixed racial ancestry. As Spillers has argued, "The 'mulatto/a,' just as the 'nigger,' tells us little or nothing about the subject buried beneath them, but quite a great deal more concerning the psychic and cultural reflexes that invent and invoke them." As the term *mulatto* "originates etymologically in notions of 'sterile mule,'" it bears the traces of mid–nineteenth-century scientific theories of racial difference that claimed to identify not only distinct racial types but also unique racial *species*.[37] Despite the overwhelming evidence that individuals of mixed racial ancestry were not sterile (and thus not "hybrids," the products of interspecies reproduction), the literary mythology of the "tragic mulatto" (who dies and does not reproduce) kept alive culturally a notion of absolute biological differences between the races.[38]

Du Bois's American Negro portraits engage and disturb the "psychic and cultural reflexes" that fabricate the myth of the mulatto as an object in a racial taxonomy. If "the mulatto" is a fabrication, a misrepresentation that objectifies and freezes the potential force of historical actors, then the *photograph* of a white-looking African American might drive a wedge into the equation that would collapse an individual under the sign of "the mulatto." In this case, the tenacity of the photograph's representation, its indexical claim on the real, works toward a potentially radical end. If the photograph carries a trace of the historical subject it objectifies, then a photograph can depict "the mulatto *type*" only after first acknowledging the presence of an individual. Here, then, I am interested in the ways that Du Bois's portraits of white-looking African Americans signify on the figure of "the mulatto."

If one considers a turn-of-the-century European or white American viewer engaged in looking at the photograph of a white-looking child in Du Bois's albums, one might imagine a viewer invested in maintaining the fantasy of the mythological mulatto confronted by the image of an actual child. As a historical subject with eyes that look back at viewers, the child refuses the objectifying category of "the mulatto." But what does the image of this child make possible? According to the literary scholar Ann duCille, the image of a white-looking African American could enable an author "to

insinuate into the consciousness of white readers the humanity of a people they otherwise constructed as subhuman—beyond the pale of white comprehension."[39] In thinking about Europeans and white Americans perusing Du Bois's visual archive at the Paris Exposition of 1900, one might imagine the possibility of a kind of racial identification as those viewers turned to face the images of white-looking African Americans in a "Negro" archive. If we suppose a positive, if only momentary, identification between viewer and viewed in this case, an identification bridged by visual signs of similarity, then such images would serve not only to humanize African Americans in the eyes of white viewers but also to suggest that self and other were very much the same.

While one can imagine this moment as one of psychological recognition, in order for the legally defined white viewer to identify with the image of a white-looking African American, to see a unified image of self in this photograph of the purported other, the viewer would have to suture over a long history of both visible and repressed violence. At the turn of the century, a superficial identification between white and African American subjects (on the basis of common hair color or skin tone) would have been enabled primarily by the history of rape perpetuated in slavery. In this sense, then, Du Bois's photographs of a white-looking African American child signal both white violence upon African American bodies and white desire for the black body. Indeed, as Robert J. C. Young describes it, colonial desire is constructed precisely around the dynamic of the colonist's simultaneous repulsion from and attraction to the other.[40]

This white desire for the black body, coupled with the brutal enactment of white power on that body in slavery, finds a direct corollary in turn of the century lynchings. The shadow lurking behind a possible moment of visual identification between individuals divided by the color line is the image of white subjectivity foregrounded against a black corpse in the photographs of lynchings. In order to sustain an identification with African Americans, the authorized white viewer would have to confront the legacy of the utter racial divide engendered by the "new white crime" of lynching.

The photographs of lynched bodies that circulated at the turn of the century signified at the limits of white images of black otherness. As records of the lawless brutality of white supremacists, they registered a different kind of power than the mug shots procured in the police station. If the mug shot signaled a form of dispersed, institutionalized power that was implicitly white in a culture of white privilege, the photograph of a lynched black body signaled the embodied nature of white power. By juxtaposing the

photographic mug shot to the terrifying photographs of lynchings that circulated in the same years, one finds two different manifestations of white power functioning simultaneously. Lynching represents an embodiment of power similar to the sixteenth- and seventeenth-century spectacles of ritualized torture that Michel Foucault describes in *Discipline and Punish*. Such scenes of torture made manifest the unquestioned authority of a monarch over his subjects, the physical power of the state as personified by one ruler. The mug shot corresponds to a later formation of power that emerged in the nineteenth century, the state of surveillance, in which power is increasingly diffused, disembodied, and located in the minds of subjects who discipline themselves according to an institutionalized image of normalcy.[41] In the coterminous juxtaposition of photographs of lynching and criminal mug shots at the turn of the century one sees that while the vehicle of power, the body that aligns itself with and enforces the bounds of normalcy and deviance, is absent from the photographic mug shot, those bodies that are the vehicles of a devastating physical power are represented over and over again with the victims of their wrath in the photographs of lynchings. In the images that display burned and mutilated black bodies set off by crowds of curious—even smiling—white spectators, one sees white supremacists attempting to locate power emphatically within the bounds of white bodies.[42] Following the artist Pat Ward Williams, one must ask: how can such images exist?[43] Or, to state the question differently: how do the photographs of lynchers, unmasked, facing the camera, and smiling, escape the rogues' gallery? Such images show the extent to which power is equated with white bodies that brutalize the bodies of others. The photographs of lynchers and of lynching demonstrate with grave clarity that the power of whiteness was not only invisible and dispersed but also particular and embodied in turn-of-the-century U.S. culture.

Photographs of lynchings circulated widely, reinforcing the association of whiteness with terror in African American minds. The images served, perhaps, as the "substitute" for slavery that white supremacists, like the *Harper's* correspondent cited earlier, hoped would ensure the "discipline" of African Americans in postslavery America. As Elizabeth Alexander argues, "There are countless stories of violence made spectacular in order to let black people know who was in control." Explaining further the psychological effects of these spectacles of white violence upon the black body, Alexander states: "Black men are contained when these images are made public, at the very same time that black viewers are taking in evidence that provides grounds for collective identification with trauma." This collective identification, felt and known in the body, can then become, accord-

ing to Alexander, a "catalyst for action." Witnessing the scenes of violence depicted in photographs can enable a first step toward African American resistance. According to Christian Walker, reclaiming "a collective historical identity" is "the first line of defense against a legacy of cultural annihilation," and such reclamation was to become foundational in the multifaceted antilynching campaigns of the NAACP.[44]

How do such photographs function for white viewers? Whiteness is also consolidated around these images of violence, but for whites such images enable a very different kind of racial identification. On the surface these images encourage white viewers to reject the trauma of experienced physical violence and to identify with the perpetrators of that violence. On another level, the images make absolutely apparent the fact that, as Eric Lott suggests, whiteness is a split identity formulated on the violent repression of the other.[45]

If whiteness and blackness are so violently distinguished in turn-of-the-century lynching photographs, how can one understand the possibility that white American viewers may have recognized themselves in the white-looking other of Du Bois's American Negro albums? The viewer who assumes herself to be white would experience a psychological rift in such an identification, perhaps becoming momentarily conscious of the violent split that establishes white identity. In order to sustain a unified image of the visual signs that constitute superficial whiteness, the white viewer could not help but see self in other. But in this identification is also the unraveling of whiteness as a boundary between self and other, for the images of these white-looking individuals are in an archive of "Negroes." Indeed, Du Bois's albums make whiteness just one point in an archive of blackness, and specifically they show whiteness to be the repressed point in an archive of blackness. In what one might call the larger archive of "race," whiteness is the position repressed so thoroughly that it has reproduced itself everywhere. As Richard Dyer suggests, because of its very pervasiveness, whiteness becomes an invisible racial sign; it is the (repressed) norm of unseen seeing. This perhaps explains how white people in lynching photographs can be so prominently displayed and yet remain "unseen" by legal authorities. Expanding on Dyer's thesis, Isaac Julien and Kobena Mercer have argued that "whiteness has secured universal consent to its hegemony as the 'norm' by masking its coercive force with the invisibility that marks off the Other (the pathologised, the disempowered, the dehumanized) as all too visible—'colored.'"[46] But if blackness produced as dehumanized spectacle "through the eyes of [white] others" is itself an image of whiteness, revealing more about those who produce the image than about those purport-

edly represented by its sign, then the self-identified white viewer must see in the dismembering of the African American body the structures of white identity. For some at least, this recognition would produce a psychological rift, a split subjectivity imploding with the violent impact of sameness.

Du Bois's images of white-looking African Americans demonstrate the arbitrary nature of visual racial classification. But this is not to suggest that Du Bois aimed to erase racial differences or to discount racial identities, for as he explicitly states in *The Souls of Black Folk*, "He would not bleach his Negro soul in a flood of white Americanism, for he knows that Negro blood has a message for the world."[47] Rather, Du Bois's photographs challenge a visual, and biological, paradigm of white supremacist racial differentiation. The violence that engenders the image of whiteness threatens always to tear it apart, so that white subjectivity remains always on the verge of fragmentation. This instability can, of course, function powerfully to perpetuate and to reinforce the image of (a volatile vulnerable) whiteness in need of ever more aggressive consolidation. An imagined white wholeness can be recuperated quickly, out of its own fragments, by cultural privilege and the capacity for violence. The dominant culture does not force the white viewer into an identification with otherness; indeed, the culture at large works against such recognition. Yet an image of "whiteness" that is also an image of "blackness" could effect a flash of recognition, in which white viewers might glimpse the phantasmal nature of "white wholeness," in which they might see the workings of whiteness. W. E. B. Du Bois's photographs of African Americans for the Paris Exposition of 1900 pursue these ends, denaturalizing the assumed privilege of whiteness and suggesting that the violent division (between "black" and "white") upon which the myth of white wholeness is founded is itself the most entrenched of color lines.

A Note on Contemporary Viewers

The fact that images of imagined black criminality continue to function powerfully in the United States today indicates that Du Bois's photographs presented over a century ago did not radically shift the privilege of a normative white supremacist gaze. However, the images did open an important space for African American resistance to racist stereotypes, a space for contestation and for self-representation. As bell hooks has argued, "Photography has been, and is, central to that aspect of decolonization that calls us back to the past and offers a way to reclaim and renew life-affirming bonds. Using these images, we connect ourselves to a recuperative, re-

demptive memory that enables us to construct radical identities, images of ourselves that transcend the limits of the colonizing eye."[48] By reclaiming the importance of Du Bois's American Negro photographs, this chapter aims to expand an archive of antiracist representations and thereby to reinforce an early foundation for the work of contemporary cultural critics.

Du Bois's photographs asked African American and white American viewers to interrogate the images of African Americans produced "through the eyes of [white] others" and to question the foundations of white privilege. Whether or not Du Bois's first viewers engaged his images at this level, witnessing the critique of whiteness embedded in his signifying practices, is now, perhaps, beside the point. Today viewers can read the images self-consciously, with what Kaja Silverman has called a "productive look." In *The Threshold of the Visible World*, Silverman defines the "productive look" as a means of looking that is not completely predetermined by cultural paradigms or even by material objects under view. For Silverman, the "productive look" is a transformative look, a means of seeing beyond the "screen" of cultural programming. Accordingly, Silverman asserts: "Productive looking necessarily requires a constant conscious reworking of the terms under which we unconsciously look at the objects that people our visual landscape. It necessitates the struggle, first, to recognize our involuntary acts of incorporation and repudiation, and our implicit affirmation of the dominant elements of the screen, and, then, to see again, differently. However, productive looking necessarily entails, as well, the opening up of the unconscious to otherness."[49] An opening up of the unconscious to otherness would necessitate a profound disorientation for white viewers whose image of whiteness is founded on the repression of violent othering practices. Nevertheless, it is precisely this kind of interrogation of the psychological and cultural structures that enable the perpetuation of white privilege that needs to be undertaken if one is to continue Du Bois's project of pushing subjectivity past the color line.

Notes

This chapter was first published in *African American Review* 34, no. 4 (2000): 581–99, and reprinted in *The Souls of Black Folk: One Hundred Years Later*, ed. Dolan Hubbard (Columbia: University of Missouri Press, 2003), 189–217. I am grateful to both for permission to reprint the work here.

1. W. E. B. Du Bois, *The Souls of Black Folk*, intro. John Edgar Wideman (1903; rprt. New York: Vintage/Library of America, 1990), 8, 3.

2. bell hooks, "In Our Glory: Photography and Black Life," in *Picturing Us: Afri-*

can American Identity in Photography, ed. Deborah Willis (New York: New Press, 1994), 42–53, 50.

3. Du Bois, *The Souls of Black Folk*, 8–9.

4. Starting with an Askew photograph that I recognized from the Du Bois albums in Deborah Willis's *Reflections in Black*, I visited archives in Atlanta, including the Atlanta History Center, the Auburn Avenue Research Center, and the Atlanta University Center, where I was able to match several other Thomas Askew photographs to the Du Bois albums. See Deborah Willis, *Reflections in Black: A History of Black Photographers 1840 to the Present* (New York: Norton, 2000).

Although Du Bois did not make the photographs he collected, it is his name that is embossed on the album spines, and as collector, compiler, and presenter of the images, Du Bois played a central role in shaping their meaning. Therefore, in the context of the albums, it is fair to call the images "Du Bois's photographs."

Since I originally published this work, a number of other works discussing the photographs have been produced, notably: David Levering Lewis and Deborah Willis, *A Small Nation of People: W. E. B. Du Bois and African American Portraits of Progress* (New York: Amistad, 2003); Rebecka Rutledge Fisher, "Cultural Artifacts and the Narrative of History: W. E. B. Du Bois and the Exhibiting of Culture at the 1900 Paris Exposition Universelle," *Modern Fiction Studies* 51, no. 4 (Winter 2005): 741–74; and my own *Photography on the Color Line: W. E. B. Du Bois, Race, and Visual Culture* (Durham: Duke University Press, 2004).

5. These materials are housed in the Prints and Photographs Division of the Library of Congress. All of the photographs can now be accessed via the Library of Congress Prints and Photographs Online Catalog, http://www.loc.gov/pictures/collection/anedub/dubois.html. Some of the charts and graphs can also be viewed via the Library of Congress Prints and Photographs Online Catalog, http://www.loc.gov/pictures/collection/coll/item/2005679642/.

6. W. E. B. Du Bois, "The American Negro at Paris," *American Monthly Review of Reviews* 22, no. 5 (November 1900): 575–77.

7. The American Negro Exhibit at the Paris Exposition of 1900 was a relatively new kind of African American forum, inaugurated most conspicuously in 1895 with the Negro Building at the Cotton States International Exposition in Atlanta, Georgia. While Du Bois's participation in the Paris Exposition of 1900 was not nearly so prominent as that of Booker T. Washington's at the Atlanta Exposition of 1895, it marked a parallel attempt by Du Bois to represent and to shape the history of African American social advancement, and race relations, at a moment when Washington and Du Bois were becoming increasingly ideologically polarized.

8. Du Bois first made this declaration at the Pan-African Association Conference in London in July 1900. He would later repeat this now famous statement in *The Souls of Black Folk*, 3. See Manning Marable, "The Pan-Africanism of W. E. B. Du Bois," in *W. E. B. Du Bois on Race and Culture*, ed. Bernard W. Bell, Emily R. Grosholz, and James B. Stewart (New York: Routledge, 1996), 193–218, 197; and Arnold Rampersad, *The Art and Imagination of W. E. B. Du Bois* (New York: Schocken, 1990), 64.

9. Henry Louis Gates Jr., *The Signifying Monkey: A Theory of Afro-American Literary Criticism* (New York: Oxford University Press, 1988).

10. hooks, "In Our Glory," 48.

11. Du Bois, "The American Negro at Paris," 577.

12. "The Negro Problem and the New Negro Crime," *Harper's Weekly* 47 (June 20, 1903): 1050–51; "Some Fresh Suggestions about the New Negro Crime," *Harper's Weekly* 48 (January 23, 1904): 120–21. See also the following letters to the editor: George B. Winton, "The Negro Criminal," *Harper's Weekly* 47 (August 29, 1903): 1414; and Mrs. W. H. Felton, "From a Southern Woman," *Harper's Weekly* 47 (November 14, 1903): 1830.

13. Ida B. Wells, *Crusade for Justice: The Autobiography of Ida B. Wells*, ed. Alfreda M. Duster (Chicago: University of Chicago Press, 1970); Ida B. Wells, *Southern Horrors: Lynch Law in All Its Phases* (Salem: Ayer Company Publishers, 1892); Ida B. Wells, *Selected Works of Ida B. Wells-Barnett*, ed. Trudier Harris (New York: Oxford University Press, 1991).

14. "The Negro Problem and the New Negro Crime," 1050.

15. Winton, "The Negro Criminal," 1414.

16. W. E. B. Du Bois, ed., *Notes on Negro Crime, Particularly in Georgia* (A Social Study Made under the Direction of Atlanta University by the Ninth Atlanta Conference), Atlanta University Publications, no. 9 (Atlanta: Atlanta University Press, 1904), 9.

17. According to Du Bois's citation, Olivier made these comments first in the *British Friend*, December 1904.

18. Du Bois, *Notes on Negro Crime*, 55–57.

19. In "Some Fresh Suggestions," a *Harper's Weekly* editor links "the new negro crime" to "the talk of social equality that inflames the negro, unregulated and undisciplined" (121). This same writer also links the disfranchisement of African Americans in Mississippi to the eradication of "the new negro crime" in that state.

20. Du Bois, *The Souls of Black Folk*, 150–51.

21. Gates, *The Signifying Monkey*, 69. Coco Fusco also utilizes Gates's theory of signifying in her analysis of Lorna Simpson's photographic art. See Coco Fusco, "Uncanny Dissonance: The Work of Lorna Simpson," *English Is Broken Here: Notes on Cultural Fusion in the Americas* (New York: New Press, 1995), 97–102, especially 100.

22. Sander L. Gilman offers a fascinating comparative analysis of this kind in "Black Bodies, White Bodies: Toward an Iconography of Female Sexuality in Late Nineteenth Century Art, Medicine, and Literature," in *"Race," Writing, and Difference*, ed. Henry Louis Gates Jr. (Chicago: University of Chicago Press, 1986), 223–61.

23. Gates, *The Signifying Monkey*, 51.

24. Kaja Silverman provides one notable interpretation of Cindy Sherman's *Untitled Film Stills* in *The Threshold of the Visible World* (New York: Routledge, 1996), 207–27.

25. Gates's definition of signifying is much more complicated, and much more

encompassing, than I have described it here. "Repetition with a difference" and "direction by indirection" are simply two of the important ways that signifying works, according to Gates. See Gates, *The Signifying Monkey*, especially 51, 63–68, 74–79, 81, 85–86.

26. Quoted in Alan Trachtenberg, *Reading American Photographs: Images as History, Mathew Brady to Walker Evans* (New York: Hill and Wang, 1989), 28–29.

27. Thomas Byrnes, *Professional Criminals of America* (1886; rprt. New York: Chelsea House Publishers, 1969), 53.

28. Gates, *The Signifying Monkey*, 50–51.

29. For an analysis of verbal shadow meanings see Gates, *The Signifying Monkey*, 46.

30. Allan Sekula, "The Body and the Archive," *October* 39 (Winter 1986): 3–64, 7.

31. Byrnes, *Professional Criminals of America*, 55, 54.

32. bell hooks, "Representations of Whiteness in the Black Imagination," in *Black Looks: Race and Representation* (Boston: South End Press, 1992), 165–78, 167.

33. Hazel V. Carby, *Reconstructing Womanhood: The Emergence of the Afro-American Woman Novelist* (New York: Oxford University Press, 1987), 89.

34. Robert J. C. Young, *Colonial Desire: Hybridity in Theory, Culture, and Race* (New York: Routledge, 1995), 180–81.

35. On the institutionalized rape of enslaved African American women in the antebellum South, and the representations of white and black womanhood that ideologically supported that rape, see Bettina Aptheker, *Woman's Legacy: Essays on Race, Sex, and Class in American History* (Amherst: University of Massachusetts Press, 1982); Nancie Caraway, *Segregated Sisterhood: Racism and the Politics of American Feminism* (Knoxville: University of Tennessee Press, 1991); Carby, *Reconstructing Womanhood*, especially 20–61; Angela Y. Davis, *Women, Race, and Class* (New York: Vintage Books, 1983); Paula Giddings, *When and Where I Enter: The Impact of Black Women on Race and Sex in America* (New York: William Morrow, 1984); and bell hooks, *Ain't I a Woman: Black Women and Feminism* (Boston: South End Press, 1981).

36. Mary Ann Doane, "Dark Continents: Epistemologies of Racial and Sexual Difference in Psychoanalysis and the Cinema," in *Femmes Fatales: Feminism, Film Theory, Psychoanalysis* (New York: Routledge, 1991), 209–48, 235, 234. Susan Gillman provides an important analysis of this "predicament" for white supremacists in her essay "'Sure Identifiers': Race, Science, and the Law in Twain's *Pudd'nhead Wilson*," *South Atlantic Quarterly* 87, no. 2 (Spring 1988): 195–218, 205. According to Barbara J. Fields, "The very diversity and arbitrariness of the physical rules governing racial classification prove that the physical emblems which symbolize race are not the foundation upon which race arises as a category of social thought" ("Ideology and Race in American History," in *Region, Race, and Reconstruction*, ed. J. Morgan Kousser and James M. McPherson [New York: Oxford University Press, 1982], 143–77, 151).

37. Hortense J. Spillers, "Notes on an Alternative Model—Neither/Nor," in *The Difference Within: Feminism and Critical Theory*, ed. Elizabeth Meese and Alice Parker (Philadelphia: John Benjamin, 1989), 165–87, 166–67. See also Young, *Colonial Desire*, especially 122–27.

38. I am adapting Robert J. C. Young's insights about the power of the cultural

construction of "race" to my understanding of the literary figure of the tragic mulatto. According to Young, "The different Victorian scientific accounts of race each in their turn quickly became deeply problematic; but what was much more consistent, more powerful and long-lived, was the cultural construction of race" (*Colonial Desire*, 93–94).

39. Ann duCille, *The Coupling Convention: Sex, Text, and Tradition in Black Women's Fiction* (New York: Oxford University Press, 1993), 7–8.

40. Young, *Colonial Desire*, 106–9, 149–52.

41. Michel Foucault, *Discipline and Punish: The Birth of the Prison*, trans. Alan Sheridan (New York: Vintage, 1979).

42. For a reading of the convergence of "specular" and "panoptic" power in both antebellum slavery and postbellum lynching, see Robyn Wiegman, *American Anatomies: Theorizing Race and Gender* (Durham: Duke University Press, 195), 35–42. One refinement I would make to Wiegman's important analysis is simply to note that in most of the photographs of lynch mobs and their victims, white spectators are, remarkably, not veiled or masked. Thus, I would suggest that it was not only a "homogenized, known-but-never-individuated" form of white power that lynching reproduced but also an explicitly embodied form of white power that marked white men and women as the particular bearers of an otherwise diffuse power (Wiegman, *American Anatomies*, 39).

43. See Pat Ward Williams's artwork from 1987 titled *Accused/Blowtorch/Padlock* in Lucy R. Lippard, *Mixed Blessings: New Art in a Multicultural America* (New York: Pantheon, 1990), 37. See also Elizabeth Alexander, "'Can You Be BLACK and Look at This?' Reading the Rodney King Video(s)," in *Black Male: Representations of Masculinity in Contemporary American Art*, ed. Thelma Golden (New York: Whitney Museum of American Art, 1994), 90–110.

44. Alexander, "'Can You Be BLACK and Look at This?,'" 105–6; Christian Walker, "Gazing Colored: A Family Album," in *Picturing Us: African American Identity in Photography*, ed. Deborah Willis (New York: New Press, 1994), 64–70, 69. For an analysis of "the representation of whiteness as terrifying," see hooks, "Representations of Whiteness," 169. For a history of the NAACP's antilynching campaigns, see Robert L. Zangrando, *The NAACP Crusade against Lynching, 1909–1950* (Philadelphia: Temple University Press, 1980). The Library of Congress Prints and Photographs Division has an archive of photographs of lynchings collected by the NAACP (NAACP Collection of Photographs on Lynchings, Lot 10647). *Crisis*, the official magazine of the NAACP, published photographs of lynching as part of its campaign against racial terrorism and murder. For an example, see "Holmes on Lynching," *Crisis* 3, no. 3 (January 1912): 109–12.

Since I originally wrote this piece there has been a resurgence of scholarly interest in lynching photographs inspired, in part, by the traveling exhibition *Without Sanctuary*, and its companion publication, *Without Sanctuary: Lynching Photography in America*, James Allen et al. (Santa Fe: Twin Palms, 2000); see also the website of the exhibition and book for photos and a short film, http://withoutsanctuary .org/main.html. See also, for example: "Strange Fruit: Lynching, Visuality and Empire," special issue, *Nka: Journal of Contemporary African Art* 20 (Fall 2006); Leigh

Raiford, "The Consumption of Lynching Images," in *Only Skin Deep: Changing Visions of the American Self*, ed. Coco Fusco and Brian Wallis (New York: Harry N. Abrams Press, 2003), 266–73, as well as her chapter in this edited volume; Ashraf Rushdy, "Exquisite Corpse," *Transition* 83 (2000): 70–77; David Marriott, "'I'm gonna borer me a Kodak': Photography and Lynching," in *On Black Men* (New York: Columbia University Press, 2000), 1–22; Jacqueline Goldsby, "Through a Different Lens: Lynching Photography at the Turn of the Nineteenth Century," in *A Spectacular Secret: Lynching in American Life and Literature* (Chicago: University of Chicago Press, 2006), 214–281; Dora Apel, "On Looking," in *Imagery of Lynching: Black Men, White Women, and the Mob* (New Brunswick: Rutgers University Press, 2004), 7–46; Shawn Michelle Smith, "Spectacles of Whiteness: The Photography of Lynching," in *Photography on the Color Line*, 113–45; Ken Gonzales-Day, *Lynching in the West, 1850-1935* (Durham: Duke University Press, 2006); Jonathan Markovitz, *Legacies of Lynching: Racial Violence and Memory* (Minneapolis: University of Minnesota Press, 2004); Dora Apel and Shawn Michelle Smith, *Lynching Photographs* (Berkeley: University of California Press, 2007).

45. Eric Lott, "Love and Theft: The Racial Unconscious of Blackface Minstrelsy," *Representations* 39 (Summer 1992): 23–50, 36–37. Michael Rogin also examines the split racial self in his analysis of *The Jazz Singer*. According to Rogin, in *The Jazz Singer*, "the interracial double is not the exotic other but the split self, the white in blackface" (Michael Rogin, "Blackface, White Noise: The Jewish Jazz Singer Finds His Voice," *Critical Inquiry* 18, no. 3 [Spring 1992]: 417–53, 419).

46. Richard Dyer, "White," *Screen* 29, no. 4 (Autumn 1988): 44–64, especially 44–47. Isaac Julien and Kobena Mercer, "Introduction: De Margin and De Centre," *Screen* 29, no. 4 (Autumn 1988): 2–10, 6. For a discussion of how "repression" works to proliferate discourses around the objects or acts it would supposedly deny, see Michel Foucault, *The History of Sexuality*, vol. 1, trans. Robert Hurley (New York: Vintage, 1978, 1980).

47. Du Bois, *The Souls of Black Folk*, 9.

48. hooks, "In Our Glory," 53.

49. Silverman, *The Threshold of the Visible World*, 180–93, quotation on page 184.

 TEN

Ida B. Wells and the Shadow Archive

Leigh Raiford

When Ida B. Wells embarked on the sustained and highly visible anti-lynching campaign that would come to define her career, she chose to arm herself with photography as a weapon in her arsenal of evidence. Photographs, celebrated for their veridical capacity as documents of "truly existing things," could be integrated into a larger "truth apparatus"—a structure that included statistics, dominant press accounts, investigative reports— utilized by Wells and subsequent antilynching activists to offer testimony to lynching's antidemocratic barbarism. Always keenly aware of her audiences, and in particular white audiences' responses to a black woman as messenger, Wells also made use of photographic portraiture to provide a different kind of proof. Just as photographs of executed African Americans relayed the raw violence of lynching and the abjection of the black figure, the genre of portraiture conferred and confirmed black dignity, respectability, and humanity. Wells augmented her literature with professionally made photographs of lynchings, of herself, and of a lynch victim's loved ones left behind in order to present a fuller picture of what was at stake in the fight against lynching: black womanhood, the sanctity of the black family, and the credibility of American civilization as a whole.

In this chapter I consider the place of photography in Wells's work, as a mode of critique and as a form of self-presentation, situating three photographs in conversation with one another: a photographic postcard of the lynching of Ray Porter in Clanton, Alabama, in 1891 that Wells printed in her "Lynch Law" essay of 1893 and again in her pamphlet from 1895, *A Red*

Record; the portrait, circa 1892–1893, Wells commissioned of herself with Betty Moss, the widow of Wells's recently lynched friend, Tom Moss, and the Moss's two children, Maurine and Thomas Jr.; and a photograph, circa 1893, of Wells alone. Seemingly disconnected, family and individual portraits and photographs of lynchings each belong to the "shadow archive" of black representation. The photographer and theorist Allan Sekula describes a shadow archive as an all-inclusive corpus of images that situates individuals according to a socially proscribed hierarchy.[1] African Americans themselves sought to unmake the identity created for them in popular (or scientific or criminal or pornographic) derogatory depictions both by countering with their own carefully cultivated self-images and by reframing the cruelest and most sadistic of these portrayals, lynching images, as the shared shame of the entire nation. Photographs of lynchings used in antilynching campaigns signify in relation to these other archives of images.[2] Equally, though perhaps less pronounced, formal portraits can best be read in relation to lynching photography. Taken together, this shadow archive, this all-inclusive corpus of photographs depicting both the revered and the reviled, containing images of striving and of shame, of personal loss and political desire, reminds us that for African Americans exploring the landscape of photography's first century, multiple visual representations of themselves were always in intense dialogue with one another.

By placing these three photographs within a single archive, as I believe Wells herself did through her employment of these images as part of her antilynching activism, the political work of black photography is set in sharp relief. Indeed, like Wells's journalism, this use of photography works to critique nineteenth-century racial and gender logics, signaling African Americans as worthy of honorific depiction, whether as the subjects of studio portraits or as the objects of reclaimed lynching photographs. Wells's engagement with the shadow archive forces us to ask, how do we read or know the "facts" of blackness and the realities of black life? Can photography serve to construct new racial epistemologies or does it always edify dominant paradigms? That is, can the black body (photographed) as abject and discredited sign be made to signify differently? Each image, the shadow archive contends, carries within itself the traces of the others: we can better read the pathos in the portrait and the memorialization in the lynching photograph by recognizing their close if unacknowledged proximity to one another. As Shawn Michelle Smith has powerfully demonstrated, in order to "make the photographic archive resonate with all its cultural and historical significance," we must read "visual archives against

one another to find photographic meaning in the interstices between them, in the challenges they pose to one another, and in the competing claims they make on cultural import."[3] Wells recognized the challenges and competing claims these different types of images presented to one another and sought to exploit these contradictions for her antilynching campaign.

Wells's engagement with the shadow archive not only forces us to rethink the categorization and classification of black visual subjects but also poses a challenge to and critique of visual aesthetics and photographic sensibilities. In appropriating a commercially made lynching photographic postcard, Wells draws our attention to the complicity of photography (and capitalism) with racial violence. In navigating both the liberatory possibilities engendered by the portrait and the violent limitations enforced by the lynching photograph, Wells highlights the deep entanglement of the visual, as well as the rhetorical, with white supremacy. Photography then is one staging ground in Wells's battle for black political, economic, and cultural representation. Finally, a focus on Wells's limited yet pointed use of photography offers a glimpse into how a skilled activist, an international speaker, a pioneering social scientist, and a turn of the century "Afro-American woman" navigated the complex visual terrain at the end of the nineteenth century and participated in the construction of a "new visual language for 'reading' black subjects."[4]

Mapping the Shadow Archive of Black Representation

In his classic essay "The Body and the Archive," Allan Sekula attempts to chart the paradoxes of photography by specifically drawing connections between "the honorific and repressive poles of portrait practice."[5] He finds this relationship between the late nineteenth-century emergence of state forms of visual control and bourgeois portraiture, the portraits of the rogues' gallery and the National Gallery, most clearly articulated in the logics of the archive. "Every portrait," Sekula argues, "implicitly took its place within a social and moral hierarchy." He continues:

> The *private* moment of sentimental individuation [embodied in bourgeois portraiture] . . . is shadowed by two other more *public* looks: a look up, at one's "betters," and a look down at one's "inferiors." . . . The general, all-inclusive [shadow] archive contains subordinate, territorialized archives: archives whose semantic interdependence is normally obscured by the "coherence" and "mutual exclusivity" of the social groups registered within each. This general, shadow archive necessarily con-

tains both the traces of the visible bodies of heroes, leaders, moral exemplars, celebrities, and those of the poor, the diseased, the insane, the criminal, the nonwhite, the female, and all the other embodiments of the unworthy.[6]

According to Sekula then, photographs are not simply singular images of exemplary or common or degenerate individuals. Nor are the subordinate archives, the police mug shot or the bourgeois portrait, from which they emerge wholly distinct. Rather these archives, and the photographs within, signify in relation to one another. They function as visual indicators of the social and moral status of their subjects. More than this, each form, each visual territory, works to discipline its subjects and its viewers into discrete class groups, "provoking both ambition"—the look up—"and fear"—the look down.[7]

While Sekula is speaking here specifically about the function of the portrait in a capitalist society, I am extending the concept to emphasize that the multiple visual representations of African Americans were always, and continue to be, in intense dialogue with one another. By mapping the vast, if mostly bleak, terrain of nineteenth-century photographic representation of the black figure—as scientific object of study, as refined elite, as slave caricature, as criminal type, and as quieted savage—we can begin to reveal the interdependence of the various subordinate archives of the larger shadow archive articulating racial, gender, as well as class hierarchies on the social terrain of this period. In this interdependence we can begin to see the contradictions and ambivalences of these representations.

Sekula argues that from the pressures placed on the interstices of the shadow archive emerged the "characteristically 'petit-bourgeois' subject," pressed into compliance by a belief in the promise and threat of an "imaginary" class mobility as visualized by the police profile and the sentimental portrait. For African Americans in the nineteenth century, the contours of the shadow archive surely provoked "ambition and fear," as well as shame and anger. For Wells, these juxtapositions also encouraged identification and incited an opportunity for a kind of visual solidarity. Wells both refused the distinctions of the shadow archive while also enacting them. She chose to use photographs of lynching, which depict black people at their most bereft, abject, and seemingly unredeemable, and to enlist this growing archive as antilynching photography in order to repair, redress, and call to action. Using these images in conjunction with private, sentimental portraits suggests a disavowal of this hierarchy while counting on their perceived distinction within political cultural circles.

(En)framing the Black Body: The Lynching Photograph

Wells would come to rely upon photography's paradoxes, both its indexical function and its mercurial capacity to defy fixed or easy interpretation. During Wells's two successful speaking trips to Great Britain in 1893 and 1894, she came to understand the power of photographs, along with other documents produced by whites, to corroborate her accounts of lynchings and to open an avenue for further discussion. In order to mount a plausible and effective case against the crime of lynching, Wells believed she would have to show the body, literally. In her autobiography, Wells recalls that the Liverpudlian Reverend C. F. Aked refused to invite the journalist to address his congregation on her first speaking tour of Great Britain because he did not "believe what I said is true." It was not until Reverend Aked visited America and read detailed accounts of lynchings in white newspapers that he believed Wells's veracity and invited her to speak to his congregation when she returned to England in 1894.[8]

Like the reports published in the "reputable" white press, photographs gave legitimacy to the words of African American antilynching activists since even drawings of lynchings were suspect. Wells relied on audiences' confidence in the power of photography to faithfully apprehend and dispatch the "truths" of the material world. When Sir Edward Russell, an editor and journalist himself, saw a lithograph made from a lynching photograph reproduced in the British journal *Anti-Caste*, he denounced the image in an editorial, "as an illustration drawn from the imagination." Informed that the image was taken from an actual photograph, Russell became wholly sympathetic with the antilynching cause, lending his name and support to Wells's efforts in England.[9]

As an outspoken black woman denouncing the American South, Wells understood that photographs could function as passports that provided entry into progressive circles and the dominant public sphere. While the white press in the United States attempted to besmirch Wells's character, as the *Memphis Commercial Appeal* had sought to do beginning with her first antilynching polemic, *Southern Horrors* (1892), Wells armed herself with facts—written, quantitative, as well as visual—gleaned mostly from the dominant press. As she declared, "All the vile epithets in the vocabulary nor reckless statements [could] not change the lynching record" that the press had so copiously reported in their own pages.[10]

Upon her June return to the United States after her first speaking tour in 1893, Wells engaged in another battle over black representation. Here she would not only have to employ photographs as proof but reconstruct

the lynching narrative as well. Wells hastened to produce, publish, and distribute "a credible little book" protesting the exclusion of African Americans from and the debased representation of black people in that year's World's Columbian Exposition taking place in Chicago.[11] Joining together with Frederick Douglass, the newspaper man Irvine Garland Penn, and Wells's future husband the Chicago lawyer Ferdinand Barnett, *The Reason Why the Colored American Is Not in the World's Columbian Exposition* aimed to ask, "Why are not the colored people, who constitute so large an element of the American population, and who have contributed so large a share to American greatness, more visibly present and better represented in the World's Exposition?"[12] Through six essays covering topics from the convict lease system, the rise of Jim Crow legislation, and mob violence to "Afro-American progress since Emancipation," the slim volume sought to "better represent" African Americans effectively marginalized from all aspects of an event commemorating the four hundredth anniversary of Columbus's arrival in the New World and heralding the United States's steady march into a gilded future.

Though marginalized, black peoples were "visibly present" in pockets of the exposition: as African primitives in the "Dahomey Village," as domestics via Nancy Green's performance as the new logo of Aunt Jemima, as segregated visitors on the much-caricatured "Colored People's Day," complete with watermelon stands and an address by Douglass. Black visibility in the context of the exposition was fraught, a tapestry of competing, sometimes contradictory, but mostly demeaning and always delimited representations. Indeed, for African American contemporaries, black representation within the fair and the white supremacist policies that engendered it merely mirrored—reflected, encased, and concentrated—the landscape of black representation outside the gates of the exposition's celebrated "White City." *The Reason Why* draws explicit connections between cultural politics within and outside of the exposition, the desire to be "more visibly present," while also asserting the challenges faced and overcome by African Americans, to be "better represented."

Wells, already an accomplished journalist, and at the beginning of her lifelong antilynching work, authored three of the six essays in *The Reason Why*. The short piece titled "Lynch Law" would serve as the foundation for her pamphlet *A Red Record*. Both "Lynch Law" and *A Red Record* drew on a variety of sources to buttress Wells's analysis of the proliferation and severity of lynching throughout the Southern United States. Like *Southern Horrors*, "Lynch Law" and *A Red Record* were supported by accounts of lynchings in the white press, editorials, and Wells's own investigations.

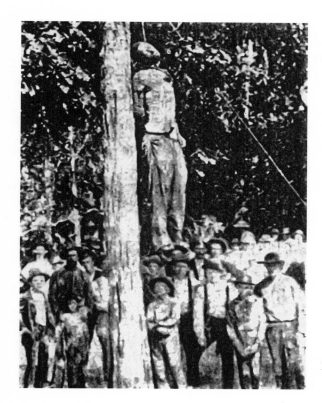

58. From Ida B.
Wells, *A Red Record*.

Notably in these two texts, Wells reproduced two images, the first a draw-
ing made from a photograph and the second a photographic postcard of
a lynching in Clanton, Alabama, in 1891. The compositions are similar: a
black male hangs lifeless from a wooden post while a multiaged crowd of
white, mostly male, onlookers poses behind the victim. The photograph
is positioned at the end of discussions regarding the innocence of many
lynching victims, several of whose guilt is questioned by their murderers
even as they are hoisted to a tree or a match is thrown at their feet (fig. 58).

The victim, Ray Porter, is situated at the center of the frame and domi-
nates it. Porter's clothes are tattered, his pants hang low around his waist,
suggesting they may have been removed and replaced, a possible castra-
tion, or perhaps were loosened in a struggle preceding the lynching. It
is not clear if Porter's arms are tied behind his back or if they are miss-
ing. His head looks upward, tilting in the sickening elongated angle of the
hanged, but his face is visible and intact, recognizable to those who may
have known him. The gruesomeness of the brutalized corpse and the ex-
tent of punishment are prominently on display. Porter's death is empha-

sized by the tall trees, leafy and full, that frame his body in the upper half of the image. Almost naturalized in this verdant setting, this man's lifeless black body is the strange fruit harvested from this unknown place. Like many similar lynching photographs, this image engenders a feeling that Porter's body is not a human being who once possessed a history and agency but a found object outside of time. Found perhaps by the crowd of white men and boys who gather in the photograph's lower half. Their presence, in their workpants and suspenders, begins to situate Porter in a time and a place; whiteness gives blackness its meaning.

In contrast to the trees that surround Porter, the long trunk against which Porter hangs seems almost as lifeless as the body tethered to it. The rough and scored bark stretches up and out of the photograph's frame. Above, beyond our view, must be the tree's branches, including the bough over which the noose is secured. We assume that the rope that curls around Porter's chest and neck, and extends above his head meets somewhere out of our line of vision with the rope that cuts taut across the right of the photograph at a nearly forty-five-degree angle, itself disappearing from view.

Rather than suturing the rope together in our imagination, the ellipsis calls our attention to the particular framing of the photograph. In his composition, W. R. Martin, a traveling photographer, evidences a concern with capturing both Porter's body *and* the crowd of white onlookers below and behind him. Had he stood further back, Martin might have caught the rope in its entirety, the tree, its limbs and leaves; but he would have sacrificed detail of mob faces. (And any less of Porter would have defeated the purpose of the photograph in the first place.)

Equally on display is the crowd, a ragtag group of white boys and white men, many moustached. Almost all wear broad-brimmed hats, shielding their eyes and faces from what was no doubt a strong August sun but not from the camera's lens. The youngest stand to the front, hands folded politely in front of them or with a hand placed rakishly on a hip, giving a more confident, more manly impression. White men stand behind their sons, some offer a bracing and paternal hand on a younger shoulder. All faces in the crowd look to the camera. Indeed the photograph is staged in a particularly flat, two-dimensional fashion so as to assure that everyone gathered can see the victim, and the camera can see all assembled. Not a crowd shot but an intergenerational community portrait. Meant for reproduction and sale as a photographic postcard, a souvenir to be kept close or circulated among community, Martin's framing suggests a keen awareness of his customers and their desires in purchasing Martin's rendering

of this event. Martin offers the fathers and sons and others of Clanton, Alabama, an image of the black brute who committed a vile crime (the alleged murder of a young white boy over money) and the manly response that brought them together. All players must be visible in the photograph for it to have its power. This framing constitutes the lynchers as racially superior white male subjects; as both viewer and viewed, these white men are capable of looking up at the camera (as Porter himself has been denied) in order to look down at the subjugated black body. Blackness here gives whiteness its meaning.

Such an image, commercially circulated and presenting all players in the lynching drama would prove useful to Wells. Though threatened herself with lynching, Wells would not be frightened into submission by either the threat of lynching or the recounting of the tale as framed by lynchers, their proponents or their apologists. She chose to tell the story in a different manner, indeed to invert and subvert the common tale of black bestiality resulting in swift white justice that culminated in, and forever echoed through, the frozen black-and-white still photograph. In Wells's hands, in the context of her "dynamitic" writing, the lynching photograph worked, and was worked, to reconceive the established narrative of black savagery as one of black vulnerability; white victimization was recast as white terrorization. Though actors and the fundamental story of crimes remained the same, in this new forum photography changed the roles and the ultimate moral.

Wells animated the lynching photograph within her activist political program by first reframing the lynching photograph, enabling African Americans to "return the gaze" of the dominant Other. Maurice Wallace alerts us to the power and persistence of "frames" in the construction of black masculinity specifically and in the hermeneutics of blackness more broadly. He offers us the term *enframement* to describe a means of imprisoning black men in the gaze of the dominant Other, contained by the fears and fantasies of black men found therein, most especially in the lynching photograph.

Wells dismantled piece by piece the racist beliefs about African Americans perpetuated in the dominant press. These components—beliefs in the innate criminality, essential barbarity, wanton lasciviousness, and meretricious aspirations of African Americans—were reassembled to reveal the fractures and flaws in the edifice of white supremacy. *White* criminality, barbarism, lasciviousness, and mendacity become visible. To borrow from Frantz Fanon's rethinking of Hegel's master-slave relationship figured in *Black Skin, White Masks*, here we are confronted with a moment in which

the victim, "the object" and "mirror" for a society's practice of justice, looks back at his executioners, "the subject," and reflects back a "flawed" image. The subject suddenly stands "naked in the sight of the object." By returning the gaze of their executioners and those gathered to watch them die, the accused begin to challenge, disrupt, and even dismantle the "corporeal . . . and historico-racial schema" of themselves constructed by "the white man, who had woven [them] out of a thousand details, anecdotes, stories." The accused intervene in their racial making and begin to undo the racial making of their executioners.[13]

Such a dismantling and reframing played and preyed upon a faith in "evidence," calling into question the truthfulness of white newspapers. In her use of the Clanton photograph, image and text are juxtaposed in order to reinforce one another. As Roland Barthes suggests, "the text constitutes a parasitic message designed to connote the image, to 'quicken' it."[14] Wells's juxtaposition extends the work of "naturalizing the cultural" reversal of the lynching narrative that the text within *A Red Record* begins. By locating this corpse within a context of doubt and uncertainty, Wells effectively makes the reality and sureness of this man's death, "proven" by the irrefutable nature of the photograph, cause to question. If Ray Porter was innocent, why then is he dead before my eyes? Here, image and text are juxtaposed in order to create a disjuncture in our visual epistemology.

This disruption is underscored by a handwritten threat sent to Judge Albion W. Tourgee, a Northern white writer and advocate for black civil and political rights, on the back of the image: "This S–O–B was hung in Clanton, Alabama, Friday August 21, 1891, for murdering a little white boy in cold-blood for 35-cents cash. He is a good specimen of your black Christians hung by white heathens" (fig. 59). Is the man a murderous "S–O–B" or a victim punished "without any proof to his guilt"? Wells casts her own interpretation into the fray. Because the photograph's evidentiary weight is assumed and understood, Wells's reframing intervenes in the received and accepted narrative of lynching, competing for the meaning of the act, the meaning of the black body.[15] Through reframing the photograph, Wells presented a competing way of "seeing" lynching; she reversed the gaze that coheres whiteness and fixes blackness.

Wells included a photograph sent to a white man, a judge and upholder of the law. Despite her journalistic intervention, Wells strengthens her argument by acknowledging a discourse that recognizes antilynching activism as necessarily a conversation between white people, particularly white men, about the fate of black men. That the chosen photograph depicts a black male corpse flanked by white fathers and sons so prominently sharing

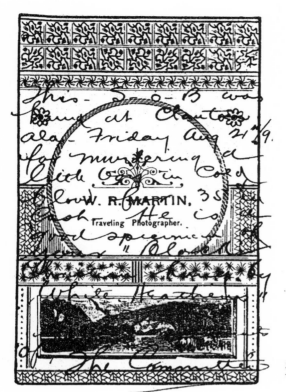

59. From Ida B.
Wells, *A Red Record*.

the lynching experience emphasizes this particularly gendered dialogue. While white women are, in the lynching mythology, the source of the conflict, the prize struggled for, black women remain on the periphery if recognized at all. Even here, Wells recognizes that the fraught public perception of her as a black woman could work to undermine the documentary power of the photograph. Not represented by the image itself, Wells absents herself from its mode of address as well. Simultaneously, the appearance of the postcard in two of her pamphlets alludes to the strong relations she has with notable and trustworthy white men.

These choices, no doubt influenced by the helpful role photographs performed in Wells's recent speaking tour, offered further "proof" of the continuity of the violent exclusions of African Americans to the international audiences who came to enjoy the spectacle of the World's Columbian Exposition. Indeed, Wells and her comrades hoped to translate and distribute *The Reason Why* in French and German as well as English, but limited funds enabled only multiple translations of Wells's preface. It is

perhaps no accident that a lynching photograph would be the *only* photograph in the pamphlet. To those few readers who did encounter *The Reason Why*, the photograph would have provided a startling contrast to the exposition's claims of American civilization and progress; it would demonstrate the dark side of happy darkey displays. As an intervention, it placed the spectacle of civilization and the spectacle of lynching within the same frame for local, national, and international audiences. The widening of the frame further suggests the fluidity of social, political, and aesthetic representation. Very likely the first deployment of antilynching photography in the political fight against mob violence, Wells's strategy of visual accompaniment would be adopted and repeated into and across the twentieth century.

Reinterpreting the Black Body: The Portrait

Lynching photography employed in the antilynching struggle makes available and discernible other ways of interpreting blackness in which the black body is read "against the grain," in which alternative meanings of blackness are asserted. This effort to reinscribe the connotation of the lynched black body and its photographic representation is one born out of the "problems of identification" for black spectators.[16] Indeed, if lynching photographs were meant for white consumption, to reaffirm the authority and certainty of whiteness through an identification with powerful and empowered whites who surround the black body, what then did black looking affirm? What concept of the black self could emerge from an identification with the corpse in the picture? Can one refuse such identification, or is "the identification . . . irresistible"?[17]

African Americans both identify and don't identify. They engage in a form of "resistant spectatorship," Manthia Diawara's term to describe a practice of looking "in which Black spectators may circumvent identification and resist the persuasive elements" of the spectacle.[18] Antilynching photography offers revised readings of black subjectivity, enabling African Americans to transcend the frames to which they have been confined, to move beyond racial fixity.[19] By juxtaposing the multiple visual representations of African Americans—as scientific object of study, as refined elite, as slave caricature, as criminal type, and as quieted savage—we can once again, see clearly the interdependence of the various subordinate archives of the larger shadow archive articulating hierarchies on the social terrain of this period.

Photography's uniqueness as a medium, and its early and enduring appeal, lay in its ability to *record*, not merely depict that which exists in the material world. Called a "mirror with a memory" by the physician and inventor Oliver Wendell Holmes not long after its inception in this country in 1839, photography quickly surpassed painting in its imagined capacity to capture history and human experience *as it truly was*, unmediated by human hands. For now, in the words of an April 13, 1839, *New Yorker* magazine article, "All Nature Shall Paint herself!"[20] The medium's magic rests in its function to offer an index, a sign of a "truly existing thing." In the same spirit in which emergent genetic technologies are heralded for their ability to deduce our unique biological essences, so too was photography lauded as a "guaranteed witness" offering evidence of our interior selves.[21] Indeed, photography emerged (and continues to thrive) in an epoch of colonial and imperial conquest, in feverish desire to order, contain, and exploit the physical world.

And yet such technologies are tools whose status, John Tagg reminds us, "varies in the power relations that invest it."[22] So perhaps there is no better technology than photography to document—to fix and to archive—the so-called fact of race. "Rather than *recording* the existence of race," the artist, curator, and cultural critic Coco Fusco asserts, "photography *produced* race as a visualizable fact."[23] Through emphasis of physical characteristics, enframement of and by text, through formalization of pose and iconization of dress and gesture, race from the nineteenth century onward became visible and identifiable, common sense confirmed by scientific apparatus. Visual signifiers captured by the camera became *proof*, signs of difference, excavations of interiority.[24] In portraits and pornography, snapshots and mug shots, we *know* race to be true because we see it, touch it, circulate it, desire it, abhor it, by way of the photograph.

Since its inception in 1839, photography has been both a cultural site of subjugation and a technology of liberation. Antilynching photographs then are always in a productive direct or indirect dialogue with cultural representations of African Americans, both portraits of uplift and images of degradation. African Americans used photography to reconstruct their image, in part, against the humiliation of minstrel icons and against the vulnerability of lynched black bodies. Blacks chose to represent themselves not only as cultured and refined but also as thriving and self-possessed, as the embodiment of bourgeois ideals. Utilizing the affirming and often liberating genre of portraiture, in particular, signified a conscious and public choice meant to counter the repressive functions of lynching images

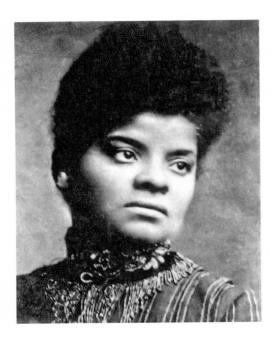

**60. Ida B. Wells
(1862–1931).**

Courtesy of the Granger
Collection, New York.

(fig. 60). The use of lynching images was likewise a performance, an attempt to affect public opinion and envision freedom through the specific dramaturgy, or staging, of black death at the hands of white Americans.[25]

Photography has been used to express a freedom to define and represent oneself as one chooses and a freedom from the ideological and material consequences of dehumanizing depictions. These portraits of uplift, self-possession, often of middle-class patriarchal respectability are inextricable from the shadow archive of black representation. More than merely "the reconstruction of the image of the black" or a "decolonizing of the eye," photography has also enabled a confrontation with and a staging of alternative futures.[26] For marginalized groups especially, bearing on their shoulders the burden of representation, photography can establish intimacy with its subject and articulate distance. As self-crafted, though always negotiated and forming a dialectic with dominant cultural depictions, these images are neither the thingly Other nor the thing itself but reside in the interstices. Photography mapped onto but not ontologically of the black body enables a space of transfiguration in the disaggregation of blackness as "an abject and degraded condition," from the humanity of actual black people.[27] I believe this is as true (though differently true) of antilynching photographs as of carefully composed portraits.

Like Frederick Douglass, Sojourner Truth, and many African Americans

before her, Wells was attuned to her own visual representation but with the youthful exuberance of the single attractive woman she was. Miriam DeCosta-Willis, editor of Wells's *Memphis Diary*, notes that "Wells frequently made 'cabinets' or photographs of herself."[28] Her early diaries, kept while in her twenties, depict a woman concerned with her appearance, who notes her various wardrobe purchases, and indeed possessed a knowledge of quality photographic work and what it would cost. On August 12, 1887, Wells wrote, "Paid $1.25 for my pictures and am afraid for that reason I shall not be satisfied with them; they are too cheap." Her concern proved correct for when she retrieved the pictures ten days later she was disappointed but not discouraged: "Monday morning bright & early I went to get my pictures . . . The pictures were ruined & I would not have them. A $1.25 thrown away, but came down to another gallery and ordered another dozen." This new set were more to her liking: "Went to look at the proof of my pictures which was very good."[29] More than merely attuned to the possibilities of photographic portraiture, Wells held clear standards and valued and actively sought out representations of herself that were aesthetically pleasing and of high quality.

As Wells's words and opinions began to circulate throughout the black press in the late 1880s, so too did her image. Like in her British speaking tour and in her earlier use of lynching images, she would again come to understand that her black female body as "document" of her interior essence could undermine the strength of her written work and the urgency of her message. In 1889 a virulent conflict arose between Wells and the editors of the *Cleveland Gazette* over an image that black newspaper printed to accompany one of Wells's articles. Apparently the picture was unbecoming enough to lead the *New York Age* to comment, "Iola will never get a husband so long as she lets these editors make her look so ridiculous."[30] Wells took care that in pictures as well as in prose she favorably represented herself and wanted no less from the publications in which she or her work appeared. She wrote that the press needed to more carefully consider the way they image women. The *Indianapolis Freeman*, who shared a turbulent relationship with Wells and her mentor, the journalist T. Thomas Fortune, belittled Wells's complaint, stating, "Iola makes the mistake of trying to be pretty as well as smart. Beauty and genius are not always companions."[31] In their mocking dismissal of Wells through her visual representation, both the *Indianapolis Freeman* and the *New York Age* concede and reproduce the perceived incongruence between Wells's chosen profession as a journalist and public intellectual and the Victorian era domestic expectations for middle-class women and black women especially. Wells navigated and at-

tempted to coalesce these roles deemed mutually exclusive, and the photograph offered both a minefield and an opportunity to present a new reading of her particular model of black womanhood.

Wells wrote in her journal that she was a woman who had "been so long misrepresented" that she began "to rebel."[32] At first glance, the portrait of Wells in 1893 displays many of the conventions of typical nineteenth-century portraiture: the medium frame that captures Wells's face and her upper body bathed in soft light, the upright pose, folded hands and raised chin of the subject, the muted grays of the studio backdrop. As a typical portrait, it must be read for its production of a middle-class female identity, "imbued with a notion of a superior interior essence" or aura, its surface form bestowing upon its subject "the 'character,' 'emotion,' 'mind,' or 'soul' imagined to reside within the body's depths."[33]

But within the context of the shadow archive of black representation, the photograph must also be understood as an attempt to confer these qualities to those bodies denied depth, indeed to make character self-evident. The framing of the portrait draws attention to Wells's fine clothes. The high Victorian collar is elaborated with a floral patterned beadwork that extends into a necklace of beads that encircle the upper bodice of the dress or jacket. Along with the pronounced buttons and the smart stripes, the photograph indicates Wells's mindfulness of fashion trends and interest in fine clothing, a passion that Wells noted frequently in her journals (as well as lamented in the amount of money she spent on gloves, hats, dresses, and the like). Clothing, the attention to the sartorial in the photograph, "reveals" Wells's middle-class proclivities, a manifestation of her consumer power and her "taste." Clothing also conceals her body literally, particularly the masking work performed by the collar and the stiff buttons. Metaphorically, clothing also conceals the readings of her body as sexual object or manual and domestic laborer.

With her body thus obscured, Wells's face becomes a focal point. Smooth and fresh, she looks up and away from the camera, a cultivated look conveying her self-presentation as female object to be considered and gazed upon within the subject affirming frame of the portrait. Wells's hair is carefully drawn up in a bun; her hair is abundant and the attention paid to its upkeep and propriety is clear. Wells here is both desirable object and self-possessed subject. The portrait speaks to Wells's own self-presentation as middle-class and thriving. Simultaneously, it attempts to interpellate an audience of black middle-class viewers, as themselves both viewing objects and subjects. In such an address, Wells represents herself as "pretty as well

as smart," using the photographic portrait to challenge the conventions of black womanhood by which she so often found herself constricted.

Bringing the Shadow Archive to Light: The Political Portrait

This portrait of Wells and the photo postcard of the Clanton, Alabama, lynching, offer two poles of the shadow archive: the ambition of a brilliant and formidable journalist who carries with her the hopes of a race, and the fear of black humanity reduced so callously and casually to bare life. The "look up" and the "look down" could scarcely be more clearly or starkly rendered. And the juxtaposition of these two images is one that would be echoed and raised by many, twinned as one of many embodiments of the positive/negative image binary that has been the mainstay of black cultural politics since. A third photograph offers a bridge, a synthesis of this dialectic into what we might call the political portrait, a photographic image made in the vein of the private realm and bespeaking the domestic but intended for public consumption with political objectives.

After the lynching at the Curve, Wells had commissioned a portrait of herself with her dear friend Tom Moss's family. The historian Gail Bederman suggests the photograph might have been publicity for Wells's first tour of England.[34] In the image, Wells, dressed in black with white adornment on her jacket, poses with Betty Moss, in a black mourning dress and gloves, and Moss's two children, Maurine and Thomas Jr., dressed in white baptismal gowns. Though the Mosses are positioned in an elaborate high-backed chair, marking their separateness from Wells and their distinction as a family unit, the four subjects are held close together in the picture's frame. Wells rests her head on Maurine, whose hand disappears behind Betty's back; Betty and Thomas Jr.'s faces touch, their support for one another in their bereavement evident in their physical closeness and intimacy.

Portraits of children and family portraits more generally have been a key photographic practice since the emergence of the daguerreotype, a means of documenting family history, representing private sentiment, and displaying pride in one's assets and lineage. The portrait of Wells and the Moss family participates in such a practice, but here we are made to acknowledge the tragedy of a family lineage severed by the cruel lynching of the patriarch (fig. 61).

Wells's own self-insertion within the (broken) family portrait as the only figure standing—she supports Maurine her goddaughter and looks directly into the camera—suggests her assumption of the role of protector.

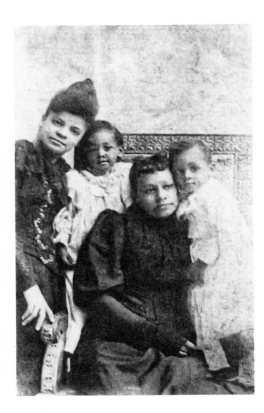

61. Wells-Moss family portrait.

Courtesy of the Special Collections Research Center, University of Chicago Library.

As godparent to the elder child Maurine, it was indeed Wells's duty to offer protection should anything happen to her. As a "private moment of sentimental individuation," this image sees Wells taking on the responsibility for this family, stepping into the role of the now-absent father. As a "public look," if indeed this image became part of her political crusade, the portrait also represents Wells assuming the role of protector of the race, stepping into the role of the race man. Not content to serve as merely bearer of race respectability, the role assigned to black women, when black people's lives as a whole are threatened, Wells in this picture is treading contested territory.

The photograph calls to light the tensions surrounding black women's public activism at the end of the nineteenth century and the particular minefield that Wells crossed and recrossed, sometimes successfully, often not. Scholars recognize the brilliance of Wells's antilynching strategies, her skilled manipulation of contemporary discourse, her radically incisive critiques of race, gender, and lynching's inextricability, her adroit engagement with emergent social science methods, her "dynamitic" writing style,

all of which would be emulated by the NAACP and subsequent campaigns against lynching. It is also generally agreed upon that Wells was often dismissed and ultimately relegated to the sidelines because her pioneering work came from an outspoken, complex black woman, who often led without the consistent backing of any reform organization in a moment when black men sought to assert their leadership based on gender "norms."

How does a black woman assert herself in public space as a race leader? How does she navigate the "politics of respectability," working to perform as a "true woman," chaste, pious, while doing the necessary radical work to end the wanton murder and sexual violation of black people?[35] How does she accomplish this work without "unsexing" herself, becoming too manly if she moves too far out of her place? And how does she take up this work without harping on the nagging question of what men are doing to stop lynching? As one editorial proclaimed, "The hour has come, where was the man? Unfortunately, the man was not forthcoming—but Miss Wells was!"[36]

The image of Wells and the Moss widow and orphans as a political portrait confronts the antinomies of lynching photography, the need to call attention to black victimization, to paraphrase the historian Patricia Schechter, while shielding the bodies of African Americans, especially black women. In her earlier work, Wells expertly wielded these textual weapons in the context of a well-crafted public speaking persona that both played upon and drew attention away from her black female body. Indeed, in Britain, Wells's own "body became an exhibit for her arguments about the South." Under the carefully chosen pen name "Exiled," Wells authored dispatches from her tours. The coupling of the androgynous moniker with charged words centered on the violent intermixture of race, sex, and place attempted, as Schechter tells us, to "resist the negative or even *non*subjectivity assigned to black women in American culture . . . [to] abandon the dominant culture's racist demand for bodily fixity . . . and challenge others to join her." Photographs helped further dislodge these "coordinates," to widen the space between the incontrovertible nature of Wells's facts and argument on the one hand and the dubious "nature" of the body that presented them on the other. Photographs achieved this in part by luring attention away from Wells's "nonsubjectivity" as black woman, as wanton and lascivious, as cheap imitation of white "true womanhood," and refocusing her audiences' gaze on the brutalized black male body.[37]

We might also take up this last image as not merely highlighting contradictions but simultaneously expanding the boundaries of interpretation, typical of Wells's work. Here, lynching is represented not solely by the ab-

ject and desecrated black male body but also by the family, the children left behind, and importantly by the women who survive and take up political struggle. For example, we are compelled to broaden our understanding of the "lynching photograph," as not simply the icon of the black man hanging from a tree surrounded by an enthusiastic white mob but as family left behind. Not simply cast in the role of mourner, the framing of this image within Wells's work and within her shadow archive also suggests mourning as a political act. As Deborah McDowell has argued about contemporary postmortem photographs of black male homicide victims, "survivors reject the role of passive mourners scripted by the media." Juxtaposed with photographs of lynching mobs, "they represent families that choose to exhibit the body not as still life but as living still in memory."[38] Though formal portrait, it is also a lynching photograph. As such, this image cannot fit neatly into either archive. A longer narrative, Wells's shadow archive enlists us all.

Notes

1. Allan Sekula, "The Body and the Archive," reprinted in *The Contest of Meaning: Critical Histories of Photography*, ed. Richard Bolton (Cambridge: MIT Press, 1989).

2. See especially Shawn Michelle Smith's important works *American Archives: Gender, Race and Class in Visual Culture* (Princeton: Princeton University Press, 1999) and *Photography on the Color Line: W. E. B. Du Bois, Race, and Visual Culture* (Durham: Duke University Press, 2004).

3. Smith, *Photography on the Color Line*, 3.

4. Deborah Willis, "The Sociologist's Eye: W.E.B. Du Bois and the Paris Exposition," in *A Small Nation of People: W.E.B. Du Bois and African American Portraits of Progress*, ed. David Levering Lewis and Deborah Willis (New York: Amistad, 2003), 52.

5. Allan Sekula, "The Body and the Archive," *October* 39 (Winter 1986), 7.

6. Sekula, "The Body and the Archive," 10.

7. Ibid.

8. Ida B. Wells and Alfreda M. Duster, ed., *Crusade For Justice: The Autobiography of Ida B. Wells* (Chicago: University of Chicago Press, 1970), 129. Habeas corpus means literally to "have the body." The writ of habeas corpus requires that a person or evidence be brought before a judge or court to determine if there is sufficient cause to prosecute, detain, or imprison. It is important to note that to show the body, in this case through the use of lynching photographs, antilynching activists needed to *have* the body, to usurp ownership of these images from the hands of the white communities and individuals who claimed them previously.

9. Wells, *Crusade for Justice*, 139.

10. Ibid., 186.

11. Ibid., 116.

12. Ida B. Wells, Frederick Douglass, Irvine Garland Penn, and Ferdinand L. Barnett, *The Reason Why the Colored American Is Not in the World's Columbian Exposition*, ed. Robert W. Rydell (1893; rprt. Urbana and Chicago: University of Illinois Press, 1999), 4.

13. Frantz Fanon, *Black Skin, White Masks* (1952; rprt. New York: Grove Weidenfeld, 1967), 212, 111.

14. Roland Barthes, *Image—Music—Text* (New York: The Noonday Press, 1977), 25, 26. For further discussions of the relationship between image and text, see Jefferson Hunter, *Image and Word: The Interaction of Twentieth-Century Photographs and Texts* (Cambridge: Harvard University Press, 1987); and W. J. T. Mitchell, *Picture Theory: Essays on Verbal and Visual Representation* (Chicago: University of Chicago Press, 1994).

15. Wells, "A Red Record," in *The Reason Why the Colored American Is Not in the World's Columbian Exposition*, 117, 119.

16. Manthia Diawara, "Black Spectatorship: Problems of Identification and Resistance," in *Black American Cinema*, ed. Manthia Diawara (New York: Routledge, 1993).

17. David Marriott, *On Black Men* (New York: Columbia University Press, 2000), 5.

18. Diawara, "Black Spectatorship," 211.

19. Homi K. Bhabha defines *fixity* "as the sign of cultural/historical/racial difference in the discourse of colonialism, [that] is a paradoxical mode of representation: it connotes rigidity and an unchanging order *as well as* disorder, degeneracy and demonic repetition" ("The Other Question: The Stereotype and Colonial Discourse," in *Visual Culture*, ed. Jessica Evans and Stuart Hall [London: Sage Publications, 1999], 370).

20. Quoted in Nicholas Mirzoeff, "The Shadow and the Substance: Race, Photography and the Index," in *Only Skin Deep: Changing Visions of the American Self*, ed. Coco Fusco and Brian Wallis (New York: Harry N. Abrams, 2003), 114.

21. John Tagg, "The Currency of the Photograph," in *Thinking Photography*, ed. Victor Burgin (New York: Palgrave Macmillan, 1982), 117.

22. John Tagg, *The Burden of Representation: Essays on Photographies and Histories* (Minneapolis: University of Minnesota Press, 1993), 63.

23. Coco Fusco, "Racial Times, Racial Marks, Racial Metaphors," in *Only Skin Deep*, 60.

24. See especially Smith, *American Archives*.

25. For discussions of the relationship between African American identity and photographic portraiture, see Willis, *Reflections in Black*; and Camara Dia Holloway, *Portraiture and the Harlem Renaissance: The Photographs of James L. Allen* (New Haven: Yale University Art Gallery, 1999). See also Henry Louis Gates Jr., "The Trope of a New Negro and the Reconstruction of the Image of the Black," *Representations* 24 (Fall 1988).

26. Henry Louis Gates Jr., "The Trope of a New Negro and the Reconstruction of the Image of the Black"; bell hooks, *Black Looks: Race and Representation* (Boston: South End Press, 1992).

27. Saidiya Hartman, *Scenes of Subjection: Terror, Slavery and Self-Making in Nineteenth Century America* (New York: Oxford University Press, 1997), 22.

28. Miriam DeCosta-Willis, ed., *The Memphis Diary of Ida B. Wells: An Intimate Portrait of the Activist as a Young Woman* (Boston: Beacon Press, 1995), insert after page 152.

29. DeCosta-Willis, *The Memphis Diary of Ida B. Wells*, 154, 156.

30. Quoted in Patricia A. Schechter, *Ida B. Wells-Barnett and American Reform, 1880–1930* (Chapel Hill: University of North Carolina Press, 2001), 61. For more on this incident, see also DeCosta-Willis, *The Memphis Diary*.

31. Quoted in Schechter, *Ida B. Wells-Barnett and American Reform*, 61.

32. DeCosta-Willis, *Memphis Diary*, 114.

33. Smith, *American Archives*, 55.

34. Gail Bederman, *Manliness and Civilization: A Cultural History of Gender and Race in the United States, 1880–1917* (Chicago: University of Chicago Press, 1995), 64.

35. For more on the politics of respectability, see Evelyn Brooks Higginbotham, *Righteous Discontent: The Women's Movement in the Black Baptist Church, 1880–1920* (Cambridge: Harvard University Press, 1993).

36. *Indianapolis Freeman*, September 29, 1894, quoted in Schechter, *Ida B. Wells-Barnett and American Reform*, 137.

37. Schechter, *Ida B. Wells-Barnett and American Reform*, 25, 34, 35.

38. Deborah E. McDowell, "Viewing the Remains: A Polemic on Death, Spectacle, and the [Black] Family," in *The Familial Gaze*, ed. Marianne Hirsch (Hanover: University Press of New England, 1999), 170.

The Photographer's Touch

J. P. BALL

Shawn Michelle Smith

James Presley Ball's photographic portrait of William Biggerstaff from 1896 presents the man seated in a simple wooden chair (fig. 62). Dressed formally in a thick woolen suit, a boutonniere pinned to his lapel, Biggerstaff assumes a contemplative pose, resting his chin in his curled right hand, and looking thoughtfully at someone or something just outside the photographic frame. His hair is neatly combed and parted, his snug-fitting suit clean and pressed. In the backdrop behind him a small winged cherub appears to adorn a circular trellis with flowers. The circular shape frames Biggerstaff's head and shoulders, creating a kind of halo behind him.

Although less ornate than some of his most inventive images, Ball's portrait of Biggerstaff is fairly typical of the photographer's work. It is a formal three-quarters portrait, a cabinet sized albumen print mounted onto a card bearing the photographer's studio insignia, "J. P. Ball & Son," and location, "opposite postoffice" in Helena, Montana. The image is almost identical to Ball's portrait of William Gay, in which the latter, seated in the same chair, in front of the same backdrop, holds a handwritten paper in his left hand as he leans his head against his right hand and looks thoughtfully outside the photographic frame (fig. 63). Other important circumstances link the two images: Biggerstaff and Gay were both executed for murder in Helena in 1896, and J. P. Ball photographed their executions.

J. P. Ball was one of the most successful African American photographers in the nineteenth-century United States. As Deborah Willis's groundbreaking research has established, Ball, like many early daguerreo-

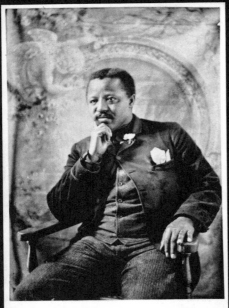

62. J. P. Ball, portrait of William Biggerstaff, 1896.

Courtesy of the Montana Historical Society Research Center, Photographic Archives, Helena, Montana.

63. J. P. Ball, portrait of William Gay, hung for murder, Helena, Montana, June 8, 1896.

Courtesy of the Montana Historical Society Research Center, Photographic Archives, Helena, Montana.

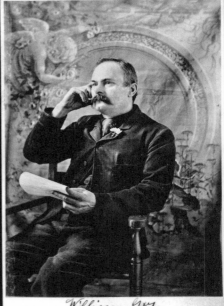

typists, first worked as an itinerant for several years in the 1840s before he opened a studio with his brother, Thomas Ball, in Cincinnati in 1849. Ball's Great Daguerrean Gallery of the West was a success, and in the late 1850s Ball opened a second gallery with his brother-in-law, Alexander Thomas. The Ball and Thomas Photographic Art Gallery became a tremendously successful family business for the next two decades, producing portraits of such famous celebrities as the actress Jenny Lind and the orator Frederick Douglass and generating an income of over one hundred dollars a day. For reasons unknown, Ball left Cincinnati for Minneapolis in the late 1870s or early 1880s and then moved again in 1887 to Helena, Montana, where he made his images of William Biggerstaff and William Gay.[1]

Ball's execution photographs of William Gay, a white man, depict the condemned man at the gallows, attended by a priest and the sheriff and surrounded by a crowd of white men. Although at least one of the images appears carefully posed, others bear a seeming spontaneity. In one, Gay kisses the crucifix Father Von Clarendon presses to his lips as Sheriff Henry Jurgens holds the noose ready. In another Gay removes his hat in preparation for the noose. These images are marked by blurs that register the movement of those in the crowd as well as the central performers in these last rites. They still action as it occurs, making them appear unplanned despite the space and uninterrupted sightline afforded to Ball and his camera.

Ball's photographs of the execution of William Biggerstaff, an African American man, lack such seeming casualness: they are formally posed, with subjects still, facing the camera. The images that document Biggerstaff's demise show his lifeless body hanging, unbound, his hooded head pitched to the right.[2] In one, Biggerstaff is flanked by a minister, the Reverend Victor Day, and Sheriff Henry Jurgens (fig. 64). Behind them a group of white men in suits peer around the prominent group of three, looking seriously and directly into the camera. In a second image the crowd has disappeared, and Biggerstaff's hanging body is flanked by a man named Fred Hoss and once again by the sheriff. The three men present a strange group: Hoss extends his left arm to place his hand in the small of Biggerstaff's back, almost as if in a fraternal embrace, and Sheriff Jurgens appears to hold Biggerstaff's left hand. These gestures, presumably meant to still the hanging body for the photograph, nevertheless unsettle the image of a measured and abstract justice with a strange intimacy. The formal posing of the three men together, facing the camera, isolated in the photographic frame, suggests a kind of macabre group portrait. But in this grouping, Biggerstaff, the central subject, has been literally objectified in death. He is both subject and object lesson, his face covered with a black hood, high-

lighting his inability to return the photographer or viewer's gaze, to look back as a subject.

Ball's photographs of William Biggerstaff's execution, of a dead and hanging African American man's body surrounded by a crowd of white men, recall the register of lynching photographs and the history of lynching, which was at its height in the 1890s.[3] In the most basic ways lynching photographs and legal execution photographs look very similar: a crowd is photographed around a hanging body. Other aspects of the images, of course, clearly distinguish them. In lynching photographs the crowd is almost always white, and its victim is most frequently black and male. Lynchers eagerly display the bodies of the men they have murdered as mutilated spectacle. And the cultural function of such images is substantially different. While lynching photographs record explicitly lawless behavior, displaying how white men and women seize and reproduce white power by taking judgment and punishment into their own hands, photographs of legal executions document the grim enactment of purportedly legal justice. Lynching photographs demonstrate a group's disregard for the law, while photographs of legal executions proclaim the law-abiding nature of communities.

Ball's photographs of legal executions draw attention to the range of executions in which lynching took its place in the late nineteenth century and early twentieth century.[4] While the lynch mob defied due process and relished photographs as signs of its vigilante justice, those who dispense justice in legal executions are the official bearers of the law. In Ball's photographs it is the sheriff who holds the noose and exercises the sentence of the law. The presence of a minister or priest lends the execution a kind of moral authority as well. Ball's images would seem to record the legitimacy of the law and the justice of its execution. The photographs of Biggerstaff and Gay are all taken in the light of day. Helena, the photographs declare, has not been abandoned to the harried "frontier justice" of makeshift posses and self-authorized vigilantes. This is not the wild, lawless West but an established and civilized community with proper courthouses, sheriffs, ministers, churches—proper executions and photographers—taking its place in the national picture.

The presentation of the West as a place of God-fearing, law-abiding citizens is especially connoted by Ball's photographs of the legal execution of William Gay, for Gay was a frontiersman, a cultural type quickly dying by the end of the nineteenth century. At different times a trader, prospector, cattleman, mail carrier, saloon owner, and gambling hall proprietor, Gay represented the mythical Wild West. After a successful run of prospect-

ing in the Black Hills of the Dakotas, he established his own town, Gay-ville. Following a darker turn of events, his life was threatened (but not taken) by a Montana vigilante group. After a series of violent confronta-tions with the law, Gay escaped from Montana, making his way via Utah and Nevada to California. He was eventually discovered in California in 1894 and charged with the murder of the Montana Deputy Sheriff James Macke. Gay was brought back to Montana for his trial, imprisonment, and final execution.[5] Within this context, Ball's photographs of Gay's execu-tion declare that the days of vigilante justice on the Wild Western fron-tier are over. The law has extended its grip, and the community is under its jurisdiction.

The photographs of Biggerstaff's execution are troubled by the dis-tinctly racialized form of vigilante justice epitomized by lynching, an extralegal practice gaining, rather than losing, speed in the 1890s. Despite the "official justice" documented in his photographs, Ball cannot have been immune to the resonance his images of Biggerstaff's legal hanging would have had with lynching photographs. And certainly legal executions have also been informed by the same culture of racism that enabled lynching. African American men still disproportionately populate the death rows of the national prison system. In 1896 in the law-abiding town of Helena, Montana, William Biggerstaff pleaded self-defense in the murder case for which he was condemned. As Jacqueline Goldsby has documented, one hundred men and women of color lobbied the governor to stay Bigger-staff's execution, and J. P. Ball, Biggerstaff's photographer, was the leader of his clemency movement.[6]

Understanding his official protest of Biggerstaff's execution reanimates Ball's photographs in perplexing ways. The stern looks of the white men who stare back at the photographer in these images newly suggest a kind of confrontation. The sheriff and preacher flanking Biggerstaff look out just to the right of the photographic frame. But the men who crowd close behind them seem to stare directly back at the photographer. They do not observe Biggerstaff or the official authorities of this proceeding, but in-stead they tilt their heads and crane their necks to look at Ball himself. Their furrowed brows and hard eyes search for the photographer, as if Ball himself has become a spectacle. They position themselves on the side of the legal authority that has been questioned, a phalanx of white men support-ing "the law." The men and women of color who protested Biggerstaff's sentence are not present in this scene, except for Ball, witnessing the events from behind his camera. Ball is one African American man confronting a crowd of white men over the body of another African American man, and

the stern faces of his antagonists would seem to dare him to question the legal proceedings they uphold, to call this legal execution a lynching.

Given the tensions in and around Ball's photographs of Biggerstaff's execution, Ball's postmortem photograph of Biggerstaff reverberates with heightened intensity (fig. 65). In this final image, the corpse has been carefully prepared; it is displayed in a lined and padded casket, adorned with an ornate brass handle. The coffin has been propped up to present the corpse for viewing in an elaborately wallpapered room that suggests a formal parlor. Ball has framed the photograph in the manner of a half portrait, and Biggerstaff's left hand is prominently displayed, bearing his wedding ring.[7] The image signals a family and community of loved ones who care for this man and will mourn his passing. As a series, the photographs of Biggerstaff's legal fate are framed by the respectful treatment of his person and body by loved ones and by the photographer. The first and last images in the series, the portrait and postmortem photographs, work to reclaim Biggerstaff from the judgments of the law, to confirm an identity distinct from that of the condemned man, celebrating him as a man with a family and a community, of which his photographer, J. P. Ball, was himself a member.

Further details embellish Ball's photographs of Biggerstaff: visible fingerprints mark two of the images. While not entirely anomalous, such "mistakes" are rare in this successful photographer's archive. In the strange group portrait that features Biggerstaff's body flanked by Hoss and Jurgens, a large fingerprint stands out against the image of the light cloth that shields the gallows from more general view. Fingerprints repeatedly mark both sides of Ball's portrait of Biggerstaff, and a large smudge is distinctly visible on the right side of the image. Pressed onto the negative (or left on the print by chemically stained hands), the fingerprints are probably those of the photographer, Ball himself. It is as if Ball has sought to register himself on his glass plates, to leave a trace of his own body on his negatives, alongside that of his subject. These signs of physical touch mark the presence of the photographer, highlighting his role as contemporary witness, and they also suggest the ways in which the photographed subject might be said to touch later viewers.[8] As Roland Barthes has proposed, light reflected off the subject resides in the photograph; the image is a trace the subject leaves behind to touch later viewers: "The photograph is literally an emanation of the referent. From a real body, which was there, proceed radiations which ultimately touch me, who am here. . . . Light, though impalpable, is here a carnal medium, a skin I share with anyone who has been photographed."[9] Ball's fingerprints heighten the tactility of the photo-

**64. J. P. Ball, execution
of William Biggerstaff,
April 1896. Left to right:
Reverend Victor Day,
William Biggerstaff, and
Sheriff Henry Jurgens.**

Courtesy of the Montana
Historical Society Research
Center, Photographic Archives,
Helena, Montana.

**65. J. P. Ball, postmortem portrait of
William Biggerstaff, April 1896.**

Courtesy of the Montana Historical Society
Research Center, Photographic Archives,
Helena, Montana.

graph, marking the image as a kind of skin *with* skin. Like the photographs themselves, Ball's fingerprints work to reclaim Biggerstaff from death, re-asserting his presence, and the presence of the photographer with him, for a moment in time. Finally, these visibly touched photographs reach out to brush later viewers, impressing upon them the fate of Biggerstaff and the testimony of his photographer J. P. Ball.

Notes

1. Deborah Willis, ed., *J. P. Ball: Daguerrean and Studio Photographer* (New York: Garland, 1993), xiv–xix. According to Willis, Ball moved to Seattle sometime around 1900 and opened the Globe Photo Studio at age seventy-five. He may have made a final move to Hawaii in 1904 (xix). See also Deborah Willis, *Reflections in Black: A History of Black Photographers, 1840 to the Present* (New York: Norton, 2000), 5–9.

2. As Jacqueline Goldsby notes, "Biggerstaff's body is not bound with the belts used to restrain the condemned during a hanging," belts that, I would note, are clearly visible on William Gay's body. According to Goldsby, such negligence, re-corded by Ball in his photographs, "underscores the cruelty of the execution itself" (*A Spectacular Secret: Lynching in American Life and Literature* [Chicago: The University of Chicago Press, 2006], 245).

3. See also Deborah Willis, "Introduction: Picturing Us," *Picturing Us: African American Identity in Photography*, ed. Deborah Willis (New York: The New Press, 1994), 3–26, 13–15.

4. See Ken Gonzales-Day's *Lynching in the West, 1850-1935* (Durham: Duke University Press, 2006) for a further discussion of the continuum on which legal executions and lynchings functioned.

5. E. Dixon Larson and Al Ritter, "Frontiersman Bill Gay," *Wild West* (June 1996), reproduced on Historynet.com, http://www.historynet.com/culture/people/3037926.html.

6. Goldsby, *A Spectacular Secret*, 246.

7. Biggerstaff's wedding ring, displayed prominently in his execution and post-mortem photographs, is not present in his studio portrait. In that image, his left hand, displayed prominently resting on the arm of the wooden chair, is unadorned. For Jacqueline Goldsby, "the absence and then presence of a wedding band on Biggerstaff's left ring finger" (*A Spectacular Secret*, 245–46) encourages viewers to consider the life course and community of the man beyond the events documented in his photographs and beyond the reach of the law.

8. My reading here is inspired by Carol Mavor's discussion of the touch in Julia Margaret Cameron's photographs. See Carol Mavor, *Pleasures Taken: Performances of Sexuality and Loss in Victorian Photographs* (Durham: Duke University Press, 1995), 43–69.

9. Roland Barthes, *Camera Lucida: Reflections on Photography*, trans. Richard Howard (New York: Hill and Wang, 1981), 80–81.

 ELEVEN

No More Auction Block for Me!

Cheryl Finley

I think of my own family at our last gathering, sitting around a table with a plastic-lined bushel basket in which we keep hundreds of old photographs, some from as far back as the 1880s, and saying as we pick up each picture, "Remember this." We look at these photographs of ourselves as children in the various rituals of growing up and being grown and we try to re-create the meaning(s) inscribed in those pictures.

—Mary Helen Washington, *Memory of Kin*

The portrait is therefore a sign whose purpose is both the description of an individual and the inscription of social identity. But at the same time it is also a commodity, a luxury, an adornment, ownership of which itself confers status.

—John Tagg, *The Burden of Representation*

Apart from a tiny minority of aesthetes, photographers see the recording of family life as the primary function of photography, continuing to conform to the strained, posed and stereotyped photography of the family album.

—Pierre Bourdieu, *Photography: A Middle-brow Art*

One could buy there so-called Negroes of every shade of color and kind of occupation: native Africans, black as ebony, some of them imported half a century previously, others recently smuggled in and knowing only a few words of any language of civilization; Creole octoroon young women as light as southern Europeans, with straight hair, beautiful figures, regular features; caulkers, masons, butlers, coopers, coachmen, lady's-maids, nurses either wet or dry, waiters, seamstresses, engineers, preachers.

—Frederic Bancroft, *New Orleans: The Mistress of the Trade*

Albums of old photographs possess a mystical power to carry us into the past. Drifting through distant lands, familiar smells, outmoded styles, and cultural rituals, we arrive at a place to contemplate our historical origins. Frequently comprised of faded black-and-white images on paper, photograph albums bring to mind another place and time that sparks the historical imagination. But what is it about old photograph albums that force us to conjure up past memories? What prompted the cultural practice of compiling albums of photographs, and why are we compelled to make them, even today, with the advent of digital technology? Exactly what characterizes their hold over us?

The intrinsically human quest for personal and group identity has been tied to the function of the photographic image since the invention of the medium of photography more than 170 years ago.[1] As John Tagg points out, "The ideological conception of the photograph as a direct and 'natural' cast of reality was present from the very beginning and, almost immediately, its appeal was exploited in portraiture."[2] Starting with the daguerreotype, the human countenance and the experience of everyday life came to be captured in photographs for perpetuity. It would take nearly fifteen years of technological evolution in photographic equipment and paper printing processes to produce the first practical form of photographic portraiture, the carte de visite, a small, inexpensive paper photograph pasted on thin cardboard and cut to standard visiting card size.[3] Capable of being printed in multiple copies, cartes de visite characteristically portrayed portraits of family, friends, or famous individuals, which were bought and sold, traded or displayed. As Henisch K. Heinz remarks, "The carte de visite was . . . the antithesis of the museum print—not an art object, but rather . . . a 'consumer product.'"[4] The popular appeal of the carte de visite led to the innovation of the photograph album in Paris in 1858, an apt receptacle for cherished personal and renowned likenesses. According to Alan Trachtenberg, "the album (from a word meaning 'blank') had emerged . . . an adaptation of the genteel visiting book, as a popular form for storing and displaying cartes de visite."[5]

Early photograph albums collected and documented portraits of the human experience: births, deaths, marriages, and rites of passage as well as civic, social, and religious events. The first of these were considered "family" albums, although often they included photographs of people who were not part of the nuclear family: friends or acquaintances who left visiting cards, and collected cartes de visite of celebrated personalities. In this way, many early photograph albums compiled in the nineteenth century reflected a "communal" definition of the notion of *family*. An announce-

ment in the March 7, 1862, *Hartford Daily Courant* encouraged this point of view, while boasting the appeal of photograph albums: "PHOTOGRAPH ALBUMS are all the rage; go where you will, on everybody's center-table, lies a more or less ornate book, with a clasp, generally rather flashy in style, silver or gilded, with Morocco or Russian leather bindings. You open, and behold papa, and mama, and the baby; Gen. McClellan, a few cousins, some handsome friends of the family, one or two fearfully-homely things, and a considerable blank space for future acquisitions. Such is the photographic album."[6]

Similar in physical appearance to Bibles and ornate books, early photograph albums tell stories utilizing a visual language, whose grammar is punctuated by the order and arrangement of the photographs within the album. These narratives, like histories, are necessarily "untrue" and subjective in nature, reflecting the taste of the person(s) that compiled them and the prevailing attitudes of the culture that produced them.[7] Nevertheless, the act of reading the visual narrative of a photograph album can serve the mnemonic function of forging personal and familial identity. For, in old photograph albums, we are reminded of our ancestors, origins, and history. As Pierre Bourdieu once commented, "The family album expresses the essence of social memory."[8] While this may be the case, what can we deduce from old photograph albums whose narratives are no longer legible to us? What does it mean when the names of the people pictured in the photographs or their histories are not recorded? Similarly, what can we gather from a photograph album that figuratively presents itself as a closed book from one culture to the next? We must ask ourselves, when the narratives cease to be intelligible, is it possible to salvage, restore, or re-create them? And what are the risks of this kind of rescue work?

As artifacts—objects made in the past—old portrait albums impart knowledge of the society and the mind that created them. According to Jules David Prown, it is primarily through their *style* that artifacts communicate conscious and unconscious evidence of their prior significance: "The formal language of objects that constitutes style with its own grammar of visual tropes and metaphors, provides evidence of unconscious belief, of culture."[9] Old photograph albums communicate something of their past through their physical construction and appearance, as well as through the content and arrangement of their photographs. An analysis of these and other elements, which make up the *style* of old photograph albums, can inform our understanding of them and perhaps reveal something of their original meaning. As Prown further explains, "The history that we retrieve [from artifacts] is our interpretation of what happened, a myth or

fiction that helps us explain how the world in which we live came to be."[10] This point applies to both our attempts to understand the meaning of old photograph albums and the individual histories that the albums themselves chronicle.

Consider this album of portraits that I found listed in the catalog of a public photography auction at Swann Galleries in New York City nearly twenty years ago. At the time, I was employed as an appraiser and consultant in the photographic arts. A regular part of my job entailed keeping a close watch on what was being offered for sale at auction in order to gauge how the market was doing. When I read the catalog description of the album, I was at the same time annoyed, pleased, and intrigued:

Lot 118.

(Blacks). Tintypes. Fine album containing 50 1/6-plate tintype portraits of black men, women, and children, possibly compiled by the studio photographer himself. Thick 8vo, contemporary embossed morocco, brass clasps, minor wear; all edges gilt. 1870s (?)

Estimate $500–750.[11]

On the same page as the typed description, there appeared an illustration of what I later discovered to be the first image in the album. This photograph showed a brown-skinned woman of African descent wearing a large, dark straw hat, a fitted, long-sleeved black jacket, a wide, full-length, white skirt, and a single gold hoop earring in her right ear (fig. 66). She stood in the center of the image before a painted pastoral landscape, with her arms resting comfortably on the gnarled, wooden fence in front of her. Her practiced, staid pose, along with the props, were the standard fare of nineteenth-century photographic portrait studios. The fence was a necessary support, which helped her to remain still and made it more comfortable for her to endure the long exposure time; early cameras were equipped with slow shutter speeds, unsophisticated lenses, and cumbersome wet plate film.

There was something about this young woman that was not as commonplace as the studio surroundings in which she stood, something that caused me to ponder what the other images in the album had to offer. Perhaps it was the way in which she proudly, confidently wore that rather large straw hat with its wide, asymmetrical brim and truncated crown. Or, it could have been the fine weave of her jacket or the marshmallowy quality of her bell-shaped skirt. Maybe it was how her smart style of dress seemed to contradict the country setting in which she stood. Perchance it

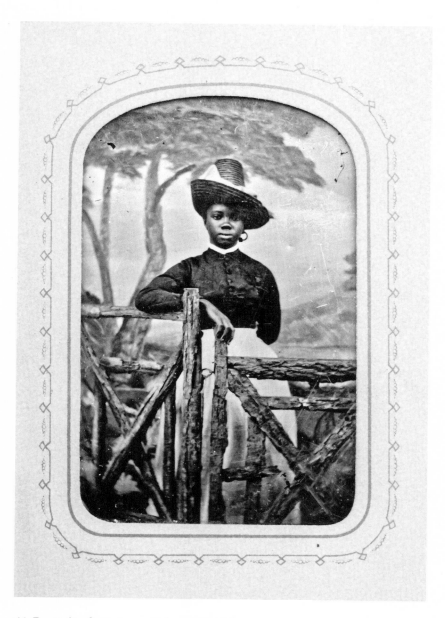

66. Portrait of a woman with earring. Tintype.

From tintype album, circa 1870s.

was the solid, content expression on her face, communicated principally by the assured look in her eyes. Such a wise appearance did not seem to fit with what I guessed to be a woman of more or less twenty years, given the dewy appearance of her skin.

I looked at her, into her eyes. I reread the catalog description, over and over again, each time becoming increasingly annoyed by the way in which the album had been classified. The primary descriptive criterion, *"blacks,"* used to signify the racial category in which the sitters in the album were to conform, coupled with the fact that the album was being offered for sale at a public auction, reminded me of a nineteenth-century handbill that I had seen announcing a raffle in which an enslaved man and woman were to be sold along with "fine rice, gram, paddy, books, muslins, needles, etc."

I could imagine my African ancestors, who were kidnapped and sold as commodities, slaves on the auction block. Objectified, naked, and submitted to public physical inspection, their identities—their histories—lay bare, prostrate, only to be forcibly reconfigured, compounded by the process of being sold and resold into human bondage. I wondered if this was the first time the *people* pictured in this album had been offered for sale at public auction.

Yet, oddly, I felt a bittersweet pang of excitement at coming across this object, for it is seldom that photographs by or of people of African descent appear at the major New York City auction houses. What is more, it was pleasing, for a change, to see something of *my* heritage in my line of work as a photography appraiser—to find their portraits included in what is normally a sale of photographs almost exclusively by or about people of European descent.

Another conundrum was the presence of this anonymous album of tintypes at an important New York photography auction, a place usually reserved for "artistic" and historical photographs rather than vernacular photographic forms, such as the tintype. The most ordinary and commonly used nineteenth-century photographic process, the tintype enjoyed more than eighty years of continued popularity from 1856 through the early 1930s, as a result of its durability, remarkable exposure time, and inexpensive cost.[12] Their quick exposure time, approximately five seconds, made them the Polaroid of the nineteenth century. Made of light sensitive collodion applied to the surface of a highly polished, blackened iron plate, tintypes had advantages over paper photographs, which required a negative printing process and cased images that were covered with glass. Tintypes were light enough to send through the mail and resistant to tears or cracks, allowing them to be quickly adapted for commercial purposes, which in-

cluded the production of political buttons and jewelry or the keepsakes of American Civil War soldiers sent home to loved ones through the U.S. Postal Service. Their size generally ranged from the tiny "gem" portraits to 8 × 10 inch hand-colored portraits. The most common size was known as a 1/6 plate tintype, which measured 2 1/4 × 3 1/4 inches, the size of the carte de visite, similar to those found in this album. Like cartes de visite, tintypes were used primarily in portraiture, and with the aid of multiple lens cameras, they could be mass produced and made into many copies. Their inexpensive cost, ranging between ten and twenty-five cents for an image like the ones in this album, made it possible for the working classes and the poor to afford to have their portraits made.

The prospect of an entire, completed album from the 1870s raised some doubt about its origins. For, as Heinz warns, "The original untouched family album is a rarity now. Albums offered for sale have usually been raided for valuable contents, and then 'reconstituted' by inserting photographs from a random pile, without historical cohesion, just to fill the vacant spaces."[13] This album, comprised solely of tintype portraits, was unusual and curious, as many photograph albums from the period mixed tintypes with cartes de visite and other paper photographs. Moreover, its apparent rarity coupled with its appearance at public auction was confusing. I wondered about how it came to be offered for sale. Who were its original owners? Were they free blacks living in the northern United States? Were they formerly enslaved? Was the album a contemporary collector's concoction put together with unrelated, found tintype photographs and an empty, old portrait album? Or was it "possibly compiled by the studio photographer himself," as the auction catalog questioned?

The album's indeterminate origins, while initially frustrating, became a symbol for its greater meaning. The riddle to this album lay in its complexity. An intricate object, like human identity or the organization of society, I knew that it would not reveal itself easily to me. All of these considerations prompted me to inspect the album at the preview exhibition prior to the auction.

The viewing room assistant reached the album from high atop a shelf in a glass cabinet, which held an assortment of small, precious objects, consisting mostly of daguerreotypes in ornate cases. Gently, I took the album from him and held it tightly in my hands. I was suspended momentarily by feelings of reverence, as I wasn't prepared for the way it would look or the way it would feel. I expected the exterior of the album to appear as matter-of-factly as the catalog description, lacking any particular style or presence. Much to my surprise, the album was small and boxlike with a chocolate

67. Front cover, tintype album, circa 1870s.

brown, morocco cover, two parallel brass clasps, and gilded edges, resembling an eighteenth-century Bible (fig. 67).[14] Measuring 6 7/8 inches long by 5 1/2 inches wide by 2 inches deep, it was compact enough for me to hold in one hand, yet I felt more comfortable using two because of its heft; it weighed two pounds, a lot, I thought, considering its size. But then I was reminded of what rested inside: fifty tintypes, each one bearing a photographic image, printed on a thin sheet of iron.

The photograph album's resemblance to a family Bible was not a coincidence. As Heinz concurs, "it is significant that many family albums have the look and weight of family Bibles."[15] According to Sue Allen, a Victorian bindings specialist, who suggested that the album is of American origin, the first commercially manufactured photograph albums were made by manufacturers of Bibles for the trade.[16] This fact is supported by advertisements in trade journals such as *Publishers' Trade List Annual* and evidenced by the photograph's early ties to truth, reality, and the portrayal of family and domestic life. An advertisement of June 15, 1863, by Wm. H. Appleton, a wholesale bookseller and publisher in New York City, lists "school, theological, Miscellaneous, and Juvenile Books, Albums and Annuals . . . in addition to Photograph Albums for Cartes de Visite, the Illuminated Photograph Album and the French Photograph Album."[17] The title page of the Philadelphia manufacturer William W. Harding's trade catalog of 1875 reads, "Family and Pulpit Bibles. Testaments and Photograph Albums."[18]

Trade catalogs provided illustrations and prices for the albums being sold, usually categorized by size (ranging from "pocket size" to oblong quarto size, measuring approximately 6 × 8 1/4 inches) or materials used for construction (French morocco, Turkey morocco, imitation of morocco, or velvet).[19] Allen dated the binding of this album between 1865 and 1875; however, several clues alluding to its superior quality of craftsmanship and other elements relating to the chronology of its assembly led her to speculate that it was made by a specialty binder rather than a commercial manufacturer.[20]

Just as the family Bible held the family history, including records of births, deaths, and marriages, the family photograph album served as its visual counterpart. Chronicling the family history in pictures, the photograph album also was treated with respect and reverence. As William Taft describes, "The Bible was the consolation of these wayfarers from a far country; the album was the most direct tie to their past life, for it contained the images of those most loved but now distant."[21] Both the family Bible and the family album served unifying functions within a family unit. Family albums traditionally were kept on the center table, a focal point in the main room of the house. Citing the testimony of a Montana pioneer written in 1864, Taft continues, "Home was complete when the Bible and the album could be brought out from the trunks and placed in the center of the room."[22] In fact, some mid-nineteenth-century Bibles were designed with photograph album pages in the front portion, close to where the family tree was to be recorded.

I paused a few moments longer to regard the album in its closed state (see fig. 67). The cover was made of one continuous piece of leather clinging snugly to the pressed boards at the front and back, while loosely embracing the spine. The cover lay bare the three brightest sides of the album, which formed a stack of twenty-five gilded leaves. Seductive, shimmering, and silky-smooth to the touch, each gilded leaf resembled a thin sliver of gold bouillon, a symbol of wealth and an indication of social class.

These contrasted with the dull glow of the two identical brass clasps, ornately stamped with an intermingling floral and heart-shaped motif. They were designed in the Eastlake style, popular in New York between 1870 and 1875.[23] The clasps consisted of three parts each: two arms and a latch. Each clasp embraced the opening end of the album, the arms hugging about two thirds of the width of the front and back covers.

I noticed that the arms were not only decorative and structural, but they also served to protect the leather cover. In some of the earliest books, clasps were used to secure vellum pages, keeping the outside covers closed

68. Tintype album, circa 1870s.

to prevent deterioration from the elements or to reduce possible damage from fire. Clasps could be said to resemble the latches to the pearly gates; in fact, the front covers to many early Bibles simulated the doors to churches or sepulchers and were covered with pearls, diamonds, and other precious stones, as well as religious iconography. The styles and number of clasps varied from place to place. Two clasps, like the ones on this album, were typical in England and the United States, while a single clasp was more common in France.

Pressed into the cover, on the front, back, and along the spine was embossing in simple geometric designs. Gold stamping in more elaborate patterns and ebbing crescent shapes adorned the upper, lower, and inside edges of the cover. The absence of religious iconography on the cover of this album, evidenced by the simple stamped lines, pointed to the likelihood that its fabrication took place as societies were becoming more secular. Such a transition was noticeable in the design of nineteenth-century Victorian era publishers' bindings, which began to lose their religious iconography for "senseless, unmeaningful patterns" by the late 1860s.[24]

The word *Photographs*, describing the contents of the album, was gilded and stamped in gothic lettering across the width of the spine (fig. 68). More graphic embossing appeared below, arranged in patterns to mimic the spine of a book whose pages were sewn together by hand. In examples of these dating from the sixteenth and seventeenth centuries, it is easy to see how

the "spine" of a book came to be called as such. The cord used to sew together the pages of the book protrudes underneath the leather cover, giving it a bumpy, ribbed appearance, similar to the vertebrae that make up the spinal column. Moreover, the spine serves the same structural purpose in books as it does in human beings: it constitutes the primary strength, central axis of movement and main support. A vital element of books, the spine provides flexibility as well as shape and form.

Eyes closed, I ran my fingers across the pebbled surface of the thick leather cover, from front to back and back again. Dipping in and out of the ridges and grooves of the embossing and wandering over the supple, wrinkled spine, I sensed the rich texture of the grain, perhaps a metaphor for the wisdom of the individuals pictured inside. The patterns of wear, which indicated how the album normally rested, how it was held, how it was opened, and how it was closed, also revealed the ordering mechanism of the spine.

Carefully, I released the clasps, one after the next. They opened reluctantly, with the strained sigh of metal rubbing against metal. Then I heard a slow click, like the sound of a door opening, and I felt as if I were entering a strange yet familiar space. Just beyond the front cover, my eyes were treated to smooth, mint-green endpapers decorated with an alternating pattern of miniature gold crosses and tiny dots. According to Allen, the conservative style of the endpapers, called Symmetry Regency, was popular during the pre–Civil War era from 1845 to 1855. I took refuge in the transitional space created by the soothing endpapers before turning the next page to regard the first image.

There she was again: the beautiful young woman with the asymmetrical hat, standing tall, confident, yet different (see fig. 66). I wondered, why did she have her photograph taken? Was it a gift to her or did she save her money for the sitting? Had she compiled the album? What was her relationship to the other people pictured inside? Were they her family and had she been the matriarch?

There was something about her portrait that drew me closer still. I now could see a tiny, rounded object that dangled from the lower left edge of her earring, almost casting a reflection upon the warm glow of her cheek. The earring held my attention for quite some time. For me, it was the "punctum" of this image, what Roland Barthes defined as "a certain shock . . . 'a detail,' a partial object [within the photograph that] has, more or less potentially, a power of expansion . . . and paradoxically, while remaining a 'detail,' fills the whole picture."[25] That which Barthes describes as the punctum "occurs in the field of the photographed thing like a supplement that is

at once inevitable and delightful."[26] The earring distinguished itself to me by its size, its singularity, and the tiny object that hung from it, which was painted with a subtle trace of gold. The fact that she only wore one earring told that me there was something special about this lady. She was a woman of style and substance, who commanded attention wherever she went. I wondered whether she was the thread that held the album together—if she had known its secrets, were they now buried like her? According to Mary Helen Washington, in family albums the person or people who compile an album are the keepers of the family history; the ones who remember the significant family events, the griots. They set the tone and pace of the album, allowing it to be a statement about themselves, their aspirations, taste, and social standing.

I turned the weighty gilded leaf, realizing that it held not just one, but two tintypes, back to back. These were visible through an arched window opening illuminated by thin gold lines. Considering the album was more than one hundred years old, the cream colored surfaces of the leaves were remarkably free of stains, fingerprints, or soiling. A quick survey of the album revealed, "50 1/6-plate tintype portraits of black men, women, and children," just as the auction catalog stated. There were individual and group portraits of one to four sitters, totaling seventy-four men, women, and children. At first glance they appeared to be an anonymous set of portraits, stranded in their histories by the passing of time, silenced, dead. Their poses were pretty standard, comprising bust, seated, and standing positions. With the exception of one, which appeared to be taken out of doors, all of the tintypes were made in studio settings, with the sitters positioned before unadorned or painted backdrops (fig. 69). The repetition of some painted studio backdrops, including landscape and architectural scenes, pointed to similarities shared by the sitters. Rigid iron head rests and simulated natural and architectural forms, such as rocks, trees, columns, and wooden mantle pieces, were used to refrain sitters from moving while the picture was being taken (fig. 70). Heavy velvet draperies and lavishly upholstered furniture, like dainty, velvet, and fringe-covered chairs, adorned the simulated parlor settings. These accoutrements were borrowed from Victorian era painted miniature portrait studios, which strove to approximate the atmosphere of the drawing room for a growing middle class. These studio "outfits," as they were called, were available from mail order catalogs distributed by manufacturers in New York, Philadelphia, and Boston, which produced a regional uniformity to the appearance of many nineteenth-century photographic studios.

All of the sitters were fully clothed, leaving visible only their heads,

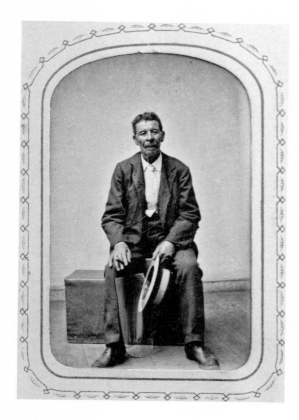

**69. Portrait of
a man, seated.
Tintype.**

From tintype album,
circa 1870s.

faces, and hands. They wore their hair short or pulled back, away from their faces. Some of the men had mustaches. The women wore long dresses, long skirts, or three-quarter length dresses, with jackets or shirts. Their outfits were accessorized with hats, gloves, scarves, and ribbons (fig. 71). Some women held purses, umbrellas, or fans, while others wore earrings, necklaces, rings, and brooches. The men were dressed in long pants with shirts, vests, or jackets. To complement their attire, some wore hats, pocket watches, or held cigarettes or walking sticks. The boys were outfitted in long or short pants with shirts, vests, or jackets, while the girls wore frilly, three-quarter length dresses. To complete their outfits, they all were dressed in lace-up shoes or boots.

The wide variation of poses and studio settings as well as the tone and condition of the tintype plates indicated no apparent narrative sequence or chronological order within the album. These inconsistencies also suggested that there were different photographers at work. Moreover, it was possible to date the tintypes over a wide range of years, beginning in the late 1860s

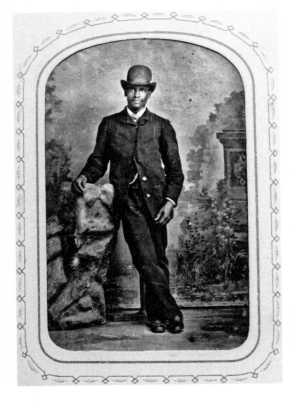

70. Portrait of a man, standing. Tintype.

From tintype album, circa 1870s.

through approximately 1915. While generally in good condition, the physical state of the tintypes metaphorically uncovered layers of the human psyche: a few showed signs of rusting; one was creased horizontally; another appeared to be scratched intentionally; some had fingerprints in the emulsion (evidence of the artist's hand at work); others still were missing emulsion due to flaking, chipping, or deterioration. These flaws seemed inconsistent with the generally clean state of the album leaves, which did not appear to be tampered with or bent, indicating that in some cases, the tintypes had been damaged prior to being placed in the album.

While the "people of early portrait photography seem distant and melancholy," or "unbending, formal, [and] reticent," as Vicki Goldberg once commented, the need to keep still during long exposures affected the manner in which people chose to pose before the camera and created a new language of comportment, an unprecedented awareness of ways of seeing oneself both before the camera and in public.[27] Their stiff poses indicated the restraints of the society in which they were made and the

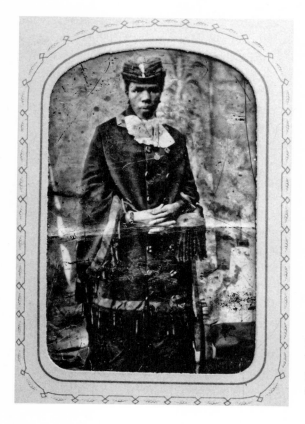

71. Portrait of a woman. Tintype.

From tintype album, circa 1870s.

control that the camera exerted over their lives. In front of the lens, they searched for a particular expression, a certain attitude that would characterize their personality or a particular occasion for years to come. People chose to be photographed in the height of fashion or wearing their "Sunday best," at leisure and never at work. To have one's portrait made was a way of creating a visual signature for one's individual and class identity. As Tagg explains, it "was one of the symbolic acts by which individuals from the rising social classes made their ascent visible to themselves and others and classed themselves among those who enjoyed social status."[28] Within an album, individual portraits and portraits of groups of people signified the distinctive class consciousness of an entire family, community, or society. In many ways, the simulated studio settings allowed sitters a means of escape: a space to assume other identities, social standings, or to travel to unknown places by posing before a painted backdrop.

I wondered to what degree the people pictured in this album were responding to a prevailing idea or image of themselves?[29] Their skin was

dark, medium, or light toned, characterizing richness and variety, while suggesting that there was no one idea, no one look of blackness. Had they self-consciously constructed this album as a mnemonic touchstone of identity and representation for the family against prevailing stereotypical depictions of others like them? Around the same time that the photographs in this album were made, a nationwide backlash against newly freed African Americans led to unprecedented racial violence and the creation of racist stereotypes that persist to this day. Sheet music covers produced in the late nineteenth century show wide-eyed, red-lipped blackface minstrels. Stereograph cards, projecting images in three dimensions, depicted derogatory satirical scenes and black children as "alligator bait" or "pickaninnies." These were sold as thematic sets by stereograph companies such as Underwood and Underwood and distributed around the country and abroad, further spreading negative stereotypes of black people. While the sitters in this album were unable to control those popularly distributed images, they did have a say over the kinds of pictures made of themselves and where they were to be displayed.

There were no spaces provided on the album pages for written words that might record the names, dates, or locations of the sitters. Nor was there a page in the album reserved specifically for that purpose. The lack of such a page supports the range of dates that Allen speculated the binding had been made, between 1865 and 1875, as pages reserved for writing in family albums became common after about 1870.[30]

But the absence of nearly any written words in the album also could mean that the history of this album was passed down orally, from one generation to the next. Charles Blockson asserts that the practice of "oral history" is an age-old tradition in black culture: "In Africa, each family had a *griot* or archivist who committed the family's entire history to memory. Each *griot*, in preparation for death, would hand over his entire log of historical stories to a younger man, who became the new family historian."[31] Thriving in intimate settings and close societies, oral traditions tend to create myths, which continually work to reinforce the power of the society they serve in order to ensure its survival. The practice of oral history reinforces certain memories and strengthens family bonds through the interactive ritual of storytelling. The participatory nature of the oral history ritual, involving storyteller and audience, is the mnemonic mechanism by which the past is passed on.

Yet the album remained private, silent, closed, and compact. Like a family Bible, it was a sacred object for private consumption. It did not re-

veal its story freely to an observer outside of the family circle. And with no blank spaces, it was a completed, closed collection.

Glancing at the portraits as I closed the album, I felt the weight of the sitters portrayed therein, their lives, their past histories. They stood so still that they appeared lifeless. Anticipating death, the portraits of these people captured on metal served as a memorial. It seemed that their identities and stories had been entombed with them, for it was impossible to remove the tintypes from the leaves of the album without causing damage to their construction, the fabric and organization of the community in which they resided. The album's sepulchral appearance also was closely linked to the original content of books—religious writings—that, through their history of humankind, served to guide people through life to death and beyond.[32]

Before returning the album to the viewing room assistant, I stroked the pebbled surface of the morocco cover once more. Placing my left hand where it was most worn, around the supple, less-textured edges of the spine, I imagined what it must have felt like long ago to hold this album and know its secrets. Once again, I wondered how it had ended up on the auction block. Then I was reminded of something Deborah Willis once wrote, "I attempt to relive family memories by incorporating old photographs from the 'collective archive' of black culture into contemporary images exploring the nuances of memory. . . . I found a way of entering the past and commenting on societal issues that I believe helped to shape my interest in visual storytelling."[33] As if entranced in a ritual of mnemonic aesthetics, I opened the clasps once more and stared into the face of that confident woman pictured on the first plate (see fig. 66). In the narrative I had constructed in the few minutes it took me to inspect the album, it was she who had begun the album and it contained portraits of her family. The fair-skinned older gentleman, who sat modestly on a covered box in the following plate, had been her husband, a milliner, who had woven that funny hat that she so proudly wore (see fig. 69). The hat he held was light, simple, and made of straw. He worked at his craft, day and night, to earn enough money to free his future wife, who had been born a slave in New Orleans. During the Great Migration, they quit the South for Philadelphia, where their first son, the dapper man in the next portrait, dressed in a dark three-piece suit, with a hat, was born a free man (see fig. 70). I went on like that, plate by plate, spinning a family narrative, consciously and unconsciously weaving parts of my own family lore, filling the unknown spaces with the familiar, until I got to the last image—which was just as bold and intriguing as the first. It was a portrait of a brown-skinned woman with

an intense stare and lusciously draped velvet clothing (see fig. 71). She too wore a remarkable hat made of silk, velvet, and netting, designed by the husband milliner, I imagined, for his sister-in-law. And around her neck was a locket, which had been painted gold, carrying the gem-sized photograph of her first child, who died shortly after being born. Before I could complete my story, I was asked to give the album to another patron waiting to inspect it. Even though I didn't own it (yet), I felt as if I were being asked to give away something that was a part of me. It was then that I resolved to place a bid on the album, feeling the same urgency of those freed slaves who rescued their own kin from the auction block.

Notes

The germ of the idea for this chapter originated when I first laid eyes on the album at Swann Galleries in New York in 1992. With so little known about its origins, makers, or sitters, I felt a compelling need to write about it. This led me to graduate school at Yale three years later, where I enrolled in the PhD program in African American studies and the history of art. The first chance I had to write about the album came in my first year in Jules Prown's famous material culture seminar, where I used material culture methodology to begin to decipher the album's meaning. The following year, in Laura Wexler's seminar, "Photography and Images of the Social Body," I wrote about the mnemonic function of the photograph and the role of the album in African American culture. That paper formed the kernel of my essay "M is for Memory," for *The Alphabet Manifesto*, an artists' book written collectively by the Photographic Memory Workshop at Yale (2005), and later published in Deborah Willis's *Let Your Motto Be Resistance: African American Portraits* (2007). When Shawn Michelle Smith and Maurice Wallace invited me to participate in the symposium that led to this volume, I knew that it would give me yet another chance to write about *my album*! I thank them, the participants of the symposium, and the readers of this volume for their helpful comments and suggestions that steered this work to completion. The next time I venture to write about my album, it will likely be a work of historical fiction, where I will begin with the narrative I started at the end of this chapter.

 1. Photography was invented in 1839 in Paris by Louis-Jacques-Mandé Daguerre, who called an image realized by his process a daguerreotype, a laterally reversed photographic image on the highly polished, light sensitive, silvered surface of a copper plate. Possessing a mirrorlike, reflective quality, daguerreotypes were unique images. They were characteristically small, covered in glass, and encased for protection.

 2. John Tagg, *The Burden of Representation: Essays on Photographies and Histories* (Minneapolis: University of Minnesota Press, 1993), 41.

 3. Andre Adolphe Disderi is credited with developing the idea for cartes de visite in Paris in 1854. The standard size of the carte de visite was approximately

2 1/4 × 3 1/4 inches. See Henisch K. Heinz, *The Photographic Experience, 1839–1914: Images and Attitudes* (University Park: Penn State University Press, 1994), 150–51.

4. Heinz, *The Photographic Experience, 1839–1914*, 151.

5. Alan Trachtenberg, *Reading American Photographs: Images as History, Mathew Brady to Walker Evans* (New York: Hill and Wang, 1989), 89. While the idea for the photograph album was a direct result of the public's demand for carte de visite portraiture, photograph albums quickly were adapted to include most types of paper prints or collages of them, as well as tintypes.

6. William F. Robinson, *A Certain Slant of Light: The First 100 Years of New England Photography* (Boston: New York Graphic Society, 1980), 83.

7. Robinson, *A Certain Slant of Light*, 2. For more on history as myth, see Henry Glassie, "Meaningful Things and Appropriate Myths: The Artifact's Place in American Studies," *Prospectus* 3 (1977): 1–49, reprinted in Robert Blair St. George, *Material Life in America, 1600–1800* (Boston: Northeastern University Press, 1988).

8. Pierre Bourdieu, *Photography: A Middle-brow Art*, trans. Shaun Whiteside (Stanford: Stanford University Press, 1990), 30.

9. Jules David Prown, "In Pursuit of Culture: The Formal Language of Objects," *American Art* 9, no. 2 (Summer 1995): 2–3, 3.

10. Prown, "In Pursuit of Culture," 2–3.

11. *Photographs*. New York: Swann Galleries, Inc., April 23, 1992, lot 118.

12. According to George Gilbert, "Tintypes were first called malainotypes (from the Greek *melaino*, meaning dark) by Peter Neff, who assumed the 1856 patent of Hamilton L. Smith for melainotype plates" (*Photography: The Early Years; A Historical Guide for Collectors* [New York: Harper and Row, 1980], 56). Also called ferrotypes, it is suggested that the name tintype is derived from the tin snips, which were used to cut apart successive exposures that were made on the same sheet of blackened iron. See Vicki Goldberg, "Social-Climbing Tintypes, Yearning to be Paintings," *New York Times*, August 1, 1993, H 33, which is an exhibition review of *Forgotten Marriage: The Painted Tintype and the Decorated Frame, 1860–1910*, Hudson River Museum, Yonkers, New York.

13. Heinz, *The Photographic Experience, 1839–1914*, 159.

14. *Morocco* is a term referring to fine leather from goat skin tanned with sumac, usually producing a soft, pebbled surface. According to William F. Robinson, "The first albums were somber little volumes, similar in appearance to small bibles" (*A Certain Slant of Light*, 83).

15. Heinz, *The Photographic Experience, 1839–1914*, 156.

16. Personal communication from Sue Allen, November 11, 1995.

17. *American Literary Gazette and Publishers' Circular* 7, no. 1–18, no. 6 (New York: Charles R. Rode, 1861–1872), 190.

18. *Publishers' and Stationers' Weekly Trade Circular* 1, no. 1–32, no. 27 (New York: F. Leypoldt, 1872–1887).

19. An analysis of the types of albums offered for sale in the Holman catalog of 1875 would suggest that this one fits the size, which describes a "center table" album. In 1875 elaborate and ornate leather bound albums, with gold or silver clasps, were advertised between $5 and $40; cheaper ones were priced in the $1.50

to $2.50 range. Bibles listed for sale by the same manufacturer were categorized in a like manner.

20. Allen noted the handwork that went into beveling the edges, blind stamping the brown morocco leather, and applying the gold paint to the edges of the leaves. In addition, she cited varying dates for the manufacture of the binding, clasps, and endpapers as noted in the text.

21. Robert Taft, *Photography and the American Scene: A Social History, 1839-1889* (1938; rprt. New York: Dover, 1964), 138.

22. Taft, *Photography and the American Scene*, 138.

23. Personal communication from Sue Allen, November 11, 1995.

24. McLean Ruari, *Victorian Publishers' Book-bindings in Cloth and Leather* (Berkeley and Los Angeles: University of California Press, 1973).

25. Roland Barthes, *Camera Lucida: Reflections on Photography*, trans. Richard Howard (New York: Hill and Wang, 1981), 41–45.

26. Barthes, *Camera Lucida*, 47. Barthes also describes the punctum as something that "pricks" him: "It says only that the photographer was there, or else, still more simply, that he could not *not* photograph the partial object at the same time as the total object" (47).

27. Goldberg, "Social-Climbing Tintypes, Yearning to be Paintings," H 33.

28. Tagg, *The Burden of Representation*, 37.

29. The album's appearance at an auction, cataloged under the subject category "blacks," reflected the organization of American society with respect to people of African descent: segregated, other, homogeneous.

30. Before this date, the written history of family photograph albums sometimes appeared in the family Bible, its companion piece.

31. Charles L. Blockson, with Ron Fry, *Black Genealogy* (Englewood Cliffs: Prentice-Hall, 1977), 13.

32. Many writers and religious leaders were buried with the important tomes written by them. In addition to books, many people were buried with things that they believed they would be able to use in the afterlife. When my brother died, we buried him with a wooden toy car, to get around in, and his favorite stuffed animal, a friend.

33. Deborah Willis, *Family, History, Memory: Recording African American Life* (Irvington: Hylas Publishing, 2005), 13.

BIBLIOGRAPHY

Archival Sources

The American Museum of Photography
The Art Institute of Chicago
Beinecke Rare Book and Manuscript Library, Yale University
 Yale Collection of American Literature
Chester County Historical Society
Dartmouth College Library
Friends Historical Library, Swarthmore College
The Granger Collection, New York
Hampton University Archives
 Camera Club Collection
Houghton Library, Harvard University, Agassiz Papers
Library of Congress, Washington, D.C.
 Abraham Lincoln Papers, select items available online via the American Memory Collection
 Civil War Reference File
 Daniel Murray Collection
 Frederick Douglass Papers, Manuscript Division, select items available online via the American Memory Collection at http://memory.loc.gov/ammem/doughtml/doughome.html.
 Prints and Photographs Division
Montana Historical Society Research Center
 Photographic Archives
National Archives

National Portrait Gallery, Smithsonian Institution
Ohio State University
Paul Laurence Dunbar Papers
Peabody Museum of Archaeology and Ethnology, Harvard University
Sarah S. Heath Collection
Schomburg Center for Research in Black Culture, The New York Public Library
 Manuscripts, Archives and Rare Books Division
 Photographs and Prints Division
Swann Galleries, New York
University of North Carolina, Chapel Hill, Libraries
 Documenting the South
Washington State University Libraries
 Manuscripts, Archives, and Special Collections
Xavier University Archives and Special Collections
 A. P. Bedou Collection

Printed Materials

Agassiz, Elizabeth Cary, ed. *Louis Agassiz, His Life and Correspondence*. 2 vols. Boston: Houghton Mifflin Co., 1886.

Alexander, Eleanor. *Lyrics of Sunshine and Shadow: The Tragic Courtship and Marriage of Paul Laurence Dunbar and Alice Ruth Moore*. New York: New York University Press, 2001.

Alexander, Elizabeth. "'Can You Be BLACK and Look at This?' Reading the Rodney King Video(s)." In *Black Male: Representations of Masculinity in Contemporary American Art*, edited by Thelma Golden, 91–110. New York: Whitney Museum of American Art, 1994.

Allen, James, et al. *Without Sanctuary: Lynching Photography in America*. Santa Fe: Twin Palms, 2000.

American Literary Gazette and Publishers' Circular 7, no. 1–18, no. 6 (1872). New York: Charles R. Rode.

Andrews, William. *To Tell a Free Story: The First Century of Afro-American Autobiography, 1760–1865*. Urbana: University of Illinois Press, 1988.

Apel, Dora. *Imagery of Lynching: Black Men, White Women, and the Mob*. New Brunswick: Rutgers University Press, 2004.

Apel, Dora, and Shawn Michelle Smith. *Lynching Photographs*. Berkeley: University of California Press, 2007.

Aptheker, Bettina. *Woman's Legacy: Essays on Race, Sex, and Class in American History*. Amherst: University of Massachusetts Press, 1982.

Armstrong, Nancy. *Desire and Domestic Fiction: A Political History of the Novel*. New York: Oxford University Press, 1989.

Askew, Thomas. Advertisement. *Voice of the Negro* 1, no. 12 (December 1904): 637.

Bacon, Alice M. "Editorial—Folklore Department." In *Strange Ways and Sweet*

Dreams: Afro-American Folklore from the Hampton Institute, edited by Donald J. Waters, 338. Boston: G. K. Hall and Co., 1983. Originally published in *Southern Workman* 28, no. 6 (June 1899): 201.

———. "Folklore and Ethnology." *Southern Workman* 24, no. 9 (September 1895): 154.

Baer, Ulrich. *Spectral Evidence: The Photography of Trauma*. Cambridge: MIT Press, 2002.

Baker, Houston. *Modernism and the Harlem Renaissance*. Chicago: University of Chicago Press, 1987.

———. *Turning South Again: Re-thinking Modernism / Re-reading Booker T.* Chapel Hill: University of North Carolina Press, 2001.

———. *Workings of the Spirit*. Chicago: University of Chicago Press, 1991.

Bal, Mieke. "The Politics of Citation." *Diacritics* 21, no. 1 (Spring 1991): 24–45.

Banta, Melissa. *A Curious and Ingenious Art: Reflections on Daguerreotypes at Harvard*. Iowa City: University of Iowa Press, 2000.

Bardagio, Peter Winthrop. *Reconstructing the Household: Families, Sex, and the Law in the Nineteenth-Century South*. Chapel Hill: University of North Carolina Press, 1995.

Barrett, Lindon W. "African American Slave Narratives: Literacy, the Body, Authority." *American Literary History* 7, no. 3 (1995): 415–42.

———. *Blackness and Value: Seeing Double*. Cambridge: Cambridge University Press, 1999.

Barthes, Roland. *Camera Lucida: Reflections on Photography*. Translated by Richard Howard. New York: Hill and Wang, 1981.

———. *Image Music Text*. Translated by Stephen Heath. New York: Noonday Press, 1977.

Baudrillard, Jean. *Seduction*. Translated by Brian Singer. New York: St. Martin's Press, 1990.

———. *Simulacra and Simulation*. Translated by Sheila Faria Glaser. Ann Arbor: University of Michigan Press, 1994.

Baxter, Terry. *Frederick Douglass's Curious Audiences: Ethos in the Age of the Consumable Subject*. New York: Routledge, 2004.

Bederman, Gail. *Manliness and Civilization: A Cultural History of Gender and Race in the United States, 1880–1917*. Chicago: University of Chicago Press, 1995.

Benjamin, Walter. *The Arcades Project*. Edited by Rolf Tidemann. Translated by Howard Eiland and Kevin McLaughlin. Cambridge: Harvard University Press, 1999.

———. "A Short History of Photography." *Classic Essays on Photography*. Edited by Alan Trachtenberg. New Haven: Leete's Island Books: 1980.

———. "The Work of Art in the Age of Mechanical Reproduction." *Illuminations*. Edited by Hannah Arendt. Translated by Harry Zohn. New York: Schocken, 1969.

Bennett, Lerone. *Before the Mayflower*. Chicago: Johnson Publishing, 1969.

Bergner, Gwen. "Myths of Masculinity: The Oedipus Complex and Douglass's 1845 *Narrative*." In *The Psychoanalysis of Race*, edited by Christopher Lane, 241–60. New York: Columbia University Press, 1998.

Berlant, Lauren. *The Anatomy of National Fantasy: Hawthorne, Utopia, and Everyday Life*. Chicago: The University of Chicago Press, 1991.

———. "National Brands / National Body: Imitation of Life." In *Comparative American Identities: Race, Sex, and Nationality in the Modern Text*, edited by Hortense Spillers, 110–40. New York: Routledge, 1991.

———. "The Queen of America Goes to Washington City: Harriet Jacobs, Frances Harper, Anita Hill." *American Literature* 65, no. 3 (1993): 549–74.

Berlin, Ira, Barbara J. Fields, Thavolia Glymph, Joseph P. Reidy, and Leslie S. Rowland, eds. *Freedom: A Documentary History of Emancipation, 1861-1867; Series 1, Volume 1: The Destruction of Slavery*. New York: Cambridge University Press, 1985.

Best, Stephen. *The Fugitive's Properties: Law and the Poetics of Possession*. Chicago: University of Chicago Press, 2004.

Bhabha, Homi K. "The Other Question: The Stereotype and Colonial Discourse." In *Visual Culture: The Reader*, edited by Jessica Evans and Stuart Hall, 370–78. London: Sage Publications, 1999.

Bieze, Michael. *Booker T. Washington and the Art of Self-Representation*. New York: Peter Lang, 2008.

Blackwood, Sarah. "Fugitive Obscura: Runaway Slave Portraiture and Early Photographic Technology." *American Literature* 81, no. 1 (2009): 93–125.

Blair, Sara. *Harlem Crossroads: Black Writers and the Photograph in the Twentieth Century*. Princeton: Princeton University Press, 2007.

Blassingame, John W., ed. *The Frederick Douglass Papers: Series One, Speeches, Debates, and Interviews*. 5 vols. New Haven: Yale University Press, 1979–1992.

Blockson, Charles L., with Ron Fry. *Black Genealogy*. Englewood Cliffs: Prentice Hall, 1977.

Boucicault, Dion. *The Octoroon; The Longman Anthology of American Drama*. Edited by Lee Jacobus. New York: Longman, 1982.

Bourdieu, Pierre. *Photography: A Middle-brow Art*. Translated by Shaun Whiteside. Stanford: Stanford University Press, 1990.

Braud, Anne. *Radical Spirits: Spiritualism and Women's Rights in Nineteenth-Century America*. Boston: Beacon, 1989.

Briggs, Laura. "The Race of Hysteria: 'Overcivilization' and the 'Savage' Woman in Late Nineteenth-Century Obstetrics and Gynecology." *American Quarterly* 52, no. 2 (June 2000): 246–73.

Brody, Jennifer DeVere. *Impossible Purities: Blackness, Femininity, and Victorian Culture*. Durham: Duke University Press, 1998.

Brooks, Daphne. "'The Deeds Done in My Body': Black Feminist Theory, Performance, and the Truth about Adah Isaacs Menken." In *Recovering the Black Female Body: Self-Representations by African American Women*, edited by Michael

Bennett and Vanessa Dickerson, 41–70. New Brunswick: Rutgers University Press, 2001.

Brown, Herbert Ross. *The Sentimental Novel in America, 1789-1865*. New York: Oxford University Press, 1989.

Burgett, Bruce. *Sentimental Bodies: Sex, Gender, and Citizenship in the Early Republic*. Princeton: Princeton University Press, 1998.

Burgin, Victor. "Art, Common Sense and Photography." In *Visual Culture: The Reader*, edited by Jessica Evans and Stuart Hall, 41–50. London: Sage Publications, 1999.

Butler, Judith. *Bodies That Matter: On the Discursive Limits of "Sex."* New York: Routledge, 1993.

Byrnes, Thomas. *Professional Criminals of America*. 1886. New York: Chelsea House Publishers, 1969.

Cadava, Eduardo. *Words of Light: Theses on the Photography of History*. Princeton: Princeton University Press, 1997.

Callum, Agnes Kane. *Colored Volunteers of Maryland Civil War: 7th Regiment United States Colored Troops, 1863-1866*. Baltimore: Mullac Publishers, 1990.

———. *9th Regiment United States Colored Troops Volunteers of Maryland Civil War, 1863-1866*. Baltimore: Mullac Publishers, 1999.

Caraway, Nancie. *Segregated Sisterhood: Racism and the Politics of American Feminism*. Knoxville: University of Tennessee Press, 1991.

Carby, Hazel. "'Hear My Voice, Ye Careless Daughters': Narratives of Slave and Free Women before Emancipation." In *African American Autobiography: A Collection of Critical Essays*, edited by William L. Andrews, 59–76. Englewood Cliffs, NJ: Prentice Hall, 1993.

———. *Reconstructing Womanhood: The Emergence of the Afro-American Woman Novelist*. Oxford: Oxford University Press, 1987.

Carroll, Anne Elizabeth. *Word, Image, and the New Negro: Representation and Identity in the Harlem Renaissance*. Bloomington: Indiana University Press, 2005.

Casmier-Paz, Lynn A. "Slave Narratives and the Rhetoric of Author Portraiture." *New Literary History* 34, no. 1 (2003): 91–116.

Castronovo, Russ. *Fathering the Nation: American Genealogies of Slavery and Freedom*. Berkeley: University of California Press, 1995.

Chaney, Michael. "Picturing the Mother, Claiming Egypt: *My Bondage and My Freedom* as Auto(bio)ethnography." *African American Review* 35, no. 3 (2001): 391–408.

Chenery, William H. *The Fourteenth Regiment Rhode Island Heavy Artillery (Colored) in the War to Preserve the Union, 1861-1865*. Providence: Snow and Farnham, 1898.

Cherniavsky, Eva. *That Pale Mother Rising: Sentimental Discourses and the Imitation of Motherhood in Nineteenth-Century America*. Bloomington: Indiana University Press, 1995.

Christian, Barbara. *Black Women Novelists, the Development of a Tradition, 1892-1976*. Westport: Greenwood Press, 1980.

Clarke, Donald. *The Rise and Fall of Popular Music*. New York: St. Martin's Press, 1995.

Cobb, Josephine. "Photographers of the Civil War." *Military Affairs* 26, no. 3 (1962): 127–35.

Collins, Kathleen. "Shadow and Substance: Sojourner Truth." *History of Photography* 7, no. 3 (1983): 183–205.

Connerton, Paul. *How Societies Remember*. New York: Cambridge University Press, 1989.

Cooks, Bridget R. "See Me Now." In "Black Women, Spectatorship, and Visual Culture," special issue, *Camera Obscura* 36 (1995): 67–84.

Cott, Nancy. *The Bonds of Womanhood: "Woman's Sphere" in New England, 1780–1835*. New Haven: Yale University Press, 1977.

Craft, William, and Ellen Craft. *Running a Thousand Miles for Freedom*. 1860. In *Great Slave Narratives*, edited by Arna Bontemps, 269–331. Boston: Beacon, 1969.

Crary, Jonathan. "Modernizing Vision." In *Vision and Visuality*, edited by Hal Foster, 29–50. New York: The New Press, 1999.

———. *Techniques of the Observer: On Vision and Modernity in the Nineteenth Century*. Cambridge: MIT Press, 1990.

Darrah, William C. *Cartes de Visite in Nineteenth Century Photography*. Gettysburg: W. C. Darrah, 1981.

David, Beverly R., and Ray Sapirstein. "Reading the Illustrations in *Adventures of Huckleberry Finn*." *The Oxford Mark Twain; Adventures of Huckleberry Finn*. New York: Oxford University Press, 1996.

Davis, Angela Y. *Women, Race, and Class*. New York: Vintage Books, 1983.

Davis, Cynthia J. "Speaking the Body's Pain: Harriet Wilson's *Our Nig*." *African American Review* 27, no. 3 (1993): 391–403.

Davis, Robert Scott, Jr. "A Soldier's Story: Records of Hubbard Pryor, 44th United States Colored Troops." *Prologue: The Quarterly of the National Archives* 31 (Winter 1999): 266–72.

Davis, William C., ed. *Shadows of the Storm: Volume One of The Image of War, 1861–1865*. Garden City: Doubleday, 1981.

Davis, William C., and William A. Frassanito, ed. *Touched by Fire: A National Historical Society Photographic History of the Civil War*. Vol. 1. Boston: Little, Brown, 1985.

DeCosta-Willis, Miriam, ed. *The Memphis Diary of Ida B. Wells: An Intimate Portrait of the Activist as a Young Woman*. Boston: Beacon Press, 1995.

De Lombard, Jeannine. "'Eye-Witness to the Cruelty': Southern Violence and Northern Testimony in Frederick Douglass's 1845 *Narrative*." *American Literature* 73, no. 2 (2001): 245–75.

Diawara, Manthia. "Black Spectatorship: Problems of Identification and Resistance." In *Black American Cinema*, edited by Manthia Diawara, 211–20. New York: Routledge, 1993.

Dickey, Marcus. *The Youth of James Whitcomb Riley*. Indianapolis: Bobbs-Merrill, 1919.

Doane, Mary Ann. "Dark Continents: Epistemologies of Racial and Sexual Difference in Psychoanalysis and the Cinema." *Femmes Fatales: Feminism, Film Theory, Psychoanalysis*. New York: Routledge, 1991.

———. "Technophilia: Technology, Representation and the Future." In *Body/Politics: Women and the Discourses of Science*, edited by Mary Jacobus, Evelyn Fox Keller, and Sally Shuttleworth, 163–76. New York: Routledge, 1990.

Dorsey, Peter A. "Becoming the Other: The Mimesis of Metaphor in Douglass's *My Bondage and My Freedom*." *PMLA* 111, no. 3 (1996): 445–47.

Douglass, Frederick. "The Claims of the Negro Ethnologically Considered: An Address, Before the Literary Societies of Western Reserve College, at Commencement, July 12, 1854, Delivered in Hudson, Ohio." In *Frederick Douglass Papers*, vol. 2, edited by John W. Blassingame, 497–525. New Haven: Yale University Press, 1982.

———. "Collection of Funds for Sumner Portrait: An Address Delivered in Washington, D.C., on 11 December 1873." In *Frederick Douglass Papers*, vol. 4, edited by John W. Blassingame, 355–60. New Haven: Yale University Press, 1991.

———. "Farewell Speech to British People." In *Life and Writings of Frederick Douglass: Early Years 1817–1849*, vol. 1, edited by Philip Foner, 206–33. New York: International Publishers, 1950.

———. "John Brown and the Slaveholders' Insurrection: An Address Delivered in Edinburgh, Scotland, on 30 January 1860." In John W. Blassingame, *Frederick Douglass Papers*, vol. 3, 312–22. New Haven: Yale University Press, 1985.

———. *The Life and Times of Frederick Douglass in His Own Words*. 1881. New York: Citadel Press, 1983.

———. *My Bondage and My Freedom*. 1855. New York: Dover, 1969.

———. *Narrative of the Life of Frederick Douglass, An American Slave, Written by Himself*. 2nd ed. Edited by David Blight. Boston: Bedford / St. Martin's Press, 2003.

———. *The Narrative of the Life of Frederick Douglass, Written by Himself*. Edited by Henry Louis Gates Jr. New York: Random House, 1997.

———. "Pictures and Progress: An Address Delivered in Boston, Massachusetts, on 3 December 1861." In *Frederick Douglass Papers*, vol. 3, edited by John W. Blassingame, 452–73. New Haven: Yale University Press, 1979.

Doyle, Mary Ellen. "Slave Narratives as Rhetorical Art." In *The Art of the Slave Narrative: Original Essays in Criticism and Theory*, edited by John Sekora and Darwin Turner, 83–95. Macomb: Western Illinois University Press, 1982.

Du Bois, W. E. B. "The American Negro at Paris." *American Monthly Review of Reviews* 22, no. 5 (November 1900): 575–77.

———. *Black Reconstruction in America, 1860–1880*. New York: Free Press, 1998.

———. *John Brown*. 1909. New York: International Publishers, 1962, second printing 1967.

———, ed. *Notes on Negro Crime, Particularly in Georgia*, Atlanta University Publications, no. 9. Atlanta: Atlanta University Press, 1904.

————. *The Souls of Black Folk*. 1903. New York: Library of America, 1990.

du Cille, Ann. *The Coupling Convention: Sex, Text, and Tradition in Black Women's Fiction*. New York: Oxford University Press, 1993.

Dunbar, Paul Laurence. *Candle Lightin' Time*. New York: Dodd, Mead, and Co., 1901.

————. *The Collected Poetry of Paul Laurence Dunbar*. Edited by Joanne Braxton. Charlottesville: University Press of Virginia, 1993.

————. *Howdy, Honey, Howdy*. New York: Dodd, Mead, and Co., 1905.

————. *Joggin' Erlong*. New York: Dodd, Mead, and Co., 1906.

————. *L'il Gal*. New York: Dodd, Mead, and Co., 1904.

————. *Lyrics of Lowly Life*. New York: Dodd, Mead, and Co., 1896.

————. *Poems of Cabin and Field*. New York: Dodd, Mead, and Co., 1899.

————. *When Malindy Sings*. New York: Dodd, Mead, and Co., 1903.

Dyer, Richard. *White*. New York: Routledge Press, 1997.

Emerson, Ralph W. *Representative Men: Seven Lectures*. Boston: Phillips, Sampson, and Co., 1850.

Emilio, Luis F. *A Brave Black Regiment: History of the Fifty-Fourth Regiment of Massachusetts Volunteer Infantry, 1863–1865*. 1891. Shmegma: De Capo Press, 1995.

Fanon, Franz. *Black Skin, White Masks*. New York: Grove Press, 1967.

Felton, Mrs. W. H. "From a Southern Woman." *Harper's Weekly* 47 (November 14, 1903): 1830.

Fields, Barbara J. "Ideology and Race in American History." In *Region, Race, and Reconstruction*, edited by J. Morgan Kousser and James M. McPherson, 143–77. New York: Oxford University Press, 1982.

Fisher, Rebecka Rutledge. "Cultural Artifacts and the Narrative of History: W. E. B. DuBois and the Exhibiting of Culture at the 1900 Paris Exposition Universelle." *Modern Fiction Studies* 51, no. 4 (2005): 741–74.

Folsom, Ed. *Walt Whitman's Native Representations*. Cambridge: Cambridge University Press, 1994.

Foner, Philip, ed. *The Life and Writings of Frederick Douglass*. 5 vols. New York: International Publishers, 1950–1955.

Foreman, P. Gabrielle. "Manifest in Signs: The Politics of Sex and Representation in *Incidents in the Life of a Slave Girl*." In *Harriet Jacobs and Incidents in the Life of a Slave Girl: New Critical Essays*, edited by Deborah Garfield and Rafia Zafar, 76–99. New York: Cambridge University Press, 1996.

————. "Passing and Its Prepositions." In "Racial Recovery, Racial Death: An Introduction in Four Parts" (written with Cherene Sherrard-Johnson). *Legacy: A Journal of American Women Writers* 24, no. 2 (2007): 157–70.

————. "'Reading Aright': White Slavery, Black Referents and the Strategy of Histotextuality in *Iola Leroy*." *Yale Journal of Criticism* 10, no. 2 (1997): 327–55.

Foster, Francis Smith. "'In Respect to Females . . .': Differences in the Portrayals of Women by Male and Female Narrators." *Black American Literature Forum* 15, no. 2 (1981): 66–70.

————. *Written by Herself: Literary Production by African American Women, 1746–1892*. Bloomington: Indiana University Press, 1993.

Foucault, Michel. *Discipline and Punish: The Birth of the Prison*. Translated by A. Sheridan. London: Penguin, 1977.

————. *The History of Sexuality*. Vol. 1. Translated by Robert Hurley. New York: Vintage, 1978, 1980.

Fox, Charles B. *Record of the Service of the 55th Regiment of Massachusetts Volunteer Infantry*. Cambridge: Press of J. Wilson and Son, 1868.

Frassanito, William A. *Antietam: The Photographic Legacy of America's Bloodiest Day*. New York: Scribner, 1978.

————. *Gettysburg: A Journey in Time*. New York: Scribner, 1975.

————. *Grant and Lee: The Virginia Campaigns, 1864–1865*. New York: Scribner, 1983.

Freud, Sigmund. *The Uncanny*. Translated by David McLintock. London: Penguin Books, 2003.

Fulton, DoVeanna. "Speak Sister, Speak: Oral Empowerment in *Louisa Picquet, The Octoroon*." *Legacy: A Journal of Women Writers* 15, no. 1 (1998): 98–103.

Fusco, Coco. "Racial Times, Racial Marks, Racial Metaphors." In *Only Skin Deep: Changing Visions of the American Self*, edited by Coco Fusco and Brian Wallis, 13–50. New York: Harry N. Abrams, 2003.

————. "Uncanny Dissonance: The Work of Lorna Simpson." *English Is Broken Here: Notes on Cultural Fusion in the Americas*. New York: New Press, 1995.

Garber, Marjorie B. *Vested Interests: Cross-Dressing and Cultural Anxiety*. New York: Routledge, 1992.

Gardner, Jane F. *Roman Myths*. Austin: British Museum / University of Texas Press, 1993.

Gates, Henry Louis, Jr., ed. *Black Is the Color of the Cosmos: Essays on African American Literature and Culture, 1942–1981*. New York: Garland Publishing, 1982.

————. "The Face and Voice of Blackness." In *Facing History: The Black Image in American Art, 1710–1940*, edited by Guy C. McElroy, xxix–xliv. San Francisco: Bedford Arts, 1990.

————. *Figures in Black: Words, Signs, and the "Racial" Self*. New York: Oxford University Press, 1987.

————. *The Signifying Monkey: A Theory of Afro-American Literary Criticism*. New York: Oxford University Press, 1988.

————. "The Trope of a New Negro and the Reconstruction of the Image of the Black." *Representations* 24 (Fall 1988): 129–55.

Giddings, Paula. *When and Where I Enter: The Impact of Black Women on Race and Sex in America*. New York: William Morrow, 1984.

Gilbert, George. *Photography: The Early Years; A Historical Guide for Collectors*. New York: Harper and Row, 1980.

Gilbert, Olive. *Narrative of the Life of Sojourner Truth: A Bondswoman of Olden Time, with a History of Her Labors and Correspondence Drawn from Her Book of Life*. 1850. Edition of 1884, edited by Nell Painter. Boston: Penguin Books, 1998.

Gillman, Susan. "'Sure Identifiers': Race, Science, and the Law in Twain's *Pudd'nhead Wilson.*" *South Atlantic Quarterly* 87, no. 2 (Spring 1988): 195–218.

Gilman, Sander L. "Black Bodies, White Bodies: Toward an Iconography of Female Sexuality in Late Nineteenth Century Art, Medicine, and Literature." In *"Race," Writing, and Difference*, edited by Henry Louis Gates Jr., 223–61. Chicago: University of Chicago Press, 1986.

Gilroy, Paul. *The Black Atlantic: Modernity and Double Consciousness.* Cambridge: Harvard University Press, 1993.

Gladstone, William A. *Men of Color.* Gettysburg: Thomas Publications, 1993.

Glassie, Henry. "Meaningful Things and Appropriate Myths: The Artifact's Place in American Studies." In *Material Life in America, 1600-1800*, edited by Robert Blair St. George, 63–94. Boston: Northeastern University Press, 1988.

Glatthaar, Joseph T. *Forged in Battle: The Civil War Alliance of Black Soldiers and White Officers.* New York: Free Press, 1990.

Goldberg, Vicki. *The Power of Photography: How Photographs Changed Our Lives.* New York: Abbeville, 1991.

———. "Social-Climbing Tintypes, Yearning to Be Paintings." *New York Times*, August 1, 1993, H 33.

Goldsby, Jacqueline. *A Spectacular Secret: Lynching in American Life and Literature.* Chicago: University of Chicago Press, 2006.

Gonzales-Day, Ken. *Lynching in the West, 1850-1935.* Durham: Duke University Press, 2006.

Gordon, Avery F. *Ghostly Matters: Haunting and the Sociological Imagination.* Minneapolis: University of Minnesota Press, 2008.

Gourdin, John Raymond. *Voices from the Past: 104th Infantry Regiment—USCT, Colored Civil War Soldiers from South Carolina.* Westminster: Heritage Books, 2007.

Gregory, James M. *Frederick Douglass, the Orator.* Springfield: Willey and Co., 1893.

Gross, Ariela. "Litigating Whiteness: Trials of Racial Determination in the Nineteenth-Century South." *Yale Law Journal* 108, no. 1 (1998): 109–88.

Hahn, Steven. *A Nation Under Our Feet: Black Political Struggles in the Rural South from Slavery to the Great Migration.* Cambridge: Harvard University Press, 2003.

Hansen, Christian, Catherine Needham, and Bill Nichols. "Pornography, Ethnography, and the Discourses of Power." In *Representing Reality: Issues and Concepts in Documentary*, edited by Bill Nichols, 201–28. Bloomington: Indiana University Press, 1991.

Harper, Frances E. W. *Iola Leroy.* 1892. Boston: Beacon, 1987.

Harris, Michael D. *Colored Pictures: Race and Visual Representation.* Chapel Hill: University of North Carolina Press, 2003.

Harris, Susan K. *Nineteenth-Century American Women's Novels: Interpretive Strategies.* Cambridge: Cambridge University Press, 1990.

Hartman, Saidiya. *Scenes of Subjection: Terror, Slavery, and Self-Making in Nineteenth-Century America.* New York: Oxford University Press, 1997.

"*The Heart of Happy Hollow.*" Book review. *Southern Workman* 33, no. 12 (December 1904): 693.

Hegel, G. W. F. *The Philosophy of History*. Translated by J. Jibree. New York: Dover, 1956.

Heinz, Henisch K. *The Photographic Experience, 1839–1914: Images and Attitudes*. University Park: Penn State University Press, 1994.

Higginbotham, Evelyn Brooks. *Righteous Discontent: The Women's Movement in the Black Baptist Church, 1880–1920*. Cambridge: Harvard University Press, 1993.

Higginson, Thomas Wentworth. *Army Life in a Black Regiment*. 1869. East Lansing: Michigan State University Press, 1961.

Hirsch, Robert. *Seizing the Light: A History of Photography*. Boston: McGraw Hill, 2000.

Holloway, Camara Dia. *Portraiture and the Harlem Renaissance: The Photographs of James L. Allen*. New Haven: Yale University Art Gallery, 1999.

"Holmes on Lynching." *Crisis* 3, no. 3 (1912): 109–12.

hooks, bell. *Black Looks: Race and Representation*. Boston: South End Press, 1992.

———. "In Our Glory: Photography and Black Life." In *Picturing Us: African American Identity in Photography*, edited by Deborah Willis, 43–54. New York: New Press, 1994.

Howells, William Dean. Introduction to *Lyrics of Lowly Life*, by Paul Laurence Dunbar, xiii–xx. 1896. New York: Citadel, 1984.

———. *The Rise of Silas Lapham*. New York: Penguin Classics, 1986.

Hunt, Lynn. *Inventing Human Rights*. New York and London: W. W. Norton and Company, 2007.

Hunter, Jefferson. *Image and Word: The Interaction of Twentieth-Century Photographs and Texts*. Cambridge: Harvard University Press, 1987.

Ivins, William M. *How Prints Look: Photographs with Commentary*. Boston: Beacon Press, 1987.

Jacobs, Harriet. *Incidents in the Life of a Slave Girl*. 1861. Edited by Nellie Y. McKay and Frances Smith Foster. New York: Norton, 2001.

Jay, Gregory S. "American Literature and the New Historicism: The Example of Frederick Douglass." *boundary 2* 17, no. 1 (1990): 238–39.

Jay, Martin. "Scopic Regimes of Modernity." In *Vision and Visuality*, edited by Hal Foster, 3–28. New York: New Press, 1999.

Johnson, James Weldon. *The Book of Negro Poetry*. New York: Harcourt, Brace, and Co., 1931.

Jones, Gavin. *Strange Talk: The Politics of Dialect Literature in Gilded Age America*. Berkeley: University of California Press, 1999.

Julien, Isaac and Kobena Mercer. "Introduction: De Margin and De Centre." *Screen* 29, no. 4 (1988): 2–10.

Kawash, Samira. *Dislocating the Color Line: Identity, Hybridity, and Singularity in African-American Narrative*. Stanford: Stanford University Press, 1997.

Kelbaugh, Ross J. *Introduction to African American Photographs, 1840-1950: Identification, Research, Care and Collecting*. Gettysburg: Thomas Publications, 2005.

Kelley, Mary. *Private Woman, Public Stage: Literary Domesticity in Nineteenth-Century America*. New York: Oxford University Press, 1984.

Kirsch, Andrea, and Susan Fischer Sterling, eds. *Carrie Mae Weems*. Washington, D.C.: National Museum of Women in the Arts, 1994.

Larson, E. Dixon, and Al Ritter. "Frontiersman Bill Gay." *Wild West* (June 1996). Historynet.com, http://www.historynet.com/culture/people/3037926.html.

Lee, Maurice. *Slavery, Philosophy, and American Literature, 1830-1860*. Cambridge: Cambridge University Press, 2005.

Lewis, David Levering. *W. E. B. Du Bois, Biography of a Race*. New York: Henry Holt and Company, 1993.

Lewis, David Levering, and Deborah Willis. *A Small Nation of People: W. E. B. Du Bois and African American Portraits of Progress*. New York: Amistad, 2003.

Lippard, Lucy R. *Mixed Blessings: New Art in a Multicultural America*. New York: Pantheon, 1990.

Loobey, Christopher. "A Literary Colonel." Introduction to *The Complete Civil War Journal and Selected Letters of Thomas Wentworth Higginson*. Chicago: University of Chicago Press, 2000.

Lopez, Ian Haney. "The Social Construction of Race." In *Critical Race Theory: The Cutting Edge*, edited by Richard Delgado, 163–75. Philadelphia: Temple University Press, 1995.

Lott, Eric. "Love and Theft: The Racial Unconscious of Blackface Minstrelsy." *Representations* 39 (1992): 23–50.

Lubiano, Wahneema. "Black Ladies, Welfare Queens, and State Minstrels: Ideological War by Narrative Means." In *Race-ing Justice, En-gendering Power: Essays on Anita Hill, Clarence Thomas, and the Construction of Social Reality*, edited by Toni Morrison, 323–63. New York: Pantheon Books, 1992.

Lurie, Edward. *Louis Agassiz: A Life in Science*. Chicago: University of Chicago Press, 1960.

Macpherson, C. B. *Political Theory of Possessive Individualism*. London: Oxford University Press, 1962.

Marable, Manning. "The Pan-Africanism of W. E. B. Du Bois." In *W. E. B. Du Bois on Race and Culture*, edited by Bernard W. Bell, Emily R. Grosholz, and James B. Stewart, 193–218. New York: Routledge, 1996.

Marcou, Jules. *Life, Letters, and Works of Louis Agassiz*. New York: Macmillan and Co., 1896.

Markovitz, Jonathan. *Legacies of Lynching: Racial Violence and Memory*. Minneapolis: University of Minnesota Press, 2004.

Marriott, David. *On Black Men*. New York: Columbia University Press, 2000.

Marten, James. *Civil War America: Voices from the Home Front*. Santa Barbara: ABC-CLIO, 2003.

Martin, Jay, and Gossie H. Hudson, ed. *The Paul Laurence Dunbar Reader: A Selection*

of the Best of Paul Laurence Dunbar's Poetry and Prose, Including Writings Never before Available in Book Form. New York: Dodd, Mead, and Co., 1975.

Mason, Herman "Skip," Jr. *Hidden Treasures: African American Photographers in Atlanta, 1870-1970.* Atlanta: African American Family History Association, 1991.

Mattison, Hiram. *Louisa Picquet, the Octoroon: A Tale of Southern Slave Life.* 1861. In *Collected Black Women's Narratives*, the Schomburg Library of Nineteenth-Century Black Women Writers, edited by Henry Louis Gates Jr. New York: Oxford University Press, 1990.

————. *Spirit-Rapping Unveiled! An Expose of the Origin, History, Theology, and Philosophy of Certain Alleged Communications from the Spirit World.* New York: Mason Brothers, 1853.

Mavor, Carol. *Pleasures Taken: Performances of Sexuality and Loss in Victorian Photographs.* Durham: Duke University Press, 1995.

McCaskill, Barbara. "A Stamp on the Envelope Upside Down Means Love; or, Literature and Literacy in the Multicultural Classroom." In *Multicultural Literature and Literacies: Making Space for Difference*, edited by Suzanne M. Miller and Barbara McCaskill, 77–102. Albany: SUNY Press, 1993.

————. *William and Ellen Craft in Transatlantic Literature and Life.* Athens: University of Georgia Press, 1999.

————. "'Yours Very Truly': Ellen Craft—The Fugitive as Text and Artifact." *African American Review* 28, no. 4 (1994): 509–30.

McDowell, Deborah E. "In the First Place: Making Frederick Douglass and the Afro-American Narrative Tradition." In *Critical Essays on Frederick Douglass*, edited by William L. Andrews, 66–83. Boston: G. K. Hall and Company, 1991.

————. "Viewing the Remains: A Polemic on Death, Spectacle, and the [Black] Family." In *The Familial Gaze*, edited by Marianne Hirsch, 153–77. Hanover: University Press of New England, 1999.

McFeely, William S. *Frederick Douglass.* New York: W. W. Norton, 1991.

McGhee, Nancy. "Portraits in Black: Illustrated Poems of Paul Laurence Dunbar." In *Stony the Road; Chapters in the History of Hampton Institute*, edited by Keith L. Schall, 63–104. Charlottesville: University of Virginia Press, 1977.

Meehan, Sean Ross. *Mediating American Autobiography: Photography in Emerson, Thoreau, Douglass, and Whitman.* Columbia: University of Missouri Press, 2008.

Merish, Lori. *Sentimental Materialism: Gender, Commodity Culture, and Nineteenth-Century American Literature.* Durham: Duke University Press, 2000.

Merleau-Ponty, Maurice. "Eye and Mind." *The Primacy of Perception.* Translated by Carleton Dallery. Evanston: Northwestern University Press, 1961.

————. *Phenomenology of Perception.* 1962. Translated by Colin Smith. London: Routledge Press, 1994.

Metcalf, E. W. *Paul Laurence Dunbar: A Bibliography.* Metuchen: Scarecrow Press, 1975.

Michaels, Barbara L. *Gertrude Kasebier, Photographer and Her Photographs.* New York: Harry Abrams, 1992.

————. "New Light on F. Holland Day's Photographs of African Americans." *History of Photography* 18, no. 4 (Winter 1994): 334–47.

Mirzoeff, Nicholas. "The Shadow and the Substance: Race, Photography and the Index." In *Only Skin Deep: Changing Visions of the American Self*, edited by Coco Fusco and Brian Wallis, 111–29. New York: Harry N. Abrams, 2003.

Mitchell, W. J. T. *Picture Theory: Essays on Verbal and Visual Representation*. Chicago: University of Chicago Press, 1994.

Morrison, Toni. *Playing in the Dark: Whiteness in the Literary Imagination*. New York: Vintage Books, 1992.

Moses, Wilson Jeremiah, ed. *Liberian Dreams: Back-to-Africa Narratives from the 1850s*. University Park: Pennsylvania State University Press, 1998.

Moten, Fred. *In the Break: The Aesthetics of the Black Radical Tradition*. Minneapolis: University of Minnesota Press, 2003.

Mullen, Harryette. "'Indelicate Subjects': African American Women's Subjugated Subjectivity." *Sub/versions: Feminist Studies*. Santa Cruz: University of California Press, 1991.

————. "Optic White: Blackness and the Production of Whiteness." *Diacritics: A Review of Contemporary Criticism* 24, no. 2 (1994): 71–89.

Murray, Albert. *Omni Americans*. New York: Vintage, 1983.

"The Negro Problem and the New Negro Crime." *Harper's Weekly* 47 (June 20, 1903): 1050–51.

Nelson, Dana D. *National Manhood: Capitalist Citizenship and the Imagined Fraternity of White Men*. Durham: Duke University Press, 1998.

Noble, Marianne. *The Masochistic Pleasures of Sentimental Literature*. Princeton: Princeton University Press, 2000.

Nudelman, Franny. *John Brown's Body: Slavery, Violence, and the Culture of War*. Chapel Hill: University of North Carolina Press, 2004.

Nurhussein, Nadia. "Paul Laurence Dunbar's Performances and The Epistolary Dialect Poem." *African American Review* 41, no. 2 (2007): 233–38.

Okwui, Enwezor, and Octavio Zaya. "Colonial Imaginary, Tropes of Disruption: History, Culture, and Representation in the Works of African Photographers." *In/Sight: African Photographers, 1940 to the Present*. New York: Solomon Guggenheim Foundation, 1996.

Ong, Walter. *Orality and Literacy: The Technologization of the Word*. New York: Routledge, 2002.

Painter, Nell Irvin. *Creating Black Americans: African American History and Its Meanings, 1619 to the Present*. New York: Oxford University Press, 2006.

————, ed. *Narrative of Sojourner Truth*. New York: Penguin Books, 1998.

————. "Representing Truth: Sojourner Truth's Knowing and Becoming Known." *Journal of American History* 81, no. 2 (September 1994): 461–92.

————. *Sojourner Truth: A Life, a Symbol*. New York: W. W. Norton and Company, 1997.

Paradis, James M. *Strike the Blow for Freedom: The 6th United States Colored Infantry in the Civil War*. Shippensburg: White Mane, 2000.

Parker, Freddie L. *Stealing a Little Freedom: Advertisements for Slave Runaways in North Carolina, 1791-1840*. New York: Garland, 1994.

Patterson, Orlando. *Slavery and Social Death: A Comparative Perspective*. Cambridge: Harvard University Press, 1982.

Peterson, Carla. "Capitalism, Black (Under)Development, and the Production of the African American Novel in the 1850s." *American Literary History* 4, no. 4 (1992): 559–83.

———. *"Doers of the Word": African-American Women Speakers and Writers in the North, 1830-1880*. New York: Oxford University Press, 1995.

"Photograph Albums." *Scientific American* 6, no. 14 (1862): 216.

Powell, Richard J. *Cutting a Figure: Fashioning Black Portraiture*. Chicago: University of Chicago Press, 2008.

Prown, Jules David. "In Pursuit of Culture: The Formal Language of Objects." *American Art* 9, no. 2 (1995): 2–3.

Publishers' and Stationers' Weekly Trade Circular 1, no. 1–32, no. 27. New York: F. Leypoldt, 1872–1887.

Raiford, Leigh. "The Consumption of Lynching Images." In *Only Skin Deep: Changing Visions of the American Self*, edited by Coco Fusco and Brian Wallis, 267–74. New York: Harry N. Abrams Press, 2003.

———. *Imprisoned in a Luminous Glare: Photography and the African American Freedom Struggle*. Chapel Hill: University of North Carolina Press, 2011.

Rampersad, Arnold. *The Art and Imagination of W. E. B. Du Bois*. New York: Schocken, 1990.

Riley, James Whitcomb. The *Complete Work of James Whitcomb Riley*. 10 vols. New York: Collier, 1916.

Robinson, Amy. "It Takes One to Know One: Passing and Communities of Common Interest." *Critical Inquiry* 20, no. 4 (1994): 715–36.

Robinson, William F. *A Certain Slant of Light: The First 100 Years of New England Photography*. Boston: New York Graphic Society, 1980.

Rodgers, H. J. *Twenty-Three Years under a Skylight, or Life and Experiences of a Photographer*. Hartford: H. J. Rogers, 1872.

Rogers, Molly. *Delia's Tears: Race, Science, and Photography in Nineteenth-Century America*. New Haven: Yale University Press, 2010.

Rogin, Michael. "Blackface, White Noise: The Jewish Jazz Singer Finds His Voice." *Critical Inquiry* 18, no. 3 (1992): 417–53.

Romero, Lora. *Home Fronts: Domesticity and Its Critics in the Antebellum United States*. Durham: Duke University Press, 1997.

Rosaldo, Renato. "Imperialist Nostalgia." *Culture and Truth: The Remaking of Social Analysis*. Boston: Beacon Press, 1993.

Ruari, McLean. *Victorian Publishers' Book-bindings in Cloth and Leather*. Berkeley: University of California Press, 1973.

Rushdy, Ashraf. "Exquisite Corpse." *Transition* 83 (2000): 70–77.

Sánchez-Eppler, Karen. "Bodily Bonds: The Intersecting Rhetorics of Feminism and Abolition." *Representations* 24, no. 1 (1991): 28–59.

Sandweiss, Martha A., ed. *Photography in Nineteenth-Century America*. Fort Worth: Amon Carter Museum, 1991.

Sartre, Jean-Paul. *The Imagination*. 1940. London: Routledge, 2004.

Schechter, Patricia A. *Ida B. Wells-Barnett and American Reform 1880–1930*. Chapel Hill: University of North Carolina Press, 2001.

Sekula, Allan. "The Body and the Archive." *October* 39 (Winter 1986): 3–64.

———. "The Traffic in Photographs." In *Only Skin Deep: Changing Visions of the American Self*, edited by Coco Fusco and Brian Wallis, 79–110. New York: Harry N. Abrams, 2003.

Severa, Joan L. *My Likeness Taken: Daguerreian Portraits in America*. Kent: Kent State University Press, 2005.

Shaw, Gwendolyn DuBois. *Portraits of a People: Picturing African Americans in the Nineteenth Century*. Seattle: University of Washington Press, 2006.

Sherrard-Johnson, Cherene. *Portraits of the New Negro Woman: Visual and Literary Culture in the Harlem Renaissance*. New Brunswick: Rutgers University Press, 2007.

Shklar, Judith N. *American Citizenship: The Quest for Inclusion*. Cambridge: Harvard University Press, 1991.

Shumard, Ann M. *A Durable Memento: Portraits by Augustus Washington, African American Daguerreotypist*. Washington, D.C.: National Portrait Gallery, Smithsonian Institution, 1999.

Smith, Shawn Michelle. *American Archives: Gender, Race, and Class in Visual Culture*. Princeton: Princeton University Press, 1999.

———. *Photography on the Color Line: W. E. B. Du Bois, Race, and Visual Culture*. Durham: Duke University Press, 2004.

Smith, Valerie. *Self-Discovery and Authority in Afro-American Narratives*. Cambridge: Harvard University Press, 1988.

Solkin, David. "Joseph Wright of Derby and the Sublime Art of Labor." *Representations* 83 (2003): 176–79.

Sollors, Werner. *Beyond Ethnicity; Consent and Descent in American Culture*. New York: Oxford University Press, 1986.

"Some Fresh Suggestions about the New Negro Crime." *Harper's Weekly* 48 (January 23, 1904): 120–21.

Sontag, Susan. *On Photography*. New York: Noonday Press, 1977.

Spillers, Hortense. "Mama's Baby, Papa's Maybe: An American Grammar Book." *Diacritics: A Review of Contemporary Criticism* 17, no. 2 (1987): 64–81.

———. "Notes on an Alternative Model—Neither/Nor." In *The Difference Within: Feminism and Critical Theory*, edited by Elizabeth Meese and Alice Parker, 165–87. Philadelphia: John Benjamin, 1989.

Stanton, William. *"The Leopard's Spots": Scientific Attitudes toward Race in America, 1815-59*. Chicago: University of Chicago Press, 1960.

Stauffer, John. *Black Hearts of Men: Radical Abolitionists and the Transformation of Race.* Cambridge: Harvard University Press, 2002.

———. "Daguerreotyping the National Soul: The Portraits of Southworth & Hawes, 1843–1860." In *Young America: The Daguerreotypes of Southworth & Hawes,* edited by Grant Romer and Brian Wallis, 57–74. New York: International Center of Photography, George Eastman House, and Steidl, 2005.

———. "Race and Contemporary Photography: Willie Robert Middlebrook and the Legacy of Frederick Douglass." *21st: The Journal of Contemporary Photography and Culture* 1 (1998): 55–60.

Stepto, Robert. *From behind the Veil: A Study of Afro-American Narrative.* 2nd ed. Urbana: University of Illinois Press, 1991.

Sterling, Dorothy. *Black Foremothers: Three Lives.* Old Westbury: Feminist Press, 1979.

Stoler, Ann Laura. *Race and the Education of Desire: Foucault's* History of Sexuality *and the Colonial Order of Things.* Durham: Duke University Press, 1995.

Stowe, Harriet Beecher. *Uncle Tom's Cabin: Or, Life among the Lowly.* 1852. New York: Collier, 1962.

"The Strength of Gideon and Other Stories." Book review. *Southern Workman* 29, no. 8 (August 1900): 487.

Sullivan, George. *Black Artists in Photography, 1840–1940.* Dutton: Cobblehill Books, 1996.

Sundquist, Eric. *To Wake the Nations: Race in the Making of American Literature.* Cambridge: Belknap, 1993.

Taft, Robert. *Photography and the American Scene: A Social History, 1839–1889.* 1938. New York: Dover, 1964.

Tagg, John. *The Burden of Representation: Essays on Photographies and Histories.* Minneapolis: University of Minnesota Press, 1993.

———. "The Currency of the Photograph." In *Thinking Photography,* edited by Victor Burgin, 110–41. New York: Palgrave Macmillan, 1982.

Tate, Claudia. *Domestic Allegories of Political Desire: The Black Heroine's Text at the Turn of the Century.* New York: Oxford University Press, 1992.

Taylor, Susie King. *Reminiscences of My Life in Camp with the 33d United States Colored Troops Late 1st S.C. Volunteers.* 1902. Athens: University of Georgia Press, 2006.

Tighe, Mary Ann. "Gertrude Käsebier, Lost and Found." *Art in America* 65, no. 2 (1977): 94–98.

Trachtenberg, Alan, ed. *Classic Essays on Photography.* New Haven: Leete's Island Books, 1980.

———. "Photography: The Emergence of a Key Word." In *Photography in Nineteenth-Century America,* edited by Martha Sandweiss, 16–47. New York: H. N. Abrams, 1991.

———. *Reading American Photographs: Images as History, Mathew Brady to Walker Evans.* New York: Hill and Wang, 1989.

Upham, Thomas C. *Elements of Mental Philosophy*. New York: Harper and Brothers, 1861.

U.S. War Department. *The Official Records of the War of Rebellion*. Washington, D.C.: Government Printing Office, 1886.

Valéry, Paul. "The Centenary of Photography." In *Classic Essays on Photography*, edited by Alan Trachtenberg, 191–98. New Haven: Leete's Island Books: 1980.

Veblen, Thorstein. *The Theory of the Leisure Class: An Economic Study of Institutions*. 1899. New York: Modern Library, 1931.

Vlach, John Michael. *The Planter's Prospect: Privilege and Slavery in Plantation Paintings*. Chapel Hill: University of North Carolina Press, 2002.

Volpe, Andrea L. "Cartes de Visite Portrait Photographs and the Culture of Class Formation." In *Looking for America: The Visual Production of Nation and People*, edited by Ardis Cameron, 42–57. Malden: Blackwell Publishing, 2005.

Voss, Frederick S. *Majestic in His Wrath: A Pictorial Life of Frederick Douglass*. Washington, D.C.: Smithsonian Institution Press, 1995.

Wald, Priscilla. *Constituting Americans: Cultural Anxiety and Narrative Form*. Durham: Duke University Press, 1995.

Waldstreicher, David. "Reading the Runaways: Self-Fashioning, Print Culture, and Confidence in Slavery in the Eighteenth-Century Mid-Atlantic." *William and Mary Quarterly* 56, no. 2 (1999): 243–73.

Walker, Christian. "Gazing Colored: A Family Album." In *Picturing Us: African American Identity in Photography*, edited by Deborah Willis, 65–72. New York: New Press, 1994.

Wallace, Maurice O. *Constructing the Black Masculine: Identity and Ideality in African American Men's Literature and Culture, 1775-1995*. Durham: Duke University Press, 2002.

————. "Riveted to the Wall: Coveted Fathers, Devoted Sons, and the Patriarchal Pieties of Melville and Douglass." In *Frederick Douglass and Herman Melville: Essays in Relation*, edited by Robert S. Levine and Samuel Otter, 300–28. Chapel Hill: University of North Carolina Press, 2008.

Wallis, Brian. "Black Bodies, White Science: Louis Agassiz's Slave Daguerreotypes." *American Art* 9, no. 2 (1995): 39–60.

Walls, Laura Dassow. "Textbooks and Texts from the Brooks; Inventing Scientific Authority in America." *American Quarterly* 49, no. 1 (March 1997): 1–25.

Washington, Augustus. "Thoughts on the American Colonization Society, 1851." In Moses, *Liberian Dreams*, 184–97. University Park: Pennsylvania State University Press, 1998.

Washington, Booker T. *A New Negro for a New Century*. Chicago: American Publishing House, n.d. (ca. 1899).

Waters, Donald J. *Strange Ways and Sweet Dreams: Afro-American Folklore from the Hampton Institute*. Boston: G. K. Hall and Co., 1983.

Waugh, Thomas. *Hard to Imagine: Gay Male Eroticism in Photography and Film from Their Beginnings to Stonewall*. New York: Columbia University Press, 1996.

Webb, Frank. *The Garies and Their Friends*. 1857. New York: Arno Press, 1969.

Wells, Donna W. "Frederick Douglass and the Power of Photography." *HUArchivesNet: The Electronic Journal MSRC-Howard University*, no. 3 (February 2000). http://www.huarchivesnet.howard.edu/0002huarnet/current.htm.

Wells, Ida B. *Crusade for Justice: The Autobiography of Ida B. Wells*. Edited by Alfreda M. Duster. Chicago: University of Chicago Press, 1970.

————. *Selected Works of Ida B. Wells-Barnett*. Edited by Trudier Harris. New York: Oxford University Press, 1991.

————. *Southern Horrors: Lynch Law in All Its Phases*. Salem: Ayer Company Publishers, 1892.

Wells, Ida B., Frederick Douglass, Irvine Garland Penn, and Ferdinand L. Barnett. *The Reason Why the Colored American Is Not in the World's Columbian Exposition*. 1893. Edited by Robert W. Rydell. Urbana: University of Illinois Press, 1999.

Westerbeck, Colin L. "Frederick Douglass Chooses His Moment." *African Americans in Art: Selections from the Art Institute of Chicago*. Seattle: University of Washington Press, 1999.

Wexler, Laura. "Seeing Sentiment: Photography, Race, and the Innocent Eye." In *Female Subjects in Black and White: Race, Psychoanalysis, Feminism*, edited by Elizabeth Abel, Barbara Christian, and Helene Moglen, 159–86. Berkeley: University of California Press, 1997.

————. *Tender Violence: Domestic Visions in an Age of U.S. Imperialism*. Chapel Hill: University of North Carolina Press, 2000.

"When Malindy Sings." Book review. *Southern Workman* 32, no. 12 (December 1903): 631.

Whitman, Walt. *Leaves of Grass*. Boston: James R. Osgood and Company, 1881–82.

————. *Two Rivulets, Including Democratic Vistas, Centennial Songs, Passage to India*. Camden: Author's Edition, 1876.

Wiegman, Robyn. *American Anatomies: Theorizing Race and Gender*. Durham: Duke University Press, 1995.

Wiggins, Lida Keck. *The Life and Works of Paul Laurence Dunbar*. Naperville: J. L. Nichols and Co., 1907.

Williams, Patricia J. *The Alchemy of Race and Rights*. Cambridge: Harvard University Press, 1991.

Willis, Deborah. *Family, History, Memory: Recording African American Life*. Irvington: Hylas Publishing, 2005.

————, ed. *J. P. Ball: Daguerrean and Studio Photographer*. New York: Garland, 1993.

————. *Let Your Motto Be Resistance*. Washington, D.C.: Smithsonian, 2007.

————, ed. *Picturing Us: African American Identity in Photography*. New York: New Press, 1994.

————. *Reflections in Black: A History of Black Photographers 1840 to the Present*. New York: Norton, 2000.

————. "The Sociologist's Eye: W. E. B. Du Bois and the Paris Exposition." In

A Small Nation of People: W. E. B. Du Bois and African American Portraits of Progress, edited by David Levering Lewis and Deborah Willis, 51–78. New York: Amistad, 2003.

Willis-Thomas, Deborah. *Black Photographers, 1840-1940: An Illustrated Bio-Bibliography*. New York: Garland, 1985.

Wilson, Jackie Napolean. *Hidden Witness: African-American Images from the Dawn of Photography to the Civil War*. New York: St. Martin's Press, 1999.

Winton, George B. "The Negro Criminal." *Harper's Weekly* 47 (August 29, 1903): 1414.

Witham, George F. *Catalogue of Civil War Photographers, 1861-1865*. Memphis: George F. Witham, 1988.

Wood, Peter H., and Karen C. C. Dalton. *Winslow Homer's Images of Blacks: The Civil War and Reconstruction Years*. Austin: University of Texas Press, 1988.

Yellin, Jean Fagan. *Women and Sisters: The Antislavery Feminists in American Culture*. New Haven: Yale University Press, 1989.

———. "Written by Herself: Harriet Jacobs's Slave Narrative." *American Literature* 53, no. 3 (1981): 479–486.

Young, Robert J. C. *Colonial Desire: Hybridity in Theory, Culture, and Race*. New York: Routledge, 1995.

Zangrando, Robert L. *The NAACP Crusade against Lynching, 1909-1950*. Philadelphia: Temple University Press, 1980.

Žižek, Slavoj. *Looking Awry: An Introduction to Jacques Lacan through Popular Culture*. Cambridge: MIT Press, 1998.

CONTRIBUTORS

MICHAEL CHANEY is an associate professor of English and African American studies at Dartmouth College. He is the author of *Fugitive Vision: Slave Image and Black Identity in Antebellum Narrative* (Indiana University Press, 2008) and editor of *Graphic Subjects: Critical Essays on Autobiography and the Graphic Novel* (Wisconsin University Press, 2011). His essays on race, literature, and visuality have appeared in *African American Review*, *American Literature*, MELUS, and *College Literature*.

CHERYL FINLEY is an associate professor in the History of Art and Visual Studies Department at Cornell University who frequently writes and lectures about photography, African American art, heritage tourism, the art market, and memory politics. Dr. Finley is the coauthor of *Harlem: A Century in Images* (Rizzoli, 2010) and *Diaspora, Memory, Place: David Hammons, Maria Magdalena Campos-Pons, Pamela Z* (Prestel, 2008). She was named one of Cornell University's "young faculty innovators" by the Office of the Vice Provost for Research in October 2009. Her work has been supported by an Alphonse Fletcher Sr. Fellowship, the Ford Foundation, the Center for Advanced Study in the Visual Arts, and the American Academy of Arts and Sciences.

P. GABRIELLE FOREMAN is the author of more than a dozen essays and book chapters as well as three books and editions, including *Activist Sentiments: Reading Black Women in the Nineteenth Century* (University of Illinois Press, 2009). In her Penguin Classic's reissue of Harriet Wilson's *Our Nig or, Sketches from the Life of a Free Black*, she and her co-editor "managed to pick up one of the coldest trails in 19th century African American studies." For her work with youth activ-

ists, she was named a Kellogg National Leadership Fellow. Until she joined the faculty at the University of Delaware as the Ned B. Allen Professor of English, she taught African American and American literature and culture as well as issues of social justice at Occidental College in Los Angeles. She is at work on a project titled "Disruptive Narratives: Harriet Wilson and the Politics of Place, Race, and Religion."

GINGER HILL is a doctoral candidate in visual studies at the University of California, Irvine, and is completing a dissertation titled "Speculative Portraits: Face, Race, and Authority in Circum-Atlantic Exchange." This study places portrayals of the face in British and North American portraits of men during the eighteenth and nineteenth centuries within the context of speculative finance capital and transatlantic slavery, thereby linking race and market society to discourses of civility and theories of progress. Through fellowships from the Robert H. Smith International Center for Jefferson Studies and Thomas T. and Elizabeth C. Tierney, she is currently researching illustrations of Benjamin Banneker's almanacs, Thomas Jefferson's gallery of worthies, and enslaved portraitists in South Carolina.

LEIGH RAIFORD is an associate professor of African American studies at the University of California, Berkeley. She is author of *Imprisoned in a Luminous Glare: Photography and the African American Freedom Struggle* (University of North Carolina Press, 2011), and co-editor with Renee Romano of *The Civil Rights Movement in American Memory* (University of Georgia Press, 2006).

AUGUSTA ROHRBACH is an associate professor of English at Washington State University and the editor of ESQ: *A Journal of the American Renaissance*. She is the author of *Truth Stranger than Fiction: Race, Realism, and the U.S. Literary Marketplace* (Palgrave, 2002), and she recently completed "Thinking Outside the Book," a study that uses the work of U.S. women writers to examine theories of the book and of literacy generally. Currently she is at work on "The Gallows's Diary of Mary Surratt, Presidential Assassin."

RAY SAPIRSTEIN is an assistant professor of history and documentary studies at the State University of New York, Albany, where he teaches nineteenth- and twentieth-century U.S. cultural history, visual studies, documentary photography, and documentary video production. Supported by a research fellowship at the Metropolitan Museum of Art, Ray is currently working on a manuscript exploring the photographer Walker Evans's commitment to photographing African American subjects.

SUZANNE SCHNEIDER holds a PhD in English from Duke University. Her primary research interests focus on the intersections of discourses surrounding race, sex, and gender in American literature and culture, both mainstream

and marginal. She has received predoctoral and dissertation Ford fellowships for her work and is currently ACLS New Faculty Postdoctoral Fellow at Bryn Mawr College.

SHAWN MICHELLE SMITH is an associate professor of visual and critical studies at the School of the Art Institute of Chicago. She is the author of *American Archives: Gender, Race, and Class in Visual Culture* (Princeton University Press, 1999) and *Photography on the Color Line: W. E. B. Du Bois, Race, and Visual Culture* (Duke University Press, 2004), and coauthor with Dora Apel of *Lynching Photographs* (University of California Press, 2007). She is also a visual artist and her photo-based artwork has been shown in a number of venues across the United States.

MAURICE O. WALLACE is an associate professor of English and African and African American studies at Duke University. Author of *Constructing the Black Masculine: Identity and Ideality in African American Men's Literature and Culture, 1775–1995*, he teaches African American literary and cultural theory, nineteenth-century American literature, gender studies, and visual culture. Wallace's essays have appeared in *American Literary History*, *African American Review*, *Journal of African American History*, and several critical anthologies.

LAURA WEXLER is a professor of American studies, women's, gender, and sexuality studies, and co-chair of the Women's Faculty Forum at Yale. She chaired the Women's, Gender, and Sexuality Studies Program from 2003 to 2007. She also holds an affiliation with the Film Studies Program and the Public Humanities Program, and she directs the Photographic Memory Workshop at Yale. From 2007 to 2010 she was a principal investigator of the Women, Religion, and Globalization Project, supported by a grant from the Henry R. Luce Foundation as well as a grant from the William and Betty MacMillan Center for International and Area Studies at Yale. She has published numerous articles, books, and journal special issues, all concerned with intersections of race, gender, class, sexuality, memory, and history in the production of visual culture in the United States from the nineteenth century to the present. Her book, *Tender Violence: Domestic Visions in an Age of U.S. Imperialism*, won the Joan Kelley Memorial Prize of the American Historical Association for the best book in women's history and/or feminist theory. Her work on Frederick Douglass and photography is part of an ongoing investigation into the visible — or invisible — past. Currently she is completing a monograph titled "The Awakening of Cultural Memory: Seeing Kate Chopin," which examines the role of the visual archive in the formation of contemporary American reading practices.

INDEX

Pages with illustrations are followed by *f*.

abject male body, 14
Adventures of Huckleberry Finn (Twain), 181, 201n41
Afghanistan war, 245
Agassiz, Elizabeth Cary, 229–30, 240n18
Agassiz, Louis, 4, 12–13, 56, 211–38; Desor affair of, 228–31, 237, 240n20; homosocial sphere of, 226–31; narrative of white male dominance of, 232–33; polygenesist project of, 212, 214, 220–22, 230, 231–38, 239n5, 241n29; pornographic photography of, 218, 220–26, 230–31, 236–38, 242n32; scientific cataloging techniques of, 221, 226; slave daguerrotypes of, 212–20, 230–31, 239n8; spectragraphia of, 233–38, 239n11
"The Age of Pictures" (Douglass), 5, 9, 41, 57–58
Aked, C. F., 303
albums. *See* photograph albums

Alexander, Elizabeth, 290–91
Allen, Sue, 336, 339
American Anti-Slavery Society, 48
American Colonization Society (ACS), 103
American Folklore Society, 169
American Negro Exhibit photographs, 206, 274–93, 294n7; as challenge to discourse of black criminality, 275–86, 295n19; as challenge to racial taxonomies, 286, 287f, 296n36; middle-class portraits in, 282–84; mug shots troped in, 278–86, 289–90; organization of, 275; photographers of, 275, 294n4; replication of misrepresentation with a difference in, 281–82
American School of Ethnology, 8–9, 44, 55, 230–31. *See also* Agassiz, Louis
Andrus, Caroline, 198n6
anekphrasis, 212, 233–34
Angelou, Maya, 201n38

antilynching images, 14, 291, 297n44, 299–318, 318n8. *See also* lynching

Appleton, William H., 336

"Ar'n't I a Woman?" (Truth), 83–85, 95–96; Gage's transcription of, 87–89, 91, 95, 97n3; public attention to, 89, 99n17; Robinson's transcription of, 98n13, 99n17; Truth's reprinting of, 87–88, 93, 95

Askew, Mary, 206

Askew, Thomas, 12–13, 275, 283f, 287f, 294n4; extant works of, 204; portrait of, 206, 207f; *Summit Avenue Ensemble* of, 204–9

Atlanta Exposition of 1895, 294n7

Atlanta's Great Fire of 1917, 204

Atlantic Monthly, 87

auctioned images, 14, 332–46

auditory media, 110

Aunt Hester (character), 114

Avedon, Richard, 31–32, 144

Baartman, Saartjie, 222–23, 240n14

Bache, Alexander Dallas, 228–29

Bacon, Alice Mabel, 182–83

Baer, Ulrich, 106–7

Baker, Houston, 169, 198n5

Bal, Mieke, 225, 231, 236, 244

Ball, J. P., 14, 321–28, 328n1; clemency activism of, 325–26; execution photographs by, 323–26, 327f; portraits by, 321, 322f; postmortem photograph by, 326–28, 328n7

Ball, Thomas, 323

Ball and Thomas Photographic Art Gallery, 323

Bancroft, Frederic, 329

Banta, Melissa, 239n9

Barnett, Ferdinand, 304

Barnum, P. T., 253, 264n26

Barrett, Lindon, 109–10

Barthelemy, Anthony, 142

Barthes, Roland, 19–20; on combining image with text, 308; on the power of the photographic image, 90, 99n24, 106, 189–90; on the punctum of an image, 339–40, 348n26; on slavery, 30–32, 144; on submission to photography, 29–32; on traces of the subject, 326

Battey, Cornelius, 35f, 272n2

Baudrillard, Jean, 86, 237

Bederman, Gail, 315

Bedou, A. P., 13; crowd picture of, 269–72; photograph of Booker T. Washington by, 267–69, 272n2; self-portrait of, 269, 270f

Bell, Charles Milton, 35f

Benjamin, Walter, 1; on aesthetics of war, 244–45, 247, 262n2; on repetition, 130n15; on reproducible photography, 208

Bennett, Lerone, 148

Berlant, Lauren, 119, 131n31, 133, 136–39, 262n4

Berlin, Ira, 246

Bertillon, Alphonse, 280f

Best, Stephen, 129n5

Beyond the Battle Field (Blight), 246

Bhabha, Homi K., 319n19

Biggerstaff, William, 321–28, 328n2, 328n7

biracialism (as term), 158, 165n109. *See also* mulatta/o

Bishop, Henry, 131n30

"Black Bodies, White Science" (Wallis), 239n8, 242n32

Black Culture and Black Consciousness (Levine), 183

black males. *See* masculinity/manhood

The Black Military Experience (Berlin), 246

Black Skin, White Masks (Fanon), 307–8

Black Soldiers in Blue (Smith), 246

black soldiers of the Civil War: arming of, 19, 23–24; before and after images

of, 252–54, 257–59, 264nn19, 21,
266n46; cartes de visite of, 251–52;
conscription of, 259, 266nn47–48; in
contraband camps, 255–57; exploita-
tion of, 258–59; legal status of, 255;
photographs of, 244–62; in the re-
organized U.S. Army of 1866, 247; as
would-be citizens in, 245, 247; writ-
ten accounts of, 246, 262n6. *See also*
Civil War; masculinity/manhood
Black Union Soldiers in the Civil War
(Hargrove), 246
Blessed Art Thou Among Women
(Kasebier), 201n40
Blight, David W., 246
Blockson, Charles, 344
Boas, Franz, 198n6
"The Body and the Archive" (Sekula),
283–84, 301–2
Bookman magazine, 175
Boucicault, Dion, 147–49, 151, 163n75
Bourdieu, Pierre, 329, 331
"Boy Time" (Dunbar), 200n22
Brady, Mathew, 36–37, 48
Braude, Anne, 165n98
Braxton, Joanne, 199n11
Brer Rabbit, 183
Brewer, Mason, 183
Briggs, Laura, 239n11
Brody, Jennifer DeVere, 134, 148, 152,
163n75
Bromfield Corey (character), 248–49
Brown, John, 11, 22–23, 81nn96,99;
Douglass on, 65–67, 81n99; Du Bois
on, 105, 107, 108n12; raids and exe-
cution of, 105–6, 108n12; A. Wash-
ington's portrait of, 101–7
Brown, William Wells, 115, 149,
163n76, 245
Buffalo Pan-American Exposition of
1901, 206
Burgett, Bruce, 112, 129n11, 131n28
Burgin, Victor, 244, 252, 257–58

Butler, Judith, 111–12
Byrnes, Thomas, 281, 284, 285*f*
Byron, George Gordon, Lord, 163n68

cabinet cards, 81n101, 208
"A Cabin Tale" (Dunbar), 196*f*
Cadava, Eduardo, 106
Calhoun, John, 36–37
Calloway, Thomas J., 275
Callum, Agness Kane, 262n6
Camera Lucida (Barthes), 19–20, 29–32,
144
camera obscura, 109, 110–11, 121–26,
129n2, 131n29
Camera obscura from *Ars magna lucis et
umbrae* (Kircher), 122*f*
Campfires of Freedom (Wilson), 246
Candle Lightin' Time (Dunbar and
Hampton Camera Club), 174, 197n1
Carby, Hazel, 111–12, 130n16, 159n5
cartes de visite, 3–4, 13, 330, 335, 346n3;
of black soldiers, 251–52; copyright
conventions on, 90, 99n20; Doug-
lass's portrait on, 67, 68*f*; of So-
journer Truth, 83–84, 88–90, 99n20
Casby, William, 31–32, 144
Cassie (character), 139
Castronovo, Russ, 133–34, 136, 144
Chaney, Michael, 11–12, 78n60
Charleston South Carolina Interstate
and West Indian Exposition, 206
Chenery, William H., 262n6
chiasmus tropes, 251–54, 259–62
Chicago World's Columbian Exposi-
tion, 304, 309–10
Child, Lydia Maria, 149
Christian, Barbara, 133, 159n5
"The Christmas Basket" (Dunbar), 185*f*
citizenship: and black Civil War sol-
diers, 245; gendering of, 131n31;
public standing in, 42, 73n7; racial
assumptions in, 47, 49–50; self-
sovereignty/autonomy in, 46, 48–54

"Civilization: It's Dependence on Physical Circumstances" (Smith), 9

Civil War: arming of black troops in, 19, 23–24; beginning of, 64–65; black women's work in, 257, 258; contraband camps of, 255–57; ending of, 25–29, 247; establishment of black communities during, 179; Northern industrial interests in, 250; portraiture of, 13; rebellious slaves during, 251; role of photography in, 244–62, 262n4. *See also* black soldiers of the Civil War

Clay, Henry, 36–37

Clotel (W. Brown), 139

Coker, Philip, 103, 104*f*

Colonial Desire (Young), 286

"The Coming of John" (Du Bois), 278

The Condition, Elevation, Emigration, and Destiny of the Colored People of the United States, Politically Considered (Delaney), 9

Connerton, Paul, 263n9

contraband camps, 255–57

Cook, Bridget, 142

A Coon Alphabet (Kemble), 181

"A Coquette Conquered" (Dunbar), 175

Cotton States International Exposition, 294n7

Craft, Ellen, 134–36, 160n17; photographic identity of, 154–55; willed blackness of, 149–53, 163n70, 163nn75–76, 164n82

Craft, William, 135, 149–53, 163n70, 163n76, 164n82

craniometry, 55

Crary, Jonathan, 121, 125, 127, 131n29, 226

criminality discourses: black males in, 13–14, 259–60, 261*f*, 266n50, 274–78, 325; in contemporary images, 292–93; Du Bois's photographic challenges of, 275–86, 289–90, 295n19; on outward signs of, 280–81, 284–86

criticism, 6–7, 29–32

cultural work of photography, 1–5, 9–15; aestheticization of war in, 244–45, 262n4; in Bedou's use of crowd perspectives, 269–72; of the Civil War, 244–62; democratizing promise of, 3–4, 6, 21–22, 248–54; the productive look in, 293; shadow archives in, 300–302, 314–18

Curtis, Thomas B., 229

Cuvier, George, 223, 227

Daguerre, Louis Jacques Mandé, 5–6, 21, 28, 45–46, 52, 74n17, 346n1

Davis, Charles Henry, 228–29

Davis, Cynthia J., 239n6

Davis, Jefferson, 22

Davis, John, 145, 146

Day, F. Holland, 202n51

Day, Victor, 323, 327*f*

DeCosta-Willis, Miriam, 313

Delaney, Lucy, 134

Delaney, Martin, 9

DeLoria, Ella, 198n6

Desor, Edward, 228–31, 237, 240n20

"De Way T'ings Come" (Dunbar), 189, 190*f*

Diawara, Manthia, 310

Discipline and Punish (Foucault), 290

Disdéri, André Adolphe, 346n3

Doane, Mary Ann, 116, 287

Doty, Alexander, 227

Douglass, Ann, 129n14

Douglass, Anna, 48

Douglass, Annie, 66

Douglass, Frederick, 4; on abuse of slaves, 114, 266n50; Anacostia home of, 50–51, 76n39; autobiographies of, 50–51, 76n37, 253–54; biographical writing on, 7, 254; on

black soldiers, 245; on the Chicago World's Columbian Exposition, 304; on criticism, 6–7; on Louis Daguerre, 28, 45–46, 52, 74n17; as Dunbar's mentor, 181, 194; emancipation of, 48; escape and exile of, 65–66, 82n103; in family portraits, 75n27; Garrison's introduction of, 253–54; on habits of viewing and imagination, 24, 43, 59–72, 74n10, 79n78, 80n85, 80n89, 82n106; on human interiority, 41–45; lectures on photography of, 5–9, 10, 19–20, 41–45, 74n15; library of, 79n63; on objecthood of picture subjects, 53–54; portraits of, 10, 18, 32–36, 41–54, 67–69, 74–75nn20–21, 75n27, 76nn32–33, 77n43, 77n45, 81n103, 323; on progress, 73n5; as *Revenant* subject, 10, 14, 19–20, 24, 33–37, 40n53, 40n58; self-representation of, 42–43, 47–48, 53–54, 71; on thought pictures, 24, 44, 54–58, 60–64, 78n55, 79n78, 80n85, 80n89, 82n106; on viewing pictures, 43, 54–58; as visual theorist, 10, 15, 16n18, 18–37, 41–45, 70–72, 78n60, 251–52. *See also* "Pictures and Progress"

Doyle, Mary Ellen, 164n78

Du Bois, W. E. B., 4, 8, 237, 274–93; American Negro Exhibit in Paris of, 205*f*, 206, 207*f*, 274–93; on John Brown, 105, 107, 108n12; challenging of racial taxonomies by, 275, 286–92, 296n36; on the color line, 275, 294n8; on double consciousness, 8–9, 184, 274–76, 284–86; on emancipation, 2–3; on social and economic equality, 277–78, 292, 295n19; "The Souls of White Folk" of, 211–13; strategies of racial progress of, 13–14

duCille, Ann, 133, 135, 159n5, 288–89

Dunbar, Alice, 174, 175–77, 199n13, 200n19

Dunbar, Matilda, 174

Dunbar, Paul Laurence, 4, 12, 167–69, 194–97; on African American identity, 171; association with Hampton Institute of, 174–75; critique of racial hierarchies of, 169; dialect poetry of, 168–69, 172–73, 176–77, 181; Kemble's illustrations of works of, 181–82; letters and papers of, 200n21, 200n24; on masking, 170–71, 186–96, 198n7, 202n52; portraits of, 175; published works of, 174, 177, 180–82, 200n22

Dunbar/Hampton Camera Club photo-texts, 167–97, 197n1; camouflaged counterhegemonic content of, 170–73, 183–86; creation of images for, 179–80; earnings of, 177; as social documentary, 187–89; subjects' complicity in, 186–97, 198–99nn7–8; symbolic domestic thresholds in, 171, 179–80, 184–86, 188, 194, 201n38, 201n40; trickster figures in, 183–84

Dundes, Alan, 183

A Durable Memento: Portraits by Augustus Washington, African American Daguerreotypist (Shumard), 107n1

Dyer, Richard, 80n80, 291

Dyer, William B., 175

Eaton, John, Jr., 256

Elder, Arlene, 159n5

Elegua, 186

Ellison, Ralph, 198n5, 201n42

Emancipation Proclamation, 2–3, 86–89, 247–48

Emerson, Ralph Waldo, 231

Emilio, Luis F., 262n6

Emmeline (character), 141, 161n40

"Encouragement" (Dunbar), 194, 195*f*

Esu (trickster), 186

family Bibles, 336–38, 344–45, 347n19, 348n30
family portraits, 8, 75n27, 148, 163n73, 165n102, 313–16. *See also* photograph albums
Fanon, Frantz, 8, 163n75, 307–8
"Farewell Speech to the British People" (Douglass), 266n50
Fathering the Nation: American Genealogies of Slavery and Freedom (Castronovo), 133–34, 136, 144
Finley, Cheryl, 14
First South Carolina Volunteers, 258–59
fixity, 310, 319n19
Folk Beliefs of the Southern Negro (Puckett), 183
Folks from Dixie (Dunbar), 181
Foreman, P. Gabrielle, 11, 12
Forged in Battle (Glatthaar), 246
Fortune, T. Thomas, 313
Forty-fourth U.S. Colored Troops Infantry, 251, 252f, 255, 260–61, 265n34
Foster, Frances Smith, 133, 157, 159n5
Foucault, Michel: on embodiment of power, 290; on the panopticon, 111; on process of reform, 73n5; on repression, 298n45; on systematic blindness, 232
Fourth U.S. Colored Troops, 259, 260f
Fox, Charles B., 262n6
framing, 13, 307, 310, 319n19
Frasier, E. Franklin, 209
Freedom: A Documentary History of Emancipation (Berlin), 246
fugitives: advertisements for, 145–48; fugitivity of, 47–48, 50, 53–54, 75n22, 75n25, 76n36
Fugitive Slave Law of 1850, 103, 149, 255
Fusco, Coco, 1, 311

Gage, Frances Dana, 87–88, 89, 91, 95, 97n3
Gallery of Illustrious Americans (Brady), 36–37
Garie, Emily, 151
The Garies and Their Friends (Webb), 151
Garrison, William Lloyd, 48, 149, 253–54
Gates, Henry Louis, Jr., 16n18, 100n30; on Douglass, 7–8, 251; on signifyin(g), 275, 278–80, 282, 295n21, 295n25
Gay, William, 321–25, 328n2
gendering: of American citizenship, 131n31; of mulatta genealogies, 132–39, 144, 146, 157–59, 162n50; of slave abuse, 114–21; of slave escape, 124–25, 126–27
genealogies of black motherhood, 132–39, 144, 146, 157–59, 162n50
Gibbes, Robert W., 239n9
Gilbert, Olive, 83, 86, 94–95
Gilman, Sander, 222
Gladstone, William, 246, 266n48
Glatthaar, Joseph T., 246
Gliddon, George Robert, 56
Goldberg, Vicki, 340
Goldsby, Jacqueline, 325, 328n2, 328n7
Gordon, Private, 258, 266n46
Gourdin, John Raymond, 262n6
A Grand Army of Black Men (Redkey), 246
Great Daguerrean Gallery of the West, 323
Green, Nancy, 304

habeas corpus, 318n8
Hahn, Steven, 246, 251
Hall, Stuart, 8
Hampton Institute, 169–70; advocacy of African American cultural identity of, 171, 182–83; Folklore Society of, 169–70, 181–83, 198nn5–6; fund-

raising of, 174–75; *Southern Workman* magazine of, 170, 174, 181, 182–83, 198n6, 199n13

Hampton Institute Camera Club, 12, 167–69, 174, 197n1, 198nn5–6; Dunbar's association with, 174–75; members of, 169, 179, 182; opposition to racial hierarchies of, 169; response to Kemble by, 181–82. *See also* Dunbar/Hampton Camera Club photo-texts

Hansen, Christian, 225

Harding, William W., 336

Hard to Imagine (Waugh), 214

Hargrove, Hondon, 246

Harlem Renaissance, 16n9

Harper, Frances E. W., 134, 136, 138, 148

Harris, Joel Chandler, 183

Harris, Michael, 15n7

Hartman, Saidiya, 110, 137, 160n17

"Heads of the Colored People" (Smith), 9

Hegel, G. W. F., 7

Heinz, Henisch K., 330, 335, 336

Hemings, Sally, 165n108

Higginson, Thomas Wentworth, 149, 262n6

Hill, Anita, 136, 137

Hill, Ginger, 10

Holmes, Oliver Wendell, 231, 311

"Home, Sweet Home," 125–26, 131n30

Homer, Winslow, 81n96

Hood, John Bell, 260–61

hooks, bell, 276, 284, 292–93

Hopkins, Pauline, 134

Hoss, Fred, 323

Hottentot Venus (Saartjie Baartman), 222, 223, 240n14

Howdy Honey, Howdy (Dunbar and Hampton Camera Club), 190f, 194, 195f, 197n1

Howells, William Dean, 181, 248–50

Hudgins, Hannah, 160n16

Hughes, Langston, 169

Humboldt, Alexander von, 227–28

Hume, David, 7

Hunt, Lynn, 46, 47

"A Hunting Song" (Dunbar), 182

Hurn, J. W., 67, 68f, 81n103

Hurston, Zora Neale, 8, 171, 198n6

Identification anthropométrique, instructions signalétiques (Bertillon), 280f

I Know Why the Caged Bird Sings (Angelou), 201n38

Incidents in the Life of a Slave Girl (Jacobs), 11–12; abuse of slaves in, 113–21, 130n16; camera obscura of the garret in, 109, 110–11, 121–28, 129nn1–2, 131n28; denunciation of sentimentalism in, 111–13, 125–28, 129n11, 129n14; mulatta relations in, 116–18, 123–24, 128, 136–39; narrator of, 109, 110–12, 114–16, 121–28, 129n1; politics of color in, 136–39; themes of visuality and embodiment in, 109–11; white master class in, 118–21. *See also* Linda Brent

incorporative practices, 263n9

indexicality of the photograph, 11, 311

Indian Wars, 247

"In Our Glory: Photography and Black Life" (hooks), 276

inscriptive practices, 263n9

In the Break: The Aesthetics of the Black Radical Tradition (Moten), 201n42

Invisible Man (Ellison), 198n5, 201n42

Iola Leroy (Harper), 137, 138–39, 147, 163n73

Iraq wars, 245, 262n2

Jackson, Andrew, 180

Jackson, Bruce, 183

Jacobs, Harriet, 4, 11–12, 133–34; on acts of looking as ideological, 112–

Jacobs, Harriet (*continued*)
13, 130n15; Berlant on, 136–39; parentage of, 138. See also *Incidents in the Life of a Slave Girl*
Janus, 185–86
Jay, Martin, 240n17
Jefferson, Thomas, 165n108
Joggin' Erlong (Dunbar and Hampton Camera Club), 196*f*, 197n1
"John Brown's Body," 105
Johnson, James Weldon, 168–69, 189
Johnson, William. *See* Craft, Ellen
Johnston, Frances Benjamin, 170, 174
Jones, William, 198n6
Julien, Isaac, 291
Jurgens, Henry, 323, 327*f*

Kant, Immanuel, 7
Kasebier, Gertrude, 201n40
Kawash, Samira, 47, 54, 71, 75n22
Kemble, Edward Windsor, 181–82
Kiquotan Kamera Klub. *See* Hampton Institute Camera Club
Kircher, Athansias, 122*f*

Leaves of Grass (Whitman), 192
"Lecture on Pictures" (Douglass), 5, 9
Lee, Maurice, 57
Lee, Robert E., 247
Legba, 186
Lester, C. Edwards, 37
Levine, Lawrence, 183
Liberia, 103–5
"The Libyan Sibyl" (Stowe), 86–89, 91, 92–93, 95, 97n3, 99n29
Life, Letters, and Works of Louis Agassiz (Marcou), 240n18
Life and Times of Frederick Douglass (Douglass), 50–51
The Life of P. T. Barnum, Written by Himself (Barnum), 253
"Life Pictures" (Douglass), 5, 9, 41
Like Men of War (Trudeau), 246

L'il Gal (Dunbar and Hampton Camera Club), 178*f*, 197n1
Lincoln, Abraham: on arming of black troops, 19, 23–24; Emancipation Proclamation of, 86–89, 247–48; first inaugural address of, 10, 22–24; photographic portraits of, 33, 48, 51–52, 76n41; reelection of, 25–26; second inaugural address of, 27–28, 37
Lind, Jenny, 131n30, 323
Linda Brent (character), 109, 110–12, 114–16; Berlant on, 136–39; escape plans of, 118–19, 123–24, 127; garret of, 110–11, 121–28, 129nn1–2; grandmother of, 117–18; as mulatta, 138; spectatorship of, 119–21
Lindsay, Thomas, 259–60, 261*f*
London Ethnographic Society, 224–25
London's Great Exhibition of 1851, 163n76
Longfellow, Henry Wadsworth, 231
Looby, Christopher, 258–59
Lopez, Ian Haney, 160n16
Lott, Eric, 291
Louisa Picquet, the Octoroon (Mattison), 136, 139–49; frontispiece engraving of, 140–44, 154; physical description of, 145–48, 150, 155
Love Lyrics (Riley), 175
Lowell, John Amory, 229
Lubiano, Wahneema, 239n11
Lurie, Edward, 240n18
Lutie Johnson (character), 165n106
lynching, 14, 209, 274–78; as embodied white power, 289–90, 297n42, 307–8; gendered contexts of, 309; NAACP campaigns against, 291, 297n44; newspaper accounts of, 303; photographs of, 290–92, 297n44, 300, 303–10, 317–18, 318n8, 324–26; Ida B. Wells's reframing of, 299–318; white spectators at, 301, 306–7, 318

"Lynch Law" (Wells), 299, 304–5
Lyrics of Lowly Life (Dunbar), 180–81

Macpherson, C. B., 46, 324
"Mama's Baby, Papa's Maybe: An American Grammar Book" (Spillers), 133
Marching Band (Askew), 207f, 208
Marching toward Freedom (McPherson), 246
Marcou, Jules, 231–32, 240n18
Martin, James, 255
Martin, W. R., 305f, 306–7
masculinity/manhood, 12–13; in Agassiz's ethnopornographies, 218, 220–26, 231–38, 242n32; of Askew and his sons, 204–9; in Bedou's photographs, 270f, 271–72; in Civil War portraiture, 13, 247–62; criminalization and, 13–14, 259–60, 261f, 266n50, 274–75, 295n19; faulty fatherhood discourses and, 208–9; in lynching scenarios, 14, 209; surveillance strategies and, 225–31
Mason, Herman "Skip," Jr., 204
Mattison, Hiram, 139–49, 160n17; description of Louisa Picquet by, 145–48, 150, 155; on photography as testimony, 154–56; *Spirit Rapping Unveiled!* of, 155–56. See also *Louisa Picquet, the Octoroon*
Mavor, Carol, 328n8
Mazeppa (Byron), 163n68
McCaskill, Barbara, 140, 148
McClellan, George V., 25
McCune Smith, James, 9
McDowell, Deborah, 318
McFeely, William, 65, 254
McPherson, James, 246
Memphis Diary (Wells), 313
Men of Color (Gladstone), 246
Mercer, Kobena, 291
Merleau-Ponty, Maurice, 44; on the imaginary, 80n85, 80n88; on phenomenology, 60–64; on viewing flesh, 226, 240n17
Miller, Hugh, 79n63
Miller, Samuel L., 48, 49f
Miner, Leigh Richmond, 177, 178f, 185f, 190f, 196f, 197n1, 202n51
Mirzoeff, Nicholas, 3
Mitchell, W. J. T., 251
modern identity, 197, 203n53
Morrison, Toni, 212
Morse, A. S., 252, 264n22
Morton, H. J., 156
Morton, Samuel George, 9, 56
Moss, Betty, 300, 315–17
Moss, Maurine, 300, 315–17
Moss, Thomas, Jr., 300, 315–17
Moss, Tom, 300, 315
Moten, Fred, 110, 201n42, 269
Moton, Robert Russa, 182, 198n5
Moynihan, Daniel, 209
mulatta/o, 110; definition of, 158–59, 165nn106–9, 288; Ellen Craft's willed blackness as, 149–53, 163nn75–76; Du Bois's visual reflections on, 286–92, 296n38; Jacob's Linda Brent as, 116–18, 123–24, 128, 136–39; maternal genealogies of, 132–39, 144, 146; multiple meanings of, 135–36, 286–92, 298n45; passing of, 153–57; photography of, 154–57; physical descriptions of, 144–48; Louisa Picquet as, 139–44; self-referencing of, 287–88; sexual vulnerability implied in, 139–44, 289. *See also* passing
Mullen, Harryette, 135
Murray, Albert, 158
music and song, 110
Mussey, Reuben D., 13, 256–58, 259, 264n21
My Bondage and My Freedom (Douglass), 50, 253

NAACP, 180, 291, 297n44
Narrative of Sojourner Truth (Truth),
 83–86; "Ar'n't I a Woman?" speech
 in, 87–88, 93, 95; "Autographs of
 Distinguished Persons" in, 94;
 "Book of Life" in, 93–96; 1875 edi-
 tion of, 90–95; ending of, 100n33;
 fractured authorship of, 96, 100n30;
 frontispiece portraits of, 84–85,
 90–92, 93, 95–96, 97n2, 99n26;
 principle of orality in, 85–86, 93–95,
 98nn4–5, 99n27; publication history
 of, 93–94; Stowe's article in, 92–93,
 95, 99n29; title page of, 92
Narrative of the Life of Frederick Douglass
 (Douglass), 50, 254
Narrative of William W. Brown (Brown),
 115
Native Son (Wright), 201n42
Needham, Catherine, 225
*The Negro Family: The Case for National
 Action* (Moynihan), 209
The Negro Family in the United States
 (Frasier), 209
The Negro in the Civil War (Quarles),
 246
Negro Life in Georgia, U.S.A. (Du Bois),
 205f, 206, 207f, 275
The Negro's Civil War (McPherson), 246
Nelson, Dana, 230
A New Negro for a New Century (B. T.
 Washington), 186
Nichols, Bill, 225
"Noddin' By the Fire" (Dunbar), 196f
Norcom, James, 145
*Notes on Negro Crime, Particularly in
 Georgia* (Du Bois), 277
Nott, Josiah Clark, 9, 56

The Octoroon (Boucicault), 147–49, 153
The Official Records of the War of Rebellion,
 262n5
Okwui, Enwezor, 144

"The Old Cabin" (Dunbar), 189, 190f
Olivier, Sidney, 277
Ong, Walter, 85, 98nn4–5
On Photography (Sontag), 199n8
Operators, 29–30
oral history, 85–86, 93–95, 98nn4–5,
 99n27, 344
origins of photography, 1–3
Our Nig (Wilson), 100n3, 165n106
"Out from Behind the Mask" (Whit-
 man), 192–93, 202n48

Painter, Nell, 90, 96, 97n2, 99n26, 251
Paley, William, 79n63
Paradis, James M., 262n6
Paris Exposition of 1900, 13–14, 174,
 206, 274–93, 294n7
Parker, Freddie, 146
Parsons, Elsie Clews, 183
passing, 12, 132–36, 153–57; Berlant's
 mulatta genealogies of, 133, 136–39;
 of Ellen Craft, 148–53; as perceived
 racial threat, 156–57, 281, 286–92;
 photography in, 154–57; semi-
 otics/signs of, 134–35, 281. *See also*
 mulatta/o
Patterson, Orlando, 40n53, 247
Payne, John, 131n30
Peabody Museum, Harvard, 214, 215–
 19f
Penn, Irvine Garland, 304
Peterson, Carla, 133, 142, 159n5
phenomenology, 60–64, 79n78
"The Photograph" (Dunbar), 175–77,
 178f, 188
photograph albums, 347n5; captur-
 ing of everyday life in, 330; 1870s
 example of, 332–46, 347n14, 347–
 48nn19–20, 348n29; rites of passage
 in, 330–31; significance of, 336–37;
 stiff poses in, 342–44; as visual nar-
 ratives, 331–32, 336–37, 344
photography. *See* cultural work of

photography; political work of photography; portraiture

phrenology, 55, 57, 220–21

Picquet, Louisa, 4, 134–36, 139–49, 160n17; engraving of, 140–44; Mattison's description of, 145–48, 150, 155; name of, 144, 162n50; photographic identity of, 154, 164n84; purchase of mother by, 142–43, 153

"Pictures and Progress" (Douglass), 5–6, 9, 19–29, 36–37, 41; on John Brown, 65–67; contemporary reviews of, 25, 43–45, 80n79; on habits of viewing and imagination, 43, 59–65, 74n10, 80n85, 80n89, 82n106; humanizing vision of photography in, 22–25, 55; on moving on from the Civil War, 27–29; on pictures as commodities, 52–54; and *Revenant* subjects, 14, 19–20, 24, 40n53; revised version of, 25–27, 37, 80n79; on thought pictures, 24, 44, 54–58, 60–64, 69–72, 78n55, 79n78; on truth and self-understanding, 69–72

Plato's cave, 185

Poems of Cabin and Field (Dunbar and Hampton Camera Club), 167–68, 174, 182, 197–98nn1–2

"The Poet" (Dunbar), 168–69

political work of photography, 103–5, 245, 313–16, 315–18. *See also* Civil War

polygenesis, 55, 57, 213–14, 220–25, 230–38, 239n5, 241n29

pornography, 218, 222–25, 231–38, 242n32

Porter, Ray, 299, 305–7, 308

portraiture, 7; by Askew, 204–9; of black soldiers, 247–48, 250–62, 264n19; of Brown, 101–7; for cartes de visite, 13, 330; as commercial transactions, 52–54; of Douglass, 10,

18, 32–36, 41–54, 67–69, 74–75nn20–21, 75n27, 76nn32–33, 77n43, 77n45, 81n103; in Du Bois's *Types of American Negroes*, 282–84; of Dunbar, 175; of families, 8, 75n27, 148, 163n73, 165n102, 313–16; of Lincoln, 33, 48, 51–52, 76n41; with political intentions, 315–18; Sekula on, 301–2; social identity through, 329–44; of Truth, 11, 75n21; as visual affirmations of humanity, 45–54; Wells's use of, 299, 300–301, 310–15. *See also* photograph albums

possessive individualism, 46

Powell, Colin, 245

Powell, Richard, 17n24

practice of photography. *See* cultural work of photography

Professional Criminals of America (Byrnes), 281, 284, 285f

Progressive era, 187–94. *See also* Dunbar/Hampton Camera Club phototexts

Prown, Jules David, 331–32, 346

Pryor, Hubbard, 13, 251–52; before and after images of, 252–54, 257–59, 264n19, 264n21; capture and imprisonment of, 260–62; enlistment and service of, 254–55, 259, 265n34

Puckett, Newbell Niles, 183

Quarles, Benjamin, 246

"The Queen of America Goes to Washington City" (Berlant), 136–39

Race and Reunion (Blight), 246

race science. *See* scientific racism

racial identity, 2–3; in citizenship contexts, 47, 49–50; current terminology of, 158–59, 165n106; of Dunbar's photo-text subjects, 186–97; as embodied, 109–10; in family por-

racial identity (*continued*)
traits, 8, 148; habits of viewing in, 43, 59–65; in mulatta genealogies, 132–44, 146, 148–54, 157–59, 162n50; in passing, 12, 132–36, 153–57; in slave contexts, 47–48, 135–36, 148; of Sojourner Truth, 96–97; taxonomies of, 286–92, 296n36; vernacular traditions in, 168–69; visual determinacy of, 12, 311; whiteness as, 61–64, 80n79, 291–92. *See also* mulatta/o

Raiford, Leigh, 14

Ramsey, Elizabeth, 140, 142–43

Randall, Croydon Chankler, 89

Randall, James J., 89

Reading American Photographs (Trachtenberg), 37

The Reason Why the Colored American Is Not in the World's Columbian Exposition (Wells, Douglass, Penn, Garnett), 304, 309–10

Reconstruction era, 186, 196–97, 201n41, 245, 247

Redkey, Edwin S., 246

A Red Record (Wells), 299–300, 304–5, 308

"Representations of Whiteness in the Black Imagination" (hooks), 284

resistant spectatorship, 310

the *Revenant* subject, 10, 14, 19–20, 24; definition of, 33; Douglass as, 33–37, 40n53, 40n58

Riley, James Whitcomb, 175, 191–92, 198n7

The Rise of Silas Lapham (Howells), 248–50

Robertson, Agnes, 149

Robinson, Amy, 153, 155, 164n91

Robinson, Marius, 98n13, 99n17

rogues' galleries, 280–81, 283–86

Rohrbach, Augusta, 11

Roosevelt, Theodore, 200n22

Running a Thousand Miles for Freedom (Craft), 136, 149–54

Russell, Edward, 303

Sapirstein, Ray, 11, 12

Schechter, Patricia, 317

Schneider, Suzanne, 12–13

scientific racism, 3–4, 8–9, 44, 56–57; Douglass's repudiation of, 57–58, 70–72; Du Bois's visual reflections on, 286–92; polygenesis of, 55, 57, 213, 214, 220–25; primacy of literacy in, 56, 78n53, 78n58; spectragraphia of, 233–38. *See also* Agassiz, Louis

Scottish realism, 57, 79n63

Sekula, Allan, 1, 15n7, 222, 230, 283–84; on the cultural work of photography, 249–50; on shadow archives, 300, 301–2

self-representation, 5, 8–9, 42; of Douglass, 10, 33–37, 42–43, 47–48, 71; of mulatto-ness, 287–88; of Picquet, 144; of political leaders, 103–5; in shadow archives, 300–302, 314–18; of Truth, 11, 75n21, 83–84, 95–97

Sensational Designs: The Cultural Work of American Fiction (Tompkins), 129n14

Sherman, Cindy, 279–80

Shumard, Ann M., 107n1

signifyin(g), 275, 278–80, 282, 295n21, 295n25

signs of blackness, 281

Silas Lapham (character), 248–50

Silverman, Kaja, 293

Simpson, Lorna, 295n21

Slavery and Social Death (Patterson), 247

slaves/slavery, 11–12; abolition of, 260; abuse and torture of, 113–21, 130n16, 266n50; auctions of, 334; commodified bodies in, 116–18; conceptual challenges of, 45; contraband camps of, 255–57; as fugitives, 47–48, 50,

53–54, 75n22, 75n25, 76n36, 145–48;
physical descriptions of, 145–48;
racialization of, 47–48, 135–36, 148;
and social death, 30–37, 40n53,
40n58; status of husbands under,
209; transformation into criminals
of, 259–60, 261f, 266n50, 274–75,
276; Truth's iconography of, 84–85,
92, 97n3
Smith, Adam, 52, 77n44
Smith, John David, 246
Smith, Shawn Michelle, 11–14, 147,
156–57, 300–301
Smith, Sidonie, 122
"Sojourner Truth: The Libyan Sibyl"
(Stowe), 86–89, 91, 92–93, 95, 97n3,
99n29
Sollors, Werner, 203n53
Sontag, Susan, 1, 199n8
The Souls of Black Folk (Du Bois): on
double-consciousness, 274; on social
and economic equality, 277–78, 292
"The Souls of White Folk" (Du Bois),
211–13
Southern Horrors (Wells), 303
Southern Workman magazine, 170, 174,
181, 182, 198n6, 199n13
Spanish-American War, 247
Spectators, 29–30
spectragraphia, 233–34, 239n11
Spectrum, 30–31
Spillers, Hortense, 133, 159n4, 159n6,
287–88
spirit rapping, 165n94, 165n98
Spirit Rapping Unveiled! (Mattison),
155–56
Stauffer, John, 41
Stealing a Little Freedom (Parker), 146
Stewart, Dugald, 79n63
Stieglitz, Alfred, 175
Still, William, 149, 151
Stoler, Ann Laura, 232

Storer, D. Humphreys, 229
Story, William Wetmore, 87
Stowe, Harriet Beecher: "The Libyan
Sibyl," 86–89, 91, 92–93, 95, 97n3,
98n9, 98n11, 99n29; *Uncle Tom's
Cabin*, 139, 140, 149, 161n40, 180
Stratton, Charles Sherwood, 264n26
Street, Brian, 157
The Street (Johnson), 165n106
Stripes but No Stars (Lindsay), 259–60,
261f
subjects of photography: agency of, 15,
17n24; in antilynching campaigns,
310–15; in Dunbar/Hampton Cam-
era Club photo-texts, 186–94; as
Revenant subjects, 10, 14, 19–20, 24,
33–37, 40n53, 40n58
The Summit Avenue Ensemble (Askew),
204–9
Sundquist, Eric, 133
"Sympathy" (Dunbar), 201n38, 202n52

Taft, William, 337
Tagg, John, 230, 311, 329, 330, 343
Tate, Claudia, 135, 202n50
Taylor, Susie King, 245, 262n6
Their Eyes Were Watching God (Hurston),
165n106
Thirteenth Amendment to the U.S.
Constitution, 260
Thomas, Alexander, 323
Thomas, Clarence, 137
Thompson, George, 163n76
thought pictures, 24, 44, 54–58, 60–64,
78n55, 79n78, 80n85, 80n89, 82n106
The Threshold of the Visible World (Silver-
man), 293
tintypes, 334–35, 347n12
Titus, Frances, 92–93, 99n14
Tompkins, Jane, 129n14
Tom Thumb, 253, 264n26
Tourgee, Albion W., 308, 309f

To Wake the Nations: Race in the Making of American Literature (Sundquist), 133

Trachtenberg, Alan, 1, 37, 242n32; on Agassiz's slave daguerrotypes, 234–36, 238, 242nn37–38; on the language of photography, 154; on photograph albums, 330

trickster figures, 183, 186

Trudeau, Noah, 246

Truth, Sojourner, 4, 10–11, 28, 83–97; "Ar'n't I a Woman?" speech of, 83–85, 87–89, 93, 95–96, 98n13, 99n17; authors' representations of, 86–89, 92–93, 98n9, 98n11; cartes de visite of, 83–84, 88–90, 99n20; frontispiece portraits of, 84–85, 90–92, 93, 95–96, 97n2, 99n26; "I Sell the Shadow . . ." slogan of, 89*f*, 90, 93, 96; memorial to, 99n14; *Narrative* of, 83–86, 90–95; oral culture of, 85–86, 93–95, 98nn4–5, 99n27; racial attitudes of, 96–97, 100n33; visual self-fashioning of, 11, 75n21, 83–84, 95–97

Turner, Nat, 123

Tuskegee Institute, 182, 198n5

Twain, Mark, 181, 201n41

Twenty-fourth Annual Report of the Board of Managers of the New-York Colonization Society, 105

Two Rivulets (Whitman), 192, 202n48

Types of American Negroes, Georgia, U.S.A. (Du Bois), 206, 275–86, 287*f*

"Uncle Step," 194, 196*f*, 202n51

Uncle Tom's Cabin (Stowe), 139, 141, 149, 161n40, 180

Underground Railroad (Still), 151

Up from Slavery (B. T. Washington), 174

Upham, Thomas, 79n63

uplift, 248–54

Valéry, Paul, 2

vernacular (dialect) language: in Dunbar's poetry, 168–69, 172–73, 176–77, 181; white authors' uses of, 180–81

Vlach, John Michael, 76n39

Waldstreicher, David, 135

Walker, Christian, 291

Wallace, Maurice, 13, 75n27, 233–34, 239n11, 271, 307, 310

Wallis, Brian, 223, 239n8, 242n32

Walls, Laura Dassow, 226

Washington, Augustus, 11, 101–7

Washington, Booker T., 4, 174; at Atlanta Exposition of 1895, 294n7; Bedou's photography of, 267–69, 271–72; lecture tours of, 269, 272n2; on the new century, 186; at Tuskegee Institute, 182, 198n5

Washington, Mary Helen, 329, 340

Waters, Donald J., 183

Waugh, Thomas, 214

"We Are Not Always Glad When We Smile" (Riley), 191–92, 198n7

Webster, Daniel, 36–37

Weems, Carrie Mae, 242n32

Wells, Donna, 41

Wells, Ida B., 4; antilynching campaign of, 14, 299–318, 318n8; as female political leader, 316–17; on lynching, 276–77; pen name of, 317; photographs of, 300, 312*f*, 313–16; racial progress strategies of, 13; speaking tours of, 303, 315, 317; threats against, 307; use of portraiture by, 299, 300–301, 310–18

Westerbeck, Colin, 41, 76n33

"We Wear the Mask" (Dunbar), 171, 183–84, 186–96, 198n7, 202n52

Wexler, Laura, 1, 10, 346; on Agassiz, 242n32; on *anekphrasis*, 212, 233–34; on Mattison, 148; on photographs of domesticity, 150–51, 163n73

Wheatley, Phillis, 149
"When Malindy Sings" (Dunbar), 172–73, 177
When Malindy Sings (Dunbar and Hampton Camera Club), 196*f*, 197n1
White (Dyer), 80n80
white mulatta. *See* passing
Whitman, Walt, 51, 192–93
Wiegman, Robyn, 236–37, 297n42
William Casby, Born a Slave, 31–32, 144
Williams, James, 100n30
Williams, Patricia, 134
Williams, Pat Ward, 290
Willis, Deborah, 1, 4, 273n3, 346; on the Askews, 206, 294n4; on family photographs, 345; on J. P. Ball, 321–23, 328n1
Wilson, Harriet, 100n30, 134
Wilson, Jackie Napolean, 3
Wilson, Joseph T., 245

Wilson, Keith, 246
Without Sanctuary exhibition, 297n44
Woman in Door (Hampton Camera Club), 189–90, 191*f*
Works Progress Administration, 183
World's Columbian Exposition, 304, 309–10
Wounded Knee, 247
Wright, Richard, 201n42

X (black Muslim), 144, 162n50

Yates, Beverly Page, 103, 104*f*
Yellin, Jean Fagan, 159n5
Young, Robert J. C., 286, 289, 296n38

Zaya, Octavio, 144
Zealy, Joseph T., 218, 220, 239n9
Žižek, Slavoj, 237–38
Zoe (character), 147–48, 149

MAURICE O. WALLACE is associate professor
of English and African American studies at
Duke University.

SHAWN MICHELLE SMITH is associate professor
of visual and critical studies at the School of the
Art Institute of Chicago.

Library of Congress Cataloging-in-Publication Data
Pictures and progress : early photography and the
making of African American identity / edited by
Maurice O. Wallace and Shawn Michelle Smith.
p. cm.
Includes bibliographical references and index.
ISBN 978-0-8223-5067-5 (cloth : alk. paper)
ISBN 978-0-8223-5085-9 (pbk. : alk. paper)
1. Photography—Social aspects—United States—
History—19th century. 2. African Americans—
Race identity—History—19th century. I. Wallace,
Maurice O. (Maurice Orlando). II. Smith, Shawn
Michelle.
TR23.P53 2012
770.89′96073—dc23
2011041912